ALFRED A. KNOPF

100 YEARS 1915–2015

The Catskills

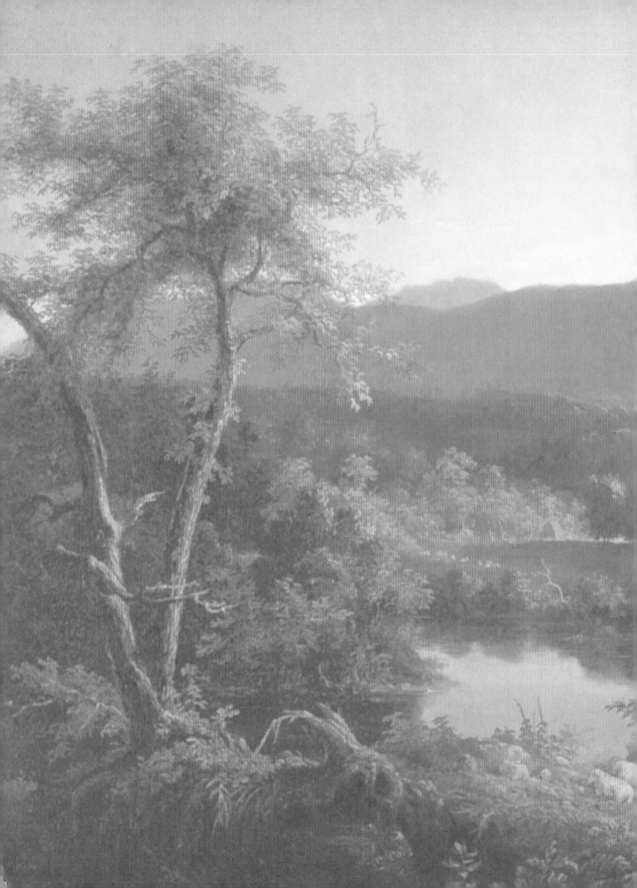

The Catskills

Its History and How It Changed America

STEPHEN M. SILVERMAN

RAPHAEL D. SILVER

ALFRED A. KNOPF NEW YORK

2015

THIS IS A BORZOI BOOK
PUBLISHED BY ALFRED A. KNOPF

www.aaknopf.com

Knopf, Borzoi Books, and the colophon are registered trademarks
of Penguin Random House LLC.

Library of Congress Cataloging-in-Publication Data
Silverman, Stephen M.
The Catskills : its history and how it changed America /
Stephen M. Silverman and Raphael D. Silver.–First edition.
pages cm
Includes bibliographical references and index.
ISBN 978-0-307-27215-7 (hardcover : alk. paper)–
ISBN 978-1-101-87588-9 (eBook)
1. Catskill Mountains (N.Y.)–History. 2. Catskill Mountains Region
(N.Y.)–History. 3. Catskill Mountains (N.Y.)–Social life and customs.
4. Catskill Mountains Region (N.Y.)–Social life and customs.
I. Silver, Raphael D. II. Title.
974.7'38–dc23 F127.C3S55 2015 2014039675

Jacket image: *Kindred Spirits* by Asher Durand, 1849
(detail) © Fine Art/Alamy

Back-of-jacket images: Catskills postcards,
collection of Stephen M. Silverman

Jacket design by Kelly Blair

Manufactured in Singapore
First Edition

From Stephen, to Victoria Wilson

Map of

HARDENBERHG.

PATENT

DELEWARE RIVER

PENSILVANIA

PEPACTON RIVER

BEAVER KILL

The Heirs of Johannis Hardenbergh

Contents

❦

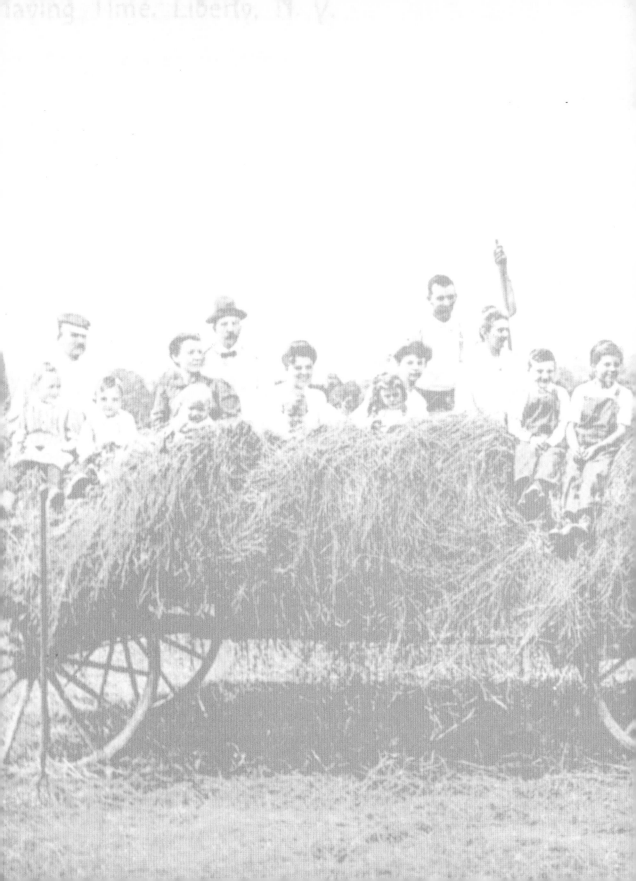

Introduction

As best as can be determined, the first book ever published about the Catskills was a slim volume devoted entirely to a 1753 expedition into researching the plant life of upstate New York, although valuable light was also shed on these early explorers' accommodations: "7 or 8 of us . . . in ye hut hardly big enough for A hen roost."

Since then, the Catskills have inspired any number of books, articles, websites, television stories, and movies, not to mention far better places to bunk. These accounts have run the gamut from general fishing and camping guides, to obscure academic treatises, to nostalgia-rich compendiums about the glory days of the Sullivan, Orange, and Ulster County summer resorts. No less glorious was local historian Alf Evers's encyclopedic *The Catskills: From Wilderness to Woodstock*, first published in 1972 and still the go-to resource for regional lore.

What is presented here, beyond an abiding appreciation for those writers and adventurers who blazed the first trails, is an effort to capture a sense of the color, charm, and even lunacy that for the past four hundred years have characterized the Catskill Mountains and the people attracted to them. At the same time, attention must be paid to how these individuals also managed to place their stamp on America, and how impossible it often was for them to exist anywhere else but in the Catskills. Among the earliest, Henry Hudson arrived purely by accident, only to make the foolish mistake of moving on. Others, chiefly Prohibition-era mob figures famous enough to be remembered by their nicknames (Waxey, Lucky, Legs, Dutch), literally got there by hook or crook, conspiratorially aware of how the remoteness of the terrain protected them. And others still, among them businessman manqué Selig Grossinger, wandered into the woods wishing nothing more than to become simple farmers, only to find themselves (in Selig's case, by necessity) evolving into the standard-bearers for the world-class American hospitality industry.

Besides providing a perfect hideaway as well as an incubator for new ideas, the Catskills offered an abundance of remarkable and marketable resources: bluestone for the early nation's sidewalks, forests for the materials to process the world's leather supply, and lakes and streams to quench the water demands of New York City–possibly even a repository for the natural gas supply that could power the nation. The pioneers who helped exploit the area's assets ranged from the put-upon "quarry Irish," to the miserly leather tanner Winthrop Watson Gilman, to Aaron Burr, whose double-dealing first forced New York City to tap the Catskills for its H_2O, something more than eight million people continue to do to this very day.

The first Christmas trees ever sold in the United States are attributed to a Catskill village farmer named Mark Carr. "About two weeks before Christmas" in 1851, *The New York Times* reported, Carr, whose crops had failed, took his axe to some firs and spruces and "drew two large shed-loads of these trees to the river with his oxen, and started with them to the Metropolis." Renting space at what is now the TriBeCa corner of Greenwich and Vesey Streets, the "jolly woodman . . . found buyers at good prices" for what the newspaper termed "his mountain novelties."

By then, the Catskills had achieved practical recognition as an American brand. Credit here belonged to the publicity generated by the formidable reputation of the Catskill Mountain House, the first such facility of its kind, and the romantic Catskills landscapes conceptualized by the painters of the Hudson River School, the nation's first art movement. The earliest American folk heroes were also firmly rooted in the Catskills: the somnolent Rip Van Winkle and the indefatigable Natty Bumppo.

The Catskills boasted nonfiction heroes too. As the British noose tightened around New York City in 1776, General Washington's orders to evacuate ultimately delivered the state Constitutional Congress to the Ulster County town of Kingston–causing the redcoats to view the new capital as so traitorous that they burned it to the ground. Another virulent act of rebellion, the Anti-Rent War of the 1840s, conclusively extricated Catskills tenant farmers from the stranglehold of their dictatorial landlords and redefined the principles of land ownership in America. It also gave birth to the Free Soil Party and the later Republican Party.

Not that the high elevation always equated with a gift for loftiness. On the subject for which the Catskills remain best known, the Jewish resort area known as the Borscht Belt, Canadian author Mordecai Richler mordantly dissected a

seasonal stay for a July 1965 *Holiday* magazine piece that is still quoted to this day. Referring to the entire stretch as the "Land of Milk and Money," he coined a permanent nickname for the Kosher Acropolis that was Grossinger's: "Disneyland with knishes."

To Richler,

> [E]verywhere you turn, the detail is bizarre. At the Concord, for instance, a long hall of picture windows overlooks a parking lot. There are rooms that come with two adjoining bathrooms. ("It's a gimmick. People like it. They talk about it.") All the leading hotels now have indoor ice skating rinks because, as the lady who runs The Laurels told me, our guests find it too cold to skate outside.

Little could Richler realize that while he was beatifying the Borscht Belt for both its beauties and its blemishes, his visit coincided with the beginning of the end of *La Kvell Epoch*. Still, the author was no more myopic than the skilled social observers (and the inevitable real estate speculators) who grandly predicted that once the primarily Jewish hotels and bungalow colonies closed their doors, the mountains would turn into one giant molehill–forever. On the contrary, as what has been occurring during the past few years bears witness, the story of the region has yet to play out.

"A road trip through New York's Catskills shows that the once-sleepy area is giving the Hamptons a run for its money," *Travel + Leisure* trumpeted in the summer of 2011, showing the love for the "hot" Sullivan County town of Narrowsburg, "where creative New York City transplants have set up shop on Main Street." At Narrowsburg Roasters, for instance, former West Village set designer Will Geisler "makes a killer latte, and his biscotti and maple shortbread are addictive"–a long leap from knishes.

In another highly detectable sign of Catskills transformation, sales for the Chapin Estate, a newly developed twenty-five-hundred-acre gated community in Bethel, are handled exclusively through Sotheby's International Realty. One of Chapin's hundred homes, a seventy-six-hundred-square-foot private residence on Woodstone Trail, comes complete with six bedrooms, two bunkrooms, nine bathrooms, and a 1950s-style diner in the basement. Calling itself Great Bear Lodge, the estate sits on more than five and a quarter wooded acres that lead to a reservoir connected to the Delaware River.

The original owners bought the property for slightly more than $3 million in 2007. A February 2013 listing set the price at $4.25 million.

"IT HAS BEEN a major boost to the economy," the official historian of Sullivan County, John Conway, said about the Bethel Woods Center for the Arts, a state-of-the-art concert, film, and festival venue that stands, symbolically, on the site of the original Woodstock Festival. "There are other things, as well," said Conway. "A very upscale motor track has been built, the Monticello Motor Club, which caters to New Yorkers who have sports cars. The county has also made several efforts in recent years to attract environmentally friendly businesses to the area, with some success. Casino gambling certainly would be another brick in that foundation."

Only that, too, comes with no guarantees. "Historians don't like to talk about the future. It's the one thing we haven't studied," acknowledges urban and environmental historian David S. Stradling, author of 2007's *Making Mountains: New York City and the Catskills*. "One thing is certain: regardless of what happens in the Catskills, New York City plays a role in determining what happens here."

Not that it has ever been an easy blend. According to Stradling, "The real estate boom, felt throughout the Northeast, has been especially evident in the Catskills, where rural homesteads have sold for suburban prices." The latest rush to build safe-haven second homes in the Catskills started in the wake of the September 11, 2001, terrorist attacks, and then picked up again as the post-2008 economic collapse finally began to ameliorate.

While recognizing the positive effects New York City money has had on the local economies, Stradling also notes that "the arrival of so much city capital has increased talk of 'them' and 'us' and sparked fears that higher real estate values and taxes might force locals from their homes." Then again, if history is any lesson, "the only thing the past assures us," Stradling asserted in a 2010 interview, "is that it's difficult to know exactly what will happen."

The Catskills

The Dawn

<div align="center">✦✦═◉═✦✦</div>

I

If ever a compelling Fate set its grip upon a man and drove him to an accomplishment beside his purpose and outside his thought, it was when Henry Hudson—having headed his ship upon an ordered course northeastward—directly traversed his orders by fetching that compass to the southwestward, which ended by bringing him into what now is Hudson's River, and which led on quickly to the founding of what is now New York.

—THOMAS A. JANVIER, historian, 1909

Two years before his own crew condemned him to an icy death, a gamely determined Henry Hudson set sail from Amsterdam on April 4, 1609, having recruited sixteen Dutch and four English sailors for what all knew would be a rigorous journey. Their three-masted, eighty-ton *Halve Maen*, or *Half Moon*, took her name from Vice Admiral John Kant's victorious flagship in a decisive 1602 naval battle against the Spanish, but for Hudson the mission at hand was not military but mercantile. It also marked the obsessive English explorer's third attempt at finding a financially advantageous shortcut to the spice-rich Orient.

Hudson's two unsuccessful earlier efforts, in 1607 and 1608, had been financed by the Muscovy Company, a London-based commercial enterprise that traded with Russia and as early as 1585 had employed navigator John Davis to search for a Northwest Passage to Asia. As the self-proclaimed "Merchant Adventurers of England for the Discovery of Lands, Territories, Iles, Dominions, and Seignior-

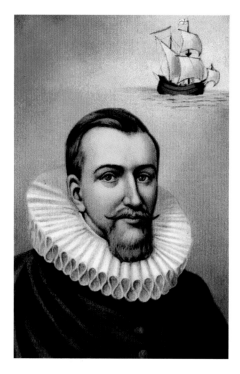

ies Unknown," the Muscovy Company was banking on Hudson to discover a route that would supersede the existing yearlong course around South Africa's Cape of Good Hope.

But Hudson, having already disappointed his benefactors not once but twice, could not sell them on a third sailing, and, in what came as a blow to his healthy ego, suddenly found himself a free agent. Enter Emanuel van Meteren, the Dutch consul in London, who proffered a friendly suggestion that carefully steered Hudson toward England's great trading rival, the Netherlands—specifically, the Dutch East India Company. In fact, the firm had instructed Van Meteren to usher the explorer through their door. According to company intelligence, Russell Shorto reported in his exceptional modern account of the Dutch colonization of Manhattan, *The Island at the Center of the World*, the Dutch East India Company had very good reason for wanting him: "Hudson was on the verge of discovering the long-sought northern passage of the Asian markets."

Such information was hardly a secret; just as the Dutch East India Company was pursuing Hudson, the English found themselves reversing their position about letting him loose, and the French were also hoping to entice him over to their side. What ultimately persuaded Hudson to align with the Dutch merchants, beyond their already placing a deal on the table, was that he simply felt at home in Holland. Shorto suggests that Hudson, in his midforties at the time of this proposed third voyage, may have spent an earlier part of his life in the country. Certainly he could claim friends in the Netherlands, among them Joost de Hondt, a mapmaker who hosted Hudson at his home in The Hague, then served as interpreter during the mariner's negotiations with the East India Company.

Among the many details of the contract was the immovable provision that Hudson was to devise a brand-new route and sail northeast on the Arctic Ocean, toward Russia, rather than northwest, toward Greenland, as he had in the past. As the terms firmly stipulated, he would "think of discovering no other routes or passages."

And while Henry Hudson would meet his death without finding a shortcut to Asia, he did manage to chance upon something that he most surely never anticipated.

The Catskill Mountains.

ONLY EIGHTY-FIVE FEET LONG, with her unmistakable bright colors, bold geometric patterns on her wooden sides, and a single four-foot-long falconet to serve in her defense, Hudson's *Half Moon* was further distinguished by her six sails, steep stern, and a bow that arched forward into a curve, or a half moon. Her main deck rose only a few feet above water, a burdensome constraint that, except on those rare days of calm seas, forced the domineering captain's disgruntled men to remain below, where they shared space so dark and narrow that they could never fully stand or recline.

While little is known about Hudson's early years, or even his exact year or place of birth (likely London, in the 1560s), the best estimates place him in his teen years learning to navigate the rocky shores in an area on the North Sea known as the East Marches, in the small Northumberland coastal village of Longhoughton. He married a woman named Katherine and had three sons with her: John, who accompanied Henry on his four voyages from 1607 to 1611, including the fatal one; Richard, who became a successful businessman with the East India Company and reputedly the first Englishman to acquire a residency permit in Japan; and Oliver, about whom little is known.

By the time Hudson set sail aboard the *Half Moon*, his reputation was such that Captain John Smith, of the two-year-old Virginia Colony in the Americas, was happy to share the latest French maps with his fellow Englishman, as well as the notion, based on Native American speculation, that a body of water existing to the north of Virginia would eventually spill out into the Sea of Cathay. This may explain why Hudson took it upon himself to change course off the coast of Norway a month into the voyage, when the ship encountered what crewman Robert Juet, a fifty-one-year-old from Limehouse, London, described as "much trouble with fogges, sometimes, and more dangerous of Ice."

Blatantly disregarding his Dutch East India Company agreement, Hudson ordered the *Half Moon* westward across the North Atlantic, on what his twenty-first-century chronicler Douglas Hunter would term "a rogue voyage of discovery."

"IN THE NIGHT we had much Rayne, Thunder, and Lightning, and windshifting," recorded Robert Juet in early July, as the *Half Moon* reached the Grand Banks, south of Newfoundland. By mid-month Hudson had landed on what is now Nova Scotia, where his crew replaced the ship's masts with fresh timber, feasted on lobster, and, according to Juet, were greeted by "two Boates . . . with sixe of the *Sauages* [o]f the Countrey, seeming glad of our coming."

Continuing south along the coast to the Chesapeake Bay and the present-day North Carolina Outer Banks, Hudson then backtracked up to Delaware Bay, frustrated at being nowhere closer to his intended goal. Steering farther north, on September 3 he entered the same harbor that eighty-four years earlier had welcomed both the Lyon-born navigator Giovanni da Verrazzano and the Portuguese explorer Estevan Gómez. Except, unlike his predecessors–Verrazzano, commissioned by King Francis I of France to find a westward passage to Asia, got as far as the broad harbor between what are now Brooklyn and Staten Island, only to continue north along the coast of North America; Gómez, sailing for Spain in the fleet of Magellan, found the mouth of what later became the Hudson River, then shifted course for Florida–Hudson decided the *Half Moon* would proceed upstream.

His hope, based solely upon gut instinct, was that the waterway he christened the "Great River of the Mountains" was in fact what he had set out to find: the long-sought-after gateway to the East.

THE WEATHER THAT WEEK was "fair and very hot," Juet wrote. From his September 4 entry:

> At night the wind blew hard at the north-west, and our anchor came home, and we drove on shore, but took no hurt, thanked be God, for the ground is soft sand and ooze.

On the river shore, Hudson made contact with members of the Algonquin nation, recording in his journal that they were "swarthy natives [who] all stood around and sung in their fashion; their clothing consisted of the skins of foxes and other animals, which they dress and make the skins into garments of vari-

ous sorts." In return, according to an 1801 account by Moravian missionary John Heckewelder, the Algonquins couldn't help but notice how the haughty Hudson was dressed, either: in a "red coat all glittering with gold lace."

The hosts presented the captain with gifts of tobacco and his first taste of American corn, a discovery Hudson called "Turkish wheat, which they cook by baking, and it is excellent eating."

Further describing his new acquaintances, Hudson wrote:

> They had no houses, but slept under the blue heavens, sometimes on mats of bulrushes interwoven, and sometimes on the leaves of trees. . . . They appear to be a friendly people, but have a great propensity to steal, and are exceedingly adroit in carrying away whatever they take a fancy to.

Within that same week in September, Hudson and the *Half Moon* crew coasted past the steep ridge known to Native Americans as the Wall of Manitou, or the "Wall of Great Spirit," in tribute to the invisible force that delivered both strength and balance to life. Standing more than three thousand feet high, the escarpment rises like a straight shot, practically without foothills, from the Hudson Valley floor. Clearly impressed, Juet, after several days of simply recording how unbearably hot the weather had been, suddenly grew expansive. In documenting the sighting, he provided what is the first known written account of the Catskills:

> The fourteenth, The land grew very high and mountainous. The River is full of fish. . . .
>
> The fifteenth, in the morning was misty untill the Sunne arose: then it cleered. So wee weighed with the wind at South, and ran up the River twentie leagues, passing by high Mountaines. Wee had a very good depth, as sixe, seven, eight, nine, ten, twelve, and thirteene fathomes, and great store of salmons in the river. . . . At night we came to other Mountaines, which lie from the Rivers side. There we found very loving people, and very old men: where we were well used. Our Boat went to fish, and caught great store of very good fish.

According to nineteenth-century historian John Stevens Cabot Abbott, Hudson and his men first viewed the Catskills following the onset of fog so dense that they could only see a few yards ahead of themselves. In Abbott's words:

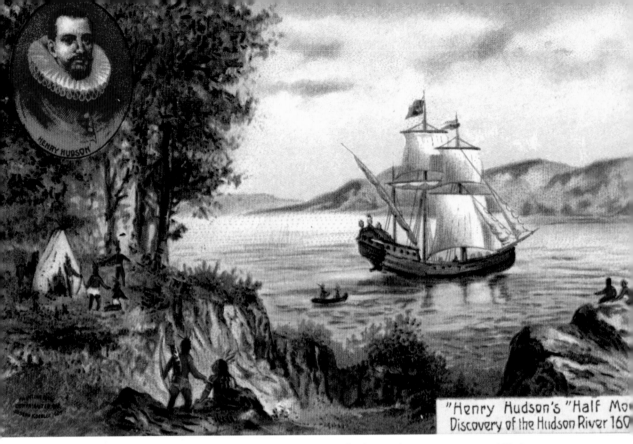

"Henry Hudson's "Half Mo[...]
Discovery of the Hudson River 160[...]

By the time of Hudson's 1609 voyage, the navigator "had gained a reputation as a skilled seaman who bravely ventured into little-known waters and returned with ship intact and his crew alive," said historian Peter C. Mancall.

The sun soon dispelled the fog, and the voyage was continued, and by night the *Half Moon* reached a point supposed to be near the present site of Catskill Landing. The natives were numerous, and very friendly. They came freely on board, apparently unsuspicious of danger. It was noticeable that there were many very aged men among them. The river seemed full of fishes, and with their hooks they took large numbers. The next day the Indians came on board in crowds, bringing pumpkins and tobacco. The vessel's boats were sent on shore to procure fresh water.

As best as can be determined, those experiences marked the extent of the explorers' first visit. "Early the ensuing morning," wrote Abbott, "they pushed up the river five miles, to a point probably near the present city of Hudson."

Although some sources credit the name "Catskills" to Hudson, while others

cite a Mohican chief named Cat, it is generally thought to have come about by combining the Dutch word for "creek," *kill,* with the mountain lions that roamed the wilderness.

Claiming the territory in the name of the Dutch, Hudson wrote in his navigation documents, "It is as pleasant a land as one need tread upon; very abundant in all kinds of timber suitable for shipbuilding, and for making large casks or vats." Glimpsing the copper tobacco pipes used by the natives, "I inferred that copper might naturally exist there," he noted, also surmising the same about iron, at least "according to the testimony of the natives, who, however, do not understand preparing it for use."

Hudson progressed upriver into the following week, sailing 150 miles, as far north as present-day Albany. The Northwest Passage once more proving to be beyond his grasp, he reversed course and headed back downriver–only to run into a mud bank "in the middle of the river nearly opposite the present city of Hudson," according to Abbott. The historian also wrote:

> Without much difficulty the vessel was again floated, having received no injury. But contrary winds detained him upon the spot two days. In the meantime several boat parties visited the banks on both sides of the stream. They were also visited by many of the natives who were unremitting in their kindness.
>
> A fair wind soon springing up they ran down the river eighteen miles, passing quite a large Indian village where Catskill now stands, and cast anchor in deep water, near Red Hook.

Over the next few days Native Americans boarded the ship, trading some small skins for the crew's knives and other trinkets. "This is a very pleasant place to build a Towne on," wrote Juet, alert to assessing the value of the land, given that metals and mining also fell within the purview of the Dutch East India Company.

> The Road is very neere, and very good for all winds, saue an East Noth-east wind. The Mountaynes looke as if some Metall or Minerall were in them for the trees that grow on them were all blasted and some of them barren with few or no leaves.

Foul weather believed to be a nor'easter slammed the *Half Moon* upon its October 3 return to the waters between present-day Hoboken and Manhattan's West

Side ("Very stormy," wrote Juet), but with the calm that returned on October 4, the *Half Moon* hoisted anchor and journeyed back across "the main sea." Noted Juet:

> We continued our course toward *England*, without seeing any Land by the way, all the rest of this moneth of October. And on the seuenth day of November, stilo nouo, being Saturday : by the Grace of God we safely arrived in the Range of *Dartmouth in Deuonshire*, in the yeere 1609.

Hudson returned to his native England and not the Netherlands primarily because he had violated the Dutch East India Company's command that he sail east. After he ensured that his ship's log was delivered to Consul Van Meteren, thereby granting the Netherlands the right to lay claim to his discoveries, "English authorities detained Hudson bodily," wrote Shorto. Their claim against him: "voyaging to the detriment of his country" by sailing under the Dutch flag. As a condition of his release, Hudson was ordered back to the Americas, this time aboard the English ship *Discovery,* and was once again commissioned to find the Northwest Passage. His backers, besides five noblemen and thirteen private merchants, were,

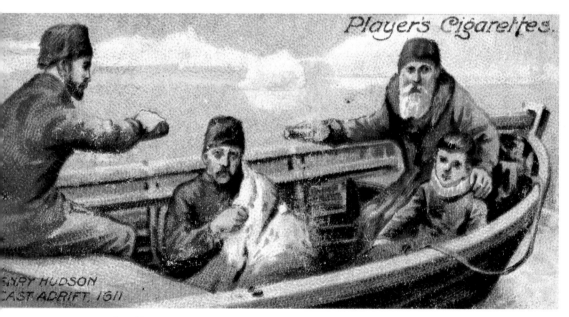

British soldiers in World War I could open their cigarette packs and find illustrated cards showing Hudson, cast adrift by his own crew, as he faced his final days.

at a combined equal investment of 600 pounds sterling, the British East India Company and, once again, the Muscovy Company.

This time the voyage played out tragically. After spending the summer plying what would eventually come to be called Hudson's Bay, the *Discovery* crew suffered a particularly harsh winter. Hudson allegedly hoarded food for favored crew members, while others, on the captain's orders, had their sea chests searched for any concealed provisions. Finally, the men could tolerate Hudson's pomposity and bullying no more. When the packed ice that had trapped their ship finally broke in late spring and Hudson prepared to resume his quest for the route to Asia via the frozen north–based on a theory that not only was there perpetual sunlight at the top of the world but also warm currents–he was ambushed on June 22, 1611, by those who wished to return to England. As one participant recounted, according to Abbott:

> They had been detained at anchor in the ice about a week, when the first signs of the mutiny appeared. [Crew member] Green, and Wilson the boatswain, came in the night to me, as I was lying in my berth very lame and told me that they and several of the crew had resolved to seize Hudson and set him adrift in the boat, with all on board who were disabled by sickness; that there were but a few days' provisions left; that the master appeared entirely irresolute, which way to go; that for themselves they had eaten nothing for three days. Their only hope therefore was in taking command of the ship, and escaping from these regions as quickly as possible.

Reputedly led by Juet, the crew struck at daybreak. Seizing Hudson, tying his hands behind his back, and placing him along with seven of his loyalists, including his teenage son John, on a tiny sloop with oars–as a still-clueless captain demanded to know, "What is the meaning of this?"–the thirteen mutineers cast their prisoners adrift into freezing open water somewhere off the coast of Newfoundland.

They were never seen again.

At the time Henry Hudson sailed up the "Great River of the Mountains," the Catskills were inhabited by some two to three thousand Mohicans, also known as Mahicans—although the Dutch, having trouble with the pronunciation, most frequently said "Manhigan." Unlike another Eastern Algonquian–speaking sub-group of the Algonquian peoples encountered by Hudson, the hostile Wappingers (who lived on the eastern bank of the river, in what would later become Dutchess County), the Mohicans who welcomed the navigator were both approachable and eager to trade, as were (in the area between the Catskills and the Adirondacks) the Mohawks, considered the "Keepers of the Eastern Door" from the Iroquois nation and the protectors of the land against native invasion from New England and lower New York regions.

Despite its failure to produce a Northwest Passage, Hudson's 1609 journey upriver from Manhattan did serve as the catalyst for what would become a lucrative fur-trading business; in 1614, a Dutch trading post was founded by the New Nether-land Company, which was to evolve into the West India Company, for the purposes of exploiting the region for profit. The post's location, named for the Dutch House of Orange-Nassau, was Fort Orange, later renamed Albany by the English, and its setting was a riverbank that had served as the hunting ground of the Mohicans. The tribe apparently welcomed the Dutch and, according to Russell Shorto, the various foreign products they brought to trade: "fishing hooks, axes, kettles, glassware, nee-dles, pots, knives and duffel (the rough wool cloth . . . which gives us the term 'duffel bag')."

Farther south, the Dutch gained an even stronger foothold with Peter Minuit's May 24, 1626, purchase of Manhattan island from the natives, a legendary transac-tion that made New Amsterdam the capital of New Netherland. To the north, in the Hudson Valley, Esopus, later called Kingston, was settled in 1653, and other villages would be developed over the next century—although by then the Dutch empire in America had not only weakened but crumbled.

In 1664, the British, eager to expand their influence on the American continent, drove out the Dutch and instituted more than one hundred years of colonial rule. Accordingly, New Amsterdam underwent a name change, to New York, in honor of its conqueror, James, Duke of York.

Rich merchants dreamed of land as a hiding place for the profits of trade, since undeveloped lands were not taxed. Others dreamed of founding towns in the wilderness and seeing their wooded valleys converted into patchworks of productive fields and meadows. To some, land was a means of indulging in the excitement of speculation. . . . All a land speculator had to do was sit tight.

—ALF EVERS

The development of the Catskills officially began on April 20, 1708, when Johannes Hardenbergh, an enterprising speculator, acquired by grant from England a two-million-acre tract of land within the region, roughly the equivalent in size to all of modern-day Delaware and Rhode Island. The bargain price for the enormous parcel, which became known as the Hardenbergh Patent, was only sixty pounds—the modern equivalent of $1,500.

"The annals of the ancestry of the Hardenberg family reach back into the twelfth century, stretching in an unbroken line more than seven hundred years to 1174, when the old Castle Hardenberg in the Harz Mountains, Germany, was the abode of Dietrich von Hardenberg, the supposed founder of the family," according to an account in the 1913 *Genealogical and Family History of Southern New York and the Hudson River Valley*, which also explained that the Dutch side of the family added the final "h" to the Germanic name. The first member of the family to set foot in America, in 1644, was Arnoldus Van Hardenberg, whose younger brother Jan was Johannes's grandfather. Arnoldus was a cargo merchant from Amsterdam, and though he would remain in the New World for only ten years, until 1654, he served on the council of the director-general of the New Netherlands. Jan also arrived from Amsterdam in 1644, and, according to family records, owned a house and garden on what is now the northwest corner of Broad and Stone Streets in Lower Manhattan. With his wife, whose name does not appear to have been recorded, Jan fathered a son, Gerrit, who would become Johannes's father. As told in *The Hardenbergh Family*, a 1958 genealogical study by Myrtle Hardenbergh Miller:

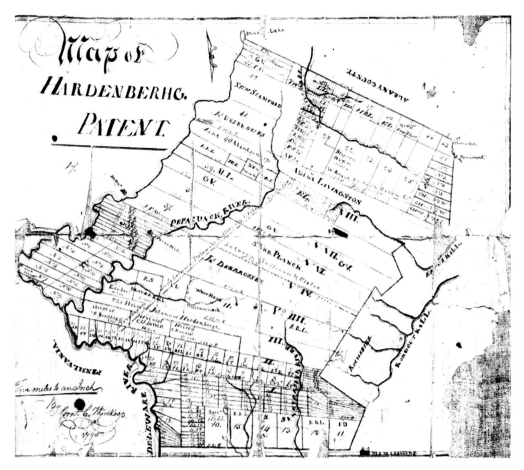

Much of the eighteenth century was spent arguing over the boundaries and even the legalities of the Hardenbergh Patent, shown here in a 1749 map.

In 1690 Gerrit was the owner and captain of the sloop "The Royal Albany," and received on July 3, 1690, a commission to act against the French. A few months later, on September 22, 1690, he was appointed a member of a committee to take inventory and made appraisal of the cargoes of certain vessels at New York.

"Johannes, eldest son of Gerrit Janse and Jaepie (Schepmoes) Hardenbergh, was born about 1670, at Albany, and appears on record, January 2, 1689, as the purchaser of a lot from the trustees of the town 'on the corner of the street opposite the house and barn of Corneis Masten' in the village of Kingston, Ulster County, New York," states the family record. Johannes was twenty when acting governor Jacob Leisler of the New York Colony appointed him high sheriff of

Ulster County, although the position lasted little more than a year, until Leisler was hanged as a traitor to the Crown for refusing to surrender his position to the royally appointed governor, Colonel Henry Sloughter.

In his personal life, per the Hardenbergh ancestry record, Johannes

married (first) July 10, 1696, Hillegonde Myers, a young woman from New York, probably the daughter of Andries and Vrountje (Van Vorst) Myers, as they are on records as sponsors at the baptism of the only child of this marriage, a daughter Katherine, baptized October 4, 1697, and died previous to October, 1708. The mother died previous to September 1698, and he married (second) December 5, 1699, by license granted September 12, 1698, Catherine Rutsen. Children: Gerardus and Jacobus, twins, the second died young; Marrytie, Jacoba, Johannes, Catherine, Rutse, Abraham.

"In 1709 he was again appointed High Sheriff of Ulster County," the record states, "and was a trustee of the town of Kingston in 1707–09–12." It was during this time that Johannes made his request to the Crown for the land parcel on behalf of himself and his business partners, whose original intention was to fend off a modest appeal by farmers regarding land along the Esopus Creek in Ulster County. Their filing read:

Petition of Johannes Hardenbergh and others for a patent for lands "beginning at ye Sandberg or hill" at ye N. E. corner of ye lands of Ebenezer Wilson & Co. (Minnisink Patent) thence northwesterly to ye Fish Kill River, and west to the headwaters thereof, including the same, thence to a small river called Cartwright's Kill, and so by ye said Kill to ye northwesternmost bounds of Kingston, on said Kill, thence by ye bounds of Kingston, Hurley, Marbletown and Rochester, and other patented lands to the beginning.

The farmers had been seeking grazing fields for their cattle, although in their petition they had not adequately surveyed the property or its proper boundaries. Their other mistake was neglecting to negotiate permission to purchase the land from the Nanisino Esopus Native Americans who owned it in the first place.

This was how both luck and circumstance conspired to favor Johannes Hardenbergh, who in the name of the Crown was granted the patent and thereafter took on an unofficial title: the Lord of the Catskills.

THE INDIVIDUAL FROM WHOM the Hardenbergh Patent was secured, Edward Hyde, Third Earl of Clarendon, styled Viscount Cornbury, was not your typical bureaucrat. As governor of the colony of New York between 1701 (when he was forty) and 1709, Cornbury represented the interests of his cousin Queen Anne of England, in whose image he enjoyed dressing, his mustache and Napoleon III–style whiskers notwithstanding. Cornbury was also known to have a fetish for ears; his targets, often mistaking him for a drunken streetwalker, would find him lurking in the dark shadows near Wall Street, waiting to pull on their lower lobes when they would approach him for a good time. (He was also fascinated with his wife's ears, and when he finally tired of them, it was said, he tired of her.)

Cornbury was so notorious that a posthumous portrait purported to be of him in female dress has hung for years in the collection of the New-York Historical Society, even well after it was determined that the subject of the painting really wasn't his lordship. (The society tolerated the portrait's inaccuracy because it was believed the work represented the American attitude toward "the decadence of British culture," the head of the Historical Society, Valerie Paley, said in 2012.)

Described by nineteenth-century historian John Romeyn Brodhead as "a mean liar, a vulgar profligate, a frivolous spendthrift, an impudent cheat, a fraudulent bankrupt, and a detestable bigot"–another called him a "degenerate and pervert who is said to have spent half his time dressed in women's clothes"–Cornbury is reputed to have convened the 1702 New York Assembly clad in a hooped gown and carrying a fan as a self-designated tribute to his cousin on the throne. This prompted the eighteenth-century English art historian and politician Horace Walpole to tell a friend, "When some of those about him remonstrated, his reply was, 'You are very stupid not to see the propriety

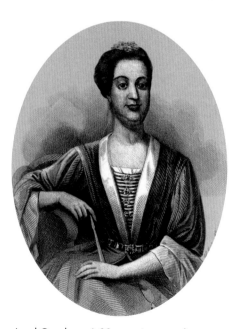

Lord Cornbury (1661–1723) granted the Hardenbergh Patent but is better remembered for emulating in both dress and demeanor his rotund royal cousin Queen Anne as was gamely depicted here.

of it. In this place and particularly on this occasion I represent a woman and ought in all respects to represent her as faithfully as I can.'"

Regarded as possibly the worst governor Britain ever imposed on an American colony (Queen Anne also made him governor of New Jersey, in 1702), Cornbury was relieved of his position and imprisoned for unpaid debts in 1708. After his death, in 1723, he was singled out by nineteenth-century historian George Bancroft for embodying the English aristocracy's "arrogance, joined to intellectual imbecility."

Because approval of the Hardenbergh Patent was carried out in the last remaining days of the Cornbury administration, it has been speculated that in all likelihood many of the transaction's illegalities were overlooked. For his part, Cornbury was openly prejudiced against mountains and rocks, just as he was disdainful of "any such nonsense as letting people have a larger share in their government," according to Alf Evers, who also detailed the governor's July 1702 state voyage up the Hudson to confer with the Iroquois. Although Cornbury did not outfit himself as a woman for the occasion, he did dress up his barge and crewmen "in smart new uniforms," wrote the historian. Beyond that, Evers suggested that "Queen Anne's remarkable cousin" saw the Catskills as nothing more than a tangible asset that he could sell to the highest bidder, who was, apparently, Hardenbergh.

"If anyone wanted them—and was willing to pay for them—Cornbury was in no position to hesitate," said Evers. "He would simply make the best bargain he could."

ANOTHER UNUSUAL ASPECT of the deal was that the Hardenbergh Patent was extended not to an individual but to a corporation. By the time the gift was made in the name of "Anne by the Grace of God of England, France, and Ireland, Queen, Defender of the Faith," to "our loving subjects," as New York provincial secretary George Clarke put it, grants were commonly bestowed upon a particular person in recognition of service to the mother country and rarely exceeded two thousand acres. Grants to corporations, meanwhile, were not subject to such restrictions, and Hardenbergh had shrewdly formed a business operation with six others, including some who were only acting as front men: Leonard Lewis, Philip Rokeby, William Nottingham, Benjamin Feneuil, Peter (Pierre) Fauconnier, and Robert Lurting, who later became mayor of New York.

As observed by the young land surveyor Jay Gould, long before his days as a financial speculator, in his 1856 *History of Delaware County:*

The vast compass of the Hardenbergh Patent, when its limits had been sur-
veyed and located—a grant of something less than two million acres to a single
individual—was a species of monopoly, which, even the British government,
with her aristocratic notions, failed to relish, and an order was issued [afterward]
preventing grants of more than a thousand acres to single individuals, or when
associated together, of a number of thousand equal to the number of associates.

Despite fifty years of ongoing but fruitless legal challenges to the patent's
validity, the original owners and their heirs were left title to nearly two million
acres. To this day, those lands comprise much of what is known as the Catskills.

III

A stubborn and sometimes inspired defense, and the great good for-
tune of General George Washington and his armies, kept the Hudson
from ever falling completely into enemy hands. And this contributed
mightily to the winning of the War of Independence.

—CARL CARMER

As America marched toward independence, sympathies in the mountains were
stubbornly divided. Owners of Hardenbergh Patent lands favored the Revolution-
ary cause, primarily out of fear that the British might confiscate their properties
(or, at the very least, impose a crippling land tax), while the region's growing
number of tenant farmers, eager to retaliate against their often-despised Whig
landlords, threw their support behind the redcoats. As a further incentive, rumors
abounded that the Crown had promised the Catskills farmers free land and inde-
pendence from their landlords in exchange for joining the British army.

In late June 1776, an armada of British ships under the command of General
William Howe arrived precipitously in New York Harbor, gateway to Atlantic
shipping and the Hudson River access route to the northern frontier. "I could
not believe my eyes," Private Daniel McCurtin wrote in his journal after gazing
upon the sudden invasion. "Keeping my eyes fixed at the very spot, judge you of
my surprise when, in about ten minutes, the whole bay was full of shipping. . . . I
declare that I thought all London was afloat."

Aboard the fleet were thirty-two thousand British and Hessian troops, pre-

pared to do battle with the nine thousand men (only seven thousand of whom were able-bodied) led by the Continental Army's general George Washington. Master tactician that he was, Washington chose to deal with so formidable an opponent by dividing his forces between Long Island and Manhattan. "Prompted by fear, a tremendous exodus of women and children left New York," wrote Washington biographer Ron Chernow. Those evacuated included Washington's wife, Martha, "exiled," said Chernow, "to the comparative safety of Philadelphia."

In late August, having lost Long Island, the Americans fell back to their fortified position in Brooklyn Heights. From there, Washington, in a perilous six-hour operation, successfully got them to Manhattan in a flotilla of small boats that managed to go undetected by the British (the night's dense fog worked to great advantage). There was no time to bask in his victory; Washington next had one of two options: retreat and burn New York City, or abandon it to the British.

Instructed by the Continental Congress to leave Manhattan standing, Washington prepared fortifications in upper Manhattan, turning away General Howe's troops in the Battle of Harlem Heights and allowing the Americans to withdraw into New Jersey.

NEW YORK DECLARED ITSELF an independent state on July 9, 1776, the same day Washington gathered his troops to have the Declaration of Independence read. Not only was the document met with cheers by Washington's men, but their celebration reached a near riot. Storming Bowling Green at the southern tip of Manhattan, they toppled the statue of King George III perched proudly on his horse and removed his majesty's head so they could parade it around as preparations were made to melt down the rest of the figure and turn old King George into forty-two thousand musket balls.

According to an 1879 account titled "Birth of the Empire State, Formation of the First Constitution of New York," by John Austin Stevens, founder of the Sons of the Revolution in the State of New York, "On the tenth May 1776, the Continental Congress adopted a resolution recommending" that the Provincial Congress meet to draft a constitution for New York on "the second Monday in July." That they did, and the delegates, their lives threatened for having broken with the Crown, "continued to meet, taking action for the organizing of regiments and providing for the defense of the city, until the thirtieth of June, when the British fleet and army under Sir William Howe . . . entered the harbor." The

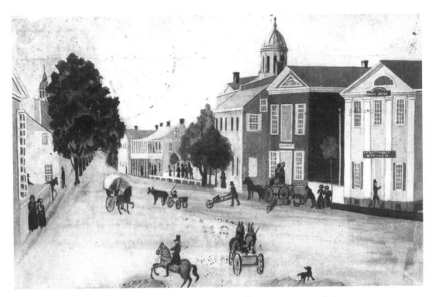

Artist Herman Gould Smith's 1830 rendering of Kingston's Wall Street was described as "[t]he scene of thrilling historic events attending the Birth of New York State."

arrival prompted the delegates to take all documents and the state treasury to White Plains, but that too was a location not free of danger. Still, parliamentary procedure was followed.

On July 10, a day before the Congress received its copy of the Declaration of Independence, "it was resolved and ordered that the style or title of the House be changed from that of the 'Provincial Congress of the Colony of New York' to that of the '*Convention of the Representatives of the State of New York.*'" Once again, however, this was no time to stand still. Having resolved to form a state government, the delegates learned "the state of affairs in and about the city of New York had become alarming [because] a second fleet, under command of Lord Howe, arrived at Sandy Hook." It also happened to be moving upriver in their very direction.

On July 29, the Congress reconvened in a church in "the town of Harlem," but remained there only a month. This time, word reached them that they were "liable to surprise by a small body of men from the enemy's ships of war in the Sound and the situation of their army on Long Island." According to Stevens's account, "the Convention adjourned to Fishkill, in Dutchess County."

Safety wasn't the issue in the new location; uncomfortable lodgings were, along with a voiced complaint that their meeting place, Trinity Episcopal Church, was "foul with the dung of doves and fowls and so uncomfortable without any benches,

seats or other conveniences"—not to mention the general threat of an encroaching smallpox epidemic. The dreaded disease did arrive in the dead of winter, yet again forcing the Congress, on January 25, 1777, to seek new headquarters.

Such were the confluence of events that on February 11 brought the fifty delegates, including their leaders, John Jay, Gouverneur Morris, and Robert R. Livingston, to their next—and, for the purposes of their congress, final—destination, where the New York State constitution would be written and approved: a quiet country home to wheat farmers for the past century, the Ulster County town of Kingston.

IN 1652, five Dutch families from the Rensselaerwyck Patroon, which later became Albany, migrated south on the river to settle on the fertile floodplains that bordered the Esopus Creek. For the previous five hundred years it had served as the farmland where the Esopus Indians, of the Algonquin nation, had grown their maize, but within a year it was sold to the Dutch in exchange for blankets and clothing, along with ammunition and alcohol. At the beginning the two groups coexisted peacefully, until such time as the Dutch farmers' rapidly multiplying livestock trampled the Esopus crops.

As the relationship grew retaliatory, in 1658 Peter Stuyvesant, director-general of the New Netherland Colony, met with about fifty members of the Esopus and demanded they stop killing settlers and their animals—indeed, have no contact whatsoever—and sell the remainder of their farmland to him. Stuyvesant further ordered the settlers to isolate themselves by moving their log cabins and barns to a bluff on higher and more centrally located ground, demanding the construction of a fourteen-foot-high wooden stockade around an enclosed area that stretched thirteen hundred by twelve hundred feet.

This negotiated peace between the Dutch and the Native Americans lasted only a year. The First Esopus War began in 1659, after colonists attacked and killed a group they accused of being intoxicated. As retribution, several Europeans outside the stockade were captured, some were tortured, and although the stockade could not be penetrated, Dutch buildings outside the barricade were burned and farm animals slaughtered. A treaty ending the skirmish on July 15, 1660, deeded the entire Esopus property to the Dutch, who in turn were to make restitution on crops their enemies had lost. Soon after, Stuyvesant enacted a law to rename the village Wiltwyck, or "wild woods." It would take the English to name it Kingston.

By the time those drafting the constitution arrived, making the already his-

toric town the state capital, Kingston's allegiance to the cause was well established. According to nineteenth-century town historian Marius Schoonmaker:

> Ulster County had then already contributed largely in men toward the defence of the country. A considerable number of residents had enlisted and were serving in the Continental Army. Several of its regiments had been drafted and were serving in the passes of the Highlands, and the rest were under orders to march at a minute's notice with five days' rations. Thus was Ulster County situated when General Washington's order was issued.

A marked improvement over Fishkill, Kingston still had its deficiencies. The courthouse, which served as the delegation's meeting place, had the misfortune to be located over the town jail. "These prisoners were kept in such state of crowding and filth," the prolific historian of the Revolutionary era, Sydney George Fisher, wrote in his 1908 *Struggle for American Independence*, "that the stench rose up into the room of the convention; and a curious resolution was passed on motion of Gouveneur Morris, describing the 'nauseous and disagreeable effluvia' in which the members were compelled to sit, and allowing them to smoke 'for the preservation of their health.'"

After laboring for two months, the delegates created "[i]n forty-two sections and fewer than seven-thousand words," according to *The Oxford Handbook of New York State Government and Politics,* a constitution that "embodied the great ideas and institutions for which it is justly praised."

> Its preamble incorporated the Declaration of Independence, and in particular its treatment of executive power directly influenced the work of the 1787 Constitutional Convention in Philadelphia. Just as important are the issues that were not addressed . . . no clause prohibiting domestic slavery was included. No provision mentioned education, and most surprisingly, no method of amendment was provided.

Voting rights for property owners, separation of church and state, religious freedom, a right to trial by jury, due process, protection against bills of attainder—all were secured by the document.

"On Tuesday, the 22d day of April, 1777, the members of the convention, together with people in the vicinity, were called together by the merry peal of the

Kingston residents fled en masse when the word spread that the British—referred to as "the vandal hordes"—were coming.

church and other bells in the village, to listen to the reading and promulgation of the constitution of the State in front of the Court House," wrote Schoonmaker.

> At the appointed hour Colonel Pierre Van Cortlandt, Vice-President of the Convention, and Robert Berrian, one of its secretaries, mounted the primitive rostrum . . . consisting of a few planks resting on barrels . . . and the secretary at once proceeded to read the document in the presence of the assembled people. Thus was New York placed under a model constitutional government, and all the sacred rights of freeman guaranteed to her citizens.

AS A SEVERE REPRISAL for New York's having formed a government, on October 16, 1777, British major general John Vaughan and his troops moved up the Hudson River from New York City to Kingston. The military man considered the town nothing less than a "hotbed of perfidy and sedulous disloyalty to King George the Third and His Majesty's Parliament." The British mission: to attack and torch the town.

Citizens prepared for the onslaught as best as conceivably possible. "In Kingston," Schoonmaker wrote, "there was, of course, the greatest excitement and commotion, the inhabitants striving to get away themselves, and moving as much

of their worldly possessions and valuables as possible out of reach of the vandal hordes." The majority took refuge with friends in Hurley, Marbletown, Rochester, and Waswasing as the cries went out, "Harness the horses before the wagon, and to Hurley ride. . . . Run, boys, run, the red-coats are coming."

Vaughan and his men landed at the mouth of the Rondout Creek, opposite Columbus Point, where they opened heavy fire before burning down houses along the water's edge. They then seized a slave and forced him to lead them to Kingston, where they arrived around four o'clock in the afternoon. As related by Schoonmaker:

> As soon as the troops reached the village they were divided into small parties and led through the different streets, firing the houses and outbuildings as they proceeded. They did not tarry long, but made haste to complete their work of destruction, as they were informed by the Tory Lefferts [Jacobus Lefferts, from New York City, now residing with his family in Kingston], and knew from other sources, that Governor [George] Clinton was en route with his army to meet them, and could not be very far distant.

Given Clinton's approach, the British worked fast as they "wantonly destroyed" all of Kingston, save for one house and one barn, then "gathered what plunder they could, and returned to their ships within three hours of the time of their embarkation," said Schoonmaker. Though the village was reduced to ashes, providentially for the Continental Army, the very next day, October 17, 1777, the tide turned in a battle for control of the Hudson River Valley—and the Catskills' position in history for having provided the backdrop for "a major turning point in the American Revolution" was secured, according to Thomas Fleming, former president of the Society of American Historians.

As recorded (and most distinctively, given his spelling) in the diary of one Elijah Fisher, a farmer and a soldier in Washington's personal guard:

> Gen. Burgoin and his howl army surrendered themselves Prisoners of Ware and Come to Captelate with our army and Gen. Gates. . . . Then at one of the Clock five Brigades was sent for Albeny (for there come nuse that Gen. Clinton was a comin up the North river). . . . Gen. Clinton having nuse that Gen. Birgoyne had capetlated and had surrendered his army prisoners of war he Returned back to New York.

"Handsome Jack," as the "cool and resolute" playwright-soldier John Burgoyne was described by military historian Reginald Hargreaves, would lead the British in an ambitious but ultimately ill-fated ploy intended to shorten the war. By bringing his army down from Canada, Burgoyne could link his forces with troops coming up from New York City under the command of General William Howe, as well as with a third British contingent from Fort Niagara on Lake Ontario.

The Crown, in theory, would then control the entire Hudson Valley, and a British victory in the war would be assured. Burgoyne's plan was to isolate the New England states from the rest of the country with the force of the two armies heading in different directions before they combined their might in Albany.

What the plan did not take into consideration were time and distance, and the fact that the separate forces had no way of communicating with each other. With his collective army some seven thousand strong—nearly four thousand British infantrymen, some three thousand Germans, as well as Canadians and Tories, "and four hundred Indians," said Hargreaves—Burgoyne discovered that his troops

Continental Army lieutenant Jacob Rose was court-martialed in early 1777 and fined thirty pounds for refusing to obey orders from his military superiors. Striking back, he recruited sympathizers to the Tory cause in the Catskills, largely from among a squad of tenant farmers who had their own distaste for authority.

Rose pledged them five dollars' bounty, a dollar to drink to the king's health, and, after the Crown victory, one hundred acres of land for the recruit and another fifty for each of his children, though this grand promise never had the backing of England. Eventually numbering several hundred, Rose's Rangers snaked their way through the Hudson Valley to join the redcoats in New York, hiding out or else being sheltered and fed by loyalists along the way, until their capture by fifty Whig militiamen near Schunemunk Mountain in Orange County, about sixty miles north of the city.

Placed on trial for treason five days later by the same New York State government that had been established one month before, most of the Rangers were found guilty and sentenced to the noose, only to be pardoned in exchange for joining the patriot army.

For Rose, no such option was available. On May 13, 1777, with Tory sentiment in the Catskills already breathing its last, Jacob Rose was hanged in Kingston.

were no match for the daring Americans, who used any means available to stop the British advance, including cutting down trees to block their path. Companies of British soldiers heading down from Fort Niagara also ended up delayed by the pitched battles along the route down from Albany, while General Howe's British force of thirty thousand coming up from New York City found themselves diverted south, toward Philadelphia.

Sent up the Hudson in their place was a much smaller expeditionary force under General Vaughan, whose instructions were to act offensively but stay out of the way of General Burgoyne's approach to Albany. After incinerating Kingston, Vaughan triumphantly continued north toward Albany, only he was too late. Burgoyne, surrounded and outnumbered, surrendered his entire army to American general Horatio Gates at the Battle of Saratoga, forcing Vaughan to turn his expeditionary force around and head back to New York City.

"And it was the defeat of the British," wrote Hargreaves, "which turned French sympathy for the colonists' cause from a secretive gesture into an active policy."

America would be independent.

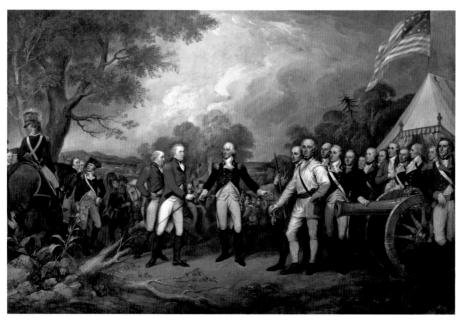

John Trumbull's painting *Surrender of General Burgoyne* depicts the surrender of the British major-general to the Continental Army under the command of George Washington at Saratoga, New York, in 1777. The painting hangs in the rotunda of the United States Capitol in Washington, D.C., and was commissioned in 1817.

Driving Dreams

❧—⊙—❧

I

Only two American writers, Washington Irving and James Fenimore Cooper, were reported to earn enough from their writings for a family to live on (family in Irving's case comprising mainly nieces). In fact, Cooper's earnings had dropped ever since the 1820s, to the point in the early 1840s "no stratagem Cooper could devise—not even a return to the approved form of romance or greatly increased productivity—could surmount the conditions of the trade," as James Franklin Beard observed in *The Letters and Journals of James Fenimore Cooper.*

—HERSHEL PARKER, professor, author,
and expert on Herman Melville

By 1809, 125,000 people lived in New York City—twice the population of Philadelphia and three times that of Boston. Keeping them informed were more than twenty daily newspapers. Among the events reported in that one year were Robert Fulton's February 11 patenting of the steamboat; the May 8 founding of the New York Bible and Common Prayer Book Society and, a month later, at 263 Mulberry Street, the laying of the cornerstone for the original St. Patrick's Cathedral; and, on October 26, if one read a small notice in the *New York Evening Post,* Diedrich Knickerbocker's going missing.

Headlined "Distressing," the newspaper's coverage of this last event warned that while Knickerbocker possessed the kindly demeanor of a "small elderly gentleman," he also gave "some reasons for believing he is not entirely in his right

mind." What warranted this publicity was that he had walked out on the bill for his Lower Manhattan hotel room. The infuriated management sought to hunt him down for the sole purpose of extracting payment immediately.

The public's curiosity aroused, the *Evening Post* wasted no time in shedding further light on the culprit, this time through a letter signed by Seth Handaside, landlord of the Independent Columbian Hotel on Mulberry Street:

> Sir, You have been good enough to publish in your paper a paragraph about Mr. Diedrich Knickerbocker, who was missing so strangely from his lodgings some time since. Nothing satisfactory has been heard of the old gentleman since; but a *very curious kind of written book* has been found in his room in his own handwriting. Now I wish you to notice him, if he is still alive, that if he does not return and pay off his bill, for board and lodging, I shall have to dispose of his Book, to satisfy me for the same.

Had the truth been told—as it later was—no outstanding hotel bill existed, let alone any scofflaw named Diedrich Knickerbocker. He had sprung full-blown from the fertile imagination of Manhattan native Washington Irving, the witty and sagacious writer who would give both the Catskills and the nation something neither had experienced before: their very first taste of literary fame.

The young Washington Irving was "exceedingly handsome, and his head was well covered with dark hair," said a relative, who also let it be known that the writer was wearing a wig.

By the time he was twenty-six, the author and future diplomat to England and Spain had shown himself to be as gifted at self-promotion as he was at prose. Riding the wave of interest he had created with his widely discussed hoax, Irving published, under Knickerbocker's name, a book titled *A History of New York from the Beginning of the World to the End of the Dutch Dynasty*. "It took with the public," a stout and satisfied Irving would later say, "and gave me celebrity, as an original work was something remarkable and uncommon in America."

W e go to Europe to be Americanized," Ralph Waldo Emerson observed about his own young country's influences, despite its break from England. The poet could have gone on to say that Americans looked across the Atlantic to shape their cultural, literary, and artistic tastes. Those with the education and means tended to plant their gardens in the English style, adorn their walls with Joshua Reynolds portraits and Thomas Gainsborough landscapes, and read the novels of Sir Walter Scott, Henry Fielding, and Daniel Defoe, and the poems of Samuel Coleridge and William Blake.

In manner of speech, eighteenth-century Americans similarly took their cues from England, particularly because an American accent, let alone an American style of writing, simply did not exist.

"Literary emancipation took much longer to achieve than political emancipation," said Richard Freedman, author of The Novel, in which he noted that the Declaration of Independence "is written in a highly formal, eighteenth-century British English that is useless for the novelist seeking to capture the peculiarities of the native American idiom."

While it would take decades before distinctive American customs would begin to develop, the self-imposed dependence on Old World culture and conventions began to erode with the War of 1812—three years after Washington Irving published A History of New York.

The youngest of eleven children (three of whom died in infancy), Washington Irving was born to the Scottish parents Sarah Sanders, a genial Anglican, and William Irving, a stern Presbyterian, in 1783, just as the thirteen colonies had won their independence from England and New York City's census figure had climbed to twenty-five thousand. A prosperous merchant family that imported luxury European goods, the Irvings lived at 131 William Street, between John and Fulton Streets in Lower Manhattan, although when the budding writer was fifteen and already showing signs of the ill health that was to plague him the remainder of his life—and New York City was faced with the yellow fever epidemic of 1798—his parents sent him to live with family friends in Tarrytown, twenty-five miles to the north.

"I visited the neighboring villages and added greatly to my stock of knowledge by noting their habits and customs, and conversing with their sages and great men," Irving recalled. What the young man also happily discovered in the

THE STORY OF RIP VAN WINKLE

NEAR to the town, in a cottage small,
Lived Rip Van Winkle, known to all
As a harmless, drinking, shiftless lout,
Who never would work, but roamed about,
Always ready with jest and song—
Idling, tippling, all day long.
"Shame on you, Rip!" cried the scolding vrows;
And old men muttered and knit their brows.
Not so with the boys, for they would shout,
And follow their hero, Rip, about,
Early or late—it was all the same,
They gave him a place in every game.
At ball he was ready to throw or catch;
At marbles, too, he was quite their match;
And many an urchin's face grew bright,

bucolic setting, with its Dutch farms and old country church in Sleepy Hollow, was a bottomless cauldron of legends about witch-craft still being practiced in the hills. Residents, he noted ob-jectively, "are subject to trances and visions, and frequently see strange sights, and hear music and voices in the air."

On stormy nights, locals claimed to see ghostly figures, including the so-called Woman in the Cliffs, just as super-stitious farmers calling their oxen would speak of hearing faint, echoing replies from the hills—the voices of long-dead tribal chiefs, crying out to their warriors, the farmers insisted.

"It is remarkable that the visionary propensity I have mentioned is not confined to the native inhabitants of the valley, but is unconsciously im-bibed by every one who resides there for a time," Irving, in his guise as Diedrich Knickerbocker, informed his readers in "The Legend of Sleepy Hollow." "However wide awake they may have been before they entered that sleepy region, they are sure, in a little time, to inhale the witching influence of the air, and begin to grow imaginative to dream dreams, and see apparitions."

It was while he was still in Tarrytown, "in the happy days of boyhood, when all the world had a tinge of fairy-land," that Irving—having been weaned on Daniel Defoe's *Robinson Crusoe,* and "astonished to find how vast a globe I inherited"—boarded a sloop and took his first journey to the Catskill Mountains, which, in his words, "called forth a host of fanciful traditions."

I shall never forget my first view of these mountains. It was in the course of a voyage up the Hudson in the good old times, before steamboats and railroads had driven all the poetry and romance out of travel. A voyage up the Hudson in those days was the equal to a voyage to Europe at present, and cost almost as much time; but we enjoyed the river then—we relished it as we did our wine, sip by sip, not, as at present, gulping all down at a draught without tasting it.

Remembering the voyage as "full of wonder and romance," even through the biased eye of "a lively boy, somewhat imaginative, of easy faith, and prone to relish everything which partook of the marvelous," Irving in particular recalled one of the passengers on the sloop, "a veteran Indian trader, on his way to the lakes to traffic with the natives." Finding an attentive audience in Irving, the trader provided the boy with "Indian legends and grotesque stories about every noted place on the river, such as Spuyten Devil Creek, the Tappan Sea, the Devil's Dans-Kammer, and other hobgoblin places."

In these mountains, he told me, at least in Indian belief, was kept the great treasury of storm and sunshine for the region of the Hudson. An old squaw spirit had charge of it, who dwelt on the highest peak of the mountain. Here she kept Day and Night shut up in her wigwam, letting out only one of them at a time.

Hers was the spirit responsible for making and hanging the new moons in the sky every month, said the trader, who went on to explain that she was employed by the great Manitou, or master spirit, to manufacture clouds:

[S]ometimes she wove them out of cobwebs, gossamers, and morning dew, and sent them off flake after flake, to float in the air and give light summer showers. Sometimes she would brew up black thunder-storms, and send down drenching rains to swell the streams and sweep everything away.

On the long summer day he listened to these tales from the trader, Irving would gaze

upon these mountains, the ever-changing shapes and hues of which appeared to realize the magical influences in question. Sometimes they seemed to

From Washington Irving's "The Catskill Mountains," as it appears in E. (Eliakim) Littell's *Living Age* (1851):

The Catskill, Katskill, or Cat River Mountains, derived their name, in the time of the Dutch domination, from the catamounts by which they were infested; and, which, with the bear, the wolf, and the deer, are still to be found in some of their most difficult recesses. The interior of these mountains is in the highest degree wild and romantic; here are rocky precipices mantled with primeval forests; deep gorges walled in by beetling cliffs, with torrents tumbling as it were from the sky; and savage glens rarely trodden except by the hunter. With all this internal rudeness, the aspect of these mountains towards the Hudson at times is eminently bland and beautiful, sloping down into a country softened by cultivation, and bearing much of the rich character of Italian scenery about the skirts of the Apennines.

Here are locked up mighty forests that have never been invaded by the axe; deep, umbrageous alleys where virgin soil has never been outraged by the plough; bright streams flowing in untasked idleness, unburdened by commerce, unchecked by the mill-dam. This mountain zone is in fact the great poetical region of our country, resisting, like the tribes which once inhabited it, the taming hand of civilization, and maintaining a hallowed ground for fancy and the muses. . . .

The Catskill Mountains, as I have observed, maintain all the internal wilderness of the labyrinth of mountains with which they are connected. Their detached position, overlooking a wide low-land region, with the majestic Hudson rolling through it, has given them a distinct character, and rendered them at all times a rallying point for romance and fable.

approach; at others to recede; during the heat of the day they almost melted into a sultry haze; as the day declined they deepened in tone; their summits were brightened by the last rays of the sun, and later in the evening their whole outline was printed in deep purple against an amber sky.

"As I held them thus shifting continually before my eye, and listened to the marvellous legends of the trader," Irving wrote of the mountains, "a host of fanciful notions concerning them was conjured into my brain."

Those notions, he was not shy about claiming, "have haunted it ever since."

"As a young man his face was exceedingly handsome, and his head was well covered with dark hair . . . he wore neither whiskers nor moustache, but a dark brown wig, which, although it made him look younger, concealed a beautifully shaped head," a relative of Irving's told Charles Dudley Warner for an 1881 biography.

Financially supported by his family and, as characterized by others, erudite and flirtatious, Irving at age nineteen in 1803 was contributing regularly to the *Morning Chronicle*, the year-old political newspaper published by the then former U.S. senator from New York and state attorney general Aaron Burr and edited by Irving's older brother Peter. Under the name Jonathan Oldstyle, the first in a long line of pseudonyms over a five-and-a-half-decade writing career, Irving covered the Manhattan theater and social scene, as well as fashion and weddings—though he himself would remain a lifelong bachelor, and was in all likelihood gay, despite being engaged to marry when he was twenty-six. His fiancée, Sarah Matilda Hoffman, was the pretty seventeen-year-old daughter of a lawyer in whose office Irving had worked while he was briefly considering a career in law. "She always looked too delicate and spiritual for this rough, coarse world," Irving once said of her. The couple's betrothal ended with Sarah's death from tuberculosis, shortly before she turned eighteen. Irving, at her bedside, and still mourning the recent death of his father, later wrote, "I saw her fade rapidly away, beautiful and more beautiful and more angelical to the very last."

In 1807, the writer's talent to lampoon found a perfect home in *The Salmagundi Papers; or, the Whim-Whams and Opinions of Laucelot Langstaff, Esq., And Others*, "salmagundi" literally meaning a hodgepodge, though at the time the publication appeared it was also the name of a popular spicy pickled-herring hash. A pamphlet-sized periodical published every other week (when the editors could meet their deadlines), *Salmagundi* lasted twenty issues and contained a satirical point of view much in the manner of today's *The Onion* and television's *The Daily*

Native Americans in the seventeenth century, seen performing ritual dances by the campfire on the cliffs between Newburgh and Crom Elbow—known as the Devil's Dance Chamber—helped give rise to superstition in the Catskills.

To protect themselves, colonists adorned their front doors with crosses to ward off the demons, while iron spikes, known as "witch catchers," would be attached inside their chimneys to halt those on broomsticks from paying a visit.

Less fearful than their Salem Colony counterparts who burned any suspected witch at the stake, Catskills residents trusted their strong Protestant faith to shield them from harm. Still, tales abounded of spirits, some playful—such as the gnomes dwelling behind the New Grand Hotel, where it is believed they made the moonshine that knocked out Rip Van Winkle for two decades—and some anything but.

"When the Dutch gave the name of Katzbergs to the mountains west of the Hudson," documented journalist (and self-proclaimed "myth collector") Charles M. Skinner, who like Walt Whitman had served as editor of the *Brooklyn Daily Eagle,* "they obliterated the beautiful Indian Ontiora, 'mountains of the sky.'"

In one telling, said Skinner, the hills were actually the bones of a great monster that fed on human beings "until the Great Spirit turned it into stone as it was floundering toward the ocean to bathe." Two lakes near the peak formed the creature's eyes, and here lived "an Indian witch, who adjusted the weather for the Hudson Valley with the certainty of a signal service bureau."

Should the natives not show her their obedience, she would send black clouds to drown them with rains, or else she would assume the shape of deer or bear and then, as she was being hunted, lead them into Kaaterskill Clove, to fall 260 feet into "the stream born of the witch's revenge . . . known as Catskill Creek."

Show. It was in these pages that Irving, in a review of an unsuccessful City Hall concert, coined the nickname "Gotham" for New York City, after the town of Gotham in England during the Middle Ages.

In England's Gotham, residents had gained the reputation for being mad (to punish an eel for eating the town's fish, the madmen of Gotham drowned it), although as the name evolved in America after Irving introduced it long before Batman called the metropolis home, Gotham came to mean a place where citizens were wise enough to play the fool. Observed *The New Yorker* in 1965, "The

The gangly schoolteacher Ichabod Crane—chased through Sleepy Hollow by the Headless Horseman—has unrequited love for the wealthy Katrina Van Tassel; in *Sleepy Hollow,* the 2013 Fox television incarnation of Irving's tale, dashing swashbuckler Crane and Katrina are not only married, but she is a witch. Below, Rip Van Winkle, after he awakens.

founders of the Hotel Gotham, the Gotham Book Mart, the Gotham Corrugated Container Company, the Gotham Exterminating Corporation, the Gotham Realty Company, and the Gotham Watch Company, to mention but a few of the many Gothams listed in the phone book, were evidently unaware of any pejorative connotations."

Packed off to England in 1815 for what ultimately was a futile effort to save the family import business during the economic collapse that followed the War of 1812, Irving found that "all of his expectations as the son of a relatively wealthy American merchant had gone up in smoke," said historian William P. Kelly. "He decided that if he was going to recoup his fortune, it was going to be with his pen."

Via a letter of introduction, Irving arranged to meet Sir Walter Scott, the former Edinburgh attorney who both invented and became the

great practitioner of the historical novel (*Ivanhoe* and *Rob Roy* among them). "Everyone who read, read Scott," said Kelly, who called him "a kind of reigning literary king of the English-speaking world. And it's a suggestion of the day gone by when you can simply present yourself and be greeted."

According to Scott's 1871 biographer, Robert Shelton Mackenzie, Irving arrived at the gates of Scott's baronial manor, Abbotsford, where the great man "quitted the breakfast-table, came out in company with a troop of dogs," and after "instantly" making Irving "at home with his family, detained him for several days."

Though his writing contained melodramatic plots and stereotypical characters, Scott also filled his impressive output—thirty-one popular historical romances—with a strong narrative drive and heroic moral sense, both of which found an appreciative acolyte in Irving. Irving's own contribution to the genre was a highly readable tongue-in-cheek attitude that put into perspective the attitudes and social mores of his contemporaries. In addition, he infused his protagonists with character blemishes (cowardice, brutishness, sloth) with which readers could easily identify, if not project onto other people they knew. "The function of a writer," said Kelly, "is to create a kind of social glue that [Irving] understood as Scott's practice and adapted to his own American purposes."

Over the course of his seventeen years in England, Irving published a group of serialized essays and stories, including two that would become international classics, one set in the Catskills and the other in Sleepy Hollow. These appeared in a collection titled *The Sketch Book of Geoffrey Crayon, Gent.* Walter Scott found the work "positively beautiful"; Lord Byron said, "I know it by heart; at least, there is not a passage that I cannot refer to immediately"; and William Makepeace Thackeray called Irving the "ambassador

Irving on Rip's drinking: "One taste provoked another, and he reiterated his visits to the flagon so often, that at length his senses were overpowered, his eyes swam in his head, his head gradually declined, and he fell into a deep sleep."

whom the New World of Letters sent to the Old." Until this time, no American author had received any degree of recognition in Europe, let alone been deemed worthy of consideration. ("In all the world," asked Sidney Smith, the first editor of the *Edinburgh Review,* "whoever reads an American book?") The success of *The Sketch Book* was such that its British publisher not only paid the author, but urged Irving, so tender toward pseudonyms, to write under his own name.

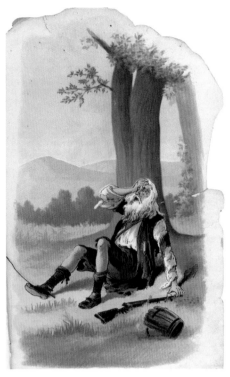

Irving: "He rubbed his eyes. . . . 'Surely,' thought Rip, 'I have not slept here all night.'"

Irving's next step was to reach an American audience and protect his work at a time when no international copyrights existed. Sending *The Sketch Book* to his brother Ebenezer and his friend Henry Brevoort in New York, in June 1819, Irving, thanks to Brevoort, who had publishing connections through his relatives, found an American publisher with the improbable name of Cornelius S. Van Winkle, who at the hefty cover price of seventy-five cents put Irving's book on the stands. It sold an impressive two thousand copies once it reached New York, Baltimore, Philadelphia, and Boston.

While most of *The Sketch Book*'s pieces featured English backdrops and customs, "The Legend of Sleepy Hollow" became a Halloween staple and cemented Irving's reputation as the inventor of the American short story. The tale traces the tribulations of the timid schoolteacher Ichabod Crane, who is so terrified of Brom Van Brunt, his aggressive rival for the hand of Crane's adored Katrina Van Tassel, that one night at the church Ichabod sees "a headless horseman," said to be the ghost of a Hessian soldier decapitated by a cannonball during the Revolutionary War. Believing the apparition, whose head rests on his saddle, won't follow him out of the churchyard, Ichabod takes off for the bridge, only to have the horseman hurl his severed head and knock the schoolteacher off his horse. The only trace of Ichabod ever to be seen in Sleepy Hollow again is his hat, which has hoofprints next to it, along with a smashed pumpkin–leading less superstitious villagers to

Washington Irving not only helped popularize the rustic setting of the Catskills, but gave birth to the artistic commercial spin-off. Nine years after "The Legend of Rip Van Winkle" was first published, an 1828 stage dramatization by an anonymous local opened in Albany, followed by another version at Philadelphia's Walnut Street Theatre.

In 1865, and for the next forty years, Pennsylvania-born actor Joseph Jefferson played the role both onstage and in early silent films. But when Prohibitionists promised Jefferson sold-out houses if only he would revise the script and have Rip decline the keg of liquor, the outraged leading man replied, "I would sooner expect to hear Cinderella striking for higher wages or a speech on woman's rights from Old Mother Hubbard as to listen to a temperance lecture from Rip Van Winkle."

Musically, African-American stage performer Sherman H. Dudley sang a popular rendition of 1901's "Rip Van Winkle Was a Lucky Man," while in the 1914 Broadway show *The Belle of Bond Street,* the British comedian Sam Bernard introduced the novelty number "Who Paid the Rent for Mrs. Rip Van Winkle When Rip Van Winkle Went Away." That same year, Al Jolson also delivered the same song, but in a thick Dutch dialect, for Broadway's *The Honeymoon Express.*

Rod Serling loosely adapted the original fable for a 1961 episode of *The Twilight Zone.* Titled "The Rip Van Winkle Caper," it concerned robbers who after stealing gold bricks from Fort Knox plan to sleep for one hundred years inside an atmosphere-controlled desert chamber. (The final Serling twist: gold is no longer worth anything in 2061.) Also looking to the future, Walt Disney populated a portion of the General Electric Progressland pavilion at the 1964 New York World's Fair with an Audio-Animatronic parrot named Rip Van Wrinkles. Falling asleep at the 1939 fair, the bird awakens twenty-five years later to learn of the advancements in plug-in appliances.

E. G. Marshall donned Rip's overalls for a 1958 *Shirley Temple Theater* TV presentation, with later small-screen renditions starring Harry Dean Stanton (directed by Francis Ford Coppola, in 1987) and Maya Angelou (as the voice of the fairy godmother narrating the tale, in 1999). Even Frank Capra couldn't resist expanding upon the myth, when he brought the Jimmy Stewart character George Bailey back to his

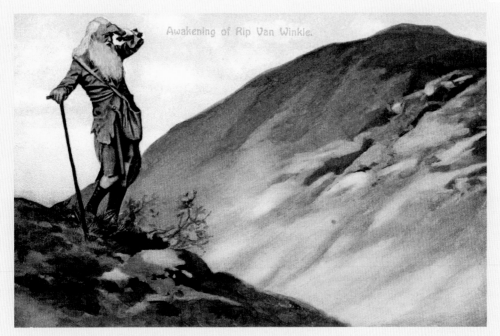

Irving created Rip Van Winkle to represent a personality that was uniquely American.

hometown as a Van Winkle–like total stranger living out a fever dream in the overtly sentimental 1946 film *It's a Wonderful Life.* (Marrying two Irving legends, Fox Broadcasting Company presented in the fall of 2013 the weekly series *Sleepy Hollow*, which had a suddenly heroic Ichabod Crane waking up 250 years after the American Revolution to find the world on the brink of destruction and overrun by CGI effects.)

Like George Bailey's situation, Van Winkle's "entertains the fear that we can never go home, and then resolves that fear," observed William P. Kelly. "We end with Rip smoking his pipe, sitting in front of the inn, and invoking the worst nightmare we can have of being utterly and totally alone in the world . . . because telling us that you can always go home is sentimental."

Terrifying and comforting the reader "at exactly the same time and in the same way," said the historian, "is the power of that story."

believe he was run out of town by the prankster Van Brunt. But others blamed the Headless Horseman.

The hero of Irving's other account, "The Legend of Rip Van Winkle," is a guileless husband who, accompanied by his dog Wolf and squirrel-hunting rifle, seeks refuge from his tyrannical wife and the drowsy tranquillity of his village. Heading for the Catskill Mountains, Rip encounters a mysterious old Dutchman who leads him to a rendezvous with the ghosts of Henry Hudson's crew from the *Half Moon*, and they, in turn, engage him in a noisy game of ninepins that causes thunderous volleys to shake the mountains. When the Dutchman's keg turns out to be filled with liquor, the happy-to-imbibe Rip joins in the festivities before dozing off to sleep–for the next twenty years.

When he awakens, ignorant of the passage of time or his whereabouts, Rip stumbles out of the mountains into a vastly changed reality, where he is forced to question "whether both he and the world around him were not bewitched." Suddenly a stranger to one and all, the old codger finds his daughter happily married, his nagging wife and faithful dog deceased (the former succumbed when she lost her temper at a New England peddler), and the America he knew no longer the royal protectorate of King George III but the democratic nation of President George Washington.

Seized by the townspeople and branded a madman, a displaced Rip is saved in the nick of time by his own son, whose appearance allows Rip to claim his rightful identity.

"To make a long story short," wrote Irving, "Rip's daughter took him home to live with her; she had a snug, well-furnished house, and a stout cheery farmer for a husband, whom Rip recollected for one of the urchins that used to climb upon his back. As to Rip's son and heir, who was the ditto of himself, seen leaning against the tree, he was employed to work on the farm; but evinced an hereditary disposition to attend to anything else but his business."

"Irving not only realized the desires of Americans of his time for legends of their own but also pioneered the very themes that were later to make American romantic writing great," said English literature professor Curtis Dahl, who credited Irving with setting "a pattern that would be followed by Longfellow in his legends of Paul Revere and Miles Standish, and Hawthorne in his gloomy allegories of Puritan New England." Concurring, William P. Kelly said, "Irving's stories really became the first declaration of an American literary independence, the first stories that enjoy an international audience and are taken to speak to U.S.

life, history, interests in ways that are quite particular. The interesting thing about both stories is that neither is based on American material. They're both German folk stories that are adapted to an American setting—in this case, the Catskills, which Irving identifies as a place of memory, a place of organic community. It's an imaginary place, really, where the American Revolution has disrupted the bonds of social connection, as has the economic meltdown of Irving's time. Emerson spoke of 1837 as a year in which the land stank of suicide. So the Catskills became this imaginary place where the center holds, where there's an anchorage. There's a kind of snug harbor he talks about—Sleepy Hollow, for example, which becomes this place where legend exists, where a connection to the past is possible, fulfilling a desire for a place where order prevails."

"But however his memory may be appreciated by critics," Irving wrote of his famous slumberer, "it is still held dear by many folks, whose good opinion is well worth having." Nearly two hundred years after he first drifted off to sleep, Rip's name or image, sometimes both, continues to pop up in any number of places, be it the Rip Van Winkle Bridge connecting the towns of Hudson and Catskill over the Hudson River; the Rip Van Winkle Foundation of Hillsdale, New York, which awards seed money to projects with the potential to have a national impact; the Rip Van Winkle Campgrounds ("leave the fast life behind") in the Hudson Valley; the Rip Van Winkle statue at the summit of Hunter Mountain; the Rip Van Winkle gas station in Catskill; and countless restaurants and motels that bask in the Van Winkle glory.

There's even Rip Van Winkle bourbon, distilled not in the Catskills but in Frankfort, Kentucky. According to a 2012 holiday feature in the *New York Post*—indeed, the very publication that first published the goings-on of "small elderly gentleman" Diedrich Knickerbocker—"it's gone in recent years from a niche item favored by a cult of bourbon connoisseurs to an object of fervor, hunted by an ever-growing number of devotees the way Paris pursued Helen of Troy." Hard to find in the nation's liquor stores, coveted bottles go at auction for as much as $250.

But leave it to Washington Irving for the final word. When it came to Van Winkle's influence on Catskills residents, by the author's reckoning, "Even to this day they never hear a thunderstorm of a summer afternoon about the Kaatskill, but they say Hendrick Hudson and his crew are at their game of nine-pins; and it is a common wish of all hen-pecked husbands in the neighborhood, when life hangs heavy on their hands, that they might have a quieting draught out of Rip Van Winkle's flagon."

II

What did Cooper dream beyond democracy? Why, in his immortal friendship of Chingachgook and Natty Bumppo he dreamed the nucleus of a new society. That is, he dreamed a new human relationship. A stark, stripped human relationship of two men, deeper than the deeps of sex. Deeper than property, deeper than fatherhood, deeper than marriage, deeper than love.

— D. H. LAWRENCE, *Studies in Classic American Literature* (1923)

While Washington Irving carved a niche for himself as the first American man of letters, it was the country's first major novelist, James Fenimore Cooper, who became known as "the American Scott" and delivered the American myth on the grandest scale. He would also promote the Catskills in the process.

Set in the mountains and conceived in tribute to the vast American wilderness where he had grown up, Cooper's five Leatherstocking novels—*The Pioneers, The Last of the Mohicans, The Prairie, The Pathfinder,* and *The Deerslayer*—immortalized the fictitious frontiersman Natty Bumppo, a white man raised by the patrician Mohican named Chingachgook, chief of the Delaware tribe. Known as "Leatherstocking" and "the Pathfinder" to the European settlers, Bumppo was "Deerslayer" and "Hawkeye" to the Native Americans, and an exciting hero to American boys who devoured the books just as quickly as they were published.

Though the two writers were born into the advantages of wealth and social prominence, and both into large families, Irving and Cooper were as dissimilar as their two literary creations (each of whom they respectively resembled): Irving's urbane, social gadfly Diedrich Knickerbocker, and Cooper's rough-and-tumble frontiersman Bumppo.

Six years Cooper's senior, Irving was a proud product of the city, while Cooper grew up on the edge of the frontier, in a village founded by his father. Compared to Irving's generous spirit and zest for life (it was said that the thoughts flowed so quickly from Irving's mind that his pen could barely keep up), Cooper was matter-of-fact, disposed to prolonged grudges, and, as the years wore on, increasingly argumentative—traits that came to haunt his literary reputation.

Cooper, said William P. Kelly, "felt that Irving was a writer of modest achievements who basically told European folk stories [and] that the geniality of Irving's

writing missed the power of the American moment, [while] he, Cooper, was the great American writer who wrote about national themes and national concerns, not just Natty and Chingachgook, but the struggle to establish a democracy."

Not surprisingly, Kelly pointed out, "It was difficult for him to see Irving succeed so wildly while he was consigned to the shadows."

COOPER WAS the eleventh of thirteen children, of whom only four brothers and two sisters survived childhood. "Cooper's father, a resident of Burlington, New Jersey, had come, closely after the close of the Revolutionary War, into possession of vast tracts of land, embracing many thousands of acres, along the head-waters of the Susquehanna," said Cooper's 1883 biographer, Thomas Raynesford Lounsbury. On the tenth of November, 1790, when James was thirteen months old, William Cooper uprooted the entire household—with servants, this totaled fifteen people—from 457 High Street in the quiet English Quaker town of Burlington to his land on the outskirts of the Catskills. Lounsbury wrote, "His father had determined to make the new settlement his permanent home. He accordingly began in 1796, and in 1799 completed, the erection of a mansion which bore the name Otsego Hall. It was then and remained for a long time afterward the largest private residence in that portion of the State."

"Here he passed his childhood, with the vast forest around him, stretching up the mountains that overlook the lake, and far beyond, in a region where the Indian yet roamed, and the white hunter, half Indian in his dress and mode of life, sought his game," said William Cullen Bryant, describing Cooper's childhood setting as "a region in which the bear and the wolf were yet hunted, and the panther, more formidable than either, lurked in the thickets, and tales of wanderings in the wilderness, and encounters with these fierce animals, beguiled the length of the winter nights."

James Fenimore Cooper considered himself a great writer of American themes.

William Cooper built the family home, eventually called Otsego Hall, on a vast tract of wilderness at the headwaters of the Susquehanna River, on the southern tip of Lake Otsego—which in his writings James Fenimore Cooper called "Glimmerglass."

"All these characteristics of his early home made deep impression upon a nature fond of adventure," said Lounsbury, "and keenly susceptible to the charm of scenery."

Called Cooperstown (and known, since 1939, as the home of the National Baseball Hall of Fame and Museum, and since 1975 of the Glimmerglass Opera), the land was purchased by William Cooper in 1785 from Colonel George Croghan, a Dublin-born Indian agent during the 1754–63 French and Indian War. William's determination to relocate in central New York State expressly conflicted with the wishes of his wife, the equally strong-willed Elizabeth Fenimore, who opposed the abandonment of the social scene in nearby Philadelphia for the starkness of life on a frontier that, admitted Lounsbury, "had terrors to some as real as were its attractions to others."

As recounted by James Fenimore Cooper's great-great-great-grandson Henry Cooper, Elizabeth could simply not be persuaded to move—just as her husband could not be dissuaded. "So William loaded all the family furniture into a covered wagon, then looked around for his wife and new baby James," said Henry Cooper, explaining that William eventually found them sitting on the front porch in a Queen Anne chair, with the baby on Elizabeth's lap. "And she was saying, 'I'm

not going!' Only William Cooper would not have any of that." Ready to set off to Cooperstown, "He picked her up, chair and all," said Henry Cooper, "and put her in the back of the covered wagon."

Tutored at a small Episcopal school in Albany, James was taught "the immense superiority of the mother-country in morals as well as manners," according to Lounsbury. At fourteen, in 1803, the boy entered Yale College, at a time when admission was based not on age but on proficiency in Latin and Greek. His collegiate life was short-lived, however; though strong in Latin, by his second year (Lounsbury reports that Cooper himself admitted that all he did his freshman year was play), James was expelled on two charges of misconduct. The first was for bringing a donkey into a lecture hall, where it sat on a professor's chair and smashed it, and the second was for inserting a gunpowder charge into the keyhole and blowing off the dormitory room door of a rival classmate. James's older brother William's collegiate career followed a not dissimilar path: he was booted out of Princeton in 1802 as the prime suspect in burning down Nassau Hall. Sister Hannah lamented of her male siblings, "They are very wild and show plainly that they have been bred in the woods."

At the insistence of his disciplinarian father, James went to sea, initially as a foremast hand and then as a midshipman, later using his five years' navy experiences in his 1823 novel *The Pilot*, based on the Revolutionary War's naval hero John Paul Jones, and his 1827 pirate novel, *The Red Rover*. Not only did the works launch the genre of the sea novel, but Joseph Conrad and Herman Melville both praised Cooper's contributions to the field, expressing a preference for them over Cooper's more commercial Leatherstocking novels.

Following a respectable career as a judge and then a Federalist congressman during the Washington and Adams administrations, William Cooper died in 1809 (Sarah died in 1817), leaving James with an inheritance of $50,000, the majority of it in property. The next year, at age twenty-one, he married a "fair damsel of eighteen," Susan Augusta De Lancey, a descendant of one of the early governors of the New York Colony. "I loved her like a man," said Cooper, "and told her of it like a sailor." Resigning his navy commission, the new groom settled into the leisurely life of a gentleman farmer in Mamaroneck, about twenty-five miles north of Manhattan—only to see his wealth evaporate when land values collapsed amid the financial panic after the War of 1812.

As related by Henry Cooper, "[James's] oldest brother took on the management of the father's estate. Among the five brothers remaining, one after the other

blew the estate further into the sky." As insolvency loomed, James considered his next move. "Living in Mamaroneck," said Henry Cooper, "his wife used to love the latest English novels, and every month or so a cargo boat would sail into New York Harbor, and the ladies in New York would gravitate toward their favorite bookstore near the dock and grab off the first books, which were usually drawing-room comedies by women." Picking up the story, James and Susan's daughter, also named Susan, revealed in an 1883 essay titled "Small Family Memories" ("Recorded," she wrote, "for the pleasure of my dear nephews and nieces, none of whom have known personally their Grandfather and Grandmother Cooper"), "My mother was not well; she was lying on the sofa, and he was reading this newly imported novel to her; it must have been very trashy; after a chapter or two he threw it aside, exclaiming, *'I could write you a better book than that myself!'*"

According to Susan, "Our mother laughed at the idea, as the height of absurdity–he who disliked writing even a letter, that he should write a book!"

Having reached the age of thirty, Cooper, wrote Lounsbury, "[u]p to this time . . . had written nothing nor had he prepared or collected any material for future use. No thought of taking up authorship as a profession had entered his mind. Even the physical labor involved in writing was itself distasteful."

"He persisted in his declaration, however," said Susan, "and almost immediately wrote the first pages of a tale, not yet named, the scene laid in England as a matter of course." Added Henry Cooper, "His first novel was a book called *Precaution*, and it was terrible."

Published anonymously in 1820, *Precaution* pretended to capture English society in the elegant style of Jane Austen, whose vastly superior *Pride and Prejudice* had appeared seven years before. "I confess I have merely dipped into this work," said the poet and *New York Evening Post* editor William Cullen Bryant, later a staunch supporter of Cooper's literary output. But when it came to *Precaution*, Bryant dismissed it as an "experiment . . . deformed by a strange punctuation–a profusion of commas, and other pauses, which puzzled and repelled me." Even Cooper knew he had blundered: "The manuscript, he admitted, was bad; but the proof-reading could only be described as execrable," wrote Lounsbury, who added that "the work has never been much read even by the admirers of the author."

Determined to recoup his fortune, Cooper began writing about a world familiar to him. Choosing the American Revolution as his subject, the Hudson River highlands above New York City as his setting, and the historical romances of Sir Walter Scott as his model–in particular the Scotsman's 1814 *Waverley*–Cooper

produced *The Spy*, which was published in late 1821 and told of Harvey Birch, an agent for George Washington who masqueraded as a British loyalist.

In Lounsbury's analysis of the novel, "It was the story of adventure, using adventure in its broadest sense, that he was fitted to tell: and fortunately for him Walter Scott, then in the very height of his popularity, had made it supremely fashionable. In this it is only needful to draw character in bold outlines; to represent men not under the influence of motives that hold sway in artificial and complex society, but as breathed upon by those common airs of reflection and swept hither and thither by these common gales of passion that operate upon us all as members of the race."

Abetted by a wave of post–War of 1812 anti-British popular sentiment, Cooper struck gold with *The Spy*—the book sold more copies than any other American novel before it. Within four months it went into a third printing, just as "the story was dramatized and acted [on the stage] with the greatest success," said Cooper's biographer. Putting the work and the reaction to it into perspective, Lounsbury said that *The Spy* "definitely determined his career, though at the time he did not know it. As yet he was not sure in his own mind whether the favor his book had met with was the result of a lucky hit or was due to the display of actual power."

Moving forward, Cooper "set about a task that lay near his heart. This was to describe the scenes, the manners, and customs of his native land, especially of the frontier life in which he had been trained."

TWO YEARS AFTER the publication of *The Spy*, Cooper produced his subsequent novel, *The Pioneers*, which, according to William P. Kelly, "was sold out before it actually appeared in bookstores. This never happened in America before."

"Though not a poor story," opined Lounsbury, a Yale professor of English who could be frank in assessing his subject's literary output, *The Pioneers* "is much the poorest of the series in which it forms a part." The academic found Cooper so in love with his subject as to be self-indulgent, with the author fashioning the work in the first place "to show he could write a grave tale." What saved him, and *The Pioneers*, insisted Lounsbury, was clever marketing: "The public curiosity . . . had been fully excited. Extracts from [the book]—according to a custom then prevalent in England—had been furnished in advance to some of the newspapers, and though these were not the most striking passages, they served to direct attention and awaken expectation."

Originally to have been published in the fall of 1822, but delayed by the summer's yellow fever epidemic that shut down, among other businesses, New York's printing presses, *The Pioneers* hit shelves in late January 1823, four years after the first installment of Irving's *The Sketch Book* and thirteen years before Charles Dickens's debut novel, *The Pickwick Papers*.

"Success was certain from the start," said Lounsbury, "but the degree of it outran all anticipation. The evening papers of the first of February were able to state that up to twelve o'clock that day there had been sold three thousand five hundred copies . . . remarkable"–and this at a time when the population of New York City barely exceeded 123,000.

"In his crude way," said literary critic Richard Freedman, touching upon *The Pioneers* author's status as the inventor of one of the most enduring of all American literary forms, the frontier saga, "Cooper first realized the epic potentialities of the restless, self-reliant American pioneer who had turned his back on bourgeois civilization for life on a rapidly receding frontier." Regarding the public's response, early-twentieth-century American historian and Cooper biographer Van Wyck Brooks wrote, "His fiction romances were mostly stories of flight and pursuit, and they struck some deep ancestral chord in the hearts of his readers who remembered or imagined remembering the struggles of their forebears in the silence and solitude of the primal woods."

Similar to the *Star Wars* saga, in which episodes were produced and presented out of chronological sequence, *The Leatherstocking Tales* began with part four of the narrative (its complete title was *The Pioneers: The Sources of the Susquehanna; a Descriptive Tale*), set in 1793. Although Cooper is presenting his characters for the very first time, Natty is well advanced in years, just as Chingachgook, who dies by suicide in this story, is already disabled by age. Among the other characters, the patriarchal Judge Marmaduke Temple of Templeton was modeled after James's own father, William Cooper of Cooperstown, just as Elizabeth Temple is fashioned after James's sister Susan Cooper.

The novels "go backwards, from old age to golden youth," observed D. H. Lawrence. "That is the true myth of America. She starts old, old, wrinkled and writhing in an old skin. And there is a gradual sloughing of the old skin, towards a new youth. It is the myth of America." The English novelist also posited that "probably, one day America will be as beautiful in actuality as it is in Cooper. Not yet, however. When the factories have fallen down again."

"Cooperstown, of course, sits at the far end of the Catskill Mountains,"

explained Vassar professor H. Daniel Peck, "and even though Cooper wouldn't have thought of it this way, his second and third novel, *The Spy* [set in the Hudson Highlands] and *The Pioneers*, can be said to describe the developing relationship between New York City, the environs of New York, and the Catskills."

In the most frequently quoted passage from *The Pioneers*, Natty Bumppo, now in his seventies, expresses his passion for a particular high plateau in the Catskills, overlooking the Hudson River Valley:

> "There's a place in them hills that I used to climb to, when I wanted to see the carryings on of the world, that would well pay any man for a barked shin or a torn moccasin. You know the Kaatskills, lad; for you must have seen them on your left, as you followed the river up from York, looking as blue as a piece of clear sky, and holding the clouds on their tops, as the smoke curls over the head of an Indian chief at the council fire. . . . But the place I mean is next to the river, where one of the ridges juts out a little from the rest, and where the rocks fall for the best part of a thousand feet, so much up and down, that a man standing on their edges is fool enough to think he can jump from top to bottom."
>
> "What see you when you get there?" asked Edwards [his young protégé].
>
> "Creation!" said Natty . . . "all creation, lad."

"With his straightforward temperament and homespun dialect," said Brooks, "Natty became the archetype of the American frontier hero, creating an iconic figure that linked Americans to their past."

THE RECEPTION ACCORDED the January 1826 publication of *The Last of the Mohicans* made the greeting of *The Pioneers* look tepid. "In this work," said Lounsbury, "two great achievements were accomplished by Cooper. The first was idealization of the white hunter whom he had described in *The Pioneers*." In the later work, the English professor had found that "Leatherstocking has gained in dignity . . . a poetic elevation which raised it at once to the front rank of the creations of the imagination." No more "merely an old man who has made his home in the hills in advance of the tide of settlement," as Bumppo had come across in *The Pioneers*, by the time of *The Last of the Mohicans* "[he] is the solitary hunter who views with dislike clearings and improvements who cannot breathe freely in the streets, who hates the sight of masses of men, who looks with especial loathing upon the civilization whose first work is

In *The Last of the Mohicans,* Cora and Alice Munro, the daughters of Lieutenant Colonel Munro, are escorted from Fort Edward to Fort William Henry. En route, the scout Magua leads them into an ambush, with Natty and Chingachgook rescuing them in the nick of time.

to fell the trees he has learned to love, whose first exercise of power is to draw the network of the law around the freedom and irresponsibility of forest life." Thanks to this maturation process, Lounsbury averred, "All that is weak in his character is in the background; all that is the best and strongest comes to the front."

The commercial success of *The Last of the Mohicans* so enriched Cooper's bank account that he could "move to Europe," said William P. Kelly, "because he felt that it was a place where he could meet other writers and enhance his literary possibilities." Through his American publisher, Charles Wiley, he sought the assistance of Washington Irving, already living in England, in finding a British publisher for *The Sea.*

First moving to France, Cooper spent seven years abroad, largely for the sake of educating his son and four daughters—as well as himself. Befriending the celebrated Marquis de Lafayette, he also became very grand in his writing, injecting it with political polemic that increasingly did not sit well with an American constituency that fancied itself attached to the author's bare-knuckled folk hero. Writing from Paris to a friend in 1832, he said:

> I know not why it is so, but all that I see and hear gives me reason to believe that there is a great falling off in popular favor at home. I rarely see my name mentioned even with respect in any American publication, and in some I see it coupled with impertinences that I cannot think the writer would indulge in were I at home.

"Wolfert's Rooset" was built on the banks of the Hudson in Tarrytown around 1690 by the Brooklyn-born Wolfert Acker, who worked in the Dutch colonial government. It was renamed "Sunnyside" after Washington Irving purchased the property in 1835 for $1,800 (nearly $50,000 in today's dollars). Since 1947 it has been open to the public as a museum and historical site.

Cooper returned to the United States in 1833, a year after Irving ended his own European stay, but while Irving's homecoming was cause for celebration that saw the adored author "carried off to a series of banquets," said Kelly, what Cooper received was a cold shoulder.

"While he was in Europe he was presented in the Jacksonian press as an aristocrat, as someone who had lost his connection to America and his American touch," said Kelly, labeling the charges "wildly untrue. Cooper had spent most of his European time defending American democracy and the prospect of the nation's future. But he returned [to America] and rather than passing on the criticism and the bad reviews that some of his writing had received while he was in Europe, he took the reviewers in the newspapers to court, and spent most of his time and his resources fighting libel suits."

To Lounsbury's eagle eye, "The extent to which Cooper was affected by hostile criticism is something remarkable, even in the irritable race of authors. He manifested under it the irascibility of a man not simply thin-skinned, but of one whose skin was raw. Meekness was never a distinguishing characteristic of his nature; and attack invariably stung him into defiance or counter-attack."

erhaps the greatest tribute paid Cooper came from the young boys of his time, who found his tales irresistible, as did later generations of filmmakers. This especially proved to be the case with *The Last of the Mohicans.*

Standout screen adaptations of that work alone include a lavish 1920 production, with English silent-movie actor Harry Lorraine as Natty (and a bone-thin Boris Karloff as a homicidal Mohican); a 1932 serial, with early western star Harry Carey; a 1936 feature, with matinee idol Randolph Scott, looking more like Daniel Boone than Hawkeye; and another, in 1992, with a brooding, loinclothed Daniel Day-Lewis. Television also mined the material for a late-1950s syndicated series starring western actor John Hart as Hawkeye and, in an anomalous bit of casting, Hollywood's signature Wolfman, Lon Chaney Jr., as faithful Chingachgook, sporting a feather in his headband.

"It's a great story, one that has inspired more than a dozen film adaptations," said Turner Classic Movies host and historian Robert Osborne. "The first version was done way back in 1911. Over the last hundred years, there have been versions of all types: silent and talkies, black-and-white and color versions, versions in English, German, French, and Spanish languages, versions on the big screen, and television versions. The story's even been told in comic books and operas."

Cooper's high-minded Catskills hero also paved the path for such far-flung real-life and fictitious heroes as Henry David Thoreau, Ernest Hemingway's titular protagonist in his 1925–30s *Nick Adams Stories* (as Nick heads off alone to fish the

Although Cooper tended to win these legal battles, after spending a fortune in attorney fees, "characteristically he would receive a dollar in damages," said Kelly. And even then, newspapers did not necessarily let up; in Cooper's obituary, the *New York Tribune* reported, "His more recent performances, in which he endeavors to use the novel for political declamation, are wholly unworthy of his fame. . . . Their general style is forced, artificial, and often repulsive."

In his own defense, Cooper—whom Kelly considered "constitutionally unable not to get into a fight if one were on offer"—wrote the lengthy *A Letter to His Countrymen,* which appeared as a paid notice in American newspapers. In it, he criticized his country's culture and championed his own views on democracy and wealth, taking personal issue with those who "repeatedly and coarsely accused [me] of writing for money" and "undue meddling with the affairs of other nations."

Big Two-Hearted River), and William Faulkner's bear-hunting Isaac McCaslin in the author's 1942 *Go Down, Moses.*

Even Mark Twain, no doubt defiantly, was unabashedly tipping his hat to Cooper when at the end of *The Adventures of Huckleberry Finn* his protagonist expresses sentiments worthy of Natty Bumppo. As Huck laments, "I reckon I got to light out for the Territories ahead of the rest, because Aunt Sally she's going to adopt me and sivilize me, and I can't stand it."

James Fenimore Cooper's great-great-great-grandson Henry Cooper paid a visit to the U.S.S.R. and found that the Soviets worshipped the work of his ancestor, who was paid tribute on a series of 1989 postage stamps, as was his *The Last of the Mohicans.*

"Cooper's problem was that he was a Republican living in a Democratic age," said Kelly, adding that the writer also "managed to alienate himself from his countrymen so strenuously that he left New York [and] went back to Cooperstown, where he entered into a set of quarrels with villagers over the use of land that his father had owned at one point."

Staging protests on the lawn of Otsego Hall, Cooper's detractors also accused him of trying to undermine the Republic, "and Cooper wound up his career as an extraordinarily alienated and, it's fair to say, impoverished figure. The money was gone, and when he died his children had to sell the house that he had spent so much time trying to protect and develop."

Cooper had also grown so disillusioned with his critical standing that he instructed his wife to keep his papers out of the public eye. As a result, it would be nearly a century before any of his correspondence became available to researchers. His private papers remained sealed even longer.

IN SPITE OF the lasting sales of Cooper's books, critics have long favored the lighter style of Washington Irving, an admired and much-quoted figure who, in 1859, at age seventy-six, died in his bed at Sunnyside, his home in Tarrytown. When word of his passing traveled overseas, London's *Morning Herald* eulogized:

> [T]he United States have lost at once one of the most respectable and estimable of diplomatists and men of letters. The name of WASHINGTON IRVING, indeed, is quite as much identified with any place where the English language is spoken as it is with America. Few writers of any class, and none who have pioneered the literature of a new country, have ever shown so much cosmopolitan feeling and absence of prejudice, and the works of the distinguished author just deceased will long hold their place amongst a very high order of their various departments of English literature.

While Irving's tales were scintillating, precise, and filled with nuance, Cooper saddled his with creaky plots, wooden writing, and female characters who were overly sweet and one-dimensional. Edgar Allan Poe found Cooper remarkably inaccurate, while Mark Twain (never a fan of romantic fiction, which had fallen out of favor since the end of the Civil War) was so outraged by Cooper's novels, which he deemed romantic drivel, that in 1895, forty-four years after Cooper's death from dropsy one day shy of his sixty-second birthday, he penned a lengthy piece titled "Fenimore Cooper's Literary Offenses." Besides faulting Cooper's grammar and word use—"in the restricted space of two-thirds of a page [in *The Deerslayer*], Cooper has scored one hundred fourteen offenses against literary art out of a possible one hundred fifteen"—Twain attacked his fellow author for stories that were formulaic and implausible.

Not that Cooper was without his defenders, including those who credit him for providing the first representations of Native Americans and African Americans in American literature. In Europe, Victor Hugo singled him out as more estimable than the great masters of the modern romantic novel, while Honoré de Balzac, writing for the *Revue Parisienne* of July 25, 1840, cited "the magical prose of Cooper," insisting that *The Pathfinder* "not only embodies the spirit of the river, its shores, the forests, and its trees; but it exhibits the minutest details, combined with the grandest outline." Of Cooper's canvas, Balzac said, "The vast solitudes,

in which we penetrate, become in a moment deeply interesting. When the spirit of solitude communes with us, when the first calm of these eternal shades pervades us, when we hover over this virgin vegetation, our hearts are filled with emotion."

Measuring the extensive reach of his ancestor's work, Henry Cooper tells a story of his visit to Russia in the 1980s to interview cosmonauts for *The New Yorker*. With his sessions arranged by an arm of the KGB that specifically handled foreign reporters, Cooper recalled, "I went in to see my handler and he said, 'I'm ready to talk to you, but first there is someone who wants to meet you.' I said, 'Okay,' but my heart sort of plunged. It's not generally a good thing to meet the highest guy around in the KGB. So we walked down a hall and got into an elevator, and as the handler pressed the button for the top floor, he said, 'The higher the floor, the more important the guy.' So, we got up to the roof and walked down a long corridor, and before we got to the fellow's office the handler said, 'The more important the guy, the bigger the office.' They threw open this door, and there was this room about the size of a tennis court with a little desk, and you could see a view out the back of the Kremlin, which is something that you have to have if you're going to maintain your position in the hierarchy. I was scared to death that they were going to tell me all my appointments had been canceled, but I walked up this red carpet and this man walked down, we met in the middle, we embraced, and he said, 'I am so happy to meet the great-great-great-grandson of Fenimore Cooper. Come over, I have a samovar and some cookies.' Then he said, 'Is there anything you'd like to know about your great-great-great-grandfather?' And I said, 'Well, how many books of his have you printed over the years?' 'We have printed in Russia seventy million copies of your great-great-great-grandfather's books.' I should've said, 'Where's my check?' but I restrained myself. Then he said, 'Do you want to know how many of those seventy million books were printed in the last twenty years? Fifty million'—which is to say that the number was going up, not down. So I said, 'What do you think accounts for Cooper's great popularity over here?' He thought for a minute, and, taking into account that I was over there to write about the space program, he said, 'Both Russia and the United States are continental-sized countries. And in both countries, you from the east and we from the west, we have progressed, have filled out our continental base, and arrived at the Pacific. And then we had no place to go but up. Your great-great-great-grandfather's novels captured the challenge of new frontiers for all of us.'

"Which I thought was a pretty good comment, off the cuff."

Capturing the Light

—⧳⧲—

Apart from their work it was a joy to them to walk in the woods, climb the mountains, and breathe the clean, dry air. They glorified in the boundless views of the Hudson Valley seen from the Catskills. They accompanied the first explorers into the wilds of the Rockies and the Yellowstone. They thought that the size of the great lakes, the mighty rivers, and the boundless prairies must reflect itself in the greatness of the national art. They were patriotic, boasted themselves to be the first really native school (which was true), and spared an incredulous Europe not one jot of the blazing vermilion of the autumn foliage.

—SAMUEL ISHAM, on the Hudson River School

Between 1800 and 1835, American artists by and large contented themselves with imitating what was produced in Europe, while American collectors followed the accepted principle that the only important art came from there. A disdainful Old World, meanwhile, viewed America as nothing more than a cultural backwater, or, as sharply summed up by the reformer Frances Trollope, mother of the celebrated English novelist Anthony Trollope, in her 1832 *Domestic Manners of the Americans,* "I should hardly be believed were I to relate . . . the utter ignorance respecting pictures to be found among persons of *first standing* in [American] society. Often when a liberal spirit exists and a wish to patronize the fine arts is expressed, it is joined to a profundity of ignorance on the subject almost inconceivable."

Among American artists, the fortunate few who could claim a patron or inde-

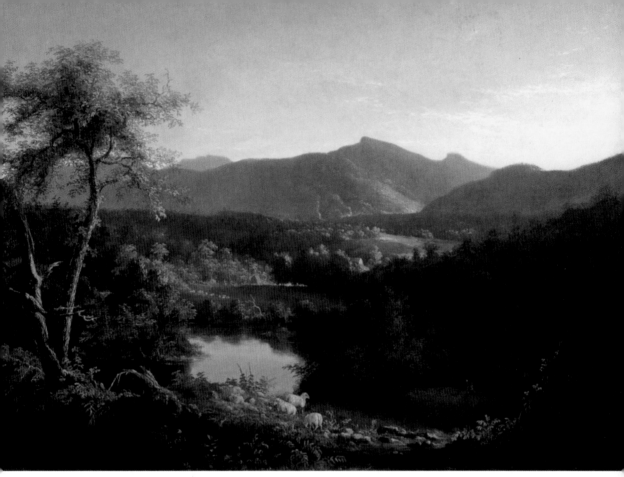

The unofficial father of the Hudson River School, Thomas Cole helped shape the mythos of the American landscape; here, his 1827 *View Near the Village of Catskill.*

pendent financial means usually went to Italy to study the masters of the Renaissance, or to England to learn from Benjamin West, president of the Royal Academy of Art. Despite his religious and historical tableaux being much favored by the English aristocracy, West hadn't always traveled in such refined circles. The tenth child of a Pennsylvania tavern owner, he was first taught by the local Native Americans to make paint by taking clay from the riverbank and mixing it with bear grease.

When Thomas Cole was born, at Bolton-le-Moors, Lancashire, England, on February 1, 1801, West was still in charge of the Royal Academy, and it seemed unlikely that he and the only son of James and Mary Cole would ever be mentioned in the same breath. Shortly after Thomas was nine, his father, a woolen manufacturer once described as "better fitted to enjoy a fortune than accumulate one," hoped to apprentice Thomas to an attorney. Instead, the boy, whose artistic

O nce trained in Europe, early-eighteenth-century American artists would return to the United States only to execute what they had learned abroad: portraiture, depictions of key historical events, or scenic views dotted with ruined abbeys or pastoral landscapes. Those who never ventured abroad usually ended up as itinerant portrait painters, rendering whatever the client might demand, be it family portraits, paintings of farms and barns, or pictures of pets, pigs, or gardens.

Some gained exposure by sprucing up a central element of the American home, the fireplace. Decorative overmantels, also called "chimney paintings," typically featured country landscapes, hunting parties, naval battles, or a trompe l'oeil. By the early nineteenth century, another artistic ornament had been added to the family residence: a paneled ornamental "chimney board," which could be set in place to screen the hearth during the warm months.

To customize the ledge above the fireplace concealing the chimney, artists could either attach a canvas or paint directly onto the plaster or wood paneling. One of the earliest examples of these works, from the 1730s and considered the first landscape

ambitions were first demonstrated when he painted a face on the family clock, ended up working as a printer of designs for calico, learning not only the designs of his trade but also how to cope with its solitude. For Cole, downtime was spent playing the flute, wandering the parks, and reading, mostly books about distant travel. He was particularly captivated by descriptions of North America.

At age seventeen, Thomas, with his parents and seven sisters, sailed to America, where his father opened a dry-goods store in Philadelphia, and the former

More than seven feet wide and fifteen and a quarter inches high, the oil-on-wood *Van Bergen Overmantel* provides a circa-1730 snapshot of a prosperous Catskills farm, including its racial diversity.

painting in America, was the *Van Bergen Overmantel,* attributed to the Albany, New York, painter John Heaton for the Van Bergen family in the Greene County hamlet of Leeds. Depicting a prosperous Catskills farm in its mountain surroundings, the large oil-on-wood piece provides a colorful snapshot of Catskills life at the time.

As historian Alf Evers described the work, "There is the Van Bergen haystack, the substantial farmhouse, the cows, the sheep, the horses, and wagons." Populating the scene is a Native American with his wife carrying their baby on her back, a young slave girl accompanying a cow, and a horseman taking a comic tumble off his steed on the road adjacent to the house.

"And above it the Catskills," said Evers, "brooding in all their wilderness mystery, make an impressive entrance into the world of art."

calico printer became the assistant of a wood engraver. Within less than a year, James Cole's shop failed, the first of many ventures of his that would go sour, and the family resettled in Steubenville, Ohio. This time James set up shop manufacturing wallpaper, and his son crafted patterns and decorated muslin window shades. The Cole daughters ran a local school for girls, and it was from them that their brother learned the poetry of Byron, Coleridge, Keats, and Wordsworth. Thomas still continued to play his flute, usually accompanied by one of his sisters

on piano, and on his own he was a tireless hiker through the woods on the outskirts of town, where the only company was an occasional wild hog.

As James's business struggled—wallpaper was an extravagance Steubenville could do without—Thomas made the acquaintance of an itinerant and not particularly gifted painter named John Stein, who lent him the first book he ever read about prominent artists. Cole also learned from Stein the essentials of mixing colors and applying strokes, and was soon trying his hand at producing portraits of his own family.

"What was now wanting in order to step at once into the path of his chosen art," wrote Cole's 1856 biographer and friend, the Episcopal minister Louis Legrand Noble, "were the requisite materials. With these he presently supplied himself, very crudely, by making, in part, his own brushes, and getting his colours from a chair-maker, by whom he was employed, for a short time, as a kind of ornamental painter. His easel, palette, and canvas corresponded."

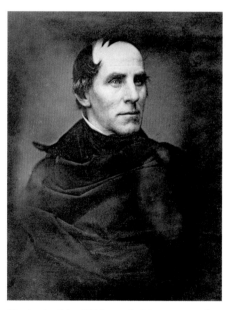

"An invincible diffidence led him to avoid society and to wander alone in woods and solitudes, where he found that serenity which forsook him in the company of his fellows," William Cullen Bryant said of Thomas Cole.

Now ready to seek out his own paying clients, Cole spent several weeks in surrounding towns, despite an innate shyness, "a constitutional timidity," said Noble, "that made him shrink, even in the presence of persons in no way distinguished."

The family next moved to Pittsburgh, where James would fail at manufacturing floor cloth. Thomas, meanwhile, remained in Steubenville to settle the sale of the house and find solace in the wilderness on the outskirts of town, where he would sketch trees, clouds, and streams along the banks of the Monongahela River. "The spring had arrived, and the young painter seemed to awake to the beauties of nature in landscape, and to feel not only his love for, but his power in that branch of art," the prominent artist and colonial and Federalist Era historian William Dunlap wrote about Cole in 1834.

"[Cole] probably timed his visit because just the year prior to that was the opening of the Catskill Mountain House, which was an enormous influence on people in all walks of life," said Elizabeth Jacks, executive director of the Thomas Cole Historic Site.

Every morning before it was light, he was on his way to the banks of the beautiful Monongahela, with his papers and pencils. He made small, but accurate studies of single objects; a tree, a leafless bough—every ramification and twig was studied, and as the season advanced he studied the foliage, clothed his naked trees, and by degrees attempted extensive scenes. He had now found the right path, and what is most extraordinary, he had found the true mode of pursuing it.

Deciding that a large city such as Philadelphia might suit his aspirations, Cole, after a brief reunion with his family in Pittsburgh, moved to the City of Brotherly Love, where "too close upon beggary to refuse the offer of regular employment,"

said Noble, he found work painting commercial murals for shops and restaurants. "Scenes of frolic and drinking would sell in the bar-room, the barber's shop, and the oyster-house," wrote the biographer, "when simple representations of nature could not find a purchaser." At his lowest point, the timid artist was commissioned to paint a portrait of a corpse.

"Unfortunately," said Noble, "the corpse was obliged to be taken to burial sooner than was expected, and [Cole] had to finish the portrait from recollection."

One gift Philadelphia offered was the Pennsylvania Academy of the Fine Arts, where Cole was introduced to the work of the local-born artist Thomas Doughty, a former leather currier whose first landscape the academy exhibited in 1816. With an eye for realism, Doughty, using muted colors, specialized in atmospheric, small-scale vistas—rather than the portraiture far more common to the period—and applied the conventions of Continental landscape painting to American scenery.

A visit from his sister Sarah and her husband in late April 1825 hastened Thomas's move, at age twenty-four, to New York, to rejoin the rest of his family. "He put a tablecloth around his shoulders and walked," said one profile of the artist. "So you can really imagine the definition of a struggling artist at the time."

As Noble contended, "Obstacle was his stepping stone, and embarrassment his element. . . . In a word, training had made Cole at home with difficulties. Where most men would have retired with impatience and disgust, and many have surrendered in despair, he could labour on not only resigned, but with hope and right good cheer."

Home in New York was a cheerless garret on Greenwich Street, a windowless room "so narrow as to afford him barely space enough, in the process of painting, to retreat the requisite distance from his canvas," said Noble, adding that despite the darkness and confinement, "the brilliancy of strong day-light" still emanated from Cole's work.

Able to sell four of his early works for ten dollars apiece to his first patron, the commercial merchant George W. Bruen, Cole could afford a summer sketching trip to a place he had been eager to explore, "not so much in the romantic sense to pioneer into the wilderness," said Franklin Kelly, since 2008 the chief curator of the National Gallery of Art. "He went there thinking there's a potential market for scenery."

"HE PROBABLY TIMED his visit because just the year prior to that was the opening of the Catskill Mountain House, which was an enormous influence on people in all walks of life," said Elizabeth Jacks, executive director of the Thomas Cole Historic Site, in Catskill, New York. "And he, living in New York, and being interested in the landscape, it was really the place to be."

"There was already a market developing," said Franklin Kelly. Exploring Cole's motivations for his trip to the Catskills, the curator said, "Not to overuse the term 'perfect storm,' but you've got these elements that came together. First of all, New York was the major market for art by far. People who didn't necessarily live in New York would go to New York to acquire art. Then there was a whole shift in patronage, from the aristocrats to the merchant class. Aristocrats, it's fair to generalize, tended to treat artists in the traditional role of patron. In other words, they thought of themselves as enabling an artist to do this, part of their good deeds. At the time, Cole felt fallible. He was commissioned by a landowner in New York State named [George William] Featherstonhaugh to come and do these views of his [upstate] estate, then Featherstonhaugh basically treated him like a servant. 'You eat with the children and you do what I say.'"

With the recent opening of the Catskill Mountain House, explained Kelly, "people really were enjoying getting out of the city, and they did get out of the city. The other thing was the opening of the Erie Canal and the influx of wealth into New York. New Money, and people with all the growing pains of New Money." This evolution included collecting art, although, Kelly noted, "the market was nonexistent, virtually, in terms of supply. And in some ways, Cole was a perfect figure to see that playing out."

Taking a steamship to the village of Catskill, Cole walked "his way up into the Catskills, going all the way up river to the point at which the Mohawk River

John Trumbull, whose sketches of British forts during the Revolutionary War aided the American cause, was nearly seventy by the time he came upon Thomas Cole's early canvases of the Catskills.

joins the Hudson River near Albany," said Vassar professor H. Daniel Peck. "And during this expedition he drew a number of sketches of landscape, which he then brought back to New York City and his studio and painted several landscapes from these sketches."

"They depicted the American landscape in a new way," said Elizabeth Jacks. "Before that, landscape painting existed, but it was really painting someone's great estate . . . painted in a very beautiful, calm, picturesque kind of way that was very different from Thomas Cole's paintings, which were full of wild, untouched nature, like no one had ever been there."

Three of the works—*The Falls of the Kaaterskill*, *Lake with Dead Trees*, and *A View of Fort Putnam*—went on display in the Lower Manhattan shop of the frame-maker William Colman. "Despite the obvious exaggerations of those early Catskill views of Cole's—excessively contorted trees, improbably chiaroscuro effects, and a palette tending to overheat—they were nothing less than small miracles," observed Metropolitan Museum curator of American decorative arts Oswaldo Rodriguez Roque.

Indeed, as the *New York Evening Post* reported on November 22, 1825, a transformative moment not only in Cole's life but also in the history of art in America arrived when the esteemed painter John Trumbull, a onetime protégé of Benjamin West's, happened into the Colman gallery:

> On casting his eyes upon one of the pictures by Mr. Cole, he exclaimed, "where did these come from!" and continued gazing, almost incapable of understanding the answer. When informed that what he saw was the work of a young man, untutored and unknown, he immediately purchased the painting for twenty five dollars, the price Mr. Colman had prevailed upon the painter to affix to his work, adding, "Mr. Colman, keep the money due to me, and take the balance. If I could sir, I would add to the balance. What I now purchase for 25 dollars I would not part for 25 guineas. I am delighted, and at the same time mortified. This youth has done at once, and without instruction, what I can not do after 50 years of practice."

In his studio, Trumbull revealed *The Falls of the Kaaterskill* to his friend the prominent theatrical producer and painter William Dunlap, and the two went on to share the find with a younger member of their circle, the engraver Asher B.

Seeking to throw a light on New York's intellectual world in the early 1820s, James Fenimore Cooper founded an informal Manhattan lunchtime social and cultural coterie of about thirty-five members.

Originally called "Cooper's Lunch" and held in the back room of a bookstore owned by Cooper's publisher Charles Wiley, the gatherings usually ran until dinnertime and then gradually began meeting every other Thursday afternoon at the Washington Hotel, on the southeast corner of Broadway and Reade Streets. Members supplied the food, and the African-American artist Abigail Jones usually acted as cook.

Soon calling themselves the Bread and Cheese Club, the group derived the name from its membership ritual: a piece of bread placed on a passing plate signified an applicant's acceptance, while a bit of cheese meant rejection. In such a setting Cole, Durand, and other leading artists networked with men of taste and education, literary celebrities, technological innovators such as Samuel F. B. Morse, and scholars, merchants, politicians, and attorneys.

"These were natural gathering points for people from the sister arts who really did believe that they were working on the same cultural program," said H. Daniel Peck of Vassar. "They were advancing the cause of American cultural independence. They were advancing the same kinds of themes and ideas and writing about the same settings. And the setting about which they were writing, the Hudson River Valley and the Catskill Mountains beyond, became the first national landscape."

Yet American literature scholar William P. Kelly suggested that it didn't take a formal club in Manhattan to link together the cultural world's movers and shakers of their day. "There's a letter from Thomas Cole to Washington Irving, suggesting that they collaborate on a project in which Irving would write about the Catskills and Cole would paint scenes from the Catskills, and that this would become a great success. Irving really didn't have time to do it—he was involved in commissions to do biographies of Columbus and Washington—but it speaks to Irving's role as a magnet and attracting a wide variety of cultural figures to the region, and why the Hudson River School and the Hudson River in general and the Catskills, more particularly, became the center of America's first literary salon."

A member of John Trumbull's and Asher B. Durand's clique, the actor, painter, producer, playwright, and historian William Dunlap wrote the three-volume *A History of the Rise and Progress of the Arts of Design in the United States* (1834), which is still considered essential.

Durand. Observing Cole's daring scene of broken branches wedged between rocks in a stream framed by thick underbrush and capped by a dramatic sky, all from the perspective of inside a cave behind a waterfall, the men were hooked.

Following Trumbull's lead, Dunlap and Durand returned to the Colman gallery and bought the two other Cole canvases, for what Dunlap termed a "paltry" twenty-five dollars each. "When I saw the pictures I found them to exceed all that this praise had made me expect," Dunlap said. Insisting upon a meeting with the artist, Durand volunteered to run the unpaved path to Greenwich Village and bring Cole back to Trumbull's studio, and Cole hesitatingly accepted the invitation.

Tongue-tied to stand before the three accomplished men, and embarrassed by the threadbare state of his clothes, Cole was "a young man in appearance not more than one and twenty, of slight form and medium height, soft brown hair, a face very pale, though delicately rosy from agitation, a fair fine forehead, and large light blue eyes, in which it would have been difficult to say whether there was more of eloquent brightness, or feminine mildness," said Noble.

Quickly assuming the role of mentor, Trumbull introduced the young artist to his wealthy friends and prospective patrons, such as his son-in-law, Daniel Wadsworth of Hartford, while Dunlap, in his role as a critic for the *New York Mirror,* spread word of Cole's special skills. "The 1820s were a period in which the relationship between writers and artists and their programs for art were unusually interconnected," said H. Daniel Peck. "It wasn't only that they knew one another, which they did, and the New York art world was a much smaller world than it is today, but they actually were, in a sense, working off each other's work."

Within a month of Trumbull's introducing him, Cole exhibited at the Amer-

ican Academy of Fine Arts, and six months later he helped found the National Academy of Design. "Those early wilderness pictures of Cole's," said William P. Kelly, "started out at twenty-five dollars and then they got to fifty very quickly."

"His fame spread like fire," Durand said of Cole, while William Cullen Bryant, a poet of the wilderness, as well as the influential editor in chief of the *New York Evening Post*, placed the artist on a pedestal. "From that time he had a fixed reputation," said Bryant, "and was numbered among the men of whom our country had reason to be proud."

"One aspect of Washington Irving's cultural significance that is rarely credited is his consequence for the Hudson River School," said William P. Kelly. "The power of Irving's writing about the Catskills, particularly Rip Van Winkle and Ichabod Crane, and the way he invents that space, is picked up by a generation of American painters, writers, and essayists who see this region as a sacred space that Irving imagined. Not a space that Irving knew particularly well, but a place of the American imagination—so that when Thomas Cole decides to move to that area, he is largely driven by Irving's example."

"Thomas Cole continued to paint in New York, and continued to come up here to the Catskills to do sketches," said Elizabeth Jacks. "Then he started to frequent a property historically known as Cedar Grove, now known as the Thomas Cole National Park site."

As Cole said about a Catskills sketching trip:

> At an hour and a half before sunset, I had a steep and lofty mountain before me, heavily wooded, and infested with wolves and bears, and, as I had been informed, no house for six miles. . . . After climbing some three miles of steep and broken road, I found myself near the summit of the mountain, with (thanks to some fire of past times) a wide prospect. Above me jetted out some bare rocks; to these I clambered up, and sat upon my mountain throne, the monarch of the scene.

"Cole's preferred way of working was to go out into the Catskills and work with pencil, and so there's book after book of sketchbooks of these pencil sketches that he did," said Jacks. "He would make detailed notes right on them and say, right here is the sunset and the color of this tree is kind of purplish and orange with autumn's changing colors."

Of using his oils, Cole, who kept up an active correspondence with Durand, wrote the engraver in 1838, "I never succeed in painting scenes, however beautiful, immediately on returning from them. I must wait for time to draw a veil over the common details, the unessential parts; which shall leave the great features, whether the beautiful or the sublime dominant in the mind."

Jacks noted another reason for stalling the process. "It was really quite complicated to paint outdoors then. Now we have paint that comes in these neat little tubes and you can squeeze them out. Back then, they had to grind up these minerals into powders to make the pigment, and then they'd mix it with the oil, and then they would sometimes stuff them into little fish bladders to carry them around. If it got too hot, the fish bladder would explode. You'd have paint all over."

William Cullen Bryant, poet and the longtime editor of the *New York Evening Post,* put aside his newspaper duties in June 1840 when Thomas Cole dispatched an invitation: "There is a valley reported 'beautiful' in the mountains a few miles above the [Kaaterskill] Clove—I have never explored it & am reserving the delicate morsel to be shared with you."

AMONG COLE'S EARLIER and more generous benefactors was the Baltimore merchant Robert Gilmor, "very well traveled in Europe and a collector of things," said Franklin Kelly. "He had all the master paintings. He had medieval things. In the beginning, when Cole painted those first pictures that he showed in New York in 1825, people said, 'I want one of those.' And that's how Gilmor came into the picture. He basically said, 'Paint me something like that.'"

The merchant also exerted a heavy hand when it came to trying to steer Cole's paintbrush. "Early on, Gilmor was talking to Cole and saying that he'd been to the Catskills, and saying that Cole ought to do what [James Fenimore] Cooper did," said Kelly. "Gilmor would say, 'It's very nice to have these landscapes, but you maybe ought to think about the canoe race in *The Last of the Mohicans,* when Leatherstocking and the British girls are escaping from the Indians.'"

"Thomas Cole was very much aware of the literary traditions of the time," Jacks asserted. "He, in fact, painted paintings that illustrated the novels of James Fenimore Cooper, and he conversed in letters and in person with writers of the period."

In making his desires clear to the artist, in a letter of December 27, 1826, Gilmor went so far as to dissect a recent addition to his collection, Cole's *Sunrise in Catskill Mountains:*

> Your landscape arrived here two days ago. It is extremely well painted with great truth in nature, [but] I think you have hardly given enough of this light to the tops of trees or the rock, which should have caught it and perhaps a little more of its effect in warming the mountainside where the mists rise, would have given more force to the cold shadowy form of the center of the mountain. . . . If you ever come this way I think I can satisfy you that a figure or two on the rock in the foreground, particularly Indians, would have done a great deal to assist its effect.

Gilmor also questioned the yellow in Cole's depiction of the sun, which the merchant felt required more red. He further took issue with the height of the horizon, which, the patron believed, "should not be carried beyond the middle of the picture."

Cole, who believed, "If the imagination is shackled, and nothing is described but what we see, seldom will anything truly great be produced either in Painting or Poetry," responded diplomatically:

> I have received your letter of the 27th of last month, enclosing fifty dollars, for which accept my thanks. I was gratified to learn that the picture pleased. . . . I think the colour of the sky will be much improved by varnish; but whether it will have the true saffron tint of morn I cannot say. Mornings vary much in their tints—sometimes rosy, sometimes pale yellow, golden, and often of a greenish tint.

Visiting England under Gilmor's sponsorship in 1829, Cole rubbed shoulders with the artists John Constable, J. M. W. Turner, and others, but found the art of his native country to be as cold and uninviting as its climate. Striking a patriotic note for his adopted home, he declared, "The painter of American scenery has,

indeed, privileges superior to any other. All nature here is new to art. No Tivolis, Ternis, Mont Blancs, Plinlimmons, hackneyed and worn by the daily pencils of hundreds; but primeval forests, virgin lakes, and waterfalls, feasting his eye with new delights."

"Thomas Cole was originally from England, he came over to America as a teenager, and it's been said that it really took an outsider to notice what beautiful assets America had, so he was able to look at it with fresh eyes," summarized Jacks. "Coming from England especially as a young man, he saw the Industrial Revolution happen there and change the landscapes around him dramatically. So when he came here, it's been hypothesized, he saw the landscapes as he may have seen them as a child in England, that here they were untouched again. It was as if he was going to watch the Industrial Revolution happen all over again."

Riding the wave of Cole's commercial popularity at home, in 1832 a gallery exclusively devoted to his works opened at the heavily trafficked corner of Wall Street and Broadway. Within five more years, Cole's paintings had become the chief attraction at public exhibitions. "We should like to see such pictures gracing the drawing rooms of the wealthy, instead of the imported trumpery of British naval fights, or coloured engravings, and above all, in place of that vulgar, tasteless and inelegant accumulation of gilded finery which costs more than a dozen fine landscapes," advised writer and critic (and Washington Irving's chief collaborator on *Salamagundi*) James Kirke Paulding, while former New York City mayor and notable diarist Philip Hone was moved to write, "I think every American is bound to prove his love of country by admiring Cole."

"It was a time in America when Americans were deciding what does it mean to be an American," said Jacks. "It was so recently a colony. They were all recently immigrants. But what did it mean back then to be an American? What were our cultural traditions? And Thomas Cole filled that niche very well. People were looking for something that was uniquely American, not from somewhere else. And the landscape was ours. It wasn't imported. It was here. It was something no one else had. Thomas Cole's landscape painting was a native art. It was our own invention. It was something Americans could be proud of."

THE MAN WHO DISCOVERED Cole at the Colman Gallery, then served as his mentor, also turned out to be Cole's first disciple: Asher B. (for Brown) Durand,

"the acknowledged dean of American landscape painters," in the words of Kevin J. Avery, of the Department of American Paintings and Sculpture at New York's Metropolitan Museum of Art. "Durand at that time was not a painter, actually," said Elizabeth Jacks. "He was an engraver. Durand then got into portrait painting, and then later on–this is where the relationship becomes interesting–Thomas Cole started encouraging Durand to become a landscape painter."

The eighth of eleven children born to a silversmith whose Jefferson Village, New Jersey, shop also manufactured bayonets for the Continental Army, Durand began his artistic training by engraving the business cards that went inside his father's watches. Leaving home at fifteen, he walked the sixteen miles to meet the mule-powered, paddle-wheeled boat that would ferry him across the Hudson River to Manhattan, where he aimed to become a novice engraver. The dream came crashing down, however, when, lacking the necessary $1,000 an expatriate English engraver demanded to teach him the trade, Durand was forced to turn on his heels and head back to New Jersey–where he landed a six-year apprenticeship with Peter Maverick, a Newark bookplate, banknote, and map steel engraver sixteen years his senior. Though Maverick's name appeared on all the work, it soon became evident whose young hand was responsible for the accurate, lifelike characters and firm, harmonious lines in what the shop produced.

At twenty-one, Durand was made a full partner, and in October 1817 Maverick & Durand established a branch of their business at the corner of Manhattan's Pine Street and Broadway, which was how word of the younger man's finesse reached the historical painter John Trumbull. Outraged that Heath of London wanted $6,000 to reproduce his portrait of the signing of the Declaration of Independence, Trumbull approached Maverick & Durand with the offer of $3,000–which Maverick declined. Durand thought better of the deal and accepted it, immediately dissolving his partnership with Maverick and then spending the better part of the next three years on the ambitious plate.

"[T]he result is the masterpiece we know so well," the artist and president of the Century Association, Daniel Huntington, said of Durand's reproduction of the Trumbull work, and "established his reputation as a master of the art." By now, Durand was all of twenty-five.

Acknowledged Avery of the Metropolitan Museum, "[T]he engraving significantly boosted Durand's standing in the New York art world, and in 1825 he

joined with Samuel F. B. Morse, Thomas Cole, William Sydney Mount, and others in founding the New-York Drawing Association, soon to be called the National Academy of Design; shortly after, he was elected to the Lunch Club, ancestor of the Bread and Cheese Club, the Sketch Club, and the Century Association."

COLE SPENT 1829 through 1832 in Europe, causing his friend William Cullen Bryant to worry that he was following the courses set by Washington Irving and James Fenimore Cooper and abandoning America for an extended stay, although this proved not to be the case. What his European Grand Tour did yield, besides Catskill landscapes painted from sketches he had made before setting off, were five large canvases whose series he named *The Course of Empire*. "He shows an entire civilization over centuries at the same spot," said Jacks, "so you can see in the background of the painting this mountain with a rock on it. That appears in the back of every painting in the series, so you know you are looking at the same scene, but it's vastly changed over time. In the beginning, it's what he calls the savage state, and nature dominates. Man is not a dominant figure in it. Then it goes through the pastoral state, which is where man and nature

Thomas Cole produced four exhibition paintings based on James Fenimore Cooper's newly published *The Last of the Mohicans* in 1826, just as "artists and writers aimed to dispel harsh remarks about the nation's young culture by envisioning a shared heritage of place, legend, and history," according to contemporary art historian Roberta Gray Katz.

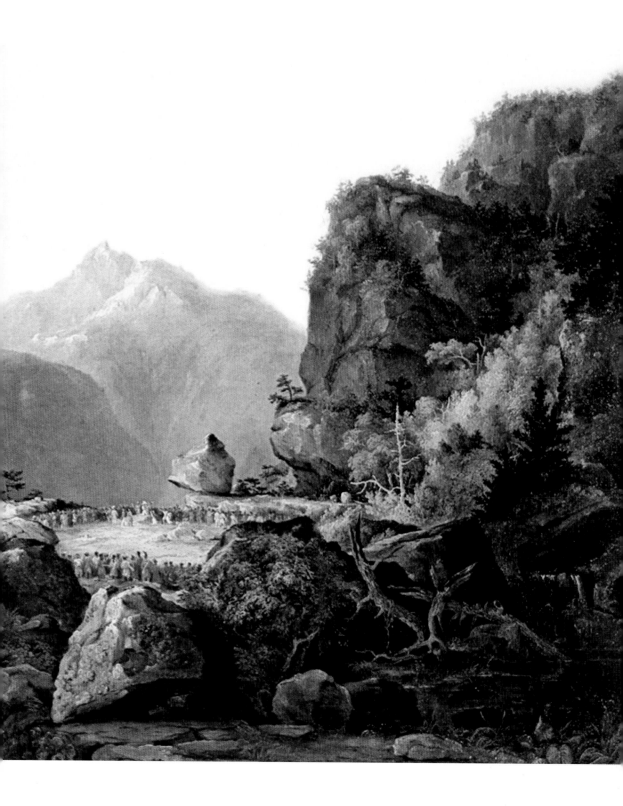

are in harmony. Then it goes through this culmination, where you have palatial architecture, a triumphal arch, and an empire marching through it. It's kind of the height of civilization, in a way. This then falls into, in Cole's view, the inevitable—greed takes over. Fighting erupts. Wars. Violence. The architecture is destroyed, so is the civilization. Then it falls into the last painting, which is desolation, in ruins. You have a column, you have a few remaining pieces of rubble. Cole has written extensively about this series himself. He sees it as a statement about universal mankind, not one particular civilization, but a kind of universal statement about just the way things unfold."

The series inspired James Fenimore Cooper to tell Louis Legrand Noble, "Not only do I consider *The Course of Empire* the work of the highest genius this country has ever produced, but I esteem it one of the noblest works of art that has ever been wrought."

When Cole returned to the Catskills for a summer sketching trip in 1833, his stature stood so unchallenged and his subject matter so permanently etched in the public's mind that the "mere mention of Catskills was enough to bring a rush of pleasing romantic images into the minds of sensitive people," Alf Evers confirmed.

On November 22, 1836, the artist, now thirty-five yet still intensely shy but tired of being single, married for the first and only time. The bride was Maria Bartow, the youngest niece of Catskills gentleman farmer John Alexander Thomas, in whose house, Cedar Grove, in the village of Catskill, the ceremony took place, in the west parlor, which faced the Catskills. As Cole was to tell friends, including Durand, he found that Maria matched him in mood and, like him, enjoyed collecting the summer mosses. Still standing at 218 Spring Street and offering the same unobstructed view of the Catskills enjoyed by Cole when he was only renting the place in the early years of his visits to the mountains, Cedar Grove became the permanent home of the couple and their five children: Theodore (born in 1838), Mary Bartow (1839), Emily (1843), Elizabeth (1847), and Thomas II (1848).

Visiting the Coles during a sketching trip, Durand, in the throes of a genuine midlife crisis only partially rooted in the recent loss of both his wife and their two-year-old daughter to illness, wished to abandon his lifelong career in engraving, which he found led to lonely tedium. Having taken up painting, and rendering portraits of Presidents James Madison, John Quincy Adams, and Andrew Jackson, he now believed it was time to try landscapes—although as he modestly assured Cole, "I am still willing to confess myself a Trespasser on your ground, though I trust, not a poacher."

"There's a wonderful letter in which Thomas Cole writes to Durand and describes everything he needs to bring on a sketching trip, and you can really hear the master and the teacher roles switching around," said Elizabeth Jacks. "When Thomas Cole describes the different paint colors, and how you'll need a camp-stool to sit on, and you'll need this and that . . . Durand writes back kind of hesi-tantly, 'Well, are you sure you know this is what I need?' The mentoring switched. The elder Durand became a kind of student to the younger Thomas Cole."

One common belief shared by Cole and Durand was that nature was a man-ifestation of God, which is why any human figure that appears in Cole's works is always subordinate to the grandeur of his setting. This is especially true in his *Landscape Scene from "The Last of the Mohicans,"* where the scout Hawkeye and oth-ers gathered with him are dwarfed by an expansive fall landscape brightly lit by an all-embracing sky; this wilderness is a welcoming one that invites exploration, rather than threatens satanic darkness.

"To walk with nature as a poet is the necessary condition of a perfect art-ist," was Cole's dictum, while in his 1855 *Letters on Landscape Painting,* Durand wrote that "the true province of Landscape Art is the representation of the work of God in the visible creation, independent of man, or not dependent on human action. . . . The external appearance of this our dwelling place . . . is fraught with lessons of high and holy meaning, only surpassed by the light of Revelation."

While Cole finessed broad, heroic landscapes filled with vibrant color, Durand rendered his richly textured rocks, trees, and foliage in a mellow light with a more limited palette, never losing his engraver's attention to detail ("scrupulously exe-cuted," according to the Met's Avery), even when he came to specialize in mon-umental, large-scale formats. "Cole was born a painter, and for his reputation is indebted to the stars," professed Oswaldo Rodriguez Roque, who considered both men "among the master artists of the age," although in likening one to the other concluded, "Cole is impotent in every department but that of landscape, while Durand has the ability to paint a superior portrait."

"In his landscapes," Daniel Huntington said, Durand used "the facts of nature to express a certain feeling and poetical sentiment. His aim was thus creative, though in his studies he was marvelously realistic and exact."

Continued Huntington, "Cole, to be sure, lived at Catskill, in full view of magnificent scenery, and was endowed with a wonderful memory, so that he gave an astonishing look of exact truth to many of his pictures of American scenery, but he rarely, if at all, up to that period, painted his studies in the open air.

fter the last spoonful of potage had been consumed, imagine the delight of a nineteenth-century dinner guest finding a landscape scene by Thomas Cole at the bottom of his or her soup plate, revealed under layers of broth, vegetables, and bits of meat. What better complement to such a satisfying meal than reminding the diner of America's bounty, scenic wonders, and the success of democracy in the New World," said art historian Nancy Siegel.

With the United States still a rural nation in the eighteenth century, midday lunch functioned as the main meal of the day, as members of the household hastily helped themselves to a large stewpot placed in the middle of the dining table before diners rushed back to farm chores. With the Industrial Revolution and men leaving home to work in city factories, the

From the age of eighteen to twenty, Frederic Edwin Church studied with Thomas Cole, who praised his young protégé for having "the finest eye for drawing in the world."

"Durand went directly to the fountainhead, and began the practice of faithful transcripts of 'bits' for use in his studio, and the indefatigable patience and the sustained ardor with which he painted these studies not only told on his elaborate works, but proved a contagious influence, since followed by most of our artists, to the inestimable advantage of the great landscape school of our country."

So faithful was Durand in his depictions of nature that one observer noted that because the artist painted in the field, "When he got home there would often be bits of leaves and grass stuck to his paintings and occasionally a dead insect."

COLE AND DURAND BOTH FLOURISHED under the patronage of a liberal New Yorker, Luman Reed, a farmer's son from Green River who made a fortune shipping midwestern produce to New York through the Erie Canal. Believing that

focus shifted to more formal family dinners, made elaborate with soup, meat, vege-table, and dessert courses and necessitating an array of plates, saucers, and bowls.

To supply the American market, the Staffordshire, England, pottery firms of William Adams & Sons and Enoch Wood & Sons created distinctive lines of dinnerware with such names as "American Views" and whose images included that of the Catskill Mountain House as adapted from the engraving of Thomas Cole's painting for *The History and Topography of the United States.* These china and earthenware services, available in pink, black, and sepia, were manufactured through a process called transfer printing, in which decorative-motif engravings were printed onto paper forms that were transferred to the pottery, then baked in and overglazed.

"The English potters produced sets of this china for the American market, tar-geting a very specific local audience, who would readily have recognized the scenes, either because they knew the sites themselves or because they were familiar with them from contemporary engravings," said Nancy Finlay, curator of graphics at the Connecticut Historical Society.

In 1830, nearly fifteen million pieces of Staffordshire pottery were sold in the United States, and within five more years, another three million.

those who encouraged their own country's talent were "more entitled to praise than any purchaser of other works of by-gone days," Reed "gave an impetus to the art of our country," said Daniel Huntington, who also praised the benefactor as enlightened, friendly, and generous. It was Reed who persuaded his friend Durand to give up his engraver's tools for the paintbrush.

"Essentially, Cole told Reed, 'This is what I'd like to do. Will you pay for it?'" said Franklin Kelly, explaining the artist's working relationship with the bene-factor, which even included how work would be installed in the Reed residence. Owning several of Cole's and Durand's Catskills canvases, Reed invited people of influence to view his collection in the private gallery atop his Greenwich Street mansion, often motivating his guests to visit the actual destination themselves, to partake of what Cole called "its delightful tranquility."

As for exposing art to the masses, although galleries operated in New York,

Philadelphia, and Boston, clients were limited to the wealthy. Charging admission to art exhibitions further restricted the audience, as very few Americans were in a position to purchase an original work. (The $25 paid for Cole's early paintings would be the equivalent of nearly $600 today—still relatively paltry, but nonetheless beyond the grasp of many average households.) As a result, any relationship with art by the middle class would have to come secondhand, via reproductions or engravings in books, newspapers, and periodicals—and here too, Cole made a significant contribution.

In 1829, during Cole's stay in England, the Congregational minister John Howard Hinton commissioned him to produce ten paintings and two drawings from which engravings could be made. These, along with works by others, were included in an 1830 volume, hugely popular in both England and the United States, titled *The History and Topography of the United States.* The book featured two of Cole's Catskills landscapes—the falls of the Catskill River, and a view of

Now a New York State Historic Site, the Persian-style Olana, Frederic Church's home for the last twenty years of his life (he died in 1900), was built between 1870 and 1891; here, the exterior and the court hall looking toward the main entrance.

the Catskill Mountain House—both of which were often removed from copies of the book, hand-colored, framed, and displayed in homes on both sides of the Atlantic.

"This book," said art historian Nancy Siegel, "addresses the popular demand for American landscape imagery in the mid-nineteenth century and the dissemination of such imagery in the art market through engraved and ceramic variations and copies. Although economic reality often superseded the feasibility of an individual's owning a painting by Thomas Cole, possessing engravings and ceramics with imagery based upon Cole's artistry was the next best thing. The demand for such imagery coincided with an increase in literacy, and when combined with economic and therefore social progress, finely illustrated books and periodicals became necessities for the well-adorned American parlor by mid-century."

The historian further noted, "In the case of Thomas Cole's work, taste was disseminated through the purchase of objects adorned with the artist's imagery." His images, she contended, "functioned as barometers of aesthetic, didactic, and even patriotic significance as a rise in nationalism coincided with a rise of interest in American landscape imagery by the 1830s."

Prevailed upon by his affluent Connecticut patron (and the son-in-law of John Trumbull) Daniel Wadsworth, Thomas Cole took on as his one and only pupil: eighteen-year-old Frederic Edwin Church, the son of a prominent Hartford banker and jeweler. "Although a mere youth, and fonder, perhaps, of the beauties spread in profusion around him than of the painting room," Cole's biographer, Louis Legrand Noble, said of Church, who was born in 1826, only a year before Cole's paintings of the Catskills excited the American art scene, "he yet exhibited in his sketches of nature a facility and correctness of drawing that gave high promise."

Living at Cedar Grove for two years, Church accompanied his teacher on sketching trips in the forests Cole never tired of exploring. What neither of them realized, however, was that the very first of the Hudson River School artists was in the process of surrendering his mantle to arguably the very last—certainly, as time would prove, the most commercially successful. At least the passing of the torch was a gesture born of mutual respect. "Church," said Cole on several occasions, "has the finest eye for drawing in the world."

"They became fast friends," said Elizabeth Jacks, "and then had a great relationship for the rest of their lives."

A year after ending his tutelage under Cole, in 1849, Church "graduated to

ven though women were educated in the arts, "being a professional artist in the nineteenth century was the province of men. Most art academies didn't admit women, and neither did the clubs that linked artists with patrons," journalist Judith H. Dobrzynski wrote for Smithsonian.com in 2010, when the Thomas Cole National Historic Site in Catskill held the exhibition "Remember the Ladies: Women of the Hudson River School."

"Often they were the sisters, daughters, and wives of better-known male artists. Harriet Cany Peale, at first a student of Rembrandt Peale, became his second wife. Sarah Cole was Thomas Cole's sister," said Dobrzynski. Sarah's daughter Emily Cole also took up the brush, as did Gilbert Stuart's daughter Jane Stuart. "Evelina Mount was niece to William Sidney Mount, while Julia Hart Beers was the sister of two artists, William Hart and James Hart."

Some had no family link to the art world, such as Susie M. Barstow, who proceeded to scale the "principal peaks of the Adirondacks, the Catskills, and the White Mountains, [and] sketched and painted along the way, unhindered by blinding snow," Dobrzynski recounted.

The works by these women weren't "particularly feminine; they're not flowery," said the director of the Cole site, Elizabeth Jacks. "If you walked into the show, you'd just say these are a group of Hudson River School paintings. They are part of the movement.

"It's our own problem that we haven't included them in the history of the Hudson River School."

the ranks of the true lovers of nature," said art historian Oswaldo Rodriguez Roque, "when he finished *West Rock, New Haven*." The painting, featuring distant mountains and a pasture in its forefront, celebrated the unique pastoral charm of the American landscape as it also paid tribute to the labors of those who were reaping the bounty of this American Eden, and caused the *Bulletin of the American Art-Union* to report, even prior to the work's display at the annual National Academy of Design exhibition, "The sky and water of this piece are truly admirable. . . . Church has taken his place, at a single leap, among the great masters of landscape."

Establishing a studio in New York City, Church excelled at painting vivid if idealized New York and New England landscapes on a much grander scale than had Cole or Durand, producing canvases as large as five feet high and ten feet wide, or, as one critic called them, "grandiose and stupefying." In 1857, his seven-foot-long *Niagara* distinguished Church at home and then in Great Britain, both for its unprecedented expanse and its exciting sense of reality. "Your third visit will find your brain gasping and straining with futile efforts to take all the wonder in," Mark Twain wrote his brother after attending a presentation in 1860. Two days after its first public unveiling at New York's Lyrique Hall on Broadway near 9th Street, as police kept the crowds at bay, twelve thousand people, at twenty-five cents each, flocked to see Church's *The Heart of the Andes* during the three weeks it was exhibited at the Studio Building on West 10th Street.

In its review, *The New York Times* said, "A work of such proportion and intrinsic merit is a matter of public concern, inasmuch as it indicates a very high standard of landscape art in America. Mr. Church has plucked from the land of the Andes the secrets of its charms, and poetically places them before the senses."

When *Andes* was displayed in England, *The Times* of London dropped its typical reserve and raved, "The study and labor that must have been expended on Mr. Church's picture deserves to be called 'colossal.'" Even more popular than his *Niagara*, the work was the culmination of Church's obsession with the legendary naturalist Alexander von Humboldt, whose accounts of his 1799–1804 explorations of the New World stirred artists to bypass the European Grand Tour and make a beeline to equatorial South America for inspiration. Retracing Humboldt's journeys to Colombia and Ecuador by heading south of the border in 1853 and 1857, Church came home with sketches that resulted in the most popular single artwork of the Civil War era. Today, the enormous canvas belongs to New York's Metropolitan Museum of Art.

The Heart of the Andes also had an effect on Church's bank account. After the painting's New York premiere and national and British tours, he went on to sell the canvas for $10,000, at that point the highest price ever paid for a work by a living American artist. While *Andes* was still on view in New York, he also courted one of the visitors to its exhibition, Isabel Mortimer Carnes, causing one newspaper to gossip, "Church has been successfully occupied with another heart than that of the Andes." Poised to live idyllically ever after, the two married and settled on a hillside farm overlooking the river in Hudson, New York, and had a

son and a daughter, Herbert and Emma, only tragedy soon struck. The boy and girl, aged two and one respectively, died in the course of the same week during the diphtheria epidemic of 1865.

First escaping to Jamaica, and then, for philosophic and artistic comfort, to the Holy Land, Rome, and Athens, Church and Isabel started a new family (Frederic Jr. was born in 1866, and three more children followed) before seeking refuge once again in the Catskills.

In a symbolic gesture intended to keep the sadness of the outside world from ever intruding again, the Churches built the fortresslike Olana, named for an ancient Persian treasure house. With its unobstructed views of the mountains and the Hudson, the mansion blended architecture with nature by featuring open courtyards, such furnishings as French and Chinese porcelains, Kashmiri chairs, Incan idols, Turkish rugs, Moroccan tabors, South American butterflies, and stuffed quetzals and birds of paradise. "Church sited his great house specially in a landscape that he then designed," said Linda S. Ferber, director of the museum division for the New-York Historical Society. "The windows framed specific views, they also framed a view across the river of Cedar Grove, which was his homage to his master, Thomas Cole."

Olana and its 250 acres, which are still open to visitors, became Church's final artistic statement. After he added a studio for himself to the property in 1891, he was all but forced to stop painting because of the crippling effects of rheumatoid arthritis in his right arm. He died in New York City in 1900, disregarded and nearly forgotten by an art world that now found itself bowing before the shrine of the Impressionists.

After Thomas Cole succumbed unexpectedly to pleurisy at the age of forty-seven on February 11, 1848, a grief-stricken William Cullen Bryant said at his memorial service, "His departure has left a vacuity which amazes and alarms us. It is as if the voyager on the Hudson were to look at the great range of the Catskills, at the foot of which Cole, with a reverential fondness, had fixed his abode, and were to see that the grandest of its summits had disappeared, had sunk into the plain from our sight."

In romanticizing the wilderness, Cole inspired not only Durand and Church, but dozens of other artists, including John Frederick Kensett, George Inness, Jasper Francis Cropsey, and Albert Bierstadt. Yet for all their prolific output, after the Civil War the Hudson River painters lost substantial ground as "the aesthetic orientation of the United States shifted from Great Britain, the mother culture,

to the Continent, especially France," wrote Kenneth J. Avery of the Metropolitan Museum of Art. The lure of landscapes also yielded to figure painting under "the influence of the softer, more intimate French Barbizon style first adapted to American scenery by George Inness." By the 1880s, Inness, an Orange County, New York, native influenced by the Old Masters, "had become," according to Avery, "the most highly regarded landscape painter in America."

As the new callously brushed away the past, at the time of Durand's death in 1886, at age ninety, his obituary in *Harper's Weekly* stated that his landscapes "belonged to what has of late years been disparagingly called the 'Hudson River School,' and their manner has been rendered obsolete by the works of painters which had the advantage of a wider and deeper technical knowledge."

Once so eagerly sought by private collectors, Hudson River landscapes began gathering dust in museum basements and sat unsold in gallery back rooms in the United States and Europe, only to reemerge in recent years. (The style reemerged, too, in mass marketer Thomas Kinkade's late-twentieth-century kitschy pastoral scenes, featuring foliage and lighting reminiscent of Cole's, as could also be said of the computer-generated dreamscapes surrounding Hogwarts in the *Harry Potter* movies.)

Perhaps the most celebrated work of the Hudson River School, *Kindred Spirits* (1849), by Asher Durand, was occasioned by Cole's death. Commissioned by William Cullen Bryant, the painting imagined Cole and Bryant together, gazing out from a rocky Catskill promontory toward a composite of two famous Catskill sites, Kaaterskill Falls and Kaaterskill Clove. In the scene, the artist is carrying his sketchbook in one hand and his flute in the other, gesturing toward the waterfall as he and the poet take in the monumental vista before them.

After initially being donated to the New York Public Library by Bryant's descendants, *Kindred Spirits* was sold at sealed auction in 2005 for an estimated $35 million, at the time the highest amount ever paid for a painting by an American artist. Although the bidder was anonymous, that the work, along with a 1797 Gilbert Stuart *George Washington,* Norman Rockwell's 1943 *Rosie the Riveter,* and Andy Warhol's 1985 *Dolly Parton,* became part of the permanent collection of the Crystal Bridges Museum of American Art in Bentonville, Arkansas—points to the fact that the anonymous checkbook belonged to Alice L. Walton, heiress to the Walmart fortune.

Rich Man's Playing Ground

I

De Tocqueville talks about how he never saw a people as restless as Americans, who, when they weren't at leisure, chose to go on these strenuous journeys to see what there was to see in their country. Rather than relax, the form of leisure for Americans, and I think this still holds true, was enormously strenuous, and usually involved some form of travel to some picturesque destination.

—LINDA S. FERBER, director of the museum division for the New-York Historical Society

A mong the earliest written records of a traveler passing through the Catskills were those from a Pennsylvania Quaker naturalist, John Bartram, who, besides having been appointed royal botanist by King George III in 1765, is considered the father of American botany. At the prodding of various people, including his close friend Benjamin Franklin, Bartram began to catalog indigenous plant life, especially that which existed in the nation's wilderness. "Bartram was essentially a lover of nature, its plants, and animals and fossil remains; he was not a systematic scholar, but a practical farmer, with a bent for experiment and the talent of acute observation," said Whitfield J. Bell Jr., a former executive officer and librarian of the American Philosophical Society, which Franklin and Bartram had cofounded in Philadelphia in 1743.

After a 1753 plant-collecting expedition with his fourteen-year-old son, William, to find the Balm of Gilead tree and retrieve its seeds, Bartram, age forty-four,

wrote *A Journey to Ye Cat Skill Mountains with Billy* and described Kaaterskill Falls as "the great gulf that swallowed all down."

As reported by "A Catskills Catalog" columnist Bill Birns for the *Catskill Mountain News* in 2010:

> The two traveled to the mountains from the south, crossing the Delaware at Easton, Pennsylvania, and following the Delaware Water Gap northward on the New Jersey side. They probably took the old mine road north. That's state Route 209 today, and one of the oldest roads in America, built in 1650, 104 miles long. From Esopus the river would carry them to Catskill settlement. John and Billy Bartram entered the Catskills from the east, from the Hudson River bottom near today's Kiskatom, below North and South lakes up on the mountaintop. Up the summertime-dry bed of Silver Creek, father and son forayed into the mountains. On the banks of those twin lakes, they found Balm of Gilead. Oh, happy day.

While Bartram's published *Journey* proved popular in the United States and found an audience in England, it is unlikely his account lured many Americans into adding the rugged Catskills interior to their Grand Tour, even though a slight interest in the region was starting to percolate.

Eighteenth-century physician and belletrist Dr. Alexander Hamilton, a native of Scotland, undertook a four-month journey from his adopted home of Maryland and entertainingly described—especially when he encountered what he deemed the inelegant manners and dress of the locals—his trip from Annapolis to York, Maine, and back again. In his 1744 *Itinerarium*, he not only portrayed the outposts he visited ("The Dutch [in Albany] keep their houses very neat and clean, both without and within. . . . The neighbouring Indians are the Mohooks to the northwest, the Canada Indians to

John Bartram, the father of American botany, wrote *A Journey to Ye Cat Skill Mountains with Billy* after a 1753 plant expedition with his son William.

the northward, and to the southward a small scattered nation of the Mohack-anders"), but he also put forth the notion that travel for business was an advanta-geous way of advancing the cause of uniting the colonies.

Very much a travel diary, the *Itinerarium* offered this entry from June, under the heading BLUE MOUNTAINS:

> We now had a sight of the range of mountains called the Catskill or Blue Mountains, bearing pretty ar [*sic*] N. W. and capped with clouds. Here the river about two miles broad, and the land low, green, and pleasant. Large open fields, and thickets of woods, alternately mixed, entertain the eye with variety of landscips [*sic*].

Although the restrictions of access–dense forests and few trails–leading into the Catskills deterred him from venturing into the mountains, Hamilton did use them as a navigational signpost to track his progress up the Hudson River.

> At one o'clock we scudded by Livingston Manor, then the Catskill Hills bore west by south. At three o'clock we sailed by a Lutheran chapel, larboard, where we could see the congregation dismissing, divine service being over.

The return trip proved far more adventurous.

> We could now observe the Catskill Mountains bearing southwest, starboard. At half an hour after ten, the wind freshened so much that the batteau broke loose from the sloop and overset, and one of the Dutchmen that was step-ping down to save her was almost drowned. The fellows scampered away for blood in our canoe to recover their cargo and loading, which was all afloat upon the water, consisting of old jackets, breeches, bags, wallets, and buckets.

Dr. Hamilton, who was to return safely to Maryland, noted that during the incident on the water, he and his fellow travelers were forced to drop anchor as the loose belongings were retrieved from the river, "excepting a small hatchet which by its ponderosity went to the bottom." He further observed, "My fellow passenger, Mr. Douw, was very devout this morning. He kept poring upon [gospel preacher Reverend George] Whitfield's sermons."

In the very first American travel guide, Gideon Minor Davidson's self-published 1822 *The Fashionable Tour: or a trip to the Springs, Niagara, Quebec, and Boston in the Summer of 1821*, the author refers to the village of Catskill "as being in the immediate vicinity of the Kaatsberg or Catskill Mountains, which are seen for many miles along the Hudson, and here assume a truly majestic and sublime appearance."

In the early nineteenth century, a few spirited souls, drawn to the area's two lakes and various rock platforms, began exploring what was called the Pine Orchard, a secluded seven-acre glen on the high plateau behind the town of Catskill—the very same spot that would later allow an expansive Natty Bumppo to survey "all of creation."

In an account for the 1805 periodical *The Miscellany*, the reporter found the ascent "so very difficult, that a dog, who accompanied us part of the way, made hideous lamentations before he dared to follow us, and at last left us altogether." Despite the canine's reaction, when the party finally reached the top, the author discovered to his delight, "Our view of the Hudson, and the country on each side, was beyond description, beautiful and sublime."

The only thing lacking was a hotel equally beautiful and sublime.

AS WITH MANY a great romance, it started with a dance. On the evening of September 18, 1822—"one of those clear and beautiful autumnal days that seem to diffuse life and gladness everywhere," according to an account at the time in the *Catskill Recorder*—at an elevation of twenty-eight hundred feet, there congregated "a large number of ladies and gentlemen of the first fashion and respectability, from the counties of Albany, Columbia, Dutchess, and Greene." The gathering was held in a ballroom set up on Pine Orchard, the secluded seven-acre glen described by the adult William Bartram, years after his botanical trip with his father, John, as "a shady vale" near "a steep rocky precipice."

"Besides the ordinary incidents of an Assembly," said the *Catskill Recorder*, which took special delight in describing "the visible accomplishments of the bold and powerful hand of Nature," "there was a novelty and pleasure attached to this, which were altogether peculiar."

The Rural Ball, as it was billed, included dancing that started promptly at seven, to music provided by fiddlers. "Coffee and refreshments were served in the course of the evening," stated the newspaper, "and at two o'clock the company retired to their respective lodgings."

By the time the word "vacation" gained currency in the mid-nineteenth century, it had been relegated to a topic of fiery debate in the Sunday pulpit and penny press, where idleness was equated with financial and spiritual decay.

Strictly speaking, a vacation required two resources most Americans couldn't claim: free time and discretionary income. Also missing were comfort and safety, along with adequate accommodations. This resulted in large numbers of people staying home, except when absolutely necessary.

Between 1790 and 1820, America upgraded its infrastructure, with more than thirty-seven hundred miles of turnpikes and toll roads built in New England alone. With that, relays of horses driving public stagecoach lines slashed the five- to six-day travel time between Boston and New York to a tolerable day and a half.

Increased passenger loads spurred a new need. Although a great tourist influx into New York didn't really take hold until 1820, in 1794, Manhattan's City Hotel, the work of British architect Benjamin Latrobe (who also designed the Capitol building in Washington), was the first structure of its kind to offer accommodations for commercial travelers. (It also housed a large assembly room used for prestigious civic and social functions and that for years served as New York's principal concert venue.) Still, the seventy-eight rooms inside the hotel's five-story brick building at 115 Broadway, between Thames and Cedar Streets, were considered an extravagance, given that New York City's population at the time was barely thirty thousand.

After the Catskill Mountain House, "[l]uxury hotels began to appear in New York City by the mid-nineteenth century," said May N. Stone, of the New-York Historical Society. "John Jacob Astor erected the Astor House on Broadway between Barclay

The Pine Orchard site already housed a modest refreshment stand, to serve North Lake fishermen, hunters, and travelers, and some bunks were available for overnight guests, but in anticipation of the ball, "a sixty-foot-long addition was built to the barroom and bunkhouse," Alf Evers disclosed. "[T]he men retired to the upstairs room where they slept in 'bins' partitioned off on the floor. The ladies had better accommodations; they slept in an adjoining structure . . . fitted up upon the principle of steamboat berths."

"The pleasure depicted upon every countenance—the animation and joy which prevailed every where—and the striking display of beauty and taste—gave to this first attempt the happiest and truest effect," gushed the newspaper, and for good

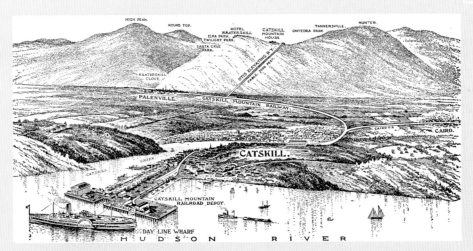

Reaching the Catskill Mountain House from New York in the nineteenth century required steamboat travel to Catskill, then a stagecoach up through what was called the best mountain road in the country, to Pine Orchard.

and Vesey Streets in 1834–36, and in the early 1850s, even more palatial hotels were built on Broadway between Canal and 14th Street."

In Boston, architect Isaiah Rogers's four-story, 170-room Tremont House opened in 1829, with such firsts as bellboys, indoor plumbing, and running water. In the basement were full-service bathrooms ("to which there is a separate entrance from the avenue south of the house," reported an 1830 description). And on the ground floor, an unheard-of luxury: eight toilets.

reason: its editor, Edwin Croswell, helped sponsor the ball. The *Recorder* story was also picked up and reprinted in papers as far away as Philadelphia.

"The real purpose of the ball was to gain additional investors for the construction of a hotel on the site. And it worked," Timothy J. Mallery wrote for the Catskills Archive. "After the ball, they formed the Catskill Mountain Association. The Mountain House was built in fall and winter of 1823, and opened in the summer of 1824."

Authorized by the New York State legislature to erect "a large and commodious hotel" on Pine Orchard, the Catskill Mountain Association proceeded with its Mountain House, which for the next fifty years would not only remain the unchallenged queen of the nation's hotels—"splendid" was how it was defined by

An early tourist trap along the route to the Catskill Mountain House, the Rip Van Winkle House was passed off as the genuine residence of the fictional character. The shanty to the left was built in 1845, while the larger structure went up in 1880, as a boardinghouse. After the Otis Company's incline railway bypassed the location in 1892, the Rip Van Winkle House began its decline. Fire destroyed it in 1918.

Grand American Hotels authors Catherine Donzel and Alexis Gregory, who marveled at its peerless location "right at the edge of a cliff"—but also defined the heart of what the general public considered "the Catskills."

"The guests at the Mountain House didn't come there just to visit the hotel. They came there to see the entire landscape," said Bob Gildersleeve, of the Mountain Top Historical Society and author of the 1993 *Kaaterskill: From the Catskill Mountain House to the Hudson River School*. "They came for adventure. They didn't stay for a day. It wasn't a quick stopover. They were there for two and three weeks. Perhaps a month."

AN INITIAL TEN ROOMS were ready in 1824, and the following year, another fifty. Resembling an oversized Federalist structure, which caused Dutch and English settlers living below to call it the "Yankee Palace," the large wooden facility, the first mountain house of its kind in America, not only stood at a dizzying height but was surrounded by three thousand acres of wild retreats and promontories, secluded glens, deep ravines, gentle forest streams, waterfalls taller than Niagara's, and miles of well-maintained trails and carriage roads.

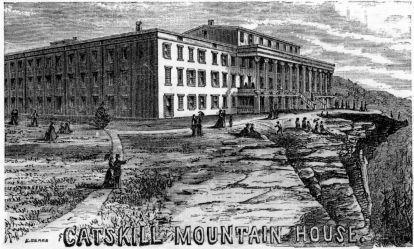

CATSKILL MOUNTAIN HOUSE.

E. BEARS

1823. 68TH SEASON. 1890.

THE CATSKILL MOUNTAIN HOUSE,

Eight Miles West of the Hudson River and Twelve Miles from the Village of Catskill, N. Y.

(Visitors can be comfortably accommodated from June 1st to 20th, at $2.00 per day.)

OPEN JUNE 20th TO SEPTEMBER 20th.

This well-known Summer Hotel is situated on one of the Eastern ledges of the summit of the Catskill Mountains, 2,250 feet above tide water, and by reason of its peculiarly advantageous location *on the Front of the Range*, is the *only Hotel that commands the Famous view* of the Hudson Valley which stretches out from the base of the Mountains below, to the Adirondacks in the North, the Green Mountains and Berkshire Hills in the East, and the Highlands in the South, embracing an area of 12,000 square miles, with sixty miles of the Hudson River in the foreground.

THE MOUNTAIN HOUSE PARK

has a valley frontage of over three miles in extent, and consists of 3,000 acres, or about five square miles of magnificent forests and farming lands, traversed in all directions by many miles of carriage roads and paths leading to various noted places of interest.

The Crest, Newman's Ledge, Bears' Den and Prospect Rock on North Mountain, and Eagle Rock and Palenville Overlook on South Mountain, from which the grandest views of the region are obtained, are included in the property. It also includes within its boundaries NORTH AND SOUTH LAKES, both plentifully stocked with various kinds of fish and well supplied with boats.

The Principal Drives include Kaaterskill Falls, Haine's Falls, Kaaterskill Clove, Palenville, Tannersville and Hunter Village.

The atmosphere is delightful, invigorating and pure, the great elevation and surrounding forests rendering it *absolutely free from Malaria*. It affords relief to sufferers from Chills and Fever, Asthma, Hay Fever, Loss of Appetite, and General Debility.

The Temperature is always Fifteen to Twenty Degrees lower than at Catskill Village, New York City or Philadelphia.

The location and surroundings are in all respects the most desirable in the entire range of the Catskills ; and no Hotel similarly situated is so easy of access or so near in time to New York City. As a resort for transient visitors to the Mountains it has many and great attractions over other localities.

Accessible by Following Routes, via Catskill.

TO CATSKILL :—New York Central & Hudson River Railroad, West Shore Railroad, Hudson River Day Line, Catskill Night Line. Catskill Mountain Railway to Mountain House Station, and stage to the Hotel. Stage fare, $1.25. Trunks extra.

Via Rhinebeck, Rondout and Kingston.

TO RHINEBECK—New York Central & Hudson River Railroad, Hudson River Day Line. Rondout Night Line to Rondout. West Shore Railroad to Kingston.

Ulster & Delaware Railroad to Phœnicia, Stony Clove & Catskill Mountain Railroad and Kaaterskill Railroad to Kaaterskill Station, which is at the western end of South Lake, within the boundaries of the Catskill Mountain House Park and only ten minutes' drive from the Hotel. Stage fare, 50 cents. Trunks extra.

Western Union Telegraph Office in the Hotel. Bowling Alley, Billiard Saloon and Tennis Court.

RATES FOR BOARD :—June 20th to July 15th, $14 to $17.50 per week ; Daily rate, $3.50. July 15th to August 1st, $16 to $21 per week ; Daily rate, $3.50. August 1st to September 1st, $16 to $24.50 per week ; Daily rate, $4.00.

SPECIAL ARRANGEMENTS FOR THE SEASON.

Address : **CATSKILL MOUNTAIN HOUSE CO.**

CATSKILL, N. Y.

By 1890, Catskill Mountain House rates at the height of the season topped out at $24.50 per week—about $630 today.

"During the nineteenth century," said Gildersleeve, "people came up to the Catskills by steamboat. Disembarked in Catskill. Traveled by stagecoach from Catskill up through what was called the best mountain road in the country, up to the site of Pine Orchard. Was quite a trip." While the overland trip from Catskill to the Mountain House was only twelve miles as the crow flew, the trek required four or five bone-rattling hours and had to be undertaken in phases: from the steamboat landing, a bulky stagecoach (fare, $1.25) whisked a dozen passengers, with their steamer trunks and valises strapped to the back, through the small village of Catskill, where they crossed the bridge spanning Kaaterskill Creek and proceeded along the valley toward the mountains. Over the next eight miles, as thunder routinely rumbled in the distant valleys, the road rose a thousand feet, until the coach reached a tollgate that had been strategically placed by a local builder who had secured the contract for the corduroy road. From there, the climb grew even more intense: up a narrow road, over streams, around boulders, the coach edging precariously close to extreme drops and steep ravines.

Two hours up the slope, the team of horses and the passengers rested at a ramshackle halfway station dubbed the Rip Van Winkle House. (Later, said Gildersleeve, a boardinghouse was built there.) An early tourist trap, the Rip Van Winkle House was where, for a fee, one could gaze upon the reputed chair of the imaginary Dame Van Winkle and the flagon from which Rip drank the sleep-inducing brew. Writing up the spot for *Harper's New Monthly* magazine in September 1883, author Lucy C. Lillie told of an elderly local's reply when asked if, indeed, this was the genuine home of the celebrated slumberer. Keenly aware that presenting any doubt about the fictional character would be bad for business, the old-timer replied, "There's some as does . . . believes it all, . . . and I don't know myself just what to think, . . . I really don't."

As the climb resumed, should the pitch become too steep, passengers would have to climb down from the carriage and struggle their way up the incline on foot, while the horses labored to haul their heavy load. "Stories have it that men and boys would have to get out of the stagecoach to go up the last mile or so till they got to the top," said Gildersleeve. "That road included things like Featherbed Hill, Dead Ox Hill. Featherbed was tongue in cheek–certainly a very rocky section of the road."

Recalling her journey up the mountain in "that purgatorial reeling stage-coach, and its protracted jigglings–wriggling–jolting and bumpings," *New York Ledger* writer Fanny Fern, née Sara Willis Parton (the nation's first female columnist and the country's highest paid, of either sex), reported to her readers in 1872:

I've tugged up that steep mountain, one of the hottest days in which a quadruped or a biped ever perspired, packed to suffocation, with other gasping sufferers, in that crucifying institution called a stage-coach, until I became resignedly indifferent, whether it reached its destination, or rolled head over heels–or rather head over wheels–over the precipice. Landing at last at the hotel, I was conscious of only one want, a bedroom.

At long last the horses would round a final curve and the exhausted passengers could see high above them the magnificent hotel. As arrivals immediately sped through the lobby to witness the fabled view, some wept. Several recorded their reactions.

Decreed one, in 1828:

With the loftiest flight of your imagination, you can form no idea of the grandeur and sublimity of the surrounding scene. I have traversed mountains and viewed cataracts, but never have I seen anything that equaled the prospect before me. . . . The wide scene that fills the eye leads the mind to a contemplation of subjects awful and grand, and ought to carry our thoughts from Nature up to Nature's God.

Capturing her Mountain House experience for her 1838 book *Retrospect of Western Travel,* the English sociologist Harriet Martineau told of arriving one late July evening at eight-thirty, to find before her "an illuminated fairy palace perched among clouds in opera scenery; – a large building, whose numerous window-lights marked out its figure from amidst thunder-clouds and black twilight which overshadowed it."

Arising the next morning, a Sunday, to view the fabled sunrise from the ledge in front of the hotel, she marveled:

I shall never forget, if I live to a hundred, how the world lay at my feet – On the left horizon are the green mountains of Vermont; and at the right extremity sparkles the Atlantic. Beneath lies the forest where the deer are hiding, and the birds rejoicing in song. Beyond the river . . . the rich plains of Connecticut: there, where a blue expanse lies beyond the triple range of hills, are the churches of religious Massachusetts sending up their Sabbath psalms.

The first large hotel to open in the resort town of Ballston Spa, New York, was the Aldridge House, in 1792. During his stay, Washington Irving used a diamond to write his name on a pane of glass in the north wing's dancing hall.

From an American visitor came the euphoric observation, "To look out in the morning, just before and when the sun is coming up full, sheds a flood of light . . . effulgent and dazzling as the world on fire." Sunrise was likened to "the eyelids of the morning," and sunset "the resplendent death of day." Both reactions were likened to religious experiences, "producing an elevation of the mind far above the cloud-capped heights of these hills."

Foreign travelers were no less dazzled. Raved a contributor in the September 1821 issue of Albany's *The Plough Boy, and Journal of the Board of Agriculture:*

Our companion had crossed the Alps; had stood upon the Rock of Gibraltar; had crossed from thence into the Barbary States and traveled through Algiers, Tunis and Tripoli, had visited the Isle of Malta . . . but [he] declared, there [was never] to be seen any prospect equal to that from the Pine Orchard, in beauty, sublimity and grandeur, and combining at one view, so great an extent and so great a variety of interesting objects.

The rugged experience provided by the Catskill Mountain House contrasted markedly with what was offered in the refined atmosphere of Saratoga Springs. John Duncan, in his 1823 *Travels Through Part of the United States and Canada 1818 and 1819*, found Saratoga, with its iron-rich chalybeate springs, to be a "resort of invalids, idlers, and fashionables, from all parts of the United States, and even foreign countries," while Jacques Milbert, a French illustrator visiting that resort during an 1815 trip to America, commented acerbically, "Time passes with a series

Whatever travel that occurred in eighteenth- and nineteenth-century America, unless for business, centered on resorts that attracted the wealthy by replicating the elegant spas to be found in Europe: Stafford Springs, in Connecticut; Berkeley Springs, in Virginia; and Ballston Spa, in New York State. Southern planters visited to escape the blistering heat of summer, while easterners came to flee the epidemics that plagued their cities during hot-weather months. "Malaria-free" was a huge selling point, according to Bob Gildersleeve.

Fresh air and wholesome food were additional lures, as were the mineral waters believed to keep one's "vital forces" in balance, to ward off gout, rheumatism, and other respiratory and gastrointestinal problems—as well as the uncomfortable medical practices of the day, which included bloodletting, leeching, and the taking of purgatives.

As with European spas, American resorts enabled the gentry to mingle with friends, gamble, and even cavort. Taking notice of the increasing presence of women during his stay at Ballston Spa in 1807, Washington Irving offered that they were there not so much for their health as they were "to exhibit themselves and their finery, to excite admiration and envy."

Helping to usher in the era of visitors to Saratoga County, in 1787, Benajah Douglas, father of Lincoln's 1860 presidential opponent Stephen Douglas, built a comfortable tavern and modest hotel on one hundred acres in Ballston Springs. Its success led to the 1803 opening of the nearby Sans Souci Hotel, advertised in its day as the largest hotel in the United States and soon to become the favored retreat of such prominent Americans as Andrew Jackson, Daniel Webster, General Tom Thumb, and Washington Irving. It was here that James Fenimore Cooper wrote *The Last of the Mohicans*.

of gay affairs; in the morning everyone drinks the water religiously, at night they make fun of it."

Activities at the Mountain House were "a lot more adventurous than we might picture," said Gildersleeve. Guests went "climbing and took risks and enjoyed being caught in a thunderstorm. There was a famous account of Thomas Cole getting lost in the woods and wandering down a deep ravine, or clove as it would be called here, and falling into the stream and making it out just after dark. There was an excitement of experiencing the wilderness firsthand, even being threatened by it. What's now called Sunset Rock used to be called Bear's Den, because they saw bears there. There were wolves in the surrounding areas, so there was a danger of just being out when you were hours away from any kind of rescue."

Nor was this kept secret from potential guests. "Thomas Nast was a very well-known political cartoonist in the nineteenth century," Gildersleeve continued. "Among other things, he was very much responsible for the visual image we have today of Santa Claus. [It was also Nast, essentially the in-house illustrator for *Harper's Weekly,* who first depicted the Democratic Party as a donkey and his own Republican Party as an elephant.] He was a very significant illustrator during the Civil War, and with the war ending, *Harper's Weekly* was looking for subject matter. He did a very well-known illustration of North Mountain, of a couple clinging horizontal, peeking over the edge of a rock while the wife is trying to pull the husband back from the ledge for fear he might fall off this cliff."

Only a few steps away from the entrance to their grand hotel, guests could feel the spray and explore Kaaterskill Falls, two cascades of tumbling water falling 260 feet, the highest falls in New York State. Beneath and behind the falls lay a vast arched cave extending three hundred feet inside. So impressed by the falls was Washington Irving that he sent Rip Van Winkle to them as he made his way home after his long nap, while Thomas Cole, after his sketching trip to the falls for his 1826 painting of them, remembered, "We stationed ourselves near the foot of the falls, where the view simply compensated us for the difficulties we had climbing to it. The steam descended in the form of a rapid from some distance above the precipice, when, reaching it, it presented an awesome perpendicular fall; then striking on a rock, it rushed down this rock enveloping it in foam."

Besides Irving and Cole, the Mountain House guest roster, today preserved by the Greene County Historical Society, included William Cullen Bryant, James Fenimore Cooper, Daniel Webster, the popular Irish stage actor Tyrone Power, and Asher B. Durand. "And their servants," interjected Gildersleeve. "I keep going

back to the Nast illustrations, because I love them. But there's another illustration, called the Children's Playing Ground, where you'll see the mother sitting there calmly reading the paper, and the children are running right near the edge of the Mountain House, right towards the edge with their hands up in the air. And trying to keep them back is someone I've always assumed was the nanny, keeping them from falling off the edge."

After a shaky financial start that by the mid-1840s finally managed to right itself under new ownership, the Mountain House remained for fifty years "the resort of so much company during the pleasant seasons of the year, that the attractions of its scenery are redoubled by the presence of agreeable and refined society," wrote Theodore Dwight in *The Northern Traveller* in 1830. A daily steamship delivered meat and fresh fish from New York City, impressing one sated visitor to praise the "many superfluities lifted from the River's level to the eagle's nest."

Yet the Mountain House was also self-reliant. The bakery handled the pastry and bread needs; the extensive garden, the seasonal fruits and vegetables; and the cattle, the dairy products. A house orchestra provided music for dances and formal balls, and night after night the windows of the Mountain House were so brightly ablaze with light that Hudson River steamboat captains would invariably point out the landmark to their passengers drawn to the shimmering jewel they saw in the faraway sky.

II

We are not celebrating ourselves. We are not celebrating the greatness and wealth of our city. . . . We celebrate in Hudson the great race of men who made the age of discovery. . . . We celebrate in Fulton the great race of men whose inventive genius has laid the foundation for a broader, nobler, and more permanent civilization the world over. . . . Standing at the gateway of the New World, we celebrate the immense significance of America to all mankind.

—U.S. SENATOR FROM NEW YORK ELIHU ROOT,
at the 1909 Hudson-Fulton Celebration

"We have sketchy information on the roads that were up here," said the Mountain Top Historical Society's Bob Gildersleeve. "We know where most of them

were. Even in the early 1700s, there were roads from Palenville [in the southwest sector of the town of Catskill] up into the mountains, when John Bartram came up here with his son searching for flora of the area to send back to England. They came up from some place called Moses Rock, and made their way up to Pine Orchard, where would be the Mountain House. So, there were those kinds of trails. Eventually, there were turnpikes, toll roads that came from Catskill. There was a Mountain Turnpike–in fact, it still bears that name–which was a toll road. Hunter Turnpike came up through Palenville, through Kaaterskill Clove [just west of Palenville], and ended up going out past Lexington and that area. In the late nineteenth century [1894], R[ichard] Lionel De Lisser went around Greene County in a horse and buggy and wrote a wonderful book [*Picturesque Catskill*]. The horse's name was Cherry Tree, and the buggy included darkroom equipment so De Lisser could photograph and process the photographs of the area. Throughout the book he has his own little notes–'The Artist Rambles' is the heading he gives the whole section. Anyway, he spends a lot of time complaining about what he called remnants of barbarism, or 'r. b.' And r. b. was a tollbooth. He complains strongly about the cost of going down the Mountain Turnpike. I think it cost him seventy-five cents–a significant amount of money in 1893 [the equivalent of slightly more than twenty dollars today] to take your horse and buggy down the Mountain Turnpike. But what this proves is, there were roads that led into the mountains, and there were settlers here before that, settlers with tanneries, and with hunting."

As far back at the late seventeenth century, the Albany Post Road extended from New York City to the state capital, following old Indian trails along the east side of the Hudson River and running parallel to–but bypassing–the Catskills. More than one hundred years later, the Post Road remained what it had been from the start, an unpredictable, 180-mile dirt path.

Launched in 1785, a stagecoach provided a regular run from New York City to Albany, cramming as many as a dozen passengers and their bags into a single compartment for at least three days. Weather and road conditions added to the time factor, as did stops for meals, changes of horses, and any unforeseen circumstances, of which there were usually plenty. "There is a certain relief in change, even though it be from bad to worse," observed Washington Irving, advising, "[A]s I have found in traveling in a stagecoach, that it is often a comfort to shift one's position and be bruised in a new place." Should an overnight stay prove necessary, the coach would detour to a tavern, where guests were advised to sleep with their valuables. Door locks did not exist.

Before the reliability and relative speed of steamships, sloops plied the Hudson River from New York City to the town of Catskill, taking anywhere from a couple of days to an entire week, depending on the wind and tides.

Among taprooms along what is now Route 9 in Rhinebeck (Route 9 still basically follows the path of the original Albany Post Road) was the Beekman Arms, a one-story stone structure that served as Aaron Burr's headquarters for his unsuccessful 1804 gubernatorial campaign and actually dated back to "the early 1700s," when "William Traphagen established a traveler's inn in Ryn Beck, which was a small settlement being carved out of a forested area initially inhabited by the Sepasco Indians and colonized since the 1680s by the Dutch," according to an account by Paul Szvift on the Beekman Arms website.

Judge Henry Beekman numbered prominently among the original English Crown land patent owners. Colonel Henry Beekman Jr. expanded and populated his father's holdings with, among others, refugees from Europe's Palatine-Rhine region. . . . Gen. Richard Montgomery married Col. Henry Beekman's granddaughter Janet Livingston shortly before heroically fighting in, but never coming back from, the Battle of Quebec, in December 1775. Col.

I n a sloop, the trip from New York City to the town of Catskill could take anywhere
from two days to a week, given the variables of tides and winds. In winter, the
frozen river would shut down entirely.

To keep the peace once the village was incorporated in 1806, Catskill passed
bylaws establishing fines for such disturbances as running a horse through any street
or alley, obstructing a thoroughfare, or failing to remove anything contrary to good
health. Neither could an "inhabitant of the village . . . spend his time during the Sab-
bath at tavern or grocery and there purchase or drink any liquor on the Sabbath, or
shall angle with a hook or line or fish with nets in any creek, or shall swim or bathe in
any creek or river within the limits of the village on the Sabbath."

Violating any of these was punishable by a stiff fine.

One dollar.

Beekman's grandson Robert Livingston participated in the First Continental
Congress and helped draft the Declaration of Independence.

During the War for Independence, the Continental troops practiced drills on
the lawn of the Beekman Arms, while inside, General George Washington awaited
couriers bringing the latest news from the front.

For those not up to the rigors of a stagecoach, a sloop (from the Dutch *sloep*),
a wide-hulled, low-draft boat with two sails, provided a more agreeable ride up the
Hudson. Manned by a minimal crew and suited to the strong tides, shallow water,
and variable winds common to the river, they were mainly used for hauling cargo
and could take as long as a week to bring the occasional passenger to the Catskills.
But with service from New York unscheduled and sporadic, travelers were forced
to wait until a sailing was advertised and then arrange to bring supplies for the
trip, including their own bedding, although that was far from being the greatest
inconvenience. As *The New York Times* reported on December 15, 1860:

About 7 o'clock yesterday morning a sloop was observed lying capsized in the
Hudson River, near Irvington, about forty rods from the shore. She lay with
her mast pointing down the river, a part of her stern being the only part out of
water. Seated upon the stern were three men, huddled together and apparently

frozen to death, as no movement was discernible. Clinging to the mast was another man, over whom the waves had washed all night.

At four in the afternoon on August 17, 1807, the *Clermont*, a one-hundred-foot-long flat-bottomed, square-stern steamboat that had been constructed in the East River shipyard of Charles Brown (located at what was, according to a 1909 account, the block bounded by Montgomery, Clinton, Cherry, and Monroe Streets), left New York City under the command of Captain Andrew Brink, a practical and respected navigator from Saugerties. Also on board was the inventor of the ship's power system, Robert Fulton.

Recalling in a letter to a friend the anxiety-fraught maiden voyage, the forty-one-year-old artist turned technologist wrote:

> The moment arrived in which the word was to be given for the vessel to move. My friends were in groups on the deck. There was anxiety mixed with fear among them. They were silent, sad, and weary. I read in their looks nothing but disaster, and almost repented of my efforts. The signal was given and the boat moved on a short distance and then stopped and became immovable. To the silence of the preceding moment, now succeeded murmurs of discontent, and agitations, and whispers and shrugs. I could hear distinctly repeated—"I told you it was so; it is a foolish scheme: I wish we were well out of it."
>
> I elevated myself upon a platform and addressed the assembly. I stated that I knew not what was the matter, but if they would be quiet and indulge me for half an hour, I would either go on or abandon the voyage for that time. This short respite was conceded without objection. I went below and examined the machinery, and discovered that the cause was a slight maladjustment of some of the work. In a short time it was obviated. The boat was again put in motion. She continued to move on. All were still incredulous. None seemed willing to trust the evidence of their own senses.

Facing strong winds and a challenging tide, the men were determined to sail up the Hudson to Albany and back on the power of the boat's twenty-four-horsepower steam engine. The day was bright and sunny as the *Clermont* chugged past the city wharves, where a skeptical crowd had turned out to watch what the press and public alike had gleefully branded "Fulton's Folly." Even the forty guests the inventor

himself had invited to witness his progress from a riverside vantage point at West 10th Street had their serious doubts.

As Fulton recounted, the ship lunged forward at first, only to stop. Then she started up again, this time picking up speed to her full throttle of five miles an hour. Engine banging, side paddles splashing, its smokestack spitting flame and belching black smoke, the ship proceeded up the river. To many she resembled a fire-breathing monster, and one farmer watching from the shore breathlessly ran home to inform his wife he had just seen "the devil going to Albany in a sawmill."

Ultimately, apprehension subsided. Surprising all doubters–including Captain Brink's wife, who had told her husband, "When I see you and Mr. Fulton driving a boat with a tea-kettle I will believe it"–the *Clermont* made the trip from Manhattan to Albany in an astonishing thirty-two hours (including an overnight stay at Clermont), and back again in thirty, burning up about thirty cords of pinewood each way.

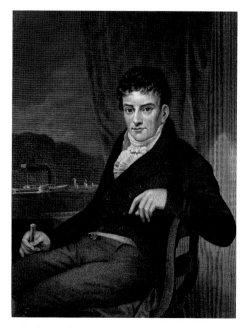

"The legends describing [Robert] Fulton's early creative genius contain some germ of truth," according to contemporary biographer Cynthia Owen Philip. "He is said to have invented a Roman candle, an air gun, a lead pencil, and a fishing boat with mechanical paddles, to have made so many experiments with mercury that he was known as 'Quicksilver Bob.'"

The era of commercial steamship travel in America had begun.

WHILE FULTON SUPPLIED the engineering, it was the investor, politician, and statesman Robert R. Livingston who funded construction of the steamboat. A descendant of the Robert Livingston who starting in the 1740s had acquired one third of the original Hardenbergh Patent, the later Robert R. Livingston–who, as chief judge of the Court of Chancery of New York State, administered the presidential oath of office to George Washington on the steps of Wall Street's Federal Hall on April 30, 1789–was master of an estate called Clermont, from which Fulton's steamboat, originally called the *North River*, took its name.

Fascinated by the various possibilities, particularly financial, of using steam as a nautical propulsion system, Livingston spent years trying to build a workable model, only to fail twice. It was during his tenure as U.S. minister to France, appointed by President Thomas Jefferson to represent America in the negotiations that led to the Louisiana Purchase, that Livingston met Fulton, a charming and persuasive Pennsylvania native with modest farm roots who had come to Europe to study art with Benjamin West.

Fulton's true interests lay in engineering, his having in the course of the previous decade invented a dredging machine, a rope-manufacturing device, and a five-man torpedo-carrying submarine capable of remaining submerged for eight hours. (Despite its capabilities, he failed to sell it to Napoleon Bonaparte.) Encouraged by Livingston to experiment with steamboats, Fulton, using a borrowed engine, created a prototype that he tested on the Seine and which the French press hailed as *"un succès complet et brillant."* With Fulton now his equal business partner, Livingston sent the inventor back to the United States via Scotland, where Fulton purchased an engine and boiler from the mechanical genius James Watt.

Through Livingston's lobbying efforts via his brother-in-law, Secretary of State of New York Thomas Tillotson, the state legislature would grant a monopoly to the first person to bring a boat by steam from New York City to Albany and back again at an average speed of not less than four miles an hour. With that, the aristocrat ensured that the success of the *Clermont* would lead to his and Fulton's gaining exclusive rights to "navigating all boats that might be propelled by steam, on all waters within the territory or jurisdiction of the State, for the term of twenty years." Referred to as "the hot water bill" for the power source that pushed the ship, this restrictive legislative measure also allowed the two business partners to seize and penalize any competing steamboat that dared operate without their license—not only in New York but, with Livingston's

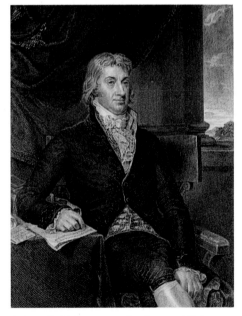

Robert R. Livingston, who financed Robert Fulton, "owned land much farther than the eye could see," said the steamboat inventor's biographer, Cynthia Owen Philip.

Hudson River Day Line – Steamer "Robert Fulton."

Hudson River Day Line souvenir postcard, bearing the legend: "The 'ROBERT FULTON' constructed at the great works of the New York Shipbuilding Co, at Camden, N.J. for the Hudson River Day Line service between New York and Albany will go in commission on May 29, 1909. It is 348 feet in length, with a beam of 76 feet, and has a capacity of 4000 passengers. Built, as far as practicable, entirely of steel, glass, and asbestolith, with metal trim, this steamer is almost absolutely fireproof and with its sumptuous decorations makes a worthy and beautiful memorial to the great engineer whose name she bears, and an adornment to the beautiful river he loved so well." The *Robert Fulton* was taken out of service on September 13, 1948, and marked the end of the Hudson Day Line steamboat travel that began with the inventor's 1807 experiment.

foreseeing a limitless future for steam travel, as far south as the lower end of the Mississippi.

Two weeks after the *Clermont*'s historic maiden voyage, during which time she was outfitted with cabins, a roof over the engine, and a protective cover over the paddle wheels to shield passengers from being water-sprayed, the steamboat went into regular passenger service along the profitable New York–to–Albany route, making the round-trip every four days and carrying as many as one hundred passengers per voyage. With stops at West Point, Newburgh, Poughkeepsie, Esopus, and

Hudson, the ship left her Manhattan dock Saturdays at 6 p.m., returning from Albany Wednesdays, setting off at 8 a.m. For the next seventeen years, from 1807 until 1824, only three steamboats were legally authorized to ply the Hudson River, and the Fulton-Livingston steamship interests owned the entire fleet. (Shortly after regular steamboat service was launched, Fulton and Livingston also became linked in their personal lives, when the forty-two-year-old inventor married for the first time. After his brief courtship of Harriet Livingston, Robert's twenty-four-year-old niece, Fulton wed her, though it was said the union was less a love match than an attempt by Fulton to secure his connection with the prominent family and climb the social ladder.)

Typical of monopolies, fares were set high and kept there, restricting travel to the wealthy. At the rate of about a dollar per twenty miles, a one-way ticket from New York to Albany cost $7, roughly the equivalent of $140 today, and more than five times the cost via the slower and far less desirable sloop.

With New York City the departure point, the earliest American Grand Tour included stops at Saratoga Springs and Niagara Falls with a detour to Montreal and Quebec, followed by a southbound stagecoach trip through New England (to view remnants of the American Revolution) into Boston, before finally circling back to New York.

Given the strenuous trip that lay ahead, those embarking on the itinerary found the possibility of undertaking the long first leg up the Hudson in the relative luxury of a steamboat irresistible. Chief among the scenic attractions along the "American Rhine" were the Palisades, a line of steep cliffs that hug the west side of the lower Hudson River; the spot in Weehawken, New Jersey, where on July 11, 1804, Aaron Burr fatally shot Alexander Hamilton in a duel; Sleepy Hollow, the town made famous by Washington Irving's tale of the Headless Horseman; and West Point, which had served as General Washington's headquarters in 1779 and was now home to the newly founded United States Military Academy.

Along the banks near New York City, one could also glimpse the baronial estates of the rich—Boscobel, Clermont, Philipse Manor, Van Cortlandt Manor, and Montgomery Place—while, farther north, the commanding view would be given over to the magnificent Catskill highlands that the first Americans had called the Wall of Manitou.

Armchair travel for those not able to afford the steamboat fare to the Catskill Mountain House was provided by panoramas that simulated the thrill of such a journey up the Hudson. These vicarious spectacles originated in Europe, where it is believed Thomas Cole saw his first while on his trip in 1829.

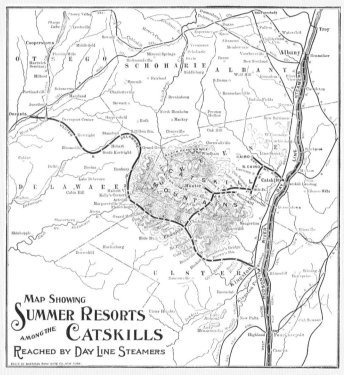

From the 1901 brochure *Hudson River by Day Line Steamers*

Though small and relatively slow, the early steamboats provided haute cuisine in plentiful portions, and light, airy, spacious cabins elegantly outfitted in mahogany, maple, and marble. Fulton himself saw that passengers were well treated by fashioning a list governing onboard conduct. Among his rules: smoking was forbidden except in designated areas, card playing in the ladies' cabin had to conclude by 10 p.m., and no lying down while wearing boots and shoes. Anyone in violation of such would be forced to pay a fine that was put to very good use.

The money would buy wine for the other travelers.

"It was a precinematic form of experience—early infotainment," said Linda S. Ferber, director of the museum division for the New-York Historical Society. "The circular panorama was the first, and that was invented abroad in the late eighteenth century. The diorama and moving panorama were probably the most popular forms. Those were invented in the 1820s and were very popular in the United States. River views, river voyages with their sort of long, lateral unfolding of scenery and events were logical and very popular subjects."

Panoramas, such as those presented at the Rotunda, a domed structure that opened at the southwest corner of Manhattan's Chambers and Centre Streets in 1818, were oversized paintings on sheer fabric and illuminated in such a way as to convey action and movement. Customers would ascend to a viewing platform to take them in, as if from the vantage point of a mountaintop.

Taking a step beyond the impressive but static vistas offered by Frederic Edwin Church's *Niagara* and *The Heart of the Andes*, panoramas had the added advantage of live orchestra and theatrical enhancements. "They were meant to surround the visitor and offer the kind of you-are-there illusion," said Ferber.

Among the more popular attractions was *A Trip to Niagara*, a two-hundred-foot moving tableau of the Hudson River from New York City to Catskill Landing (and beyond) that unfurled before a seated audience as a troupe of actors mimed the actions of passengers aboard the deck of a steamboat.

Accompanying the oohs and ahhs of the spectators, theatrical sound effects and ingenious stage lighting turned day to night, all to signal the approach of something classically typical of the Catskills: a dramatic thunderstorm.

While Fulton's steamboats docked at a number of stops en route to Albany, those wishing to explore the Catskills had but one point of disembarkation: the village of Hudson, on the eastern bank of the waterway. From there, passengers ferried westward across the river, to the town of Catskill, then proceeded by foot or on horseback up a narrow trail that wound into the mountains above town. "The road was preexisting," said Bob Gildersleeve of the Mountain Top Historical Society. "The Mountain Turnpike was used, and, before the Mountain House, the locals went up there to camp and spend the night."

No longer an untamed wilderness, the area had given rise to tiny villages that sprang up after being settled by the victims of Shays's Rebellion, the 1786 armed uprising named for insurrectionist Daniel Shays and led by farmers who had been driven off their land by confiscatory taxes imposed by the State of Massachusetts. "Shays and his followers had been convinced that merchant-creditors and their allies in government had deliberately pursued a policy of deflation after the Revolution in order to profit from the labor of indebted small producers," said historian Reeve Huston.

Crossing the Hudson River from New England, the renegades found refuge on what they called "the top of the mountains," a picturesque plateau reached by way of the Kaaterskill Clove, a narrow, obstructed passageway that breached the eastern wall of the Catskills. (The origin of "the name 'Kaaterskill,'" said Alf Evers, "remains just as obscure as 'Catskill,'" though he ascribes it to the Dutch, who might have been referring to the waterfalls, or "cataracts.")

Forcing an early demise to Livingston and Fulton's stranglehold on steamboat travel three years before their monopoly was set to expire in 1827, the U.S. Supreme Court ruled against the partners in a case brought against them by Cornelius Vanderbilt, who was seeking an expansion of his own shipping empire. The celebrated statesman and lawyer Daniel Webster argued on behalf of the entrepreneur, with the Court establishing the precedent that the government of the United States alone held the power to regulate interstate commerce.

Scenes from steamer travel

By the time their company was dealt its crippling blow, both Livingston and Fulton had been dead for about a decade; Fulton had caught a fatal cold while inspecting a ship downtown. As for the tightly regimented world they had once so carefully constructed, that too was no more. The Supreme Court effectively untied the Livingston-Fulton hold on the New York–to–Albany steamboat route, along with the very first steam ferryboat service connecting Lower Manhattan's Cortlandt and West Streets (later the site of the World Trade Center) to Hoboken, New Jersey, which the two business partners had also established. Similarly, all ferryboat connections between Lower Manhattan and Brooklyn, the nation's first suburb, as well as all steamboat operations between New Orleans and Natchez, had been theirs.

Steamboat traffic on the Hudson River multiplied—by one estimate, tenfold—while fares from New York City to Albany plummeted from eight dollars to fifty cents, then to twenty-five, sometimes even to nothing, as operators made up the difference by selling food and beverages on board. Suddenly anyone could travel, and did. By 1846, one hundred steamboats were working the river, most of them owned by Cornelius Vanderbilt. Between 1807, when the *Clermont* first raced to Albany, and the 1860s, when the railroads also began to service the Catskill region, Hudson River steamboats carried more passengers than any other arm of the national transportation system.

Magnates like Vanderbilt built bigger and faster ships to slice the travel time between New York City and Albany to eleven hours or fewer, permitting the traveler to leave early in the morning and arrive by dinnertime. Once passengers could leave New York and arrive at Catskill Landing in under eight hours, the need no longer existed for costly staterooms and sleeping accommodations, although a few steamboats insisted upon keeping their fares high and catering to the carriage trade. Among the luxurious new ships, the *Albany* housed a floating art gallery intended to appeal to the cultured traveler. Twelve paintings were commissioned for the ship's Grand Salon, including two by Thomas Cole that became among the most widely praised and viewed works of American art: *Landscape Scene from "The Last of the Mohicans"* and *The Falls of the Kaaterskill*. Positioned between the windows of the Grand Salon, *Albany* passengers could simultaneously gaze out at the passing scenery and view the paintings, as if they were all part of one large panorama.

"Cole painted for them the images that one might be traveling to see," said Linda S. Ferber, "distinguishing the environment, making you feel that you're not simply on a commercial means of transportation [but] that you were among a select few who are indulging in a cultural practice that distinguishes you as a literate, educated, and patriotic individual."

Except by then the terms "exclusivity" and "travel" no longer went hand in glove. Along the routes, towns were plastered with steamboat posters, with runners working on commission to shanghai passengers from rival carriers. In the ensuing confusion, harried passengers sometimes went by one line and their bags by another. Even less surprising, given how captains competed to set new speed records, collisions were common.

Aboard the better-appointed ships, wealthy passengers were suddenly finding themselves rubbing shoulders with just the sort of people they had spent their entire lives trying to avoid, not to mention gigolos and gold diggers. After Sophie du Pont, a young girl from a prominent Delaware family, spent a day on the *Albany*, she came back to report that she thought she had been on Noah's Ark, given what she had witnessed: *"des bêtes de toutes espèces."*

Every variety of animal.

Last Stand

❦

I

They are cutting all the trees down in the beautiful valley on which I
have looked so often with a loving eye. This throws quite a gloom over
my spring anticipations. Tell this to Durand—not that I wish to give
him pain, but that I want him to join with me in maledictions on all
dollar-godded utilitarians.

—THOMAS COLE, in a letter to Luman Reed, March 16, 1836

Delivering his *Lecture on American Scenery* to the Catskill Lyceum in 1841, a
disheartened Thomas Cole described Catskill Creek as made up of "[s]teep
arid banks, incapable of cultivation, and seamed by unsightly gullies, formed
by the waters which find no resistance in the loamy soil. Where once was beauty,
there is now barrenness."

While a rapidly growing population along the eastern seaboard during colo-
nial times had claimed the great stands of pine and other softwoods that had
once blanketed most of New York State, the sheer geographic inaccessibility of the
Catskills—where streams were too erratic and narrow to accommodate logs being
fed into the Hudson—had for three-quarters of a century kept the axe safely away
from the region. Instead, most of the serviceable lumber was rafted down from
rivers farther north to Albany, to be loaded onto Hudson River ships bound for
New York City and ports beyond. Even as America developed, Catskills deforesta-
tion was kept to a minimum. Trees would be milled close to where they fell and
the boards used locally to build barns and houses.

Such conservationism, however, would one day change dramatically. All it took was the nineteenth century.

TANNERIES FOR the treatment of animal hides existed in Virginia and Massachusetts as early as 1630; by 1650, the Massachusetts Bay Colony claimed fifty-one tanners, whose processed leathers were used for shoes, breeches, skirts, saddles, harnesses, buckets, gloves, book covers, cartridge boxes, handbags, and a host of other items, including the fan belts that eventually drove the first industrial machinery. Although early Dutch settlers tanned hides from the deer they killed at the southern tip of Manhattan, New York City did not become an active leather-processing center until around 1790, when tens of thousands of hides from the West Indies and Central and South America were processed in a low, damp neighborhood just south of today's City Hall in an area encompassing Gold, Frankfort, Pearl, Water, and Ferry Streets. Called "the Swamp," it was so named because of tanning's abysmal by-products—noxious odors and waste.

Three elements were essential to the tanning process: lime, to remove hair from the raw hides; an ample supply of oak bark, as a tanning agent; and enough clean water to see the hides through the tanning cycle before leaving them to dry. Most of the hides were deerskin, wrote leather trade reporter Frank Wayland Norcross in his 1901 *History of the New York Swamp,* although "[s]ome calfskins were tanned. Only rich gentlemen wore shoes made of so fine a material as calfskins."

In 1805, British chemist Sir Humphry Davy helped alter the manufacturing process with his discovery that the bark of the hemlock could be substituted for oak in providing the acid required to tan the hides. To distill this "liquor"—a kind of natural preservative to prevent the leather from rotting—one crushed and then soaked the bark of the hemlock tree.

Around the Swamp, tanners were encouraged to learn that hemlock trees flourished only one hundred miles away, on the northern and western slopes of the Catskills, in the shadowed valleys where sunlight was dim and the ground moist. Best of all, there were millions of these trees, which, combined with an abundance of cheap land, nearby deposits of lime, and an inexhaustible supply of pure water, made the Catskills an ideal base of operations for an industry that had long polluted New York City.

"When tanning moved into the Catskills in the 1810s," said historian David S. Stradling, "it became a different kind of industry. At this point it had been

an industry that was basically spread wherever people lived in the United States. Most of the tanning establishments were quite small, or they might have been run as part of a farm. But when the industry moved into the Catskills, the tanneries were the largest that had been built in the United States."

The first tannery in the Catskills went up in 1817 near the current northern village of Palenville, close to the Hudson River. Rawhides arrived via sloop, were hauled up to the tannery on an oxcart, then, after being cured, were taken by wagon back down to the river and sent to New York City and Boston, to be finished into leather goods. "The real innovator as far as tanning in the Catskills was concerned was William Edwards, who got his capital from a number of men who worked in the Swamp," said Stradling. "The thing about Edwards was his innovation. He brought lots of different types of machinery to bear. He was the first one to roll the hides before they were turned into leather. He also used a bark mill. All of this was turned by water power, so Edwards created a very large mill in 1817 in what became known as Hunter."

Edwards, the grandson of the Christian revitalization movement theologian Jonathan Edwards, came from "a family that had been involved in the leather business in New York City for years," said the official Sullivan County historian, John Conway. "He had traveled to the Berkshire Mountains [in Massachusetts] and had learned a new method of tanning leather, using the bark of the hemlock tree." He arrived in the Catskills with $63,000 from six investors and established what he called the New York Tannery on twelve hundred acres near the Schoharie Creek. Besides his mill, which softened the leather, Edwards's innovations included a means to speed up the distillation of the tanning liquor. "A strict Christian, and highly spoken of by all," the tanlord in the prime of his life was "of commanding presence, six feet, four inches in height, well proportioned, of great strength and self control, prompt and decisive," according to the 1884 *History of Greene County,* which also noted that Edwards "had a remarkably large head, and to children unaccustomed to him, was a source of fright. This was occasioned by a bump from the head of an Indian lad, while at play dodging around the big chimney of his father's house when four years old. The blow laid him senseless, but did not affect him more seriously than the enlargement of one side of his head to a lamentable deformity."

Amassing a fortune, Edwards then lost it all in an 1830 fire that destroyed the tannery and forced him to rebuild, if only to pay off his debts from the blaze. He died being supported by his children, including his son, the tanner Ogden E.

Edwards, although his business in the Swamp fell victim to the financial panic of 1837.

EDWARDS'S FATE DID NOT stall others from coming to seek their fortunes. "Sullivan County became the most prolific producer of leather, more durable and more supple and could be worked more easily than leathers from other areas," said Conway. "During the Civil War, there was a well-known saying: 'The war was won on boots, tanning, and Sullivan County.'" (The one-thousand-square-mile county, officially formed in 1809 with a population of about six thousand, was named for War of Independence general John Sullivan, whose name also graces a street in Manhattan's Greenwich Village.)

Overall, those who forged the Catskills tanning industry were a decidedly mixed lot, combining varying degrees of eccentricity, cupidity, and insensitivity. Many tanners were transplanted New Englanders with a knack for making money—which prompted the pejorative expression, "As smooth as a Yankee peddler"—or else they were from New York City, which carried its own stigma of distrust. Then there was the personality of the bark they used for their tanning; that too was questionable.

"Hemlock wasn't the most desirable bark for making leather," explained Stradling. "Oak-tanned leather was more valuable than hemlock leather, and that partly has to do with the color. The finished hemlock leather was a ruddy color, redder than the leather that was made by oak. So fine leather continued to be made with oak bark in other parts of the country—which meant that almost all of the leather in the Catskills, which was done with hemlock, was used for making up soles for shoes, where the appearance was much less important."

The tanner Winthrop Watson Gilman, whose father bequeathed him a prosperous tanning business in the Swamp, was born in 1808 in Maine and traced his ancestors back to the *Mayflower*. (Winthrop's older brother George was the founder of the Great Atlantic and Pacific Tea Company, or A&P.) Leaving Manhattan when he was twenty-seven, Winthrop, known as W.W., made $1 million on a $2,000 investment by buying up cheap land around Milwaukee at a time when its only buildings were log cabins. "He never spent a dollar to improve his property and never erected a building in the city," reported a Wisconsin paper, "but an old citizen says 'he appeared regularly once a year to collect his rent and fight off taxes.'" Gilman came to Sullivan County in the 1840s, just as tanning

was reaching its peak. Accumulating verdant acreage in Forestburgh, he put up a thriving tannery that encompassed thirty-two structures, as well as a prosperous lumber mill that sent four million board-feet per annum to New York City from the town that now bore his name, Gilman's.

As for the man behind the name, John Conway claimed, "[I]t is unlikely that there ever existed a more peculiar character in the annals of Sullivan County history." Cantankerous from birth, Gilman also developed a widespread reputation for stinginess that Ebenezer Scrooge would have envied. Leaving business to his son Alfred (who was later arrested for, among other charges, passing off oleomargarine as genuine butter), the reclusive tycoon wore but one set of threadbare clothes and subsisted on a daily diet of a slice of cheese and some crackers cadged from the homes of his workers. W.W.'s particular point of pride was never being so foolish as to buy insurance coverage, even in 1883, after his three thousand acres of land, including his leatherworks—indeed, the entire Sullivan County village of Gilman's—was destroyed by fire, at a loss of more than $120,000. "If I had policies on this property during the past forty years, the insurance company would have been paid its entire value. I saved that much money and had the use of it," he reasoned.

Citing the tanner's proclivity for purchasing "property and articles for which he had no use simply because he was able to beat the seller down in price," *The New York Times* reported in its 1885 obituary for Gilman that he had only recently bought several horses belonging to the Broadway stage lines, for the simple and only reason that "he could get them very cheap." The death notice also specified that Gilman, age seventy-eight, succumbed to pneumonia "in a poorly furnished room and with no affectionate voice or hands to comfort his declining days"—despite his having fathered seven children with his wife, the former Deborah Tupper, who predeceased him by eight years, according to a genealogical record of prominent eastern Massachusetts families.

At the time of his demise, Gilman was worth $3 million (approximately $78 million today), and while "on many current topics he was a most entertaining conversationalist," conceded the *Times,* "the chief ambition and motive of Mr. Gilman's life was to make money. . . .

"[I]n that respect his career was very successful."

Among tanlords, Zadock Pratt was cut from a different cloth. A prideful man with a limited education beyond the precautionary Bible lessons hammered into him by his mother, Pratt faced "early struggles . . . similar to those of most boys

T hose who visited the Catskills to see its great primeval forests saw instead vast mountainsides and hollows covered with bleaching trunks which a long dry spell would convert into fire-blackened wastes," Alf Evers wrote of the devastation wreaked on the landscape by the tanlords, whom Thomas Cole earlier had condemned as "unobservant of nature's loveliness" and "unconscious of the harmony of creation" in their "low pursuit of avarice."

For every tannery that existed, one long ton of bark, or 2,240 pounds, was required to process 250 pounds of leather. This resulted in a demand for one square mile of hemlock forest—one and a half million trees—*per factory, per year.*

Bank accounts plainly trumped the harmony of creation: a small tannery in Sullivan County with an annual overhead of $12,000 in 1856 could process fifty thousand sides of leather valued at $187,000. One dollar at the time could buy about what $25 can today, making the tannery overhead, in modern figures, $300,000, and the sales revenue from the cured leather more than $4 million.

Trees weren't the only fatalities. Fish vanished from streams as industrial waste raised the water temperature to dangerous levels. And once the supply of bark was exhausted in one area, tanners moved on to the next glen.

What they left behind were eyesores of rusting factories and ghost villages.

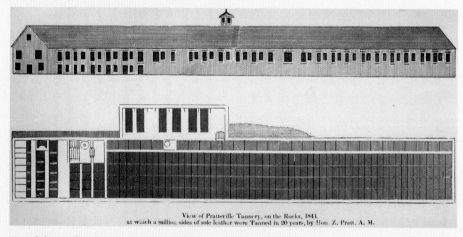

View of Prattsville Tannery, on the Rocks, 1844.
at which a million sides of sole leather were Tanned in 20 years, by Hon. Z. Pratt, A. M.

To celebrate the 1824 completion of the dam that would power his tannery, Zadock Pratt swam its adjacent creek—in the November frost. Within twenty years, that plant had processed one million sides of sole leather.

of his time who strove to rise in the world," wrote *A History of the Swamp* author Frank W. Norcross, who found the business figure "a man of imposing appearance." (Indeed, in many photos Pratt practically looks Lincolnesque.) "He stood six feet, two inches in height. He had four iron gray horses which he drove across the mountains to Albany and New York. He helped many a teamster out [of] the mud by 'giving him a lift' with his horses."

Pratt, born in 1790 in Stephentown, New York, saw his first earnings from pickling and peddling wild huckleberries. At age twenty he was apprenticed to a Greene County saddlemaker, which led to his becoming a journeyman saddlemaker under his father's wing for ten dollars a month. With the $100 he'd saved after a year, he went into business in the Catskills with his older brother Ezra and younger brother Bennett, starting a small tannery that shuttered just in time to avoid ruin caused by the depression following the War of 1812.

Ten years later, with his $14,000 from fur trading and the manufacturing of ash oars he sold to the U.S. Navy, Pratt, feeling what he called "half rich," drove a one-horse wagon into the Schoharie River Valley in Greene County. There, in the tiny village of Schoharieville, later to be called Prattsville, he bought acreage that formerly had belonged to the heirs of Johannes Hardenbergh's brother-in-law Alderman Leonard Lewis and began work on a new tannery.

Unfazed by Schoharieville's long distance from the Hudson River, which hindered the transportation of the rawhides from the river to the tannery and back again as finished leather, Pratt accurately observed, "It is easier to carry the hide to the bark than the bark to the hide."

On November 17, 1824, to celebrate completion of the dam that would supply power to the tannery and to show the locals he was no ordinary tanner, Pratt swam the length of the Schohariekill in the freezing cold. His tannery, which would become the largest in the world at its time, opened eighty-three days after the spring thaw.

"Pratt was somewhat less innovative than William Edwards," said Stradling, "but he was constantly trying to improve the efficiency of his tannery. He did work with the chemical process itself, trying to diminish the amount of time that the hides would have to sit in the vats. He also improved the amount of weight that would be gained by the hides, because all transactions were done by weight measure. So the more weight you could gain with your leather, the more profit you could gain."

In addition to the Prattsville facility, he built tanneries at Windham and Sam-

Prattsville was the pride of the Catskills, and of Zadock Pratt, who built his mansion near his tannery so he could hear work stoppages at any hour.

sonville, New York, and Aldenville and Gouldsboro, Pennsylvania. "These had over two thousand vats and their product was two hundred ten thousand sides of leather yearly," according to Norcross. His Catskills labor force was mostly made up of foreign-born German and Irish, with a sprinkling of other nationalities—and while Alf Evers claimed Pratt "kept his men satisfied with lives of hard work and small pay," Stradling averred, "He had a good reputation in the Swamp among the men with whom he did business."

Also in Pratt's employ were those seasonal workers considered the heart of the Catskills tanning industry, the "peelers." The first of every May, these men set out into the forests, peeled away the hemlock bark up to the first limbs (leaving the rest of the tree to rot), and then stacked the bark in cord piles to dry before hauling it to the tanneries. There, a water-powered mill resembling a huge coffee grinder transformed the bark into a fine powder that would be taken to a leach house, to be mixed with boiling water and left to steep for about a week until it turned into the liquor used to tan.

"The business in the Catskills was really a part of international trade," said Stradling, "because they consumed huge numbers of hides that came from great distances," with Buenos Aires a major supplier. Shipments of the salted, dried

hides were received at the tannery stiff and hard to handle, requiring that they be soaked and softened in cold water for forty-eight hours before treatment.

Tanning itself was exhausting: hefting one-hundred-pound water-drenched hides on the production line before pounding them into suppleness with huge water-powered hammers studded with multiple iron pins. Next came the removal of the hair from the exterior layer with the harsh lime solution. Only the second layer, known as "the true skin," became leather.

The treated hides were then soaked for an average of nearly six months in vats containing the tannin distilled from the hemlock bark. Finally, after a rinsing in clear water, they were ready to be transported from the Catskills to the Swamp, which by the middle of the nineteenth century had become the largest leather market on earth.

"One time just before the [1846–48] Mexican-American War, the Hudson River was frozen, so the hides could not be brought down via sloop as they normally would," said Stradling. "Pratt knew that the city was running low on available leather, and knew that prices were very high because of the gearing up for war. So he loaded up sleds and brought down his own hides and drove them right into Manhattan. There were comments in the papers about his arriving with his four horses and looking rather stately atop his tanned hides."

The words used to describe the horses were "proud" and "iron-gray."

As a boss, Pratt prided himself in training his employees in the fine craft of tanning, and he was hands-on, standing alongside his crew of sixty from the time they awoke at five every morning before a hearty breakfast together. At noon they shared a full-course meal of "good boiled beef and pork, potatoes, turnips, cabbages, wheat bread and butter, and sometimes even roasts," and after working through the afternoon, the day shift went home to their families to be in bed by nine, according to Carolyn Bennett, director of the Zadock Pratt Museum in Prattsville. Pratt purposely situated his mansion only a short walking distance from the factory, so that should a work stoppage by the night crew arise he could hear the machinery grind to a halt and rush over to handle the problem.

In a trade rife with secrets, Pratt openly shared details of his tanning process with anyone who would listen. And where most tanners exhausted the hemlocks in their area and then closed up shop, leaving behind shantytowns and jobless workers, Pratt arrived in Schoharieville and told the few families then living along

Schoharie Creek, "I come to live with you and not on you," and he kept his word. Prattsville became known as the "Gem of the Catskills."

"Pratt understood that his tannery, like all tanneries, would eventually use up all the hemlock that was close enough to make it worthwhile, and he would have to move on. This does happen in the 1840s," said Stradling. "But Pratt prepared for the eventuality that the tannery would close. That's why, besides the churches that he helped found and the bank that made it easier for people to do business in town, he also established other businesses that would diversify the economy of Prattsville." In addition, said the historian, "He loved nature, and, as most rural people, he had a real connection to this place. It was not the type of romantic connection with nature that we tend to think of today. I think Pratt would have looked upon the fallen hemlock forest as part of a cycle—it was part of what was supposed to happen here. These denuded forests eventually gave rise to saplings, most of them hardwoods. Hemlock does not sprout from a stump, and so we don't get stands of hemlock replacing these lost hemlock forests. The young hardwoods could be cut as saplings, and turned into the rings that were used to create barrels. Some of the forests were replaced by pastures and farm fields. Not coincidentally, agriculture had its heyday at about the same time that the tanning industry was peaking in the 1830s, '40s, and '50s."

"He built a planned community, one of the first in the United States," said Carolyn Bennett. "He wanted a town where workers would come with their wives and children, and bankrolled one hundred homes for his workers. He endowed three churches, two academies, and an opera house. He founded the town newspaper and printing plant, the first printing press in the Catskill Mountains. Streets were lined with shade trees. Miles of bluestone sidewalk were laid. Pratt financed a woolens factory, a cabinetmaking facility, two match factories, an oilcloth factory, a machine shop, and foundries. He opened a bank that printed its own currency with Pratt's picture on it, and his banknotes traded at parity with the U.S. dollar and were redeemable at Wall Street banks." Were someone in need of a loan, Pratt studied his face and hands (Pratt was also an avid believer in phrenology), and if the face appeared honest and the hands showed evidence of hard manual labor, the loan was granted. Once while driving near Prattsville, Pratt encountered a sad-looking boy from Oneonta, who had taken a large flock of sheep to New York on behalf of some chiseler who made a false promise of payment and a ticket home. Now on foot and hungry, the youngster told the story to Pratt, who, according to folklorist Alf Evers, "was not the kind of man to let a mere empty

pocket [in this case, his own] stop him from giving a hand to a fellow mortal in trouble." Pratt picked up a flat stone from the side of the road and scratched a check on its surface. "Take that down to my bank in Prattsville," he told the boy, "and they'll give you the cash."

"He had a good reputation among the people who lived in Greene County," said Stradling. "He was twice elected to Congress—two different stints, actually, from two different districts, once in the mid-1830s, and then once again in the 1840s." During his tenure, he founded the National Bureau of Statistics, worked to promote a transcontinental railroad, and, in addition to lobbying successfully to build the Washington Monument, introduced legislation geared to reducing the cost of postage from twenty-five cents to five. His argument was that the high rate was a tax that interfered with what mattered most in a democracy: the free flow of information.

Early roads leading into the Catskills interior were little more than steep and narrow Indian trails that demanded vast improvement, a situation rectified once the New York State Assembly knew to halt the steady flow of New Englanders who never bothered to settle before heading west. In April 1790, the assembly authorized the construction of a toll road west from the Hudson River along an Indian path called the Susquehanna Trail, which was subsequently upgraded and named the Susquehanna Turnpike but soon became simply the Catskill Turnpike—the first in a network of toll roads so overrun with people, wagons, horses, and livestock that the dust hardly had time to settle.

By 1806, sixty-seven turnpikes were planned, begun, or completed in New York State, many linking Catskill towns to one another and opening up the interior to rapid development—and to tanneries. By 1820, ambitious tanlords and those who staked them were setting up leather-processing centers in towns they often named for themselves: Edwardsville, Gilman's, Prattsville—anywhere that the large stands of hemlock could be found.

After that, tanneries became so ubiquitous that cultivated vacationers coming down from the elegant Catskill Mountain House frequently encountered a common sight and scent en route to the inland leatherworks: a wagonload of stinking hides being hauled up from the river piers by dung-encrusted oxen.

Proud and iron-gray himself, Pratt enjoyed sitting for portraits, showing off his physical strength, and being married. In all, he had five wives: three who died (the first two from tuberculosis, and the third during childbirth), a fourth he divorced, and a fifth, Susie A. Grimm, who was only twenty years old when he, at seventy-nine, married her on October 16, 1869, in Prattsville's Grace Episcopal Church. She had previously worked in the office of the industry trade paper *Shoe and Leather Reporter,* and, according to Norcross, himself a journalist for the publication, had "acquired that amiability and flavor of the Swamp that made her attractive to the old tanner." Besides a son and daughter with his third wife, Abigail, Pratt was survived by Susie, who was barely twenty-two when he died a year and a half after their wedding from an injury sustained during a fall down a flight of stairs.

Though he failed to win his 1848 bid to become New York governor, Pratt, who retired from tanning in 1859, claimed that his leather furnished the soles for ten million pairs of boots and shoes, and that if the skins he tanned were placed in a continuous line, they would stretch thirteen hundred miles and cover seven hundred square acres. Toward the end of his life, in an immodest bid for immortality, he hired an itinerant stonecutter to carve a memorial to himself in a Catskill mountainside, five hundred feet above the town that bore his name. The crude rock carvings, which can still be seen, include Pratt's bust, a rendering of his tannery, a horse, a hemlock tree, a brawny arm holding a sledgehammer, and the self-invented Pratt family coat of arms.

Its inscription: "Do well and doubt not."

II

One route for the carting of bluestone slabs ran along the Sawkill Road, past [Harry] Siemsen's house across the creek. Others went along Yager Stream or Platte Kill to the Esopus, the valley of which then provided gentler downhill slopes to its outlet at Saugerties. There, at the navigable Hudson River, the slabs could be loaded on barges.

—NORMAN CAZDEN

"Fact is," said David Stradling, "I think Thomas Cole was much more likely to complain about tourists who were at work changing the Catskills than he was

Dozens of quarries opened in the Catskills, with the bluestone business further boosted by the 1827 opening of the 108-mile Delaware and Hudson Canal.

about tanners, who were mostly gone by the 1850s." Still, at the same time the hemlock forests of the Catskills were being stripped bare for the benefit of leather, entire mountainsides were being reduced to smoke and dust as thousands of immigrant laborers pried and blasted into millions of tons of rock. Their goal: to excavate the plentiful deposits of bluestone at the mountains' eastern base and inside the region's interior, all to provide New York and the other rapidly growing cities along the eastern seaboard with sidewalk pavement and curb lining.

"Early settlers at the eastern base of the Catskills found a hard-blue gray stone . . . breaking through the earth and forming long parallel ledges which often alternated with bands of soft, red shale," Alf Evers wrote, citing geologists' findings that the higher one went in the Catskills, so too would the color of the bluish sandstone change, from blue to gray, green, and, ultimately, nearly pink, just as firmness and strength were diminished. Easily sliced into slabs, bluestone was the miracle material of its day: exceedingly durable, resistant to wear and shifts in temperature, nonslippery when wet, and quick to dry after a rain. During the pioneer years, the "blue gold of the Catskills" was used locally for tombstones, foundation walls, field walls, hitching posts, exterior and cellar steps, smokehouses, and, in some cases, entire houses. Bulky pieces of bluestone with bucket ropes through their centers covered wells, while lighter pieces served as lids on pickle

barrels inside general stores. Outside the emporia, leaning against the walls, slabs of bluestone, as the "plastic" of their day, were left as collateral for goods bought on credit.

"The bluestone belt," *Popular Science Monthly* reported in 1894, "follows the Hudson river until the town of Saugerties, in Ulster county, is reached, when it takes a westward drift, being interrupted on the east by the older limestone formations, and on the north by the quartzrose and conglomerate or pudding-stone formations of the Catskills, the latter of which undoubtedly rests on a formation of bluestone, as it again makes its appearance on the westward side of the range." Because the Hudson River was essential for transportation, the bluestone industry developed near its banks, with the excavated heavy blocks brought down the mountains by skilled teamsters driving over the steep, rough grades.

"Quarrying was a tricky and involved business that the quarrymen had to know well," stated Harry Siemsen, the official historian for the town of Kingston, who also recognized the detailed process involved in quarrying. "The bluestone was beneath layers of soil, clay, and stone. This overlay material had to be stripped. After stripping down to the block of good stone the quarryman then looked for

The William K. Vanderbilt mansion, built on Fifth Avenue in 1882, incorporated a slab of bluestone that cost the railroad tycoon $10,000, or more than $240,000 today.

the natural vertical joints called 'side seams' running north and south, and then the east and west joints called 'headoffs.' He then had to know how to delicately tap wedges into the horizontal seams so that he could pry up perfect slabs of bluestone called 'lifts.' It was a precise operation and he had to know how to use his tools well: the hammers, points, drills, wedges, crowbars, plugs and feathers, shovels and picks."

Siemsen was also quick to give credit where it was due: "The quarrymen were always taking a gamble, as they never knew if they would get a good block, or, if they did, whether or not their 'stone boats' or wagons, would make it down the side of the mountain." As he viewed the industry, in addition to the land being exploited, so were the quarrymen, with laborers having to pony up a "quarry rent" equal to 5 percent of the selling price of the bluestone to the landowner. "Cartage, tolls, and rent where due, were deducted at the time the stone was paid for at the stone dock."

As further calculated by the historian, "One time after the deductions for a two-horse load of stone at the dock," there remained for those who had excavated and transported the material a less-than-princely sum: "seventy-six cents."

"THE HISTORY OF the discovery and first attempt to quarry bluestone for the market is shrouded in uncertainty," *Popular Science Monthly* recognized in 1894. "It is known, however, that a man named Moray opened a quarry at what has since been called Moray Hill, near Kingston, as early as 1826. His son, the late Daniel Moray, of Kingston, said that his father was the first person to put bluestone as a product on the market, drawing the stone to Kingston with an ox team and selling it for window-sills and lintels."

On the record, the first bluestone from the interior to be exported to a distant market was excavated in the 1830s from Westbrookville in Sullivan County, then sent by wagon down to the village of Rondout, where it was shipped by sloop to New York City. At the time, the sidewalks of the metropolis were laid of brick or cobblestone, and New Yorkers were resistant to change—so much so that this initial shipment was rejected at the dock and "accordingly brought back to Rondout by the same sloop by which it had been sent down to New York," reported Dorothy Hurlbut Sanderson, a librarian and schoolmistress in Ellenville from 1930 to 1946, and the author of several books about the area.

Despite the early rejection, within only a few years the valued properties of the

With architects favoring Catskills bluestone when building for their wealthier clients, William Vanderbilt was reputed to have paid $10,000 for a particularly large slab in the construction of his Fifth Avenue mansion. Neither did Louis Tiffany's city castle at East 72nd Street, completed in 1885, stint. As large as a railroad station, it was crowned in what *The New York Times* called "a complex assemblage of turrets, balconies, chimney stacks, oriel windows and other elements in rough-faced bluestone and mottled yellow iron-spot brick."

Public projects benefited from the material's uses too. Surfaced in bluestone, Manhattan's Grand Army Plaza opened at the southeast corner of Central Park, designed by Carrère and Hastings "as a grand outdoor room in the manner of a French garden—New York's version of the Place de la Concorde in Paris," Robin Pogrebin of *The New York Times* reported in June 2013, in a story about how the city square, with its cracked bluestone and "gilded statue of Gen. William Tecumseh Sherman eroded," was in dire need of repair—and new bluestone.

Farther south, bluestone was vital to the 1980s restoration of Bryant Park, while by the 1990s a movement had developed to preserve bluestone sidewalks on Manhattan's Upper East Side in Yorkville and in Harlem; Brooklyn Heights, Park Slope, and other neighborhoods in brownstone Brooklyn; Long Island City, Queens; and Staten Island.

stone were recognized and its customers supplied as dozens of quarries opened in the Catskills. Business was further advanced by the opening of the 108-mile Delaware and Hudson Canal that cut east–west through the Catskills and linked the anthracite fields of northern Pennsylvania with the Hudson River at Kingston. By midcentury, twenty-five barges, sloops, and other vessels comprised the bluestone fleet at the port of Rondout–but one Hudson River port from which the stone was exported to the world.

By 1869, with the Ulster and Delaware Railroad now connecting points in the Esopus Valley with the port of Kingston, bluestone became the Catskills region's second greatest export industry.

Until the end of the nineteenth century, when Portland cement (so called because its color resembled the stone quarried on the Isle of Portland off the English coast) had replaced the more expensive bluestone in constructing city

sidewalks and curbs, the Catskills bluestone era was at its peak, with "Bluestone Men" working the quarries numbering as many as ten thousand. Known as "the quarry Irish," they had fled the potato famines of their homeland in the 1840s, and were constantly at odds with the locally settled Protestants. They were also greatly distanced from the men they worked for.

According to Trustees Records in the town of Kingston, "In Sawkill and the surrounding area many of the quarries were owned by Rondout businessmen, including S. D. Coykendall and the Booth Brothers. The owners hired unskilled, immigrant laborers to work the quarries, and built houses for these workers and their families, thereby creating small communities with distinct, independent characters, such as Stony Hollow, Jockey Hill, and Dutch Hill."

The homes were typically shanties, and as the prolific Alf Evers in his 1961 essay "Bluestone Lore and Bluestone Men" described the inhabitants themselves, "[T]hese refugees from famine and oppression had the stamina that enabled them to enjoy life in spite of its difficulties." With "every other house between the mountains and Saugerties . . . a gin mill and hell busted loose when the quarry-men were paid off on Saturday night," according to "one old-timer," nocturnal card games would turn into parties that lasted until "a rooster stood on the thresh-old of a cabin and announced the arrival of dawn." Just as common were "bloody fights in the woods and . . . queer characters who lived in isolated huts or caves."

A woman identified only as Mrs. Keegan, the wife of bluestone man Peter Kee-gan, was described as not objecting "when her husband bedded down the family cow in the kitchen because the great blizzard of 1888 was threatening to cave in the barn roof."

When it came to the quarry families' children–the Keegans alone had fifteen–historian Harry Siemsen recounted how in school "you learned to set your lunch pail near the stove in winter so the sandwiches didn't freeze, if you had sandwiches."

> Usually, there was no milk, it was just sandwiches. And of course some kids, they would just have bread and lard or something that they put on or black strap molasses. Another thing we learned going to school was to track rabbits to their dens in the stone walls and rubbish piles. You learned to dig 'em out then have rabbit stew for supper. I ain't kidding you; these pretty little bunnies that the children today admire meant meat in the pot for us.

Siemsen collected and transcribed nearly two hundred folk songs written by local musicians," said genealogists Susan B. Wick and Karl R. Wick about the Brooklyn-born Harry Siemsen, who in 1906 relocated to Kingston, where he became active in local government and served as the town's fire chief.

Before his death in the mid-1970s, Siemsen also served as president of the Ulster County Historical Society in Kingston, and, as noted by the Wicks, "He learned and practiced many old-time skills, including horseshoeing, hand-harvesting grain, and hiving bees."

Among the songs whose origins Siemsen traced was "The Bluestone Quarries," the lyrics of which follow here. While many references suggest it was sung to the tune of "When Johnny Comes Marching Home," others cite "Paddy Works on the Railway," whose same sentiments are largely expressed here.

"Jubilee Jim" Fisk was a high roller who, with Jay Gould, partnered with Kingston "Bluestone King" John Fletcher Kilgour to expedite Kilgour's stone to market on their Erie Railroad. The financial panic of 1873 put an end to the cozy arrangement, though by then Fisk was long gone—the victim of a bullet fired by a business associate in love with Fisk's showgirl mistress.

In eighteen hundred and forty-one
They put their long red flannels on,
They put their long red flannels on,
To work in the bluestone quarries.

Chorus
Tithery, hoora, hoora hey,
Tithery, hoora, hoora hey,
Tithery, hoora, hoora hey,
To work in the bluestone quarries.

We left old Ireland far behind
To search for work of a different kind,
The work was hard, but we didn't mind,
To work in the bluestone quarries.

Chorus

We brought our jigs, all kinds of good
 cheer,
Wines and such, and likewise beer,
And the fighting that drove a man to tears,
For the work in the bluestone quarries.

Chorus

The quarrymen were sometimes known,
"Sure the devil himself's in that blue-
 stone!"
'Cause they'd often be nursing a broken
 bone
That they got from work in the quarry.

Chorus

'Twas "Mike do this," and "Tim do that!"
With never a word for poor old Pat,
And him with naught but an old straw hat
To keep off the sun in the bluestone
 quarry.

Chorus

The company house that they lived in,
The siding was a terrible sin,

There wasn't a place the wind didn't get in,
That was hanging around in the quarry.

Chorus

And at night when they'd lay them down
 to sleep,
The wily pests would around them creep,
The rattlesnakes would slither and creep
'Neath the curb in the bluestone quarry.

Chorus

Tim Murphy and his striker crew
Had driven a hole in the stone so blue,
They went after a talisman in the woods
 so true,
To drill down in the quarry.

Chorus

When they returned at a quarter to one,
The drill was nowhere under the sun,
But deep in the hole that they'd begun
Came a blast that shook the quarry.

Chorus

And deep in the hole that they did fill,
Why, there was the Devil a-workin' the
 drill,
If you look real close, you can see him still
A-workin' the drill in the bluestone quarry.

Chorus

"Bluestone was a very risky business," said Sullivan County historian John Conway. "You had to invest a lot of time and energy, and therefore money, in uncovering the deposits, and oftentimes you would find that the rock would splint off and wasn't suitable for sale. But when you found a bluestone deposit that was suitable, the market in New York was almost insatiable." Whereas tanning demanded technical knowledge, skilled labor, and expensive factories, bluestone required only a proper site and raw muscle power. Given these factors, the industry attracted a different breed of entrepreneur as well: improvident speculators and fast-money men.

"Bluestone King" John Fletcher Kilgour was born in Kingston in 1841, and by the time he turned sixteen was transporting bluestone from quarry to dock as a teamster working for his impoverished quarryman father. Going independent at twenty-one, Kilgour established a quarry of his own in Kingston. At twenty-two, he added a retail stone yard at Newburgh on the Hudson to his holdings. At twenty-three, he banked his first million.

"He operated a number of quarries in the Upper Delaware Valley and became a large landowner, as well," said John Conway. "He bought the Shohola Glen amusement park [in Pennsylvania, one hundred miles from New York City] as an investment and operated that for a number of years. He built and lost several fortunes."

By age twenty-eight, Kilgour—who at his peak owned 150 quarries and employed more than five hundred men—had expanded his Pennsylvania operations by partnering with the financiers James "Jubilee Jim" Fisk and Jay Gould, who between them controlled the Erie Railroad, whose tracks were necessary to deliver Kilgour's bluestone to market.

Hailing from Vermont, Fisk, at thirty-one, had already made and lost a fortune when he launched his own Broad Street brokerage house. His fortune was remade when he brokered the 1866 sale of robber baron (and fierce competitor of Cornelius Vanderbilt) Daniel Drew's Stonington Steamboat Lines. After that, Drew brought Gould and Fisk onto the board of directors of the Erie Railroad in 1867, "and in March 1868 the three began their struggle with Cornelius Vanderbilt for control of the railroad," according to Allan J. Share in *The Encyclopedia of New York City*.

By July 1868, it was agreed that Gould would lead the search for capital—$1 million was raised—while Fisk would serve as president of the railroad. Kilgour's role was general superintendent. Added to the mix, as head of business affairs, was

William M. Tweed, better known as the unscrupulous "Boss" Tweed of New York City's Democratic Party political machine, Tammany Hall. Appointed to ensure the new company had the exclusive contract for supplying bluestone to New York City for its sidewalks, Tweed received for his participation in the new enterprise a starting bonus in company stock of $150,000 (about $2.5 million today).

"The results surpassed [Kilgour's] expectations," reported *The New York Times*. Beginning operations with fifty laborers in 1869, by 1871 Kilgour's quarries had shipped nearly four million square feet of stone to market. At the company's peak, Kilgour owned thirty operations along Fisk and Gould's Erie Railroad and the Delaware and Hudson Canal, and he was a multimillionaire. He was also terribly unlucky.

"[G]eneral disaster met the businessmen of New York in the panic of 1873," according to Pennsylvania's Pike County historical records. Adding to their troubles, Tweed fell under federal investigation for his role "in furnishing and collecting for large contracts of stone for the city." Gould, under financial pressure, was forced to divest himself of the Erie Railroad, "thereby thwarting the entire plan, which had induced Mr. Kilgour to consent [originally] to the organization of this company," read the Pike County account. Jubilee Jim Fisk had it worse. On January 6, 1872, two bullets were pumped into him as he descended the staircase of the Grand Central Hotel, on Broadway near West 3rd Street. He died the next day.

The man behind the trigger, Edward S. Stokes, was a partner of Fisk's in an oil refinery. The press wrote it off as a business deal gone sour, which it was–Fisk was preparing to sue Stokes for cheating him–but it was also learned that Fisk and Stokes were both in love with the same showgirl, Josie Mansfield, known as "the Twenty-Third Street Cleopatra" (the street being the location of the Grand Opera House, which Fisk owned and where Josie displayed her stagecraft). She may have lived with Fisk, but, it was revealed, was only attracted to his money. She was in love with Stokes.

Fisk was laid to rest, Stokes served four years in prison, and Mansfield ended her days on the dole in Sioux City Falls, South Dakota. Tweed went on trial in 1873 for his many misdeeds and died in Manhattan's Ludlow Street Jail five years later. Gould continued to make money, great sums of it. The company Kilgour had formed with Gould, Fisk, and Tweed was dissolved, and the onetime quarry king was forced to sell almost everything he owned to pay off the massive debt that he had guaranteed.

After a period of inactivity and depression, in 1887 he appeared to be on the

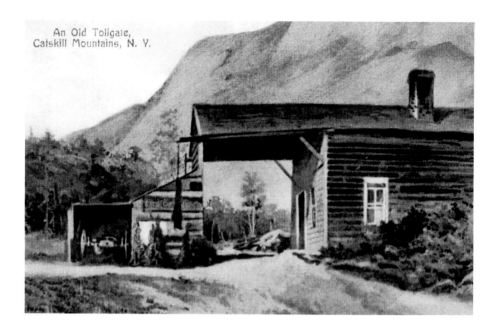

An Old Tollgate,
Catskill Mountains, N. Y.

upswing again, forming the Kilgour Bluestone Company. But the good times were short-lived thanks to business reverses. "Making millions and then losing them and then reinventing himself at another location and building another fortune," said John Conway, "this took its toll on Kilgour mentally. He began to develop what today we would call dementia."

On March 3, 1891, Kilgour boarded an early morning train from his home in Passaic, New Jersey, to New York, bounced a $500 check at a saloon he frequented, then disappeared. "His family had absolutely no idea where he had gone," said Conway. As *The New York Times* reported two months later, "He was traced to Canada where the quest for him was abandoned."

"In Quebec," said Conway, "he began to spread the money around and talk about revitalizing the asbestos mines. By the time his son appeared to bring him back home, he had disappeared again. He finally resurfaced, but was eventually confined to an asylum, where he died of chronic melancholia."

"A mental wreck," said his obituary on November 2, 1904, "due to a succession of disasters which followed his last attempt to build up a fortune after having built up and lost six."

A Call to Arms

I

> The Sheriff was to Andes sent,
> The Farmer to distrain for Rent;
> And with him three Tory hounds—
> In Delhi they do much abound.
>
> —From *The Fall Campaign; or,*
> *The Reign of Terror* (ca. 1846)

At the time the above stanza was bellowed out, roughly one-twelfth the population of New York State—more than 260,000 settlers, many of whom had come to the Catskills as tenant farmers or workers in the leather and bluestone industries—found themselves entangled in what historian Reeve Huston called "stark social and political hierarchies based on a single family's control of the land" and that "hinted at the landlords' ideal of class relations: a relationship of great men and subordinates, marked by tribute, deference, and social distance."

Extinct in England for nearly a century, this feudal system had been introduced to America by the Dutch, who granted anywhere from a few thousand to hundreds of thousands of acres of land to wealthy individuals willing to finance the colonization of the region by establishing patroonships; in all, tens of millions of acres were eventually awarded. The very first deed was given in 1629 to Kiliaen van Rensselaer, an Amsterdam diamond and pearl merchant and the original director of the Dutch West India Company. His estate, forty miles wide and spanning twenty-four miles along both sides of the Hudson River, was situated imme-

diately north of the Catskills, to include portions of what are now the counties of Albany, Columbia, Greene, and Rennselaer. Signed by the governing council that included Peter Minuit, director-general of New Netherland, Van Rennselaer's grant required him to purchase the land from its original occupants, the Mohicans, and settle no fewer than fifty adults within its boundaries for a minimum of four years. (To help satisfy the requirement, thirty-seven immigrants left Amsterdam in autumn 1636 aboard Van Rensselaer's ship, the *Rensselaerswijck*. Within six years the population of his settlement increased by more than one hundred and then doubled within the next decade—although, according to records, Kiliaen van Rensselaer himself never set foot in the colony.)

In return, Van Rennselaer was permitted to bequeath the land to his descendants as a fiefdom, as well as receive, for free from the Dutch West India Company, both protection and African slaves. As drafted and enacted, the grant permitted Van Rennselaer and his descendants total juridical authority over those who settled on their land, into perpetuity.

Strike one against the tenants.

AFTER A SERIES of wars ignited by the secret transportation of tobacco aboard Dutch ships from the English colony's Virginia plantations to ports in Europe, the British gained control of New Netherland in 1674 and incorporated the entire Hudson River Valley into their expanding empire. They also, as the Hardenbergh Patent shows, kept alive the land-grant system.

As calculated by Reeve Huston, "Beginning in the 1730s, the population of these estates grew dramatically as migrants from New England, southern and eastern New York State, Scotland, and the German states took leases. . . . By the 1810s, some two dozen tenanted estates, totaling about two million acres, spread across sixteen counties in the mid–Hudson Valley and the surrounding mountains, the foothills of the Catskills, and the Mohawk and Susquehanna Valleys."

Aware of their great asset—land, and lots of it—Johannes Hardenbergh, his partners, and their heirs seldom sold their holdings, preferring instead to offer portions of their property to farmers "on long-term leases in exchange for cash rents or payments in produce and labor," said Huston. The settlers could add houses, barns, and gristmills on their rented parcels, but contractually they owned nothing, a fact made blatantly clear whenever they fell behind in their rents—which then gave landlords the right to dispossess their tenants of everything, including

crops, livestock, and movable posses-
sions. (Technically, the tenants were
free to leave the land at any time,
albeit without their belongings.)

In those rare instances when
Hardenbergh and his ilk would con-
sent to sell land, they were careful to
restrict title to other men who shared
their standing. In 1742, Robert Living-
ston (1688–1775), the great-grandfather
of the Livingston who partnered with
Robert Fulton, bought nearly one
million acres from Hardenbergh for
about four cents an acre and ended
up controlling much of the Catskills
region. It was Livingston's desire to
exploit the timber in his vast new
holdings, and in a fanciful plan that
owed its inspiration to his Scottish
heritage, he sought to rename the
Catskills the Lothian Hills, after the
region in Scotland that encompassed
both Edinburgh and his hometown of
Livingston. His grand scheme for the
Lothian Hills of New York was to con-
struct castles on the mountaintops for
European nobility who desired get-
away homes in the New World.

From the movie preview for the 1946 screen
adaptation of Anya Seton's best-selling novel:
"[A]s the *Ladies' Home Journal* so daringly
promised when it first published *Dragonwyck,*
'This is a story to warm the hearts of those who
loved *Rebecca.*'" Only instead of the mousy
heroine of the Daphne du Maurier novel and
the threatening housekeeper Mrs. Danvers,
Dragonwyck, named for the manor in a Hudson
River feudal village, starred Gene Tierney as "the
woman who seeks love where it has feared to
flourish," and Spring Byington as the servant who
warns her, "One day you will wish with all your
heart you had never come to Dragonwyck."

Unfortunately for his idea, the War of Independence intervened, and by
the time the fighting finished, all thoughts of selling summit estates to mem-
bers of the European aristocracy had gone up in cannon smoke. Still, fortune
shined on post-Revolutionary landlords, whose estates "lay directly in the path
of migration," said Huston, taking note that "owners of heretofore undeveloped
lands in the Catskills," like their peers in the Hudson and Mohawk Valleys,
"began surveying the hilly areas in their domains and advertising for settlers."
And while "[m]ost settlers bypassed leasehold estates for areas where they could

nscreen, writer-director Joseph L. Mankiewicz portrayed the festering class divide in that era in his 1946 *Dragonwyck,* set in the Hudson Valley of one hundred years earlier and starring Gene Tierney as Miranda, daughter of the earnest farmer Ephraim (Walter Huston), and Vincent Price as the imperious patroon Nicholas Van Ryn.

As Anya Seton wrote in her 1944 historical novel on which the movie was based:

> Ephraim sat up with a jerk. "*Your* farmers! What in tunket d'you mean by that?"
>
> "Why, my tenant farmers on the manor land," answered Nicholas. "There are nearly two hundred of them."
>
> "Don't they own their own land?" asked Ephraim, frowning.
>
> Miranda . . . saw Nicholas's eyebrows raised, and an expression of annoyance on his face.
>
> "Of course they don't own the land," he said. "It belongs to me as it did to my father before me straight back to Cornelius Van Ryn, the first patroon, who took title in 1630. The tenants pay a very small yearly rent, and in return we have done a great deal for them."

Like the book, the film contains a memorable reenactment of the humbling annual ritual at which the squire of Dragonwyck receives the rents from resentful tenants while he's seated on a makeshift throne in the forecourt of his manor house. It can be counted among Vincent Price's most chilling performances.

buy farms outright," according to the historian, "great numbers of migrants took advantage of the landlords' terms. Between 1779 and 1800, the number of tenant households on Rensselaerwyck tripled, from about one thousand to three thousand. Livingston Manor's population grew from 4,594 to 7,409 during the 1790s—an increase of sixty-one percent. And the principal leasehold towns of Delaware County, virtually uninhabited by whites in 1790, became home to 11,125 people by 1820."

Typically, rent was one-tenth of all grains, fruits, and other products raised by the farmer; financial remuneration equal to 500 guilders, or $200, annually; and an abundance of services as determined by the lord of the manor.

What helped sever the otherwise generally friendly relationship between land-holder and land leaser was a growing fear among the gentry about their financial status. As original owners died, estates would be divided among their heirs. Combined with a decline in the practice of arranging marriages to consolidate land-holdings and wealth, landlords came under pressure to do something they really hadn't done before: press for rent monies owed, as well as shorten leases, from long-term to between one and five years, all of which went to undermine tenants' security. "The farmers worked so that the landlord could swill his wine, loll on his cushions, fill his life with society, food and culture, and ride his barouche and fine saddle horses along the beautiful river valley and up to the backdrop of the mountain," it was complained anonymously in a letter to a sheriff, cogently summing up the new sentiment.

Feudal practices in America began to erode with the 1839 death of Kiliaen's descendant, Stephen van Rensselaer III, whose property included Albany and Rensselaer Counties, immediately north of the Catskills. At his passing, Stephen's worth was estimated to be $10 million (nearly $250 million today), though his accounts were anything but liquid. His debts totaled $400,000 (nearly $10 million today), or exactly what was owed him by the eighty thousand tenants on his estates.

While Stephen van Rensselaer III was known as "the Good Patroon" and exercised noblesse oblige when it came to delinquent rent payments, his descendants were nothing of the kind. His son, Stephen van Rensselaer IV, who in his younger days was sent to Princeton in the hope that what his father saw as his "volatility and arrogance" might be tamed, never deigned to shake a tenant's hand, offering only his forefinger instead. Once he began prosecuting for what was owed the estate, farmers quickly responded to the Hudson River Valley sheriff assigned to serve as collection agent. Their collaborative letter read:

> The tenants have organized themselves into a body, and resolved not to pay
> any more rent until they can be redressed of their grievances. . . . The tenants
> now assume the right of doing to their landlord as he has for a long time
> done with them, viz: as they please. You need not think this to be children's
> play. . . . [I]f you come out in your official capacity . . . I would not pledge for
> your safe return.
>
> Signed, "A Tenant"

Undeterred by their words and still demanding his rents, Van Rensselaer once again dispatched the sheriff–this time abetted by a five-hundred-man posse with legal writs in hand. As they approached the farms, the sound of tinhorns was heard resounding through the valley, a shrieking signal from one household to another that the enemy had approached. The call to arms proved effective; rather than rent payments, the sheriff and his men found themselves facing a human barricade of eighteen hundred farmers, with six hundred more standing at the rear or else mounted on horseback, each and every one of them armed with a pitchfork or club. The writs were snatched from the lawmen's hands and burned.

With little choice but to retreat, the sheriff and his posse made their exit as the rear guard parted to allow them passage. But the opening salvo in the battle to banish feudalism had been fired.

THE FIRST ANTI-RENT RALLY was held during the summer of 1839 and produced a house organ, symbolically titled *The Guardian of the Soil*. At their meeting, the farmers demanded a rent boycott, vowing, "We will take up the ball of the Revolution where our fathers stopped it and roll it to the final consummation of freedom and independence of the masses."

Among the movement's founders were Smith Boughton, a country doctor with a gift for oratory (and a jail record, having served seven months in heavy irons for his "treasonous" antilandlord stance), and Ainge Devyr, a native of Ulster, Ireland, who'd been outraged by how the landed gentry of his homeland had pulled down the huts of starving peasants. "He was struck with the enormous contrast between the landholder of thousands of acres and the pauperized tenant starving on his quarter-acre potato patch, and yet driven from it by a heartless landlord," it was recorded in a 1902 account of the Great Potato Famine of 1847. Tried in his native country for sedition, Devyr took his revolutionary cry to America, where as the invited guest at a Fourth of July rally of farmers in Rensselaerville, he lectured his attentive audience, "If you permit unprincipled and ambitious men to monopolize the soil, they will become masters of the country in the certain order of cause and effect."

Devyr's message spread; in New York alone, thousands of farmers banded together in Anti-Rent associations to prevent eviction by the landlords and to pressure the state legislature into revising regulations relating to land leases.

Modeling themselves after the renegades at the Boston Tea Party, Catskills farmers protesting their rents dressed up in calico costumes and sheepskin masks, earning them the nickname "Calico Indians." "Some even more given to the wonderful, went so far as to substitute the necessary appendages of some quadrupeds," said Jay Gould.

Town and county associations made up of Anti-Renters coordinated rent boycotts, collected funds, coordinated legal campaigns against the landlords, and, working within the system, put up political candidates for office. In time, it was estimated that the monolithic movement grew to include anywhere from between twenty-five thousand to sixty thousand supporters.

As the farmers spent the summer and fall of 1839 organizing, New York governor William Seward directed the state militia to maintain order while publicly urging tenants to seek legislative redress, promising that his office would assist. In correspondence to his political adviser, Thurlow Weed, Seward wrote, "You have another anti-rent outbreak, I see. . . . The seditious spirit is still strong, and will have boldness enough to display itself this fall."

While the farmers' demands largely continued to fall on deaf ears, their increasingly noisy rallying cry soon moved south, spreading rapidly into the Catskills, centering in the town of Andes and adjoining villages that had all been part of the original Hardenbergh Patent. While a few parcels of the patent had been sold to individual farmers, most of the area remained under lease from absentee land-

lords, and Catskill farmers—some ten thousand strong—took their crusade into the towns along the Hudson, making their intentions clear.

As one handbill fervently advised:

ATTENTION
ANTI-RENTERS! AWAKE! AROUSE!
Strike till the last armed foe expires,
Strike for your altars and your fires—
Strike for the green graves of your sires,
God and your happy homes!

Modeling themselves after the renegades who had organized the Boston Tea Party, Catskills protesters dressed up in calico, earning them the appellation "Calico Indians." Donning frightening leather face masks with horns and carrying rifles, they intimidated the sheriffs, their deputies, and anyone else who tried to collect rents or, heaven forbid, evict them. Tinhorns, normally used to summon farmers home from the fields for the midday meal, now served as the unifying instrument to warn others that the rent collectors were on their way.

According to Jay Gould, in his 1856 *History of Delaware County: And Border Wars of New York, Containing a Sketch of the Late Anti-Rent Difficulties in Delaware with Other Historical and Miscellaneous Matter Never Before Published,* the calico dresses had been "furnished by the patriotism of the fair sex." He colorfully described the disguises as follows:

The covering which concealed the head was usually of *sheepskin*, with apertures through which the wearer might discern what was going on in the world without—another corresponding to the mouth, and yet another for the accommodation of the nasal organ, through which he inhaled a portion of the aerial element necessary to support the human system. The exposed or outer surface of the mask was usually painted in divers[e] shapes, to accord to the wearer's fancy as to making an impression, just as some men wear their hair long or short, curled and tastefully combed, or careless and unassuming. Some even more given to the wonderful, went so far as to substitute the necessary appendages of some quadrupeds, and imagined themselves elevated above the generality of the human species, in the capacity of sporting a huge pair of *horns* or a *horse's-tail*.

Appearing at sheriff's sales, Calico Indians would scare off potential bidders, and at livestock auctions, threaten to shoot the animals dead the moment any buyer made his purchase. They also agreed to compensate any farmer for the loss of his animals by taking up a collection among themselves.

As sides were drawn, men greeted one another with the slogan "Down with the rent" as a way to test loyalties, with the phrase displayed on flags and banners and painted on the sides of barns. Verses were written about the plight of the "down-renters" and sung to the tune of popular ballads ("Old Dan Tucker" was one familiar melody), and an amateur theatrical group in Kingston put on the play *The Calico Indian War,* performed by actors in the by now familiar sheepskin masks and calico gowns. According to the *Ulster Republican,* the production was received with "unbounded applause."

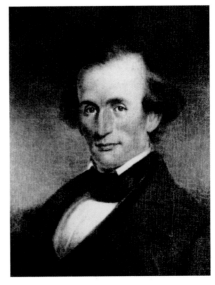

Undersheriff Osman "Bud" Steele, whose red hair matched his temper and whose resolve it was to round up and punish offenders of the rent laws

The summer of 1845 also saw a side-wheeler showboat named *The Temple of the Muses* sail up the Hudson from New York City and moor off various towns, including Rondout, where it remained for the entire second week of August. One of the plays it presented, *The Rent Day,* was an English melodrama that dealt with the sorrow of a young farmer and his wife who cannot pay their rent and a surly land agent determined to destroy their happiness. Even with tickets starting at twenty-five cents, performances generally sold out.

The inevitable clash came near the town of Andes in February 1845, when an agent of Chancellor Livingston's grandson was ordered to seize some wooden logs that a tenant farmer had illegally cut down on the property. Intercepted by a band of Calico Indians, the lawman was tarred and feathered.

Seeking to quash the rebellion, Undersheriff Osman "Bud" Steele, a tenant-baiting thirty-six-year-old with fiery red hair, as was his temper ("a fearless and faithful officer—ever ready and obedient in the performance of his duties, regardless of smiles or frowns," said Gould), resolved to round up and punish as many of the offenders as possible under a recently enacted New York Penal

Law—one that had been laid down exclusively to stomp out Anti-Rent insurrections in the Hudson River Valley. As summarized on the books, the legislation "criminalizes the wearing of masks or disguises by three or more persons in a public place unless done in connection with a 'masquerade party or like entertainment.' . . . Under the current law, wearing a bandana tied around one's face falls within the scope of the mask prohibition."

Because of Steele's concerted efforts, twenty-eight men were indicted in connection with the tarring and feathering incident, though several of them remained at large. Finally, desperate to assert his authority, Steele arrested Daniel W. Squires, a leader of the Calico Indians, and placed him behind bars in the town of Delhi.

For all the zeal of the movement, not every rural family embraced the Anti-Renters. Many, either fearful of challenging the status quo or else financially secure enough to keep up with the rent, flat-out opposed their tactics.

The financier Jay Gould, who would become one of the greatest schemers ever to hit Wall Street, grew up in the small town of Roxbury in Delaware County in a family that staunchly opposed the Anti-Renters. As a young man writing in his 1856 *History of Delaware County,* he presented the opinion that the leases were "generous in their terms and provided favorable conditions for the tenants." Gould's father, John Burr Gould, defied an Anti-Rent order that instructed farmers to use their dinner horns to call Anti-Renters together only when there was a crisis brewing. When the elder Gould continued to blow his horn to summon his workers for meals, a group of Calico Indians threatened to tar and feather him. Recalled his son:

> How bright a picture is still retained upon the memory of the frightful appearance they presented as they surrounded that parent with fifteen guns poised within a few feet of his head, while the chief stood over him with fierce gesticulations, and sword drawn. Oh, the agony of my youthful mind, as I expected every moment to behold him prostrated a lifeless corpse upon the ground.

Steadfast Anti-Rent supporters, however, were to be found in the family of one of Gould's boyhood friends in Roxbury, John Burroughs, who went on to become one of

In little time, Squires posted bail and was released, but another skirmish flared up, this time with deadly results.

MOSES EARLE HAD TILLED the rocky soil on Dingle Hill in the town of Andes for fifty-five years. The land, on the southern half of Great Lot No. 39 of the Hardenbergh Patent, was owned by a descendant of Gulian Verplanck, a partner of Robert Livingston's, who in the late eighteenth century had bought half a million acres of the original patent. By 1845, the land had transferred to the youngest child of "Old" Gulian's son, "Young" Gulian: his fifty-four-year-old, unmarried daugh-

America's most beloved naturalists. He remembered a childhood incident of trying to spy on an Anti-Rent meeting through an opening in a barn wall, only to have straw pushed in his face. Of what he was able to glimpse, he wrote:

> The men put on their Indian disguise and started for the meeting place. Their leather caps were something like a bag with holes cut for the eyes, nose, and mouth. There were horns on the caps, and a fringe around the neck, and a cow's tail tied on behind, and I don't know what-all. Oh! Those caps were hideous looking things—perfectly infernal—and no two were alike. The Indians had blouses of striped calico, belted at the waist, and some of them had pants of the same material or of red flannel. Take a hundred men dressed up in that style, and it made a sight to behold.

In contrast to Burroughs—in part because he owned considerable acreage himself—James Fenimore Cooper, squire of Otsego Hall, sided with the landlords. Three of his novels, particularly *The Redskins*, attacked the rent strikers, whose motive, the author believed, was that "the interests and wishes of numbers are to be respected, though done at a sacrifice of the clearest rights of the few."

To Cooper's mind, the Van Rensselaers, Livingstons, and their class "were simply an early abused American minority."

ter in New York City, Charlotte deLancey Verplanck, who had never set eyes on the Catskills property. Serving as her rent collector, Charlotte's nephew obtained a warrant under which Sheriff Green More of Delaware County was obliged to sell at auction enough of Moses Earle's livestock to satisfy the farmer's back rent, sixty-four dollars.

A tall, gaunt man whose wife, Sara, was twenty years his senior, the gentle, white-haired Earle was a hardworking farmer, even at age sixty-four. His father, Revolutionary War veteran Jonathan Earle, was, in 1841, the first body to be buried in the Andes Village Cemetery. Moses was also both a landowner and a tenant, having bought 100 acres of his farm, with the remaining 160 acres under lease for a yearly rent of thirty-two dollars. A sober man known for going out of his way to avoid trouble, Earle was ambivalent in his feelings about the Anti-Renters, though his many friends in the movement had encouraged him to withhold his rent for each of the past two years.

Responding to his orders, on June 17, 1845, Sheriff More knocked on Earle's door and served a warrant calling for the immediate payment of the monies overdue. "His reply was," according to Charlotte Verplanck's attorney, Peter Wright, "'You will have to go on and sell, I shall fight it the hardest.' Something was then said about his having written a letter to the sheriff in regard to it, and he stated in substance that he had since altered his mind, and should make no settlement." After Earle's refusal, the lawman scheduled the farmer's six cows and eight hogs—appraised at a value of $132.50—to be sold on July 29. As auction day dawned, dozens of Calico Indians, their guns hidden underneath their gowns, greeted Sheriff More and his posse with the threat that should any animal be sold, they would kill it. As anticipated, no bids were made, and the sale was postponed to August 7.

By the time of the second auction, Moses Earle, who had the money, was again having second thoughts about withholding the rent. What he didn't figure upon were the actions of Perthena Davis, a hired hand, who after the death of Earle's own daughter at age nineteen had assumed the position of a surrogate family member in the Earle household. Perthena was a formidable presence; her grandfather had fought in the American Revolution, and her father in the War of 1812. She herself was a rabid Anti-Renter, and whenever Moses Earle weakened in his resolve about withholding the rent, she stepped forward to serve as his backbone.

On August 7, wagons filled with two hundred men in Indian costumes came

barreling down the turnpike, making a left turn on Dingle Hill Road near the Earle farm, then disappearing into the woods surrounding his pastures to await the sheriff's arrival. They didn't have to wait long. Sheriff More, accompanied by Peter Wright, had set out early, stopping for breakfast at Shavers Tavern before heading to the Earle farm, where they again demanded his rent. Earle's already shaky tenacity wavered even further in the face of what he feared the Indians hidden in the woods might do, and he went into the house for the cash—only to run smack into Perthena.

Circuit Court judge Amasa J. Parker decided beforehand the fates of those accused of killing Osman Steele.

Grabbing his wallet out of his hands and thrusting it into the bodice of her dress, she berated him for his actions and refused to hand back his money. Earle slunk back to inform Sheriff More that he had once again changed his mind and that the sale should commence, if that was what the officer was intending to do.

The auction was to be conducted by Undersheriff Steele, who had first stopped for food and drink at the Hunting Tavern in Andes, where Ephraim Hunting, the tavern owner, asked Steele if he didn't fear for his own safety. "Lead cannot penetrate Steele," boasted the lawman, who, as legend has it, dropped a bullet from his pocket into his drink as he delivered the pronouncement.

In preparation for the sale, Moses Earle's animals had been moved to the upper pasture, where all the Calico Indians had come out of hiding to surround Sheriff More and lawyer Wright. Once Osman Steele came riding up on horseback, a Calico Indian reputedly threatened, "We'll make your hair redder than it is." Another, noticing that Steele was chewing on a toothpick, said, "We'll fix it so you can't chew at all."

History does not record who fired first, or even who among the Calico Indians fired at all, but "a volley of rifles was then fired upon us," Peter Wright later recalled, "and I should think Steele was wounded in the arm at this fire; in the course of a very few seconds, a second volley was discharged, which came like a shower bath upon Steele and the horses, taking effect in the body of Steele,

and also in both horses. Steele fell bleeding upon the ground, three balls having pierced his body, and others gone through his clothes."

Steele's horse reared and fell, and the undersheriff tumbled to the ground, shot three times: once in the arm, once in the chest, and a third time through the bowels. Carried into Moses Earle's farmhouse, he died at eight o'clock that evening. His last words to Earle were, "Old man, if you had paid your rent, I would not have been shot."

Earle is said to have replied, "If you had stayed home and minded your own business, you would not have been shot."

"HORRIBLE OUTRAGE AND MURDER ! !" read the headline in the special edition of the Delhi *Delaware Gazette* on Friday, August 8, 1845. Recounting the confrontation on the Earle farm, the paper blamed a *"lawless mob"* for the death of "a worthy and respected citizen, and a most efficient officer." The report went on to say, "The remains of poor Steele were brought into the village this forenoon, causing universal sorrow among our citizens. Every eye was moistened–but few words were spoken–the heart being too full for utterance." The Calico Indians fled en masse into the hills as sheriff's posses formed to round up those accused of the killing.

Over the next few weeks, marshals ransacked homes, innocent people were arrested, and posses broke into churches doubling as sanctuaries to find suspects. "It is very difficult to make [the arrests] as the offenders have deserted their homes and live in the mountains, in caves, and move about, are stealthily fed by friendly men and women living in those parts," reported the *Albany Argus*.

John Burroughs wrote:

I'd seen the sheriff and his posse ride past–twenty or thirty or even fifty men galloping pell-mell and I was scared. They'd go rushing along on their horses, flourishing swords and muskets. It was a terrible sight for a youngster. My fears were the greater because the posse represented the law, and my sympathies were with my own people. I wasn't afraid of the down-rent Indians.

Over the course of what was a particularly hot and dry summer, so many men had disappeared from their farms that the various fields of oats, corn, rye, and buckwheat wilted in the sun. As one woman said, "Our husbands are driven from

their homes, hunted down in the mountains like beasts of prey; our defenseless houses are broken into in the dead of night, and ransacked at will."

Even the most ardent supporters of the Anti-Renters were appalled that the situation had spiraled so far out of control. Clergymen denounced the killing. Law-and-order meetings were held, demanding that the governor bring the Anti-Renters to justice. Newspapers railed against what had happened. The *Delaware Press* called for the suspension of all Anti-Rent publications. "Liberty of the press is a sacred right," it editorialized, "but when it is perverted to such base uses . . . it should be at once stayed."

In the first few weeks after Steele's murder, 242 suspects were arrested and brought into Delhi, so many that the village jail could not contain them all. Some prisoners were housed in the courthouse, while private homes were used to hold others. Three log pens were built behind the courthouse, two for fifty prisoners and the third as a barracks for the guards.

The incarcerated "included Edward O'Conner, chief of the Bovina 'Indians,' and John Van Steenburgh, an illiterate youth who was said to have boasted after Steele's murder, pointing between his legs, '[I] put a ball into him here,'" according to history and law professor Charles W. McCurdy, who also quoted Delhi residents as saying that Moses Earle was "sure of the rope," and wanted to hang "sooner than later" (the professor's words) "but for respect to law and order" (the villagers').

The mood of the entire region was foul, and the trial that followed a sham, with Circuit Court judge Amasa J. Parker deciding in advance the fates of those accused. In his charge to the jury he directed that any man who had been present and costumed that day was entitled to a year in prison. It also was not necessary, Parker instructed jurors, to provide proof that on the day in question any defendant had discharged his gun. "All who were present at the sale, armed and disguised," the jurist instructed from the bench, "were engaged in the perpetration of a felony, and therefore were guilty of the murder, whether they designed to kill any person or not." Men called to testify against their friends faced the possibility of the gallows or years in state prison if they chose not to cooperate.

Over three weeks of trial it was never determined who shot first, or even who precisely had killed Steele, or even which "Indians" had discharged their weapons, but according to Judge Parker's interpretation of the law against disguises—a law that remained on the books and was used to bust drag queens in Greenwich Village in the weeks leading up to the Stonewall riots of 1969 and in 2011 to arrest

Occupy Wall Street protesters wearing masks—anyone entering a plea of not guilty and then found guilty by the jury would be convicted of first-degree murder and sentenced to death.

Even Judge Parker feared the bloodbath such executions would bring, and finally convinced the lawyers representing the defendants to enter guilty pleas, allowing most of them to be convicted on a charge of manslaughter and sentenced only to time in jail.

In the end, only O'Conner and Van Steenburgh, who sobbed in court before sentence was passed, were to die (later commuted to life in prison). Four received life sentences—Moses Earle among them—and nine were ordered to serve from two years to ten. Fifty others were handed fines and suspended sentences. The thirteen bound for incarceration were taken by wagon to Clinton Prison in Dannemora, where Moses Earle was put to hard labor building stone walls.

The verdicts were met with strong and varied reactions. The *New York Herald* maintained, "These signs of mercy will have good effect . . . they are the best evidence to the Anti-Renters that the administration of law has no desire to oppress or wrong them." Others vehemently disapproved. George Evans, a radical reformist and early trade unionist, wrote, "There is nothing to equal [the verdicts] in this country since the hanging of the witches in New Salem."

Whatever the point of view, the Anti-Rent farmers had attracted national attention, and public opinion had begun to turn against the landlords. As petitions poured in from across the country demanding that the condemned be spared, outgoing governor Silas Wright commuted their sentences only a week before they were to be executed.

In February 1847, incoming governor John Young made good on his campaign promise and pardoned the rest of the men, who were received as triumphant heroes in their respective hometowns. In Albany, delirious crowds welcomed them. When they reached Prattsville by sleigh, Zadock Pratt personally welcomed them, showing himself to have been an Anti-Renter all along. Hosting a dinner in their honor, with a full brass band and fireworks, the tanner furnished the men with four horses and a wagon for the remainder of their journey home.

While the old system of land tenure stood unchanged, "[b]y 1845," said Reeve Huston, "a new, bipartisan consensus emerged that the leasehold system was hostile to American liberties. More generally, political leaders came to oppose any set of class relations that smacked of deference, seemed to create permanent inequalities, or retarded the free exchange of land."

Statewide elections in November 1846 delivered victories to a number of Anti-Rent campaigners, and a ballot issue calling for a constitutional convention to consider a number of reforms—including land tenure—passed overwhelmingly. Once held, that convention abolished future perpetual leases of agricultural land and prohibited landlords from demanding a portion of the purchase price when a tenant sold his leasehold. Also in 1846, the New York State legislature struck down a landlord's right to seize and sell a tenant's movable property in order to satisfy back rents, the issue that had led to the killing of Osman Steele—whose killer remains unknown to this day.

In the pasture where the murder took place, a small marker commemorates the historical events of long ago, and in nearby Woodland Cemetery a tall monument stands in Steele's memory. Hunting Tavern, where the lawman made his boastful claim that "lead cannot penetrate Steele," has been restored and can still be visited.

On Dingle Hill, where Moses Earle lived and stood his ground, the only remains of his home is the fireplace. He died there, in poverty, in 1863. With him were his dog and three cats.

II

The president was seated at his desk. Mrs. C. [Lucy Colman, a white friend of Sojourner Truth's] said to him, "This is Sojourner Truth, who has come all the way from Michigan to see you." He then arose, gave me his hand, made a bow, and said, "I am pleased to see you."

—SOJOURNER TRUTH, on meeting Abraham Lincoln

Today, the name Sojourner Truth can be found on a U.S. postage stamp, courthouse plaques, a bust in Emancipation Hall, the letterheads of societies, and the titles of journals, even on office panels of elementary schools, while up until the time she was nine, Truth herself was to be found on the Ulster County estate in Swartekill, in the town of Esopus just north of Rifton, belonging to Colonel Johannes Hardenbergh Jr., the owner of a gristmill and the grandson of the holder of the Great Patent that bore the family name.

From *History of New Paltz, New York and Its Old Families*:

In the Revolutionary War [Johannes Hardenbergh Jr.] served a great portion of the time as lieutenant-colonel of the Fourth Ulster County regiment, of which Jonathan Hasbrouck of Newburgh was colonel. On account of the ill health of the colonel the regiment was a considerable portion of the time under the command of the lieutenant-colonel. In 1779 he received his commission as colonel.

Sojourner Truth—at the time still going by her birth name, Isabella Baumfree, although she was sometimes referred to as Isabella Hardenbergh—also belonged to the family. She was a Hardenbergh slave.

Believed to have been born on Rondout Creek in 1787, Isabella was the youngest of thirteen children of the slaves James and Elizabeth Baumfree. Her father had been brought to America after being captured in what is modern-day Ghana, and her mother's parents were slaves from Guinea. There were four or five other slaves in the Hardenbergh household, where James and Betsy Baumfree were provided their small cottage after working a specific number of days for their master, spending the rest of their time growing tobacco, corn, and flax, which they sold to pay for the raising of their offspring—until such time that the youngsters were sold.

Even under such conditions, according to Isabella, Betsy Baumfree told her children that "there is a God, who hears and sees you. . . . He lives in the sky . . . and when you are beaten, or cruelly treated, or fall into any trouble, you must ask help of him, and he will always hear and help you."

After Colonel Hardenbergh's death, the estate passed to his son, Charles, who had resided nearby in Swartekill and kept four or five slaves of his own. "Charles Hardenbergh's house served as both his dwelling and a hotel," according to Pulitzer Prize–winning biographer Carleton Mabee, "but he housed his slaves in its damp cellar, all in one room."

In *The Narrative of Sojourner Truth,* a biographical account published in 1850, it was said of Isabella, "She shudders, even now, as she goes back in memory, and revisits this cellar, and sees its inmates, of both sexes and all ages, sleeping on those damp boards, like the horse, with a little straw and a blanket; and she wonders not at the rheumatisms, and fever-sores, and palsies, that distorted the limbs and racked the bodies of those fellow-slaves in after-life."

Upon the death of Charles Hardenbergh in 1806, "the remaining Hardenberghs decided to free Isabella's father James, as he was too old to work anymore," wrote Mabee. Betsy was freed with him, in order that she might look after her

At the time of Isabella Baumfree's birth in the 1780s, as many as 60 percent of the rural New York households owned slaves, and by the turn of the nineteenth century, when the total population of Ulster County was 29,554, more than 10 percent of the inhabitants, some 3,200, were black.

"To all those who think slavery was a 'Southern thing,' think again," affirmed journalist-historian Adele Oltman. "In 1703, 42 percent of New York's households had slaves, much more than Philadelphia and Boston combined. Among the colonies' cities, only Charleston, South Carolina, had more." Writing in a 2005 article for *The Nation,* "The Hidden History of Slavery in New York," Oltman said, "The Dutch West India Company that governed New Amsterdam worked its chattel hard, clearing the land, splitting logs, milling lumber and building wharves, roads and fortifications; but slavery was so ill defined in those days that slaves collected wages."

"The Revolution had a dramatic impact upon the institution of slavery in the Northern states," according to historian Michael E. Groth. Delivered at a 1993 symposium on race relations sponsored by the Eleanor Roosevelt Center at Val-Kill, Groth's lecture, "The African American Struggle Against Slavery in the Mid–Hudson Valley, 1785–1827," cited antislavery sentiment as "[f]ueled by Enlightenment thought, a faith in the perfectibility of man, and Christian millennialism born out of the Great Awakening." The emancipation movement in the region, he said, grew steadily "in the wake of political ferment and war, as white abolitionists and African Americans linked the slaves' struggle for freedom with the colonial crusade against British tyranny."

Still, as noted by Hofstra University professor Alan J. Singer in *New York and Slavery: Time to Teach the Truth,* "In the nineteenth century, the port of New York functioned as a major international center for financing the slave trade and the trade in goods produced by slave labor." In particular, this labor was put to wide use upstate, where male slaves cleared land and maintained farms in Schenectady, Albany, and Greene, Ulster, and Orange Counties on the west bank of the Hudson, and Washington, Rensselaer, Columbia, Dutchess, Putnam, and Westchester Counties on the east. It was believed that the Hudson River made the use of slaves more practicable in New York State than anywhere else in the North.

husband in the dark, wet cellar. A decision was also made to auction off the nearly nine-year-old Isabella; paired with a flock of sheep, she was sold by the Hardenberghs for $100.

Unlike Charles, whom Isabella, or Belle, remembered as relatively benevolent, despite the "dismal chamber" where he quartered his slaves, her new owner, John Neely, of Twaalfskill, beat her, she remembered, with "a bundle of rods, prepared in the embers, and bound together with cords" because she did not speak English. (Dutch was the language used in the Hardenbergh household.) Neely kept Isabella only a short time before selling her for $105 to a fisherman by the name of Martinus Schryver, whom she found to be kinder than Neely. "Scriver," according to *The Narrative*, "besides being a fisherman, kept a tavern for the accommodation of people of his own class–for his was a rude, uneducated family, exceedingly profane in their language, but, on the whole, an honest, kind and well-disposed people." Despite such an endorsement, a year and a half later he sold her for $175 to John Dumont of New Paltz, a fellow parishioner of Schryver's in the Dutch Reform Church.

John's wife, Sally Dumont, treated Belle harshly, even sexually abused her, while John frequently whipped her. Compounding the humiliations, Isabella earned the scorn of the other slaves by attempting to labor hard in order to try to appease her masters.

Sometime around 1815, she fell in love with a fellow slave named Robert, whose owner from a neighboring farm, identified in *The Narrative* as a man named Caitlin, did not want his servant to father children who would not become his property. Caitlin brutally beat Robert over the relationship, forced Robert to marry one of his own slaves, and Isabella never saw her lover again, though it is believed she had Robert's child, a daughter named Diana. She also gave birth to four other children after Dumont forced her to marry an older slave named Thomas.

Dumont then reneged on his promise to free her in 1826, a year before the New York State legislature would abolish slavery on the Fourth of July, 1827. The owner claimed that a hand injury she had sustained impeded her work. Isabella's response to her owner's sudden shift in sentiment was to finish Dumont's demand that she spin one hundred pounds of wool, and then, convinced in her own mind that what she was about to do had the blessing of Jesus, she took her infant daughter Sophia in her arms and left the Dumont property before the morning light.

"I did not run off, for I thought that wicked," she said, "but I walked off, believing that to be all right."

Isabella found a home sympathetic to the abolitionist cause, and when Dumont

showed up to reclaim her and baby daughter Sophia, the couple offered Dumont twenty dollars for Isabella and another five for Sophia—which Dumont pocketed, given that the law was going to emancipate Isabella within the coming year as it was.

The state law, however, also stipulated that the offspring of children remained indentured for an additional, often arbitrary amount of time. Isabella therefore set about retrieving her five-year-old son, Peter, who had been leased by Dumont to another owner who had then illegally sold the child to a harsh owner in Alabama. Thanks to the intervention of activist Quakers who assisted Isabella in filing an official complaint in court, after months of legal proceedings she was reunited with Peter. It was one of the first cases in America in which an African-American woman challenged a white man in court and won.

AFTER SHE HAD BEEN auctioned off along with the sheep, Isabella seldom saw her parents. "At length her mother's health began to decline," recounts *The Narrative*, "a fever-sore made its ravages on one of her limbs, and the palsy began to shake her frame; still, she and James tottered about, picking up a little here and there, which, added to the mites contributed by their kind neighbors, sufficed to sustain life, and drive famine from the door." According to Mabee, "Her father, by this time blind and unable to care for himself, had been abandoned by the Hardenberghs and everyone else." Living reclusively in a "rude cabin" in the woods, James Baumfree died of exposure one winter, too feeble-minded to think of lighting a fire.

As related in *The Narrative*:

> The news of his death reached the ears of John Ardinburgh [the spelling of Hardenbergh throughout the work], a grandson of the old Colonel; and he declared that "Bomefree, who had ever been a kind and faithful slave, should now have a *good* funeral." And now, gentle reader, what think you constituted a good funeral? Answer—some black paint for the coffin, and—a jug of ardent spirits! What a compensation for a life of toil, of patient submission to repeated robberies of the most aggravated kind, and, also, far more than murderous neglect!!

Her mother's religious teachings intensifying in her over time, in early 1827 Isabella helped found the Kingston Methodist Church. Eventually taking her message on the road, she made her way as a traveling preacher, changing her name

to the more appropriate Sojourner Truth and, believing Jesus was her fortress, devoting herself to the causes of abolition, Methodism, women's suffrage, and temperance. Princeton professor Nell Irvin Painter, in a 1996 revisionist view that showed the human side of her subject (after so many years of myths that had been layered upon Truth), saw Isabella/Sojourner as "[a] woman of remarkable intelligence [who] despite her illiteracy . . . had great presence. She was tall, some five feet, eleven inches, of spare but solid frame. Her voice was low, so low that listeners sometimes termed it masculine."

As an abolitionist and feminist, she put her body and her mind to a unique task, that of physically representing women who had been enslaved. At a time when most Americans thought of slaves as males and women as white, Truth embodied a fact that still bears repeating: Among the blacks are women; among the women, there are blacks.

Painter also praised Truth's singing voice. "No one ever forgot [its] power and pathos . . . just as her wit and originality of phrasing were also of lasting remembrance." Her most widely quoted speech, known as "Ain't I a Woman?" and credited as an early feminist statement, was delivered extemporaneously at the 1851 Ohio Women's Rights Convention.

As she preached:

That man over there says that women need to be helped into carriages, and lifted over ditches, and to have the best place everywhere. Nobody ever helps me into carriages, or over mud puddles, or gives me any best place! And ain't I a woman? Look at me! Look at my arm! I have ploughed and planted, and gathered into barns, and no man could head me! And ain't I a woman? I could work as much and eat as much as a man—when I could get it—and bear the lash as well! And ain't I a woman? I have borne thirteen children, and seen most all sold off to slavery, and when I cried out with my mother's grief, none but Jesus heard me! And ain't I a woman?

NEARLY TWENTY YEARS before her death in 1883, in Battle Creek, Michigan—she had moved to the Midwest in 1857 and helped recruit black troops for the Union army during the Civil War—Truth was invited to the White House.

"I must say, and I am proud to say, that I never was treated by any one with more kindness and cordiality than were shown to me by that great and good man, Abraham Lincoln, by the grace of God president of the United States for four years more," she is quoted as saying in *The Narrative*.

Describing the moment when the Great Emancipator, at her request, autographed her Bible, she went on to dictate (she never learned to read or write, so her words were always transcribed):

He took my little book, and with the same hand that signed the death-warrant of slavery, he wrote as follows:

For Aunty Sojourner Truth

October 29, 1864

A. LINCOLN

As I was taking my leave, he arose and took my hand, and said he would be pleased to have me call again. I felt that I was in the presence of a friend, and I now thank God from the bottom of my heart that I always have advocated his cause, and have done it openly and boldly. I shall feel still more in duty bound to do so in time to come. May God assist me.

From left: Speaker of the House Nancy Pelosi, First Lady Michelle Obama, and Secretary of State Hillary Clinton are among the attendees of the April 28, 2009, unveiling of the bust of Sojourner Truth in Emancipation Hall in the Capitol Visitor's Center in Washington, D.C.

Boys to Men

> "Now, Jay, you broke your holt—that wa'nt far," protested John; but the
> victor, having adopted rules of his own, would answer convincingly,
> "But I'm on top, ain't I?"
>
> —CLARA BARRUS, *John Burroughs: Boy and Man* (1920)

Though their separate notorieties, and their starkly dissimilar reputations, spread far beyond the mountains, John Burroughs and Jason "Jay" Gould started out together simply enough in the small western Catskills town of Roxbury, in New York's Delaware County. For more than ten years they shared classes, first at the Stone Jug and West Settlement, and later at the Beechwood Seminary, a tree-shaded schoolhouse that Jay's father, John Burr Gould, and his brothers-in-law had built midway between their respective farms. Born a year apart, Gould in 1836 and Burroughs in 1837, the boys grew up at a time when more than 80 percent of Americans lived in small towns and villages and earned their incomes from farming.

"I was the son of a farmer who was the son of a farmer," Burroughs wrote in his autobiographical sketch *My Boyhood*, in which he also noted with pride that he shared his April 3 birthday with Washington Irving. "There are no professional or commercial people in my line for several generations; my blood has the flavor of the soil in it; it is rural to the last drop."

The seventh of ten children born to Chauncey and Amy Kelly Burroughs, John Burroughs had four brothers who all grew up to be farmers, and every one of his five sisters married a farmer. A devout Baptist who believed hard work and

prayer were the proper foundations of a purposeful life, Chauncey Burroughs saw little use for anything else. One Christmas when John was young, the boy hung his stocking by the fireplace, hopeful of what Santa might bring. What he found inside the next morning was horse manure, left by his father as a lesson that Christmas was a holy day, not an occasion for frivolity.

"Probably I get my love for the contemplative life and for nature more through my mother than through my father; Mother had the self-consciousness of the Celt, Father not at all, though he had the Celtic temperament: red hair and freckles!" said John. "But his bark was always more to be feared than his bite. He would threaten loudly but punish mildly or not at all." As a farmer toiling on the family's 320 acres, Chauncey Burroughs "improved the fields, he cleared the woods, he battled with the rocks and stones, he paid his debts, and he kept his faith," his devoted son recalled. As for John's contribution, he was more likely to be perched atop a boulder on the family property taking in the view than facing his responsibility of tending the cow.

Jay Gould's father, John Burr Gould, a distant relation of Aaron Burr, was also a farmer, although he did not enter the vocation willingly. The Goulds had been a prominent family in America since 1647, when Major Nathan Gold left England to settle Connecticut and, in 1662, was among the nineteen men who petitioned King Charles to grant the colony its charter. (Despite the sound of the surname and anti-Semitic epithets later hurled toward the adult Jay Gould during his reign as a robber baron, the Golds were not Jewish, but of Scottish ancestry. Gold became Gould when Nathan Gold's grandsons started using the name.) Jay Gould's paternal grandfather, Abraham, left Fairfield, Connecticut, in 1789 and built the modest-framed Roxbury home, which also had a barn, two miles from what constituted the main street of Roxbury on West Settlement Road, "beneath a ridge and look[ing] out over a thin valley," according to one Gould biographer, Edward J. Renehan Jr.

"He was born to neither affluence nor poverty," *A General History of the Burr Family*, compiled by historian Charles Burr Todd in 1902, said of Jay Gould. "His father was of the great middle class that forms so large a proportion of our American proletariat." Jay Gould was the sixth child born to "a man of weight and standing," John, and his wife, the former Mary More, whose Scottish grandfather John More was the founder of neighboring Moresville, today called Grand Gorge. Jay was John and Mary's first and only son. What the boy was not was the type of physically strong specimen that John Gould had hoped could help with farm

chores. Even Burroughs recalled how the strong-willed Jay told his father he had never had any intention of becoming a dairyman. The adolescent having made this pronouncement, "the elder Gould swapped his farm for a tin shop on Roxbury's Main Street and a house on the village's Elm Street," now Vega Mountain Road, according to Renehan.

"He was the pet and the idol of the household," said eldest sister Sarah. "Being frail and delicate he was all the more petted, and generally had his own way." Having five older sisters translated into having five little mothers for Jay, especially after their own mother succumbed to tuberculosis in January 1841, when he was only four. Shortly after, in need of someone to run the household, John Gould remarried, but his new bride died six months later. So John married again, this time a neighbor named Mary Ann Corbin. (She gave birth to another Gould son, Abram, only the family soon faced another loss when middle daughter Nancy perished suddenly. Two years later, stepmother Mary Ann died as well.)

Jay's father "was versed enough in the world to fully comprehend his poverty," according to Renehan, "and how low the family fortunes had fallen." Rather than accept or be humbled by his fate, John Burr Gould assumed "a bitterness which manifested itself in snobbery," said the biographer.

John Burroughs apparently noticed this too, and how it had rubbed off on Jay, whom he called "too proud to stay at our house. The Goulds were very prosperous, and naturally stiff-necked. . . .

"[T]hey lived in a little better style than the other farmers."

AN INDIFFERENT STUDENT more interested in tracking insects than cracking the books, which he bought for school by tapping trees and selling maple syrup, Burroughs was large for his age and dressed himself in a careless, almost slovenly manner. He also liked to climb down under his school desk and use a feather to tickle the bare ankles of the girls who sat in front of him.

The dark-haired and dark-eyed Gould, on the other hand, was small in stature and fastidious in his dress, as well as a precise and daunting competitor. After school the two boys would wrestle, with Burroughs later remembering Gould as "plucky and hard to beat, made of steel and rubber." They fished together in Rose's Brook and Hardscrabble Creek, traded knives and marbles, and despite their differences became fast friends.

When John drew a blank after the teacher demanded eight lines of poetry—his

punishment for lateness with an assignment–Jay came to his rescue, though Burroughs was always to admit he never understood the third line of Gould's effort on his behalf.

The poem read:

> Time is flying past,
> Night is coming fast,
> I, minus two, as you all know,
> But what is more
> I must hand o'er
> Twelve lines by night,
> Or stay and write,
> Just eight I've got
> But you know that's not
> Enough lack four,
> But to have twelve
> It wants no more.

Jay Gould was eight when a band of Calico Indians raided the family farm and demanded that his father join their ranks. The leader brandished his sword over John Gould's head, terrifying the young Jay, but John sent his hired man for his musket and refused to yield. The raiders retreated and never came to West Settlement Road again.

John Burroughs also remembered the Anti-Rent War, and how Chauncey Burroughs spied the approaching posse and fled to a neighbor's house, where "he took refuge under the bed, leaving his feet sticking out." Afterwards, "Father never denied it and never seemed a bit humiliated when twitted about it."

Considering himself "a callow youth, being jerked by the plough handles, but with my head in a cloud of alluring daydreams," Burroughs finally grew partial to learning, and though he applied himself to his farm chores, "father took less stock in me than in the other boys, mainly, I suppose, on account of my . . . proclivity for books."

Extracting Chauncey's promise that in return for spending the summer clearing rocks and preparing a field for spring planting, that fall he'd be provided with the money to continue his education at a college preparatory school, John completed the backbreaking labor only to have his father renege on the deal.

"How far the current of my thoughts and interests ran from the current of his thoughts and interests!" said his loving son. "Literature he had never heard of, science and philosophy were an unknown world to him. Religion (hard predestinarianism), politics (democratic), and farming took up all his thoughts and time."

Burroughs left home at sixteen to find a job teaching at the Tongore School, south of Roxbury ("Hither I walked one day, saw the trustees, and made my application"), and would continue teaching at local schools in New York, New Jersey, and Illinois over the course of the next decade. Years afterward, he revised his attitude toward formal education, telling a group of students, "I think I have got more help as an author from going a-fishing than from any textbook or classbook I have ever looked into. Your teacher will not thank me for encouraging you to play truant, but if you take Bacon's or Emerson's or Arnold's or Cowley's essays with you, and dip into them now and then while you are waiting for the fish to bite, she will detect some fresh gleam in your composition when you next hand one in."

THE RURAL LIFE HELD no such allure for Jay Gould, who considered farming "torture." At age thirteen, "I said one day to my father that I would like to go to a select school that was some twelve or fifteen miles from there. He said all right, but that I was too young. I said to him that if he would give me my time I would try my fortune. He said all right; that I was not worth much at home and I might go ahead. So next day I started out. I showed myself up at this school."

According to Charles Todd Burr, "The next scene shows the boy with a spare suit of clothes in his hand and fifty cents in his pocket bravely trudging over the mountain passes between Roxbury and Hobart. Arrived at the latter place, he sought out the principal of the academy and made arrangements with him to enter as a pupil; at the same time, through the latter's influence, he gained the position of book-keeper in the village blacksmith shop." The smithy, said Gould, "consented to board me, as I wrote a pretty good hand, if I would write up his books at night. In that way I worked myself through this school."

After a year's study at Beechwood Seminary, where, Todd noted, "[h]e was as reserved with his schoolmates as he was later with men of business," Gould returned home to find that his father had traded the farm for a hardware store, in the hope that his son would assist in its operation. Instead, John Gould saw that keeping shop held no more attraction to his son than did farming. Already a

pragmatist, the teen had taught himself to carve noon marks, north–south lines that ran through a window at such an angle that the sun struck the line precisely at noon (thus allowing a person to set a clock). For this Jay received a dollar apiece from farmers, enough to cover his expenses for the summer, before he again left home one month before his sixteenth birthday, this time to earn a living as a surveyor.

Not even twenty, and waiting out a prolonged convalescence from typhoid fever, he compiled the many stories he had heard from the early settlers of Delaware County as he did his surveying and published the 450-page *History of Delaware County: And Border Wars of New York,* which included, in addition to the tale of his father's face-off with the Calico Indians, affectionate observations of the rural world he had so vigorously fought his entire life to escape.

Reminiscing in its pages, and sounding older than his years, he wrote, "We should like to be transported to those good old times, were it only for a day or two, just to breakfast on those delicious trout . . . and sup on choice bits of dried elk-meat."

DURING THIS SAME PERIOD, Burroughs was teaching school in the village of Olive and spending what little money he made on books. In their only recorded business transaction, Burroughs bought two old books from Gould, *Elements of Geology* and another on German grammar. Burroughs paid eighty cents for both volumes and would later recall that Gould "was very happy to get it."

Taking his first trip to New York City in 1855 when he was eighteen, Burroughs found the noise, congestion, and squalor intolerable and sensed that a "certain element of faith and charity seems to be missing from the city." More than a half century later, from the perspective of his twenty-acre Catskills home on the west shore of the Hudson, he told the poet Joyce Kilmer, "Living in the city is a discordant thing, an unnatural thing. The city is a place to which one goes to do business: it is a place where men overreach each other in the fight for money. . . . Years ago, I think, it was possible to have a home in the city. I used to think that a home in Boston might possibly be imagined. But no one can have a home in New York in all that noise and haste." As for writing there, "I don't see how literature can be produced in the city," he insisted. "Literature must have repose, and there is no repose in New York so far as I can see."

In July 1857, at the age of twenty, Burroughs married Ursula North, and the

two boarded with her family in Olive. Disappointed by her new husband's meager income, just as she was outraged by his sexual urges ("Just as there is more than a bedroom to a house, there is more than the activity of a bedroom to a marriage," she would write her spouse. "I would like to think that our love can rise above the mere physical to a higher and more wholesome plane"), Ursula continued to live with her family in the small village. The arrangement forced John to commute in order to see her, so he would dismiss his pupils early on Friday, hike the fifteen miles to the North home, share the weekend with Ursula, then hike back. He also began to write, but in a style so imitative of Ralph Waldo Emerson that a submission he made to the *Atlantic Monthly* was rejected out of concern it might have been plagiarized from one of Emerson's discarded manuscripts. Long afterward, when John's literary reputation was something beyond reproach, his and Ursula's son, Julian, wrote that his mother, sounding like an echo of John's father, Chauncey Burroughs, "never rated literary effort very high: she often seemed to think that Father should do the work of a hired hand and then do his writing nights and holidays. . . . She could see no sense in taking the best hours of the day for scribbling."

Burroughs regretted that he did not volunteer to serve in the Civil War and instead surrendered to his wife's entreaties that he seek a job. Bolstered by a friend's recommendation, he secured one with the Treasury Department in Washington, D.C., where he "was put in charge of one of the massive iron vaults where the country's gold supply was stored, and here he sat, in front of the bank vault with nothing to do all day," said Vassar professor Jeffrey R. Walker. The impoverished writer, said the scholar, "wrote his first essays in the basement of the treasury."

DESCRIBING THE WONDERS he had just seen at the 1853 Exhibition of the Industry of All Nations in New York, where the city's own Crystal Palace arose on what is today Bryant Park (and the first elevator with a safety brake was demonstrated by Elisha Otis), Jay Gould went on to tell an acquaintance, Abel Crosby, a hardware dealer in Kingston, "Crosby, I'm going to be rich. I've seen enough to realize what can be accomplished by means of riches, and I tell you I'm going to be rich." Asked by Crosby how this would be accomplished, Gould replied, "I have no immediate plan. I only see the goal. Plans must be formed along the way."

Three years later, Gould met Zadock Pratt, sixty-six years old and in the

twilight of his career. Impressed by Gould's quickness of mind, Pratt hired the twenty-year-old to write speeches for him, and Gould, ever the overachiever, also moonlighted by writing Pratt's biography.

"Now, Gould was a very inquisitive person, a very driven person, and quite young when he made his connection with Pratt, who was at this point already the most famed tanner in the United States," said environmental historian David S. Stradling, "and Gould proposed that they go into business together, in Pennsylvania. Gould was willing to do the legwork."

With the hemlock supply in the Catskills nearly exhausted, Pratt knew that vast stands were still to be found in northeastern Pennsylvania, near the spot where the Delaware and Lackawanna had recently completed a new railroad line. "So they headed south," said Stradling, "and Gould found a place that, in keeping with tradition, took the name Gouldsboro, where he created a large tannery on the model of Zadock Pratt."

A visit to the 1853 Exhibition of the Industry of All Nations at New York's Crystal Palace encouraged Jay Gould to tell an acquaintance, "I've seen enough to realize what can be accomplished by means of riches."

With Pratt supplying the guidance and capital and Gould handling the day-to-day—for which he was presented a small interest in the enterprise—the neophyte set about striking deals with Pennsylvania landowners for the rights to the hemlocks, constructing the tannery, hiring fifty workers, and initiating procedures. "In one hundred days from the time the first tree was felled," said Charles Burr Todd, "the tannery was in full operation."

As expressed in letters at the start of their professional relationship, Gould was deferential to his partner to a degree that verged on fawning. After meeting with employees and about twenty local residents in Pennsylvania, Gould wrote Pratt that "three hearty cheers were proposed for the Hon. Zadock Pratt, the world renouned [sic] Great American Tanner and a more hearty response I am sure this valley never before witnessed." Another message to Pratt from Gould, dated February 3, 1857, informed the senior partner, "I have opened a boardinghouse in advance of your suggestions. Thanks however for it. It puzzles me how you can think of everything."

While the tannery was still under construction, Gould commuted to New York to acquaint himself with the machinations of the city's leather business. After visiting the Swamp and studying the brokering and trading of hides, he wrote his father, "I've come to realize that it is the merchants who command the true power in this industry. The brokers take what seems the smallest share [of the profit,] but is in fact the largest. Theirs is nearly pure profit made on the backs of the shippers and the tanner, never their hands dirtied."

For Gould, now all of twenty-two, it was time to start removing the constraints. Without first consulting Pratt, he transferred the brokerage business of the new tannery from the firm of Corse and Pratt, where Pratt's own son, George, was a partner, to that of Charles M. Leupp & Company, with whom he was able to negotiate more advantageous terms. At this point, the letters between Gould and Pratt took on a more formal tone, beginning with "Dear Sir" rather than "Dear Friend."

"Gould's eyes were bigger than his stomach, bigger than his purse," said Stradling, "and Pratt became nervous about the behavior of his partner. Unfortunately for Pratt, who remained an absentee owner engaged in this business only minimally, Gould made a number of missteps, particularly purchasing much too much land. The tannery did not do well in its first year, probably in part because it was not operated with the same skill that Pratt himself would have ensured by his presence."

Seeking to regain control, Pratt seized upon a clause in the partnership agreement that would give Gould ten days to buy out Pratt for $60,000. If Gould did not, the contract permitted Pratt to purchase Gould's minority interest for $10,000. "Even though the tannery started turning around in 1858," said Stradling, "Pratt wanted to liquidate his relationship with Gould."

Presenting Gould with his ultimatum, Pratt was convinced that there was no way the young man could come up with the necessary funds. But Pratt had underestimated his partner.

Gould rushed to New York, met with the newly instated Leupp & Company, and successfully convinced the brokers to provide the necessary $60,000. Pratt, who had invested more than $120,000 into the tanning works, was forced to accept the payment and write off a $60,000 loss.

"By 1859," said Stradling, "Pratt was out of the tanning business altogether, and Gould's relationship with him was replaced with a relationship with one of the Swamp financiers. That relationship also soured." Gould, now partnered with Leupp & Company, ended up with one-third interest in the business after not having invested a penny—marking the first in a long line of cagey manipulations for which he would become infamous. He was also ready to move on. By Charles Burr Todd's account, "young Gould, now come to his majority, was not satisfied with the sphere of local business. He had become interested in railroads, the building and operating of which he saw was to become the greatest business of the next half-century."

"Gould's relationship with Charles Leupp also turned bad," said Stradling. "Leupp believed that Gould had essentially stolen both the tannery and the great number of hides that were there, and then he took the tannery from Gould. Gould responded by arming some men in the neighborhood and literally retook the tannery by force. All this caused a great deal of stress in Leupp."

"[P]rominent leather merchant" Charles Mortimer Leupp, *The New York Times* let it be known, "had been afflicted with occasional bits of depression." The account in Frank W. Norcross's 1901 *A History of the New York Swamp* stated that once Zadock Pratt was out of the picture, Charles M. Leupp & Company "filled the tannery with hides and accepted Jay Gould's notes for them until they were involved to an alarming extent. It preyed upon Mr. Leupp's mind and on October fifth, 1859, he shot himself with a fowling piece and ended his life."

"After having embraced each of his daughters," said the *Times*, which blamed Leupp's tragic act on "a fit of insanity," the broker "retired to his own apart-

Fisk who wanted the government to hold onto their gold." Hoping to buy up all $15 million worth of gold in circulation, Gould calculated that he would drive up its price, which would in turn encourage farmers in the Midwest, seeking better prices for their harvest, to ship more grain east on his railroad, and thereby raise the value of his Erie stock. Gould and Fisk "wanted to make a huge profit by buying up gold cheaply and eventually selling it when the price rose," said Terrell. In other words, Gould would make a double killing.

Gould and Fisk greased the palm of President Ulysses S. Grant's brother-in-law, Abel Rathbone Corbin, to influence the president to keep the federal supply of gold off the market. So long as the government didn't sell, Gould had a chance to corner what still remained in private hands.

Eventually, however, Grant was alerted to the scheme, and ordered the Treasury to sell off some of its gold. This sent the price plummeting within minutes, taking Gould's attempt to corner the market with it. Not that he suffered; having gotten word of Grant's plan, the wily financier made an $11 million profit. Still, hundreds of others, including Corbin, were wiped out, and September 24, 1869, came to be known as Black Friday.

The scandal of its day, the maneuver permanently fixed Gould's reputation as a spoiler. Mark Twain pilloried him as having "reversed the commercial morals of the United States," and said, "The people had *desired* money before his day, but *he* taught them to fall down and worship it." Publisher Joseph Pulitzer, who had purchased the *New York World* from Gould in 1883, branded the financier "one of the most sinister figures that had ever flitted bat-like across the vision of the American people."

Even more damning was the opinion of former Gould partner Daniel Drew, a master stock manipulator in his own right ("Naturally shrewd, he soon showed what a man absolutely without conscience could make of himself," said his biographer Bouck White in 1910). To Drew, "Jay Gould was the mightiest disaster which has ever befallen this country. His touch is death."

THE STATE OF Burroughs's bank balance barely improved despite the critical success of *Wake-Robin*. In 1872, he and Ursula left Washington for a farm in Middletown on the Hudson, where he could take a job as a bank examiner and still write on the side.

With Middletown halfway between New York City, the center of publishing, and Roxbury, home to his parents and the remainder of his family, Burroughs

PLOTTING THE GREAT GOLD RING OF '69.

Plotting the Great Gold Ring of '69, Jim Fisk (seated, left) and Jay Gould (right) attempted to corner the U.S. gold market. President Grant got word of their scheme, however, and while investors crashed and burned on Black Friday, September 24, Gould, wise to the fact that the president knew what was happening, secured an $11 million profit.

could visit the Catskills at every chance, hike in the hills and fish in the same streams he enjoyed as a boy. He built his "hermit's retreat," a tiny log cabin he called Slabsides, as much an escape from his wife as it was a place to write and grow celery, which he sold in New York City to supplement his tiny income. Oftentimes total strangers would arrive unannounced, expecting Burroughs to take them on a nature walk, and more often than not, he would. The visitors also included a steady stream of young women from nearby Vassar College, who streamed into Slabsides for a chance to share time with a writer who was fast becoming an American institution.

As for Jay Gould, entirely separate from his nefarious business dealings, "[i]n his domestic life Mr. Gould was exceptionally happy," said Charles Burr Todd, whose buffed portrait makes no mention of Black Friday. "His wife was a noble woman, a loving wife, and devoted mother, and congenial in thoughts and pursuits." By all accounts, this was true. For thirty years Gould was faithfully and

happily married to Helen Day Miller, the mother of their six children. Perhaps equally surprising, he generously supported charities, albeit anonymously, to protect himself from attention. "He avoided drink, ate sparingly, did not use tobacco, refused to play games of chance, and was never known to curse," said biographer Murray Klein. Nor did the magnate care what the press said about him. "In Wall Street he could give and take heavy blows," said Todd. "In private life he was benevolent, kind, and charitable, as hundreds of instances attest."

Gould maintained two primary homes, one on Fifth Avenue in Manhattan, and the other on his estate near Irvington. Called Lyndhurst, it overlooked the Hudson, and according to biographer Edward J. Renehan, the titan of industry "would sometimes climb with his six children to the top of his ornate greenhouse—the largest in North America—and from there point northward to the distant blue of the Catskill Mountains, which he always referred to as 'home.'" As he grew older, Gould apparently found reasons to visit, however briefly, friends and cousins in Roxbury, and even came for a prolonged stay in the summer of 1888, four years before his death. Instead of his usual retinue of bodyguards, he was accompanied by many of his children and a niece, whom he guided around town.

One day in August, wrote Renehan, "a delighted Jay took time to trout at Furlow Lake: a beautiful stretch of land and water just a few miles from Roxbury. . . . 'I have never seen Father so merry,' Jay's eldest daughter Helen ('Nellie') wrote her mother during the trip. '[He] has been so different, the old memories and the old friends have quite brightened him up.'"

By contrast, Burroughs, his bushy white Rip Van Winkle beard and luxurious eyebrows projecting an image of singular rectitude, had for years carried on a double life he carefully kept concealed from nearly everyone, including his wife. Twenty years into their marriage, with he and Ursula still childless, Burroughs struck up a romantic liaison with the young German maid from Rondout who worked in his home. After a furious Ursula discovered the affair, the maid was ordered out of the house. Unbeknownst to Ursula, the young woman was also pregnant by Burroughs.

Aware of her condition, the writer quietly kept paying her wages and medical expenses, then persuaded an unsuspecting Ursula that they should adopt a child. Taking her to the Quaker foundling home in New York City, where his secret love child was being cared for, Burroughs and the doctor who had delivered the boy convinced Ursula—still in the dark as to the child's true parentage—that they should adopt his very own son. They named him Julian.

In 1901, John Burroughs met the great love of his life, the woman he considered his intellectual equal (though she was far better educated than he): Clara Barrus, a Boston University–educated physician affiliated with the state psychiatric hospital at Middletown, New York, and professor of psychiatry at the Women's College of New York.

After she wrote Burroughs an admiring letter, he invited her to visit him at his Slabsides retreat, and they soon became lovers, despite their disparity in age: Burroughs was sixty-four, Barrus thirty-three.

Although she and Burroughs traveled with John Muir throughout the American Southwest and to Hawaii in 1909, she did not become Burroughs's live-in companion until after his wife Ursula's death in 1917. Later, she became his literary executor and biographer.

Writing about the trip with Muir, Barrus described Burroughs as "not a ready talker; he gives of his best in his books. He establishes intimate relations with his reader [and] is not the least inclined to banter or to get the better of one; is so averse to witnessing discomfiture that even when forced into an argument, he is loath to push it to the bitter end. Yet when he does engage in argument, he drives things home with very telling force, especially when writing on debatable points."

"Baby came to-day—a great event," Burroughs entered in his diary on July 1, 1878. A few years later, the journal also happily stated, "Julian . . . and I walk up to the post office. See the honey bees working on the pussy willows. Walk back on the railroad track. Paint and fix our boat."

It would be eight years before Ursula, unable to ignore how closely Julian resembled John, deduced that her husband was the father of their adopted child. As Burroughs recorded, "a domestic storm for several days and nights; all about Julian . . . earthquake shocks still pretty severe."

Eventually, Ursula did find it in her heart to forgive John. But only because of her attachment to Julian.

By the 1880s Gould was the King of Wall Street. He owned a thousand acres in the Catskills with a game preserve for deer and elk, kennels for Russian wolfhounds, and a breeding pen for pheasants; a Fifth Avenue mansion; Lyndhurst, the sixty-seven-acre country estate on the Hudson; and the *Atalanta*, a 120-foot

Gould maintained two residences: his city mansion at 579 Fifth Avenue, at 48th Street, and his country retreat, Lyndhurst, which he purchased in 1880. As a gift from the Gould family, it was turned over to the National Trust for Historic Preservation in 1961.

steam yacht. He controlled ten thousand miles of track, nearly 15 percent of the entire U.S. railway system; the Western Union Telegraph Company; and, for a time, the elevated railways in New York City. He was the richest man in the United States and would become richer still, leaving upon his death an estate estimated to be worth $77 million, the equivalent of nearly $2 billion today.

Burroughs, eternally alien to the rapid pace of change, was still taking regular hiking and fishing trips into the Catskills, harvesting table grapes at his farm near Poughkeepsie, and selling celery. "Time has been saved, almost annihilated, by steam and electricity," he wrote in his 1889 *Indoor Studies*, "yet where is the leisure? The more time we save, the less we have. . . . We can outrun the wind and the storm, but . . . man becomes a mere tool, a cog, or spoke, or belt, or spindle. More work is done, but in what does it all issue?"

Fate drew Gould and Burroughs together only one more time after their boyhoods. "I never saw Jay after the Roxbury days, not to speak with him," Burroughs wrote in his *Boyhood* sketch.

Our paths lay far apart. I never followed his career very closely. One day in New York, after more than twenty years since I had known him as a boy, I was walking up Fifth Avenue, when I saw a man on the other side of the street, more than a block away, coming toward me, whose gait in some subtle way differed from the walk of any other man I had known . . . and I began to ransack my memory for a clue . . . I had seen that gait before . . . as the man came opposite me I saw it was Jay Gould.

Neither man so much as paused to greet the other.

Both had become genuine celebrities, even by today's exaggerated standards. In spite of his reprehensible business practices—or in all likelihood, because of them—Gould was the prime mover and shaker in two of the most important industries of the American Industrial Revolution, transportation and communication. He was also part of an unapologetic group of capitalists who "in the space of less than fifty years would mobilize the financial entrepreneurial and managerial resources to lay out a powerful new basis for American business and fix a course for the future," according to Columbia University social history professor Thomas Kessner.

Financial author John Steele Gordon had far stronger words. He considered Gould the "Mephistopheles of Wall Street," and in 2009 named him, along with arbitrageur Ivan Boesky and Ponzi schemer Bernard Madoff, one of the ten most notorious stock traders of all time.

Relating an anecdote that allegedly took place at the height of Gould's reign on the Street, Gordon said that Arthur T. Hadley, the distinguished American economist and later president of Yale, happened to glance out the window of his lawyer's office in Lower Manhattan. "Well, what do you think of that?" said Hadley. "There's Jay Gould standing across the street, and for once he has his hands in his own pockets."

Gordon did accord his subject some qualified praise, including the conclusion that Gould could be as creative as he was ruthless. "[H]is genius was seldom revealed in his conversation," said Gordon, suggesting that Gould's "intellect nonetheless leaked out through his extraordinary dark eyes." Others made the same notation. "While you speak," *Harper's Monthly* reported in the 1860s, when Gould was still in his thirties, "he listens, and looks at you with eyes which freeze and fascinate."

By any stretch, Gould was a far cry from the simple lad who produced an essay at Beechwood Seminary. Titled "Honesty Is the Best Policy," it began:

By this proposition we mean that to be honest; to think honest; and to have all our actions honestly performed, is the best way, and most accords with precepts of reason. Honesty is of a self-denying nature, to become honest it requires self-denial; it requires that we should not acquaint ourselves too much with the word; that we should not associate with those of vulgar habits also, that we should obey the warnings of the conscience.

BURROUGHS'S IMPACT on the world around him was something more difficult to measure than Gould's. "We are embosomed in nature," he wrote in *Indoor Studies.* "Our life depends upon the purity, the closeness, the vitality of this connection."

More a romantic than an environmentalist, Burroughs imagined a world the way it had been when he was a child. Rather than burn coal and oil for energy, he suggested man search "above the surface, from the winds and the sunshine." A man unaware that his fate was intertwined with that of the planet, he warned, was like a child "playing with fire."

So admired was Burroughs in his day that when he joined Teddy Roosevelt on a trip to Yellowstone Park, more people crowded around whistle stops to see him than they did the president. Henry Ford, Thomas Edison, and rubber tire magnate Harvey Firestone sought him out, and on camping trips together they would "cheerfully endure wet, cold, smoke, mosquitoes, black flies, and sleepless nights, just to touch naked reality once more," Burroughs recorded in his diary. Time and again Burroughs found himself in the company of men who would subordinate the world of nature to the world of capital, understanding that they were responsible for many of the rapid changes that were undermining the values he held so dear. He rationalized such friendships by the fact that he simply enjoyed their company and could accept the notion that their inventions made life easier for everyone.

"He liked them for what they were, but not because they were rich and famous," said Vassar professor Jeffrey R. Walker. "He admired Henry Ford because Ford was a farm boy who would close down the factory during hay time so that everybody could go work in the fields." Burroughs described his first impression of the automaker as "an earnest, big-hearted, ordinary man whom I liked at first sight. His personality was very attractive."

Burroughs was so devoted to Henry Ford that the naturalist carved the

magnate's name on a rock near his Woodchuck Lodge in 1916. (Ford had supplied the hammer and chisel.) The tribute arose because two years earlier Burroughs had complained that he couldn't grow anything on the plot of land he owned across from his house, "because it is full of rocks, and I don't know what to do about it."

Ford, ever rational, replied, "Why can't we go over and clear them out"—which was what the two men, sometimes joined by a couple of farmhands, did in their shirtsleeves over two full weeks. Afterwards, Burroughs christened the plot "Ford Field."

"He was a very accepting kind of a person," said Jeff Walker, of the John Burroughs Association. "He was definitely not a religious person,

Dr. Clara Barrus, shown looking over the Hudson Valley, met John Burroughs in 1901 and became the love of his life, his housemate after the death of his wife, and his literary executor.

even though he'd grown up in a very religious family and his wife was religious. He felt that organized religions had created a lot of tension in society. But he was accepting of people who were religious, as long as they let him go walking on Sundays rather than make him go to church."

On their camping trips, Burroughs openly argued with Ford and Edison over their unrepentant bigotry, which the highly tolerant Burroughs, who in his journal took note of the rabid Jew-baiting going on, found unacceptable. "At one point in the conversation," said historian Edward J. Renehan, "Ford claimed that Jay Gould was a Jew and called him a 'Shylock,' and Burroughs had the pleasure of informing him that contrary to his belief, 'All Jay's people Presbyterians.' "

WHEN JAY GOULD SUCCUMBED to tuberculosis at the age of fifty-six in 1892, London's *Standard* condemned him as "a wrecker of industries and an impover-

isher of men." *The New York Times* scolded him as being adept at "intercepting the earnings of other people and diverting them from their original destination." To biographer Klein, Gould "was a man of dubious past who has amassed immense wealth and power in secretive fashion by unscrupulous means." Honoring no values, loyalties, or any trust, "He was the embodiment of the dark side of the American Dream." British investigative journalist W. T. Stead, writing in 1893, only a year after the financier's death, speculated on the possibility of a Gould dynasty, much like that of the Rothschilds in Europe. "Jay Gould was not a Semite, although he had the Semite's nose and a more than Semitic grasp of cash," wrote Stead. "But he came of the New England stock that is Hebraic in its culture, and he had all the domestic virtues which Puritanism insists upon."

John Burroughs, in hat, in front of his study at Riverby with his son Julian and family, in the summer of 1908. Granddaughter Elizabeth, five, sits in the lap of Julian's wife, Emily MacKay. In John's lap is granddaughter Ursula, named for John's wife. Grandson John II would be born two years later. In his will, the naturalist bequeathed his library to his three grandchildren, and his writing table to Henry Ford.

John Burroughs was to outlive his boyhood friend by thirty years. During that time, in 1913, just as the old Burroughs family homestead in Roxbury was about to be seized by the bank, Henry Ford paid off the mortgages and provided Burroughs a nearby cottage, called Woodchuck Lodge, where the writer spent the summers during the final decade of his life.

"Every fall when Burroughs and his brother would leave here, they would close the shutters and get the windows closed, wind up the Victrola, play *Brahms's Lullaby*, which was one of Burroughs's favorites, and get in the car and drive away to that tune," said Joe Farleigh, president of the Burroughs Society of Roxbury.

John Burroughs, eighty-four, died in 1921 after being stricken in his Pullman car compartment aboard a New York Central passen-

ger train while returning home from a cross-country trip. "The great naturalist and author of outdoor books had hoped to return to his country home, Riverby, to die," the Associated Press reported, "and his last words, uttered a few seconds before death claimed him, were, 'How far are we from home?'"

The *New York Evening Post* likened his passing to "the crash of some patriarchal pine towering above a younger forest." He had watched the messenger pigeons being replaced by the telegraph, and lamented that man was exhausting the coal and the natural gas resources and the fertility of the soil in his beloved Catskills and beyond. "We live in an age of iron," he said, "and have all we can do to keep the iron from entering our souls."

Upon his death, the New York State Senate adjourned in his honor. Thomas Edison issued a statement, expressing his sadness and stating, "To me he always appeared to be one of the highest types yet evolved in the advance of man to a higher stage." Henry Ford said in tribute, "I believe if you had offered John Burroughs a million dollars in one hand and the sight of a new bird in another, he would have chosen the sight of a new bird."

Burroughs was buried on the hill above Woodchuck Lodge, with about one hundred people in attendance, including former president Roosevelt and Henry Ford. The Victrola was there too, brought by friends.

"It was playing *Brahms's Lullaby,* and it decides to stop right in the middle of the song, and a man gets up from the crowd and tinkers with this thing. He gets it going again, and it finishes the song," said Joe Farleigh.

"It was Thomas Edison."

"IT IS a curious thing," Burroughs recalled toward the end of his life, "that the two men outside my own family, of whom I have most often dreamed in my sleep, are Emerson and Jay Gould. The new expounders of the philosophy of dreams would probably tell me that I had a secret admiration for Jay Gould."

Apparently it was mutual. When Gould died and the contents of his vast estate were cataloged, it was found that his home library contained all of John Burroughs's books. Every one of them had been well thumbed.

Water and Power

Father told me of his uncle, Chauncey Avery, brother of Grandmother
Burroughs, who, with his wife and seven children, was drowned near
Shandaken, by a flood in the Esopus Creek.

—DR. CLARA BARRUS, quoting John Burroughs

In villages like West Hurley, Brown Station, Olivebridge, Stoney Creek, and
Ashton, prudent settlers in the 1890s built their houses on the hills—the best
insurance for avoiding the floodplain where the Esopus Creek might suddenly
swell and sweep them away. Named by the Lenape to signify "high banks," the
Esopus was gorged by great volumes of water cascading down the slopes of the
surrounding mountains from its source at Winnisook Lake, at 2,660 feet above sea
level the highest lake in the Catskills.

Every spring the creek overflowed its banks but by late summer would subside
into a shallow waterway that bubbled along a rocky bottom on its way to join the
Hudson River above Kingston. Unfortunately, according to John Burroughs's lit-
erary executor, Dr. Clara Barrus, Chauncey Avery, the grand-uncle of Burroughs,
and his family would not live to see the water recede.

Not following the conventional wisdom of the region, Avery built his house
directly on the banks of the Esopus, in Shandaken. When the flood arrived "in
April, 1814, or 1816," reported Barrus,

[t]he creek rose rapidly in the night; retreat was cut off in the morning. They
got on the roof and held family prayers. Uncle Chauncey tried to fell a tree

and made a bridge, but the water drove him away. The house was finally carried away with most of the family in it. The father swam to a stump with one boy on his back and stood there till the water carried away the stump, then tried to swim with the boy for shore, but the driftwood soon engulfed him and all was over. The two bodies were never found. Their bones doubtless rest somewhere in the still waters of the lower Esopus.

DESCENDED FROM PIONEERS who had followed ancient Indian trails into the remote Catskill wilderness not long after the Dutch founded New Amsterdam, residents of the broad, isolated valley prided themselves on their fierce independence and the steady, predictable pace of daily life. Making their own tools and clothes, villagers bartered for whatever they needed, tapped maple trees for syrup, pressed cider from apples, raised sheep, cattle, and pigs, and grew corn, the staple of the region. To break the loneliness, they socialized with their neighbors, especially at barn raisings and every Fourth of July. Little could they anticipate that their way of life was about to be uprooted.

The outside world began to infiltrate as early as the nineteenth century, when narrow macadam roads joined the valley to the rest of New York State. With the 1828 opening of the nearby Delaware and Hudson Canal, mainly for the purpose of transporting anthracite coal from northeastern Pennsylvania into New York City by way of the Hudson River, Catskills farmers could also at last deliver their cash crops to market. But the real invasion came after the heyday of the tanneries and bluestone quarries, when, following the Civil War, the railroads began bringing vacationers from New York City to the Esopus Valley.

Noisy and impatient, the visitors could be bothersome, though their aftereffect brought something positive. After two centuries of hard living, valley residents were finally able to enjoy a small taste of solid, if undramatic prosperity—until such time as some genuine drama erupted.

Stories began circulating about agents from New York City with hard cash, willing to pay for water rights along the Esopus Creek. The initial option money wasn't much, anywhere from ten to sixty dollars, depending on how much land was involved—"a miserable pittance," *The New York Times* commented. The company buying the options was the Ramapo Water Company—Ramapo meant "sweet water"—and rumor had it that Ramapo's plan was to sell water to New York City.

The general consensus among valley residents was that nothing would come

Floods were a fact of life commonplace to Zadock Pratt. On January 31, 1839, recorded Town of Wright historian Chester G. Zimmer:

The destruction on the Schoharie Creek and its tributary streams is greater than has taken place within the memory of our oldest inhabitants. . . . Col. Z. Pratt at Prattsville lost his tannery, his sawmill, and dam. The bridge was swept away, also the gristmill carried off.

The next great flood, in 1869, outdid its predecessor, bringing water "twenty-two inches higher than ever before," said Zimmer. "The village was entirely surrounded at one time."

Then it happened again. The flood of 1903, the historian said, "eclipsed that of 1869, filled the valley from mountain to mountain at some points, swept with resistless power down the Schoharie Valley destroying crops of corn, buckwheat, and hay, carrying away fences, buildings, bridges, dams, and hop poles, tearing great furrows through the valuable lands of the valley."

Lest anyone assume floods were something of the past, steady rain began to fall in the high peaks of the northern Catskills on Sunday morning, August 28, 2011. By the time the full force of Hurricane Irene blew into the region, what had been predicted to be the worst weather condition to hit the Northeast in fifty years rapidly laid waste whole villages and livelihoods within a 658-square-mile area inhabited by forty-nine thousand people. Among the victims of Irene were tombstones surrounding the grave of Zadock Pratt in Prattsville Cemetery cracked by the storm.

In the town of Middleburgh, Main Street was left with a bathtub ring seven feet high. Among the dozens of other towns hit were Windham, Jewitt, Maplecrest, Lexington, Phoenicia, Blenheim, Schoharie, Arkville, Margaretville, and Fleischmanns, where an eighty-two-year-old Holocaust survivor drowned when a nearby creek overflowed its banks and devoured her cottage.

Only fourteen months later, Superstorm Sandy visited destruction upon the

Early Catskills settlers knew to build their houses in the hills and not on the plains, where they could be swept away should the Esopus (named by the Lenape to signify "high banks") Creek overflow its banks—something it habitually did every spring.

Northeast. "There's only so long you can say, 'Well, this is once in a lifetime and it will never happen again,'" said New York governor Andrew M. Cuomo. "I believe it is going to happen again. I pray that it's not; I believe that it is."

The point the governor wanted to make was, "People will debate whether or not there is climate change, whether or not it's a cycle, whether it's global warming. That's a whole political debate that I don't want to get into." But he did say, "I think part of learning from this is the recognition that climate change is a reality."

of this. After all, how could the tiny, insignificant Esopus Creek, sometimes so low by late summer that waders could traipse across and hardly get their feet wet, become the source of water needed by a city like New York?

Supplying water to New York City had been a problem ever since the first public well was dug in front of the fort at Bowling Green when New Amsterdam was still in its infancy. A second well followed in front of the old City Hall, at Coenties Slip near Pearl Street (site of the current fifty-four-story 55 Water Street). An edict in 1677 decreed that six more wells be built and paid for by the residents of the streets being served, and by 1687 the city counted fifteen wells, although it wasn't until 1750 that pumps were added.

The pride of the system was the Tea Water Pump, so named because of the superior quality of its water when it came to making tea. "The spring over which it stood bubbled from the ground in a hollow or dell at the present junction of Chatham Street and Roosevelt," according to *The New York Times*, "and, forming a brook ran across the road to the fresh pond known as the Calchhook Kolch, or Collect." Delivery of the water in buckets from "Tea Water Men" went to those who could afford it, though the water quality gradually declined.

Just prior to the Revolutionary War, with the city's population at twenty-two thousand, a reservoir large enough to hold twenty thousand hogsheads of water went up on the east side of Broadway near Pearl Street. Its contents came pumping in through leaky, hollowed-out wooden pipelines from wells east of the reservoir that in turn had been filled by the fifty-acre, spring-fed Collect (under what is now the Criminal Court Building).

By the late eighteenth century, tanneries, rope-manufacturing factories, slaughterhouses, and breweries not only drew their water from the Collect, but shared the common practice of dumping their waste into it. Most of the city's wells contained "water so poor and disagreeable in taste that even horses refused to drink it," said the *Times*. Epidemics of cholera and yellow fever, transmitted by mosquitoes that bred around the stagnant Collect, were frequent deadly reminders that the growing city lacked adequate sources of fresh drinking water.

In response to a particularly virulent outbreak of yellow fever that claimed as many as forty-five New Yorkers a day in 1790, the lawyer Aaron Burr organized the Manhattan Company, which the State of New York authorized to provide a dependable supply of fresh water to New York City residents. Arrogant, ambitious, and devious, Burr had careers that included turns as New York State attorney general, U.S. senator, and Thomas Jefferson's vice president. He also had

something besides water on his agenda for the Manhattan Company. In its small print, the charter passed by the state legislature contained a provision allowing for Burr's company to use any profits or surplus capital "to make or engage in any other moneyed transactions."

Burr's true aim was to break the monopoly in New York City banking held by his archrival, the nation's first secretary of the treasury, Alexander Hamilton. The water company Burr organized for the City of New York was really nothing more than a front for a bank.

THE MANHATTAN COMPANY HARDLY MADE a show of meeting its contractual responsibility and delivered only tainted water from already existing wells, piping the water through wooden pipes to a few thousand homes from which it could extract a profit. To his better advantage, Burr used the Manhattan Company's capital to establish the Manhattan Bank, which later became the Chase Manhattan Bank (today's JPMorgan Chase). In terms of water supply, Burr left the city he called home no better off than it had been before.

"Scientists estimated in 1830"—when two-thirds of the city's two hundred thousand residents had to rely upon polluted wells—"that one hundred tons of human excrement were being put into the porous soil of lower Manhattan daily. There was no citywide sewer system. Privies, cesspools, and open pits were the only provisions for disposal," said Charles H. Weidner, author of *Water for a City*. "There was seepage from graveyards and the drainage from stables and filthy streets [and] the stench arising from the streets was appalling. Travelers frequently declared they could smell the city two or three miles away."

In 1834, the state legislature approved a measure that permitted New York City to remedy its water situation by venturing beyond its borders, and three years later the city began work on the Croton Dam and Aqueduct. Employing nearly four thousand immigrants in its construction, the mammoth project drew on the watershed to the north and as of June 27, 1842, began delivering water through forty-one miles of tunnels and aqueducts to a massive four-acre Egyptian-style reservoir at 42nd Street and Fifth Avenue. It remained in service for five decades, and then the reservoir site became the home of the main branch of the New York Public Library in 1911.

As for the city the aqueduct served, New York continued to swell in population, to a million and a half by 1890. On January 1, 1898, the city boundaries

expanded too, to include Brooklyn, a portion of Queens County, and what is now Staten Island. Overnight, the census rolls zoomed to nearly three and a half million, rendering the Croton watershed inadequate to meet the city's needs.

Again desperate for a new and dependable water source, the officers and directors of the Ramapo Water Company seized their opportunity. Measuring the flow from the Catskill Mountains into the Esopus Creek and determining that the entire valley could be turned into a natural reservoir, Ramapo engineers dispatched agents to option thousands of acres of valley land, positioning the company to control the unlimited mountain supply of freshwater–and make a financial killing.

During the summer of 1899, the Municipal Board of Public Improvement of New York City quietly signed a contract under which Ramapo agreed to furnish the city two hundred million gallons of water a day at a cost of $5 million a year. The contract, to run for forty years, was shepherded through by William Dalton, a onetime butcher who had been appointed commissioner of water supply by Tammany Hall and later ran a company that produced rooftop water tanks. Dalton's instructions were to railroad the scheme through the city's Board of Public Improvement. Later, when questioned on whether he possessed any special engineering knowledge to qualify him as an authority on the construction of so complex a water system, Dalton replied dryly, "Well, I owned an engine for some years . . . at my place of business. . . . It was a small engine, about eight horse-power."

Apprised of such shenanigans, New York City newspapers published evidence of several Tammany politicians' owning a piece of Ramapo. During a two-week delay in final approval, all the sordid details of the Ramapo plan went public and the contract effectively went down the drain. Once the Ramapo charter was eventually revoked by the state legislature, the city, acting upon the recommendation of city comptroller Bird S. Coler that supplying the water should stay out of private hands, formed its own Municipal Water Board to initiate plans to tap the water resources of the Esopus Valley. The state was petitioned for permission to acquire land through eminent domain and the right to build whatever system was necessary to provide an adequate water supply for the City of New York.

"Making the claim that the Esopus Valley was sparsely populated, that its hillsides were well forested, that's not entirely true," said environmental professor David Stradling. "This was an area that had been populated for quite some time, there was active farming in the area, and in fact, the tourist industry had

been growing rapidly, ever since the Ulster and Delaware Railroad ran its tracks in part along the Esopus Creek. Tens of thousands of tourists would come up into the Ulster County area and vacation in the mountainside. The arrival of reservoirs would change this dramatically, of course."

Objections in the mountains were immediate. A jurist with the serendipitous—and real—name of Judge Alphonso Clearwater, representing the interests of the soon-to-be-affected towns along the creek, declared at a packed public hearing, "The powers asked by New York are too great. They ask the power that the Almighty would not delegate an archangel, let alone, if I may use such an irreverent comparison, a Tammany contractor."

Aaron Burr founded the Manhattan Company, headquartered at 40 Wall Street, ostensibly as a public works to distribute water to the city.

Except, who could fight City Hall? Even in the face of lawsuits and complaints, the necessary state authorizations were effortlessly secured, and the city moved quickly. Test borings commenced in early August 1905, nine months before either the city or the state had formally authorized plans to develop the Catskills watershed. Once the appropriate regulations were passed, surveyors moved into the Esopus Valley without warning, trespassing onto people's property, cutting down trees, knocking down stone fences—even though no money to purchase lands had been exchanged. Signs also spontaneously sprang up, advising landowners that within two months title to their property would be vested in the city and they would be subject to a ten-day notice to vacate. "To know that you were living in a property that would soon be demolished," said Stradling, "must have been devastating."

One target for extinction was Bishops Falls, which would eventually find itself under 190 feet of reservoir water. "At the lovely small falls," said Stradling, "the Bishop family—hence the name, Bishops Falls—built not just a farmhouse, but a sawmill and a gristmill, which were on either side of the falls. They also built a boardinghouse, the Bishops Falls House. From the name alone you could see that this was a family that had lived there for generations, and expected to continue

Manhattan Reservoir, Chambers Street, near Centre

living there for generations. When New York City took their land through eminent domain, several different Bishop families went through the process of divining the right value for their property. As they did this, it became apparent that it was impossible for New York City to pay what was really the value of this place to that family. The Bishop family would not find another Bishops Falls."

Arriving from Nine Partners, Dutchess County, around 1790, Asa Bishop, a miller, and his wife, the former Rebecca Winchell, built a gristmill and stone house not half a mile from the distinctive falls. Of their ten children, Jacob was blinded by smallpox when he was four, but was determined to become a miller himself, which he did upon his father's death in 1813. Known as the "Blind Miller," he built a reputation for the remarkable precision of his work. Jacob and his wife, Catherine, had twelve children, who all grew to maturity. One son, Asa, born in 1842, "[a]t the age of nineteen," reported a 1907 history of Ulster County, "enlisted in Company D of the Twentieth [New York State Militia] and served three years in the Civil War, being severely wounded in the battle of Gettysburg." Solidifying the stature of the Bishop family in the community, according to the Ulster account, "At the close of the war he returned home and engaged in quarrying for several years. In 1885 he purchased his present store, which was established in 1860 . . . and has since been engaged in a general mercantile business. He has served five years as town clerk and sixteen years as Justice of the Peace."

It wasn't until 1895 that the family home became a boardinghouse, and further extensions were built in 1900 by Asa and Rebecca's great-grandsons Frank and DeForest Bishop. "Three Hours Ride from New York," said its flyers, which also promised "AMUSEMENTS. Boating, bathing, hunting and fishing, dancing, croquet, etc," while the Ulster and Delaware Railroad promoted the falls themselves as "two miles down the Esopus, a favorite afternoon ramble with many." Boardinghouse double-occupancy rates ran to $6 a week; single, between $7 and $8. Over the 1905 season, when 135 guests could be accommodated at any given time, the brothers took in $3,000.

The "AUCTION SALE" notice for April 29, 1908, offering "BOARDING HOUSE FURNITURE, FARMING IMPLEMENTS, Etc.," listed "20 Oak and ash bed-room suits [sic], 20 sets woven wire and coil springs, 20 mattresses[,] extra wash stands and bureaus," as well as "25 toilet sets, 6 cots, 100 yards matting," and "1 iron gray horse, 6 yrs. old; weight 1200, 1 black colt; 3 yrs. old, 1 bay colt, 2 yrs. Old, 2 cows, 50 fowls [and] 1 grind stone" among the inventory. Total sales came to $424.90. Frank and DeForest's mother, Anna Bishop, was paid $17,746.53 by New York City for her 106 acres, while her sons went to court against New York City over their boardinghouse business.

Finally, in 1919, a settlement was reached. The brothers split $2,000.

IN NOTIFYING OWNERS of the established value for their land and buildings, assessors failed to make allowance for personal property or loss of business, and remorseless lawyers for the city demanded factual justification should higher values be sought beyond those set by assessors. After being asked, "What other use, if any [other than farming], did you ever put that property to?" one farmer replied, simply, "I raised my family there. I have eight children." Such a purpose was considered immaterial.

Individuals agreeing with the valuations soon received payment in full. Those contesting the valuations would be paid half, then forced to wait out the balance until such time as the claims had been arbitrated in the courts.

Claims for compensation took years to be resolved, with many not settled until the 1930s, years after the completion of the dam. As could be expected, the big winners were not the claimants but the attorneys. Claims totaling $10 million were finally settled for $1.4 million, while the City of New York spent more than $2 million on lawyers, commissioners, and expert witnesses.

The community of Bishops Falls, founded in 1790 by Asa and Rebecca Bishop, was developed into a popular boating, bathing, and amusement destination that lasted until the early 1900s, when New York City's demand for water submerged the town under 190 feet of reservoir water.

City newspapers routinely ridiculed the objections of the locals, deriding Ulster County legal representatives as "mountain lawyers." George Sterling, a lawyer for the city, stated outright that the people of the region would be better off being displaced. "If some of them are compelled to live in a little more cleanly manner than they have been accustomed to, they will have been taught a useful lesson in decency, cleanliness, and healthfulness," he said.

Even *The New York Times* had a field day reporting on the farmer from Brown's Station in Ulster County who put in a claim for $425 for the loss of both a cow and a crucial farmhand. It seems a construction worker for the city had left a stick of dynamite in a field and the cow ate it.

"Was the cow blown up?" the farmer was asked.

"Not exactly," he replied, "but she scared us all to death."

The city settled for $150.

In a defining American era of big ideas, the Ashokan Reservoir—Ashokan being a Native American term for "place of fish"—measured up to the best of them: the Brooklyn Bridge, the Transcontinental Railroad, the emerging skyline

of Manhattan. In comparison, the Great Pyramid of Giza used only one-eighth of the materials required to build the great Ashokan Dam, which contained five hundred thousand cubic yards of masonry.

As reported in the *Hudson Valley Magazine* years later:

> And so in the fall of 1917 a great celebration took place. Schoolchildren danced a rain dance; politicians gave fine speeches and presented medals; a special exhibition of Hudson Valley landscapes was unveiled; and the crowd cheered when a jet of upstate water–clear, clean, pure water–rose on cue into the fetid city air. Improbably, miraculously, a tiny creek originating high in the Catskill Mountains had been successfully dammed to create a thirteen-square-mile drinking fountain for city folk.

Starting with a series of buried masonry conduits seventeen feet high and seventeen and a half feet wide running more than thirty miles along the mountain

Some were fortunate enough to play both sides against the middle. Kingston millionaire Samuel Decker Coykendall owned the Ulster and Delaware Railroad that ran along the defunct Delaware and Hudson Canal. (The Cornell Steamboat Company and the trolley-car system in Kingston were also his, as were other holdings.)

Fearing for the loss of his railroad's revenue once a dam was constructed and villages along his tracks destroyed, Coykendall bought the canal for $10,000, given how it might serve as a key component in Ramapo's rerouting water from the Esopus Valley before piping it down to New York City. But when Ramapo lost its charter, Coykendall became an arch-foe of New York's proposed plan, insisting that the people of the Catskills didn't want it and "their boardinghouse keepers would lose half a million a year in profits should the Ashokan Reservoir be built," according to Alf Evers.

And yet after the courts finally approved the city's plans, Coykendall invited New York State water commissioners to tour the Esopus Valley in his railroad's celebrated observation engine "Number 20," and spared no expense entertaining them at the Grand Hotel in Highmount, which his company also owned. For his hospitality, as well as for relocating thirteen and a half miles of track so construction of the reservoir could proceed, he was paid $2.8 million.

slopes, the aqueduct plunged through thirteen and a half miles of tunnels that had been blasted through solid rock, before dropping deep under the Hudson River and rising up again before finally reaching New York City. Not a single pump was required; the water traveled the entire one hundred miles by gravity. The stem was, and remains, an engineering marvel.

Construction began in 1907 and the workforce had its own city, including a hospital, fire department, police force, sewage system, mess hall, and retail stores. Thousands of immigrants, more than half of them non-English-speaking Italian stonecutters and masons brought directly to the work site from the steamship docks in New York, were hired, as were African Americans.

"There were a number of southern blacks who were expert mule handlers," said journalist Diane Galusha, author of *Liquid Assets: A History of New York's Water System*. "The contractor, Winston and Company, which was a Virginia-based company, brought many of these folks north, along with hundreds of mules. The Ashokan Reservoir was considered the last of the 'handmade' dams. When you think about 'handmade,' for one, it was built largely by the brute force of men. And mules, lots of mules. And dynamite. It was before the era of diesel-powered heavy equipment and all the rest of the sort of labor-saving construction techniques that we know today."

Different races and nationalities worked together but lived apart, with their children sent to segregated schools, in the hope of avoiding the friction that occurred anyway. Headlined "The Catskill Reign of Terror," an article in the *Ulster County Townsman* reported that "[t]en thousand men . . . mostly unskilled laborers, . . . turned the peaceful Valley . . . into a roaring camp that echoed to their drunken songs and seethed with banditry, outlawry, and murder. Though the brawls and orgies were confined, for the most part, to the

Owner of the Ulster and Delaware Railroad, Kingston millionaire Samuel Decker Coykendall initially opposed New York City's intention to tap into the Catskills for water, until he devised a plot to profit from the plan.

workmen's camps, not infrequently men stole away to rob and pillage the isolated farmhouses in the district."

"At any one time there were probably between three and four thousand workers at different camps, which were located below and a little bit to the north of where the dam is now," said Bob Steuding, a prolific author on the Catskills and professor of English and philosophy at SUNY Ulster. "Probably the largest number of nonlocal workers on the project who would have stayed in the camp were Italian, and then probably the next largest were Austrians, Russians, African Americans. Many of the individuals who were brought here from overseas went home. But many did stay."

MORE THAN TWO THOUSAND PEOPLE were forced to move from their homes to accommodate the construction. Eight villages were destroyed, as were "five hundred and four dwellings. Three times the number of barns, shops and outbuildings, nine blacksmith shops, thirty-five stores, ten churches, ten schools, one gristmill, and seven sawmills," Charles H. Weidner counted. "The transformation of what was once a tranquil rural valley became a noisy, unsightly, gigantic manufacturing zone with steam shovels, rollers, derricks, cement mixers, stone crushers, 'dirt trains,' and mules transporting materials out of the excavation site," said a Westchester Land Trust account.

With more than twenty-seven hundred bodies in cemeteries to be dug up and reburied, "[e]ighteen dollars was allotted to any friend or relative who would move a body to another location," Ernest A. Abbot told *Outlook* magazine for a 1909 issue. Fifteen dollars went for the actual remains, with the additional three for the headstone. As Abbot further related, "They had to remove the body and refill the empty grave. Any bodies not removed by November 1, 1910, would be removed by the Board of Water Supply of the City of New York to a cemetery which it would select. Three thousand bodies were removed, but about three hundred fifty were unclaimed, and they were reburied in the Bushkill cemetery in West Shokan in an isolated part of the cemetery with a numbered stone marker . . . no name."

"The company that exhumed the bodies was run by an interesting chap," said Bob Steuding. "His name was Joseph T. Rice. Rice was an Irish Catholic, an orphan, who had been raised by a religious order in Milwaukee. Besides exhuming the bodies, he was also the major contractor for the clearing of the

reservoir—cutting down all the trees and pulling out all the roots and digging up all the privies, all the barnyards, anything organic, anything pathological, in a sense, that had to be taken up. When they cleared everything, they either moved or they burned down all of the houses. All the structures."

Among "some of the more interesting exhumations" Rice encountered, according to Steuding, was "a chap who was married to a woman who apparently was quite difficult. She had been married to a chap before who had died and been buried. So the husband said, 'We don't have to have professionals do it. I will exhume the body.' And he did. Apparently, it was in relatively good shape. So he reburied the body, but he buried it upside down. After he did that, a neighbor asked him why. And the chap said, 'Well, I wanted to get back at this man, because he's the only perfect person in the world, according to his wife.'"

Steuding had another one. "It's the story of a young woman who was actually buried three times. She died, and as was often the case in rural America at the time, she was buried the same day. Apparently, she wasn't really dead. She must have had some sort of epileptic seizure or something, but she had no signs of life. She was also buried with some of her personal treasures, and the neighbors knew

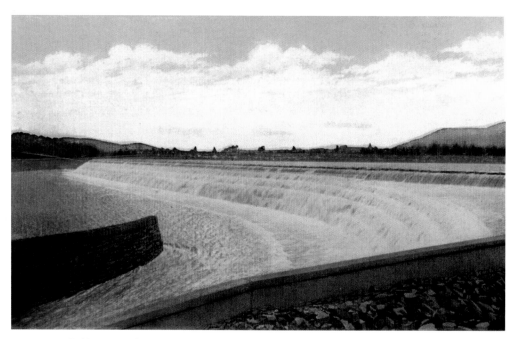

"Improbably, miraculously," read a report about the opening of the Ashokan Reservoir project, "a tiny creek originating high in the Catskill Mountains had been successfully dammed to create a thirteen-square-mile drinking fountain for city folk."

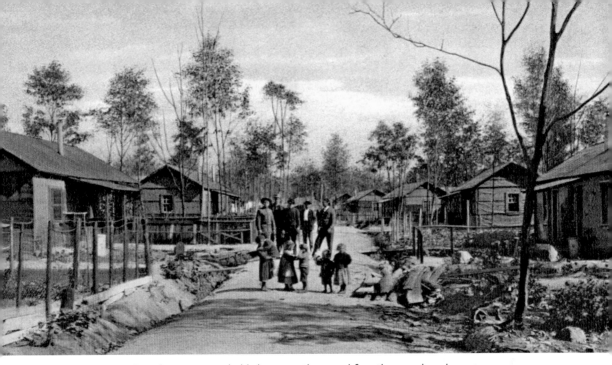

"At any one time there were probably between three and four thousand workers at different camps . . . located below and a little bit to the north of where the [Ashokan] dam is now," said Catskills historian Bob Steuding.

about this and decided to dig her up that night and get the rings and jewelry. So they did dig her up. It was a moonlit night, of course, and very spooky. And they dug her up and she came alive, and, naturally, they were shocked. The story goes that she lived a long and happy life and was buried again in the area that is now the reservoir. Then, of course, when the city came, all those bodies were exhumed. She was reburied in the cemetery on Rock City Road in Woodstock.

"And she's the woman who was buried three times."

WORK ON THE DAM, reservoir, and pipeline took nine years, three months, and twenty-four days. "The plus for New York City in constructing the reservoir was that it cost much less money than you could ever imagine," said Bob Steuding. "To build everything on the site—the dam and the dikes, five and a half miles of masonry and packstone, was $12.7 million. Today, the average baseball player on the Yankees makes more than that in one year. They did not have cost overruns. They came in on time. Relatively few people—only three hundred—were killed on the whole project, which was amazing. That was even less than the people who were dying on the streets of New York City."

Also gone were the boardinghouses and the summer trade. Once the dam and reservoir were finished, "a place and a way of life that had long been supported by old and tested patterns was forever lost," Steuding further explained. "Within the space of one, or at the most, two generations, the Catskills' vibrant traditional culture disappeared; the old folks and their old ways were quickly forgotten and, not unlike a fond and fading memory, they soon became the stuff of myth and folklore." So did villages like West Hurley, Brown Station, Olivebridge, Stoney Creek, and Ashton.

"Some people believe that when the reservoir is low, you can see church steeples and chimneys poking above the water," wrote A. J. Loftin in the *Hudson Valley Magazine*. "This is pure mythology—or perhaps wishful thinking. The engineers left not a trace of the civilization they conquered."

Completed in 1915, the Ashokan Reservoir was but the first of an eventual six reservoirs to be built in the Catskills to meet the water needs of New York City. From there, the city moved ahead almost immediately to connect the available water resources in the valley of the Schoharie to the Ashokan Reservoir via an eighteen-mile tunnel, at the time the longest in the world. Once that link was connected, the city moved west, to the Delaware River, and between 1937 and 1965 built four more dams and reservoirs and a second aqueduct.

"As each project reached its first stage, the same sequence of events followed among mountain people," said Alf Evers. "First the sense of shock at having to leave their homes; then the merging of the images of old-time landlords and New York City politicians; then the invocation of the Anti-Rent warriors; then the realization that, after all, there might be money in it; and finally the retaining of lawyers to fight for every possible penny."

Most residents found themselves on a one-way street. Even those hired to help construct the water system felt outgunned by the arsenal of a city whose needs far outweighed their own. "People were angry with the city and they had to give up their land," said Bob Steuding, "but it was also a source of revenue for them."

"I'll never forget having to witness my grandmother, Anna, a quilter, and grandfather, H. V. Dumond, crippled with arthritis, walk away from their home as it was being bulldozed, waiting for the gasoline to be poured on it and then burned," said Evelyn Norris, whose grandparents lived in Union Grove, just one of the villages buried under the waters of the Pepacton Reservoir when it opened in 1954.

At a Remembrance Day for Shavertown, another village victimized by Pepacton, a resident recalled her once "very good farmland, and now there's about a hun-

dred feet of water where our farm was. It was very hard for people to move, especially for older people. These people who are here today are still very bitter."

Dislocation was only the beginning. For years New York City refused to acknowledge that the dams were taxable improvements and paid taxes only on the amount of unimproved land it owned around the reservoirs. Local citizens felt violated, aware that there were few other places in the country where a government, unresponsive to the electorate, could impose such dramatic changes on a region's way of life.

By 1965, every key waterway in the Catskills, with the exception of the Beaverkill, had been dammed to provide water for New York City. Sixty thousand acres of land had been appropriated, twenty towns and villages

A newspaper map of December 9, 1949, traced New York City's water sources. "Dotted lines indicate flow of water from Catskill Watershed southwest of Albany and Westchester County's Croton Watershed[,] both of which are [a] major source of New York City's water supply. The reservoirs should hold 253,000,000,000 gallons. Yesterday they held 86,982,000,000 gallons."

had disappeared, six thousand people were driven from their homes, and more than ten thousand graves had been dug up and the bodies moved to other sites, all so New York City could access sixteen hundred square miles of Catskill watershed pouring through the city's aqueducts.

And access they do. In all, roughly nine million residents of New York City and its neighboring counties consume approximately a billion and a half gallons a day.

"When a New Yorker turns on the tap," said *Liquid Assets* author Diane Galusha, "perhaps 90 or 95 percent of that water comes from the Catskills."

Iron-Horse Race

I

> That which was once a long journey of fatigue and discomfort is now a short ride of notable interest and pleasure. Breakfast in town, luncheon in the mountains, or luncheon at home and dinner at your hotel on the mountaintop. That is now the order.
>
> —New York Central and Hudson River Railroad guidebook, 1895

Lavished with praise from visitors in its early years, the Catskill Mountain House also reaped the benefit of publicity generated by stage productions of *Rip Van Winkle* and William Dunlap's 1830 theatrical farce *A Tour of Niagara*, which featured a Mountain House set center stage. Yet despite the profusion of room reservations, the Mountain House Association often had trouble keeping its fiscal house in order, what with the hotel's lackadaisical management and the shaky economic conditions of the day.

By the early 1830s, wrote Alf Evers, "the Catskill Mountain House twice stood on the verge of extinction; the water wheels of the mountain tanneries sometimes stopped turning; and the idle barkpeelers and tannery teamsters found other work or starved. And finally the tenant farmers of the Hardenbergh Patent armed themselves and rose up in anger against their absentee landlords."

The Mountain House's white knight emerged in 1839, when Charles Beach, whose father, Erastus Beach, owned the stagecoach service from Catskill to the Mountain House, leased the financially troubled hotel from the Catskill Mountain Association. Six years later, in 1845, at a sheriff's auction, Beach purchased the

House outright, for $5,000, and his intention was to let the property remain what it had always been, a romantic outpost of civilization—an image only reinforced by the last leg of the exhilarating trip to get there.

In a Beach Company stagecoach.

IN LATE 1851, a new element was introduced to the Catskills: the Hudson River Railroad, chugging up the eastern shore of the Hudson from New York City to Oak Hill Station. From there, Mountain House guests could disembark for the ferry across the river to the village of Catskill, then board the Beach stage for the ride up to the hotel.

A major improvement over steamship travel—which ran the risk of shutting down those ninety to one hundred days a year when the river iced up—the railroad provided year-round transportation on modern wrought-iron "T" rails. The 111-mile journey to Oak Hill Station also trimmed sailing time by half—to three hours, forty-one minutes—while luxurious parlor cars guaranteed customers a comfortable seat and picture-window views five feet above the Hudson's high-tide line.

Attempts to establish a train line up the west side of the Hudson River had been long in coming, only to be derailed. As early as 1830, the Canajoharie and Catskill Railroad was incorporated to provide shippers a fast and cheap alternative route along Catskill Creek to either the Erie Canal or the Delaware and Hudson Canal; what the system lacked, however, was sufficient passenger and freight traffic. Only partially completed by 1835 (and not even as far as Canajoharie), the Canajoharie and Catskill went bankrupt in 1842.

While no remnants of the line still exist, one of its trains is visible in the distance in Thomas Cole's 1843 *River in the Catskills*, as a farmer in a forest clearing leans on his axe and watches the train rumble by, a not-so-subtle comment on how industrialization was rapidly destroying the untouched wilderness the artist so deeply cherished.

Another attempt to build a railroad along the Hudson's west side would not emerge for twenty years, until Thomas Cornell, a crafty Hudson River towboat operator (and Ulster and Delaware Railroad owner Samuel Coykendall's father-in-law), spearheaded construction of the Rondout and Oswego Railway, to run south of the village of Catskill and through Ulster, Delaware, Schoharie, and Otsego Counties, into the heart of the northern Catskills. Much of the route

existed along what was first an old Indian trail, then an eighteenth-century pack-horse trail, and finally, around 1800, a turnpike paved with hemlock planks. Snaking along the Esopus Creek and up the Catskill escarpment to Pine Hill, a small village fifteen hundred feet above sea level, the route was so notoriously steep that, according to Alf Evers, "old timers used to say with a wink that one curve of the route was so close that the engineer in his cab might, if he chose exactly the right moment, shake hands with a man in the caboose."

The frenzy of railroad construction unleashed by the Ulster and Delaware Railroad, as the Rondout and Oswego Railway was ultimately renamed, was so profound that it would eventually undermine the hotel monopoly held by Charles Beach at the Catskill Mountain House.

In the course of the next quarter century, a spiderlike web of new rail lines, spurs, and extensions crisscrossed the northern Catskills, forcing the necessity of dozens of boardinghouses and hotels catering to every class of traveler.

PROVIDING THE CATSKILL MOUNTAIN HOUSE with its first great rival, the Overlook Mountain House, with a capacity for three hundred guests, opened in 1871 on a peak outside the town of Woodstock. As described by travel writer T. Morris Longstreth, the Overlook House's view afforded the following:

> In summer, except on rare days, blue haze narrows the spectacle to a radius of fifty miles. In the clearer atmosphere of winter it is very impressive. The Ashokan, the Hudson, the highlands in seven States, the vast shoulder of earth, soar away from one. At last the earth is partially appreciable. It may not seem a sphere, but so much of it is seen that you are on an *Earth*. That is an extraordinary feeling.

At 2,290 feet, the Overlook stood higher than the Mountain House or any other Catskills hotel before or after, and, in one widely covered news event in July 1873, management rejoiced when it rolled out the red carpet for Ulysses S. Grant during his first term as president. As Alf Evers related the story, Grant, no stranger to imbibing, "emptied bottle after bottle as he sped toward the summit of Overlook Mountain behind relays of fast horses." Once the commander in chief reached the hotel, said one Woodstock old-timer, "they had to pour him into bed."

By the following morning he was clearly feeling none the worse for it, because, *The New York Times* reported, "After breakfast the ladies and gentlemen at the hotel put on fatigue suits and took large staves and escorted the president's party up the mountainside. During the ascent which was led by Gen. Grant and two little girls, the guests sang war choruses and patriotic songs."

Two years after Grant's historic visit, in 1875, fire overtook the Overlook, just as it did many wooden-framed hotels of the era. By the time it was rebuilt and reopened in 1878, other hotels catering to the well-to-do were also successfully operating in and around Catskills towns served by the Ulster and Delaware Railroad.

June 1879 brought the Tremper House, a few minutes' walk from a brand-new train station at Phoenicia. Nestled in a valley, the hotel could not offer spectacular views like its archrival Catskill Mountain House, so it staked its considerable success upon its first-class accommodations and the effortless efficiency it offered because of its sheer proximity to the depot.

In 1881, the hospitality arm of the Ulster and Delaware Railroad inaugurated the Grand Hotel, a 418-room luxury accommodation on the side of Monka Hill. With a matchless view down the Big Indian Valley toward Slide Mountain, the highest point of the Catskills, the Grand was more than an eighth of a mile long and a sight to behold all on its own, taking its Victorian design, with its four towers and mansard roof, from Coney Island's Oriental Hotel, a favorite of New York society since 1876. Like the Overlook and the Tremper House, the Catskills' Grand was located near the railroad station at Highmount (the highest point on the Ulster and Delaware Line) and contained every modern convenience of its time; what it also had was staying power, outlasting the competition by several decades and not shuttering until 1966.

Despite such formidable competition, not a single new arrival concerned Charles Beach, who considered the premier status of his Catskill Mountain House unassailable. Although the closest a railroad line came to the Mountain House was almost a mile (near enough to deliver guests but still far enough to pose an inconvenience), to his mind customers still relished the tradition of arriving by stagecoach the same way they appreciated his hotel's policy of mandatory Sunday church attendance.

And while the latest fashionable trend might have been dining at small private tables, meals at the Mountain House continued to be served at long communal tables, just as Beach's establishment refused to update from candles to gas lighting.

Or from chamber pots to indoor plumbing.

STEPS AWAY from where would rise a railroad station at the top of the Catskill escarpment, the luxurious Kaaterskill Hotel emerged principally as the result of words exchanged between Charles Beach and a disgruntled frequent guest.

George Harding was a wealthy Philadelphia patent lawyer known for his oratorical gifts and for his lengthy representation of Samuel F. B. Morse in protecting the inventor's patents for the electromagnetic telegraph, as well as another case for the McCormick reaper, in which his law associate was one Abraham Lincoln. Harding, by most accounts, was in the Mountain House dining room when he ordered a fried chicken dinner for his young daughter, whose diet forbade red meat. Told by a member of the staff, "There is no chicken on the bill of fare today," and having his suggestion of "Can't you send out and kill a chicken?" ignored, Harding, who spent thousands of dollars at the Mountain House every summer, asked to see Charles Beach.

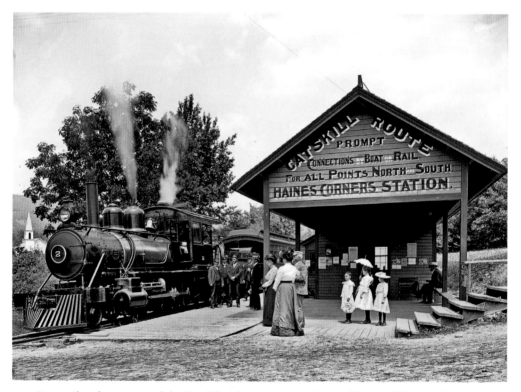

Once railroads penetrated the Catskills, they necessitated the addition of dozens of boardinghouses and hotels to accommodate guests wishing to enjoy the elevation.

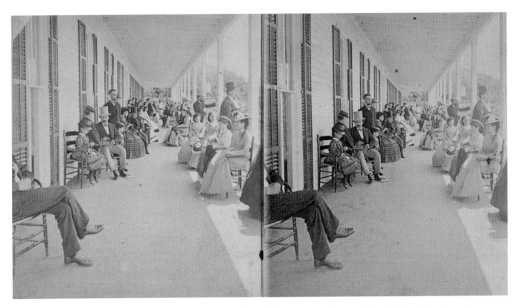

The Overlook Mountain House opened in 1871 on a peak outside of Woodstock and became the Catskill Mountain House's first chief competitor, especially after President Grant heightened its fame by paying a visit.

Once summoned, Beach told Harding he should be happy with the roast beef, and, as reported by *The New York Times* (admittedly relying on hearsay), on August 1, 1881, the starchy owner declared, "If you don't like things here, you had better build a hotel of your own."

"I have been thinking about it," Harding reputedly retorted. "A first-class hotel would be a novelty up here, and I think it would pay." (Another version had him reply, "Well, then, I will build a hotel where I can get chicken when I want it.")

Whatever words were exchanged, Harding purchased a large tract of land no more than a mile from the Mountain House, and, after only eight months' construction—and an expenditure of $900,000 (more than $20 million in 2015)—opened his opulent seven-story Kaaterskill Hotel, "the most celebrated of the 'spite hotels' in the country," reported the newspaper of record.

Touted to be the largest single-frame hotel in the world, with its six hundred rooms and grandiose main ballroom, it stretched a mile and a half long and contained such embellishments as an elevator, indoor plumbing, telephone, telegraph, and in-room closets. Posted rates in 1883 were the following: single rooms in August, thirty to thirty-five dollars a week, sixty to seventy-five a week for doubles; in September, the rate dropped by five dollars for each of

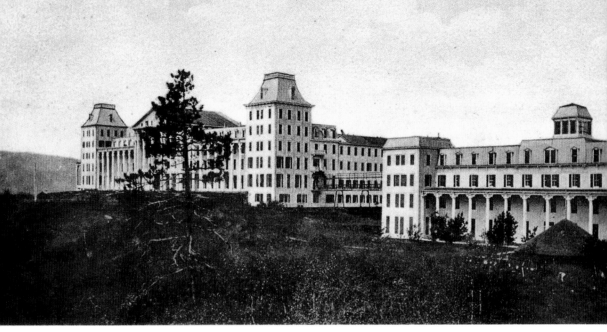

Philadelphia lawyer George Harding (in portrait) opened the luxurious Kaaterskill Hotel in 1882, primarily to teach Catskill Mountain House owner Charles Beach a lesson in how to cater to his customers.

the accommodations; maids and coachmen were charged fifteen dollars a week, servants an additional twenty-five; and transients, five dollars a day. "With the advent of the rail system and being able to come up for a day trip by train rather than having to get away from your work for days on end, there were 'excursionists,'" said Bob Gildersleeve, director of the Mountain Top Historical Society and author of the *Catskill Mountain House Trail Guide*. "They came up by train perhaps from New York City or down from Albany or maybe over from Oneonta in western New York." Once there, for however long, they were well treated and fed. "The goodness of the meats at breakfast and the vegetables," *The New York Times* said about the kitchen at the height of the 1882 summer season, was accounted for by the fact that "all the provisions are brought every morning from New York. Nothing is bought in the neighborhood except chickens." (Indeed, chicken was available whenever the guest requested it.) Credit went

to the experienced general manager, E. A. Gillette, formerly of the Colonnade Hotel in Philadelphia and a man who knew how to keep a guest stimulated.

As *The Times* also reported, "Oscar Wilde is advertised to deliver his lecture on 'Decorative Art' in the main parlor of the Kaaterskill next Monday evening, and Senator Jones, of Nevada, may be seen most any time strolling through the corridors."

After the second season, an additional wing increased the Kaaterskill's room count to twelve hundred, although it was the nearness of the Kaaterskill train station to the hotel lobby that eventually won over guests. Devotees of the Mountain House soon began to shift their allegiance to the Kaaterskill, at last awakening Beach–who by this time, it was noticed by more than one observer, was beginning to resemble Rip Van Winkle–to the fact that vacationers wanted ease and speed in reaching their destination.

Determined to compete, the Mountain House owner built the Catskill Mountain Railroad to shuttle people from steamboats across the valley to the base of the Catskill escarpment, where his four-horse stagecoaches would still whisk them on the remainder of their journey to his hotel. But this half-measure did not meet

Although both Charles Beach and George Harding died in 1902, their competing hotels still vied for discerning customers; these advertisements appeared one above the other in a 1904 travel gazette.

R eiterated Bob Gildersleeve, "Whether the story about the tiff over the fried chicken was true, or the degree to which it was true, I can't say, but it's certainly a story that's gone around for years. And the Kaaterskill Hotel was built. Higher than the Mountain House. Bigger than the Mountain House. More luxurious than the Mountain House. And an attempt to put the Mountain House out of business. The attempt never succeeded."

"Opening day" at the Kaaterskill "was an unqualified success," wrote Alf Evers, "marred only by the failure of Charles L. Beach and his sons to show a neighborly spirit of rejoicing." So intense was the dislike of Beach and Harding for one another that their hotels went so far as to use different names for the same sites in the area. "The lakes were renamed to Kaaterskill Lakes," said Gildersleeve. "The trails were renamed. Boulder Rock was renamed, the well-known rock on the Mountain House grounds called Alligator Rock—just about everything in the area."

There were, to be sure, both natural and man-made differences that distinguished the two hotels from one another. "The Hotel Kaaterskill had a very large network of carriage roads around South Mountain, something they had the luxury of doing because there were a lot of flat areas around the hotel," said Gildersleeve. "They had a carriage road that went out and came right up to the grounds of the Mountain House, with a little cul-de-sac where they could turn around and go back.

"But they didn't go any further."

with the guests' satisfaction. Caving in to the demand for something quick and comfortable (stagecoaches were hell on wheels for those with motion sickness), Beach contracted with the Otis Company to install a steam-powered cable railway to carry passengers up the sixteen-hundred-foot incline from the base of South Mountain to the area near the entrance of his hotel.

The cable-railway trip, the longest in the United States up until that time, took only ten minutes once it opened, after much delay, in 1892. "The [rail]cars have a seating capacity of ninety passengers, a caboose being provided for a proportionate amount of baggage. The seats are like those used in the elevators of the Eiffel Tower, being constructed on a curve which enables the passengers to easily adjust themselves to the different inclinations of the railway," reported *Scientific American.*

Kaaterskill-in-the-Catskills, N.Y. Alligator Rock, near Mountain House.

Guests of the Hotel Kaaterskill enjoyed the same outdoor attractions as those at the Catskill Mountain House, although the sites went by different names depending on where one stayed, such was the rivalry between the two establishments.

Soon, Beach expanded the railway from his hotel to Kaaterskill Station a mile away. Now guests could arrive by rail from either direction, and the bitter rivalry that became known as the "Fried Chicken Wars" between the Catskill Mountain House and the Kaaterskill Hotel escalated into all-out rivalry. This would last until both Beach and Harding died in the same year, 1902.

"On Monday night around 7 o'clock," the Greene County *Recorder* alerted readers on September 12, 1924, "the western sky was illuminated by a bright light, a wonderful spectacle, which proved to be a fire that was rapidly laying low the far-famed Hotel Kaaterskill, which closed its doors Labor Day after one of the most successful seasons in the history of approximately 40 years.

"The big framed structure and several buildings adjoining it were leveled to the ground by the monster demon, it being said that the blaze started in the kitchen,

In 1892, Charles Beach finally surrendered to the demand for a rail link that could deliver his guests relatively close to the Mountain House's front door. The ride also provided a preview of the spectacular view that awaited guests during their stay.

where workmen were engaged in the clearing up of the premises preparatory to closing for the winter."

At the time of the fire, from which the Kaaterskill would never again rise, the hotel was two years into the ownership of "Harry Tannenbaum, of Oak Court, Lakewood, N.J., and formerly of the Hollywood Lodge, Highmount N.Y.," according to a 1922 *Real Estate Record and Builders' Guide,* which also reported Tannenbaum's plans for "private baths throughout, running water and electricity, also general remodeling."

The Kaaterskill's great rival, the Catskill Mountain House, died a much slower death. By the time of the Great War, the cost of running the cable railroad to the hotel's entrance had become prohibitive, and in 1918 the train and track were sold for scrap. By then, not only were Charles Beach and his sons dead, but the Mountain House had lost ground to the other, more modern hotels in the region and the escalating tourist business in the Adirondacks.

The Mountain House welcomed its final guest in 1941, right before World War II. The property then lay dormant for more than two decades, eventually being turned over to New York State in 1962. At a loss for how to handle the decaying white elephant, legislators ordered the structure torched.

What had once been "a fairy palace clinging to the edge of the mountains," *The New York Times* reported on January 25, 1963, "the great white mansion, a delight to successive generations of Americans as they travelled up the Hudson through 140 years of unbroken history, had disappeared from the earth."

II

> There were trout streams in every valley in the vicinity of my old
> home, and they lured me on many an expedition with my fishpole into
> the woods and among the rocks. But a meadow brook was my favorite
> fishing-place, for it was there that the trout were most numerous.
>
> —JOHN BURROUGHS

As the grand hotels helped popularize the northern Catskills, the southern
Catskills, encompassing sections of Delaware and Ulster Counties and all of Sul-
livan County, remained virtually overlooked. It really wasn't even until the 1860s
that the region was identified as part of the Catskills; considered something sepa-
rate and distinct, the area was called the Blue Mountains or the Shandaken Moun-
tains. Traveling through in 1804, Yale college president Timothy Dwight described
the southern Catskills as "nothing but huge piles of mountains, separated by deep
and narrow valleys that shut out the few inhabitants from the rest of mankind. . . .
All else was grandeur, gloom, and solitude."

Nearly all of the southern Catskills fell within the boundaries of the original
Hardenbergh Patent. After Robert Livingston purchased more than one million
acres from the initial patent owners in 1749, he sold off only a few small parcels
to farmers willing to make land improvements and create trading centers that
would attract other settlers. By 1850, in the wake of the Anti-Rent War, Livingston
and other major landowners had sold off even more of their estates to tenant
farmers—who found the going tough. Climates were harsher than they were in the
north, with winters arriving earlier and leaving later, and twice as much rain and
snow as would fall in towns along the Hudson.

In his essay "A Bed of Boughs," John Burroughs recalled a homesteader he
visited in 1876, noting, "The scene was primitive . . . stumpy fields, log houses and
barns." Asking a young woman what it was like to live there, Burroughs was told,
"Pretty lonely."

In 1866, the fourteen backwater towns of Sullivan County contained in total
only fifty-four hundred modest houses, a few inns, and not a single hotel. The
men worked the fields while the women tended the house and the children. A
piece of red flannel tied to a door latch indicated an infected home—and a warn-

ing to stay away was about the extent of available medical help, despite frequent epidemics of tuberculosis, typhoid, and diphtheria.

"Diseases were greatly feared," said Bob Steuding, "with home remedies such as roasted onion, skunk oil, or cow-manure poultices, being applied for croup and chest colds."

Transportation also was inferior in the south, where the few rutted roads connecting tiny hamlets and isolated farmhouses could be counted on to become impassable during rainy season. Not until 1827, when the long-overdue Delaware and Hudson Canal opened, could farmers so much as send their crops to market.

But by then a different type of epidemic had already gripped America.

Railroad Fever.

SPURRED ON by their great envy of their neighbors to the north, southern Catskills residents, though few in number, insisted that the New York State legislature grant them a railroad, despite the impracticality of the endeavor.

Money was raised from the sale of bonds backed by tax revenues from those towns eager to have the railroad come through them, and bond salesmen fanned out across the region to hustle their wares. The result whistled its way through in 1868 with the arrival of the New York and Oswego Midland Railroad, which eventually ran 272 miles up steep grades, through long tunnels, and across high trestle bridges, from Cornwall-on-Hudson, near West Point, through the southern Catskills to the village of Oswego on Lake Ontario. The route zigzagged through towns that contributed to the cost of its construction and brazenly circumvented those that did not.

"Trestles and ties were of hemlock, the cheapest and least durable wood available for the purpose, and its roadbed was shoddily put together from whatever stone and gravel was handy," said Evers. Not surprisingly, derailments and fearful accidents plagued the system's early years, among other setbacks. The cost of the railroad had been gravely underestimated and projected revenues grossly exaggerated; by the time the line was completed in 1873, the New York and Oswego Midland was bankrupt and the bond owners who'd financed it were left holding worthless paper.

Undergoing a reorganization, the railroad was renamed the Ontario and Western and sold to New York investors who kept it running. By 1880, the new owners had connected its system at Cornwall-on-Hudson to the New York, West Shore,

and Buffalo Railroad, which ran up the west side of the Hudson River from its terminal in Weehawken, New Jersey. The O&W now transported passengers and freight the full distance from the southern Catskills to New York City.

Still, success was elusive. While the railroad turned a profit hauling coal from the anthracite fields of western Pennsylvania to New York City, it was unable to generate the passenger traffic it desired and needed.

AN UNLIKELY SOURCE saved the day: the fly fishermen who for years had been going to Sullivan County's Neversink, Beaverkill, and Willowemec Rivers.

"Trout fishing in this area dates back at least to the days of the Lenape," said Sullivan County historian John Conway. "Although they preferred to fish for shad because of its many uses, the Lenape developed a rather unique method of fishing for trout, which utilized the bark of the walnut tree."

In 1823, the *American Journal of Science and Art* verified that there was still an abundance of trout, especially in the Plattekill, Kaaterskill, and Schoharie Creeks, and found one angler who had caught five hundred of them in a single day. In the 1830s, two influential sports publications, the *American Turf Register and Sporting Magazine* and the *Spirit of the Times,* began offering regular coverage of fly fishing and the rivers of the southern Catskills, which only led to frustration. Great as it was to know that the fish were biting, how on earth were the anglers supposed to get there?

Said John Conway, "Most of the early tourists were fishermen who came here to try their luck in the many lakes and streams that were being promoted by the railroad and by the writings of people like Charles Fenno Hoffman," whose 1846 essay "A Fishing Frolic in Sullivan County" told of his journey that ended with a feast on the catch from White Lake, and Alfred B. Street, whose prose appreciation of Sullivan County's Mongaup Falls drew visitors to the natural wonder. "By 1845, so many tourists were coming to Sullivan County that a man by the name of J. Beekman Finley built a hotel in White Lake specifically for summer boarders."

Make that "a very rich man," said Conway, "one of New York City's most eligible bachelors when he purchased Great Lot Sixteen of the Hardenbergh Patent around 1800." Even so, "The hotel was not profitable, it didn't last very long, and the name was lost in history. But within a few more years, a second man, David Barton Kinney, built the Mansion House nearby. That was a profitable operation

and operated well into the 1970s. In fact, it is currently the oldest hotel still standing in Sullivan County."

BY 1848, the same year the Mansion House opened, the New York and Erie Railroad skirted the western edge of the Catskills and was the one line that came closest to the mountains' best fishing streams–although once the traveler had reached the station at Deposit, on the West Branch of the Delaware River, there was still the matter of a six- or seven-hour carriage ride over difficult terrain.

The situation would eventually improve thanks to the route of the O&W, which cut directly through some of the richest fishing spots in the southern Catskills. Once the system was completed, fishermen could disembark only a stone's throw from where they could happily cast their lines.

"The first scheduled passenger service on the O&W began on May 2, 1870, and on June 1 the *Kingston Journal* advised its readers that the first trout ever shipped over the rail line appeared at its office," fly fisherman and author Ed Van Put documented in his *Trout Fishing in the Catskills.* Soon, thousands of trout were being packed in ice and shipped south to market in New York City, and hundreds of fishermen began using the O&W as the most expedient way to reach their favorite fishing holes. As a further enticement, railroad management began stocking the rivers with fish to attract more anglers still.

"They ordered their baggage men to carry cans of young fish and boxes of fish eggs and to assist anyone loading or unloading trout," said Van Put. "Conductors were told to stop their trains at any stream and plant fish as long as they could do so without missing connections."

With that, fishermen started coming to the southern Catskills by the thousands. The *Windham Journal* reported in 1874 that "every house and barn in the towns of Denning and Neversink was filled with trout fishermen," and in 1878 some twenty thousand trout were seeded into the rivers of the region. By 1886, the number had grown to nine hundred thousand. So important was the commitment of the railroad to stocking the rivers of Sullivan County that in 1891 a specially built train car was designated for the sole purpose of transporting and distributing fish along the railroad's right of way.

Also contributing to the boom were writers and artists, who, unlike Cooper and Cole, had no need to idealize the region. Henry Inman, a New York City–based painter who, according to John Conway, "never lost his love of field

Fishing in Sullivan County, where an abundance of trout could be found in the Plattekill, Kaaterskill, and Schoharie Creeks, "dates back at least to the days of the Lenape," said historian John Conway.

and stream," rendered the canvas *Trout Fishing in Sullivan County* (1840–41), which the historian called "in its time, the most renowned landscape work of one of America's most renowned artists." Alf Evers said in his own praise of Inman, "In throwing a fly or spinning a mirror, he had few equals."

John Burroughs, who had initially been taught to fish by his older brother Curtis (and claimed, "Trout streams gurgled about my family tree"), described the riches of the region in one of his most celebrated essays, "The Heart of the Southern Catskills":

> But the prettiest thing was the stream . . . amid the moss-covered rocks and
> boulders. How clean it looked, what purity! An ideal trout brook was this, now
> hurrying, now loitering, now deepening around a great boulder, now gliding
> evenly over a pavement of green-gray stone and pebbles; no sediment or stain

of any kind, but white and sparkling as snow-water, and nearly as cool. Indeed, the water of all this Catskill region is the best in the world.

BOOSTING THE APPEAL of its destinations, the O&W offered discounts on the shipment of materials to builders who would construct new hotels, and in 1878 began publishing a free booklet it called *Summer Homes,* a guide to where to stay and what to do in the Catskills. (The actual publishing offices were at 56 Beaver Street, below Wall Street, and where today still stands the last remaining original Delmonico's restaurant.) In its first edition, twenty-eight hotels and boarding-houses made print, with four boardinghouses listed in the town of Liberty, able to accommodate 319 guests. By 1909, fifty-two major hotels could be found along the eighty-three miles of track between Cornwall-on-Hudson and Roscoe in the heart of trout country, and inside them were enough beds for some fifteen thousand guests.

The single greatest contribution to the decline of the northern Catskills and the ascent of the south, however, was the automobile, only four of which were registered in all of the United States in 1895. In the beginning, it was Jay Gould and Charles Fleischmann, of the yeast-making fortune, who could afford to be driven to their Catskills estates—their staffs went ahead by train—but soon farmers and factory workers were hitting the road behind their own set of wheels, thanks to Henry Ford. Putting the Model T into mass production in 1907, he delivered the automobile to within the financial grasp of most Americans. Not that motorized wheels were necessarily a welcome addition to the mountains, especially when big-headed "auto scorchers" raced their cars at high speeds down narrow country roads, frightening horses and endangering pedestrians. Boys who once made money by pouring water into overheated radiators for the first motorists whose Pierce-Arrows and Duesenbergs would stall on the steep climb up the Catskill escarpment were now throwing stones at passing cars. There were even reports of cars and drivers being shot at.

NOTING THE GROWING DIVIDE between the haves and have-nots in America while he was still president of Princeton, Woodrow Wilson, speaking at a formal dinner, said in widely quoted remarks, "Nothing has spread Socialistic feeling in

A June 29, 1929, "Talk of the Town" item in *The New Yorker*, titled "Skeptic," recounted an incident when Thomas Edison (left), John Burroughs (second from left), Henry Ford (second from right), and rubber tire magnate Harvey Firestone (right) were out on one of their jaunts when a tire blew. At the nearest garage, the attendant said he'd replace it with a new Firestone, upon which Edison, pointing to his companions, said, "That's Mr. Firestone in the car. And that's Mr. Ford next to him." When the attendant saw Burroughs, he is reported to have remarked, "Hello, Santa Claus."

this country more than the use of automobiles. To the countryman they are the picture of the arrogance of wealth with all its independence and carelessness."

Coincidentally bridging this widening gap between rich and poor was that curious friendship of that exceedingly odd couple, John Burroughs and Henry Ford. The industrialist, a former farm boy himself, was a fan of the naturalist (and later a friend), even though Burroughs had condemned the car as a "demon on wheels" with the capability, in his words, "to seek out even the most secluded nook or corner of the forest and befoul it with noise and smoke."

Burroughs's criticism prompted Ford to ponder how the writer might react should he be given his own car. If Burroughs were to accept such a gift, the sight of the venerable seventy-six-year-old behind the wheel of a Model T would assure rural America that a car was safe, practical, and, among their crowd, socially acceptable.

"One day," Burroughs recalled, "I got a letter from a man at the head of Ford's advertising department saying that Mr. Ford had read my books and they had given him a great deal of pleasure, and he wanted to make me a present of a Ford car. I didn't know what the dickens to think of such an offer, and I talked it over with my friends. They advised me to take the car, and I wrote back. 'If it would please Mr. Ford to present me with one of his cars, it would please me to accept the car.'"

On New Year's Day 1913, Ford furnished Burroughs not only with a shiny black touring car but also a chauffeur to teach the essayist how to drive, a skill that by no means came naturally. "Burroughs grew up driving teams of horses, driving teams of oxen," said historian Jeffrey R. Walker. "And the difference is that when you're driving a team of horses you don't have to watch the road all the time, because the horses watch the road. All you have to do is slow them down and stop them and start them and things like that. But you can look around and so John Burroughs would, of course, look around . . . he'd hear birds and he'd want to know what the bird was and things like that, so he did have a few accidents with his cars. He drove one through the barn up at Woodchuck Lodge and crashed into trees and things."

As a driver, Burroughs took "some time to manage it himself," Ford recalled in his memoir, but "he found that it helped him to see more, and from the time of getting it, he made nearly all his bird-hunting expeditions behind the steering wheel."

Whatever pitfalls Burroughs encountered on the road, Ford had calculated correctly. Burroughs at the wheel—and the extraordinary sight of Ford and Burroughs touring in a car together—turned out to be one of the auto company's greatest public relations coups.

The Outsiders

I

Hebrews will knock vainly for admission.

—Hotel sign in the Catskills, circa 1880

Records dating back to 1773 pertaining to the Hardenbergh Patent indicate a lessee known as "Jacob the Jew" as occupying land on the Livingston estate around Woodstock. Jacob, it is believed, holds the distinction of being the first Jewish person to live in the Catskills.

The first full colony of Jews to be established in the mountains—it has also been credited as the first Jewish agricultural colony in the United States—was called Sholam, Hebrew for "peace." Here, in 1837, in the Ulster County town of Wawarsing on the periphery of the Hardenbergh Patent, thirteen families led by Moses (the organizer's full name was Moses Cohen) settled and opened the first synagogue. "The land was divided into lots of five acres each, and a site was selected for a village," Leo Shpall wrote in 1950 for *Agricultural History* magazine. "Contracts were awarded to build houses at a cost of four hundred dollars each [not quite $10,000 today]. The settlers requested that Congregation Anshe Chesed of New York loan them a *sefer Torah* until they could secure one from Europe, and they also asked for lamps for their synagogue."

As Shpall also reported, "The newcomers cleared the land and built roads. For five years they tried to make farming pay, but circumstances forced them to add to their earnings from the produce of the land by manufacturing and trading"—quill

pens and fur caps, as well as peddling mended cast-off clothing around the countryside, according to a 1934 periodical called *Our Jewish Farmers.*

"Notwithstanding," said Shpall, "the colony carried on. The climax, however, came when the factories in the neighborhood were shut down." Doors also closed on the synagogue; the religiously observant were forced into the city of Hudson for their Sabbath meals and rituals.

"After a few years of further struggling," said Shpall, "the settlers found it impossible to continue." In 1842 they sold their belongings and moved on.

THE JEWISH PILGRIMAGE to the Catskills from New York's crowded Lower East Side, the first stop for most Eastern European Jews upon their arrival in America, did not begin "until the late 1800s and early 1900s, when Sullivan County . . . developed an important summer resort trade," sociologists Abraham Lavender and Clarence Steinberg state in their 1995 study *Jewish Farmers of the Catskills: A Century of Survival.*

Crediting the influx to the proximity of the lower Catskills to New York City, the authors also said that "it was in the mountains of Sullivan County and the southern part of Ulster County that the largest and most successful Jewish farm settlements developed." As corroborated in the *Kingston Daily Freeman,* "Jewish shop workers and small store keepers from the city wended their way for a whiff of fresh air, and in the meantime began transforming a poor, run-down agricultural area into flourishing, prosperous Jewish resort and farming communities."

In contrast, the upper Catskills had already become a comfortable home to Christian summer resorts starting with the very first, in 1823, in Haines Falls. Others followed in Greene County (named for "the Fighting Quaker" general of the American Revolution, Nathanael Greene), northern Ulster County (after the Irish province), and the northeastern reaches of Delaware County (named for its river, which was in honor of Thomas West, Third Baron De La Warr). The accommodations included the Catskill Mountain House and its growing number of competitors once the railroads expanded.

"The O&W [Railroad]'s vacation guide, *Summer Homes,* listed all the hotels," said Sullivan County historian John Conway. "In addition, there were page after page of testimonials from Manhattan and Brooklyn doctors, saying how efficacious the air was. In fact, for years the O&W slogan was, 'Doctors say, "Go to the

mountains.""" Some didn't need the O&W to tell them. "New York's Christian (primarily Protestant) semi-aristocracy," said Lavender and Steinberg, "had vacationed in the Catskills for decades before the advent of railroads [and] watered at the great resorts of the period such as Lackawack House, Yama Farms Inn, and Mt. Meenahga, all near Ellenville."

At first, a mini-melting-pot atmosphere existed. In the 1870s, visitors to the upper Catskills were mostly German-speaking Protestants and Catholics, though it wasn't their religions that prompted their travels there. Some Jews visited too, and the assorted groups all shared the same boardinghouses. As the 1880s drew to a close, however, "boardinghouses began to be segregated into Christian or Jewish houses," said Lavender and Steinberg. Such categorization was voluntary, as was an eventual division by nationalities. This saw the rise of separate boardinghouses for Russian, Polish, and Hungarian Jews.

The Catskills were often capable of yielding enough milk and butter, maple syrup, apples, potatoes, cauliflower, and wool to feed and clothe the family growing them, but as a commercial enterprise, farming in the region was generally a no-win situation, with the terrain offering "two stones for every dirt."

FIVE YEARS AFTER the end of the Civil War, the Midland Railroad was up and running from New York City to Summitville, at the foothills of the Catskills, as part of an elaborate blueprint to extend the line as far as Chicago, in order to compete with the rival New York Central. Although the dreamed-for expansion only made it as far as the New York State border, the Midland proved "significant both as the world's first milk line and as a developer and mainstay of summer resorts," said Lavender and Steinberg, citing the establishment of Jewish farmhouses offering summer board in Midland's main Sullivan County stops of "Centreville (later renamed Mountaindale), Liberty, Liberty Falls (later renamed Ferndale), Luzon Station (later renamed Hurleyville), Pleasant Lake (later renamed Kiamesha Lake), Loch Sheldrake [the former Sheldrake's Pond], Livingston Manor, and Parksville."

"The mountains in Sullivan County and southern Ulster County were not as high as those in the upper Catskills, but to Jews who knew no mountains in Russia or Poland, they were high enough to have scenic beauty and cool breezes," said Brown University professor Phil Brown. "There were also more lakes and streams, and less pollution from tanning, in the lower Catskills."

"It's a period that we today refer to as the Silver Age," said Conway, "which began about 1890 and lasted until about 1915. Hundreds of hotels grew up in Sullivan County, mostly around towns that were served by the railroads. If you had a natural body of water nearby that was a plus. We probably had two hundred or more hotels, as well as literally thousands of old farmhouses. Farmers began to take in boarders, because everyone wanted to come to the mountains."

And while the Jewish worker from the city, staying in his modest accommodation, was likely to be satisfied with his "whiff of fresh air," the Wall Street and Tammany Hall power brokers who partook of the rarefied Victorian elegance at the Christian resorts achieved their own sense of satisfaction, too—"cigars, bustles, parasols, oysters, and, of course . . . dairy products, produce, and, in some cases, game," according to Lavender and Steinberg.

Not to mention a total lack of fear about any face-to-face encounters with "Hebrews."

AT CHARLES BEACH'S CATSKILL MOUNTAIN HOUSE, a gentleman's agreement tacitly kept non-Christians from being admitted under the hotel's mandatory

Sunday church service rule—unless, that is, the affluent Jews staying there were willing to pass, which sometimes was the case.

One of Beach's sons, speaking to a *New York Herald* reporter for the newspaper's July 16, 1878, editions, candidly explained why the old man dragged his feet when it came to allowing a cog railroad to whisk would-be guests up the mountain to his hotel: "[Because it] would bring a great many people here who wouldn't be desirable and whom I wouldn't care to have." As interpreted by Alf Evers, Beach's remark was meant to refer to "the poor and the near-poor of the sort who used the Ulster & Delaware [Railroad]. But he probably also had in mind Jews" who would not observe Sunday services or indulge in "the particular brand of reverence for nature" as was promoted at the Mountain House.

The Beaches and other Protestant hotel owners in the Catskills certainly were aware of the potential risks involved, given how easy it would be for them to lose customers to any number of the emerging socially prominent resorts in Newport, Saratoga, or even the South's "Queen of the Watering Places," White Sulphur Springs in West Virginia. At such rarefied retreats, immigrants were virtually unheard of.

Those wishing to remain within carefully restricted reserves could avail themselves of the Catskills' private residential parks of Onteora Park, Sunset Park, and Twilight, whose original intention was to provide a more congenial environment than the large, impersonal hotels.

Overlooking the Esopus Valley, Onteora Park in Tannersville, which would eventually encompass two thousand acres, had served as the original base for Thomas Cole's and Asher B. Durand's sketching expeditions. In 1883, it was laid out as a summer residence for artists, writers, and select wealthy families by its founders, Candace Wheeler, the country's first important female textile designer; her brother, wholesale food merchant Francis B. Thurber; and his wife, the former Jeannette Meyer, who'd gone to the mountains to cure her bronchitis.

Immediately falling for the area's charms, Thurber purchased the property, which the three called Lotus Land. "It was Mrs. Thurber who dubbed the colony 'Onteora': 'Hills of the Sky,' in the language of the Mohawk Indians who populated the area," according to *Cultivating Music in America: Women Patrons and Activists Since 1860.* "Over the next few years the Thurbers, Candace Wheeler, and Samuel Coykendall formed the Catskill Mountains Camp and Cottage Company, which later became the Onteora Club, a private corporation established to sell and rent summer cottages, build and manage a guest inn ('The Bear and Fox'), and maintain the land."

eginning in the early 1800s, Irish Catholics, Germans, and a sprinkling of other nationalities entered America's low-wage labor force, to dig the canals and work the tanneries and bluestone quarries. Unlike the country's earlier émigrés, primarily northern and western European Protestants, this group sparked a fervent nativist movement that included protests and even riots.

In the Catskills, once the tannery and quarry jobs dried up after the Civil War, many of the immigrants took jobs cleaning rooms, preparing and serving meals, and washing and ironing clothes in the growing number of summer hotels and boardinghouses. Despite their legion—in the thousands—their daily presence barely registered with the wealthy guests upon whom they tirelessly waited around the clock.

At about the same time, the floodgates of Jewish immigration to the United States were opening wide because of the Russian pogroms of the 1880s. Every year between 1871 and 1880, about four thousand Russian Jews entered the United States; in the next decade the annual number climbed to twenty thousand. From the late nineteenth century to 1924, the total Russian Jewish population in the United States reached two million, sounding an alarm so loud that it helped prompt passage of the national Immigration Act.

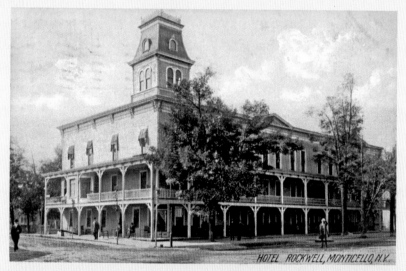

The Silver Age of tourism in Sullivan County "began about 1890 and lasted until about 1915," said John Conway. "Here the city man may find good hotels and attractive farmhouses," *The New York Times* wrote in 1902. "At Monticello, the Hotel Rockwell, the Palatine Hotel, and the Frank Leslie are reliable places."

Mark Twain and his daughter Susy, as Hero and Leander, at Onteora

In the summer of 1890, Mark Twain, his wife, Livy, and their three daughters called Onteora Park home—although the author, who had planned to use his quiet time there to write a sequel titled *Tom Sawyer and Huckleberry Finn Among the Indians*, complained that the walls of his cottage were so thin that one could hear a woman changing her mind in the next room. Twain at the time was suffering rheumatism in his shoulder and arm that crimped his ability to write, and after first thinking he'd take in the waters of European spas, brought his brood instead to Onteora, chiefly because, as reported in *The Hemlock*, the quarterly newsletter of the Mountain Top Historical Society, members of his professional and social set resided there, including *Harper's Magazine* literary editor Lawrence Hutton.

As Twain's daughter Susan (Susy) Clemens wrote of the resort's setting in her biography of her father:

[T]here were farmhouses here and there, at generous distances apart. Their occupants were descendants of ancestors who had built the houses in Rip Van Winkle's time, or earlier; and those ancestors were not more primitive than were this posterity of theirs. The city people were as foreign and unfamiliar and strange to them as monkeys would have been, and they would have respected the monkeys as much as they respected these elegant summer-resorters. The

muning with nature less important, a fact that also decreased the appeal of high mountains."

Hotel managers were not about to stand idly by. To maintain the atmosphere they desired, they set up a covert communications network to exchange information and weed out unwanted guests. By the 1880s, the sifting had become so prevalent that *The New York Times* referred to it as "the anti-Jewish crusade in the Catskills."

Not that everyone knuckled under.

SHORTLY AFTER the Civil War, the Hungarian-born (in 1834) Charles Fleischmann, having settled in Cincinnati (in 1868, two years after having arrived in New York), had "built the present-day equivalent of an industrial, biotech empire," said his great-great-grandson Christian R. Holmes IV. Fleischmann biographer P. Christiaan Klieger, in chronicling the "well-timed business acumen, political dexterity, and the cultivation of civilization" of the patriarch, went on to laud, "The Fleischmann story also reveals landmark innovations in the history of American advertising, with perhaps the first and most successful application of the brand-name concept that was to dominate the American market to this day."

And all from yeast.

But while Fleischmann and his wife, the former Henriette Robinson, raised their three children as Unitarian Christians, Fleischmann was actually part of the great second wave of Jewish immigrants to America, following those first arrivals who settled along the eastern seaboard. After 1830, others crossed the Appalachians into the Ohio and Mississippi Valleys, while some headed even farther west with the forty-niners during the California gold rush. They included traveling salesman Levi Strauss, who, from his headquarters in San Francisco, supplied the miners with his patented work pants that wouldn't rip.

Around 1883, according to local lore, Charles Fleischmann was experiencing respiratory problems that called for mountain air. Rather than deal with the prejudice of the times, he eschewed the better Catskills hotels and purchased sixty acres west of Griffin Corners, a Delaware County hamlet named for prominent attorney Matthew Griffin. Businessman John M. Blish handled the sale and sought a reasonable price, having realized what an advantage an investment by someone such as Fleischmann could mean to the town. Blish was correct. According to Klieger, "Turning Griffin Corners into a monument of gracious living–not far

from New York City—attracted other people of Jewish ancestry who were snubbed by society watering holes elsewhere, and other mansions and hotels followed."

Charles Fleischmann built his mansion near the Ulster and Delaware Railroad station and outfitted a musical band in uniforms to greet arriving guests and family members. "The magnate's playground," said *Catskills Culture* author Phil Brown, "included a heated pool, a trout pond guarded by a watchman in a tower, a riding academy, and a baseball stadium" for the semipro Mountain Athletic Club.

Herbert Lehman, governor of New York, had a home in the town that when it incorporated, in 1913, sixteen years after Charles Fleischmann's death, was renamed Fleischmanns.

Among those ill-suited to their new existences on the Lower East Side were the many Eastern European Jews who had worked in the Old Country as farm managers on Christian estates or had owned farms registered under fictitious Christian names in order to bypass laws prohibiting Jews from holding property. Still dreaming of haystacks and cows, they abandoned their tenements and headed for the southern Catskills, as evidenced by the large number of property sales to "Hebrews" in local town records.

"[M]any Jews were affected by the 'Back to the Soil' movement then coming into popularity among the Russian intelligentsia, and expressed in the writings of such Russian literary greats as Tolstoy and Turgenev," said Jewish historian Joel S. Geffen. "It was also widely believed that anti-Semitism was at least in part due to the fact that Jewish people earned their livelihood as middlemen and were 'nonproductive' members of the community. One solution would be for Jews to turn to vocations requiring physical labor and to establishing agricultural colonies."

Only once settled in the mountains, the Jews found, in addition to the bad weather, land that was virtually useless from overfarming. Money-starved and devoid of other resources, they faced but one alternative: rent out rooms to paying friends, relatives, and other escapees from the city. Records from the Jewish Agricultural Society bear out this transition, indicating as many as 1,000 Jewish farms in Sullivan County by the turn of the century. By 1904, 161 of them were doubling as boardinghouses for New York City Jews. By 1910, that number had increased to 710.

Facilitating this development, "Strictly Kosher" and "Hebrews Only" boardinghouses began being listed in the O&W Railroad's *Summer Homes* catalogs, with the train line promoting specially discounted weekend commuter round-trip fares

nother famous Fleischmanns summer resident—of the household-name variety—wasn't well known when she lived there. In fact, most people might not even have given a second thought to Tillie Edelstein, unless they happened to speak to her.

Born in 1899, the only child of Jacob and Dina Edelstein, residents of the Jewish section of Harlem, Tillie spent her summers at the boardinghouse run by her father in Fleischmanns, where she wrote skits to entertain the guests' children, along with many of the adults.

At eighteen, Tillie married Lewis Berg, a Columbia University engineering student she had met at the boardinghouse four years before. The young bride enrolled in Columbia extension courses in playwriting, and, continuing to hone her craft in the Catskills, she sold CBS a radio script called *Effie and Laura*, about two salesgirls in a department store.

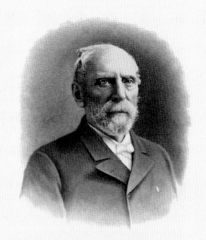

Rather than kowtow to the prejudice of Catskills hotels, yeast magnate Charles Fleischmann bought his own mountain town.

Though the show was an instant flop, Tillie, now going by the more professional-sounding name of Gertrude Berg, quickly prepared another pitch. Afraid, however, that NBC executives might not understand it, she performed all the roles herself. The move prompted the network to insist she be the star of the show.

Called *The Rise of the Goldbergs,* the program debuted a month after the stock

to Liberty, Hurleyville, Loch Sheldrake, Livingston Manor, and other primarily Jewish areas. Free freight for building materials to be used by prospective farmers or boardinghouse owners was also provided. This ensured that there would be even more of these new businesses.

Discrimination was not strictly limited to non-Jewish hotels, and within their own ranks there were harsh and clearly delineated Jewish social strata. At the turn of the century, advertisements for Sullivan County's Jewish-owned High View Farm promoted its clientele of "a good class of Hebrews," which was to be inter-

market crash, November 20, 1929, and delivered just the sort of homespun escape the public craved, whatever the listener's cultural background. Set in the Goldberg family apartment at 1038 East Tremont Avenue in the Bronx—occupied by matriarch Molly Goldberg (Berg, affecting a malapropism-heavy, Yiddish-inflected speech), husband Jake the tailor, children Rosalie and Sammy, and Molly's brother Uncle David—the sitcom, one of the first, had a seventeen-year run on radio before moving to television from 1949 to 1955. (*The Goldbergs* was such a radio phenomenon that Berg was said to have sealed the TV deal with CBS founder William S. Paley in a three-minute meeting.)

Berg not only produced and starred in every episode but wrote nearly every script—in longhand, forty-five hundred scripts in all—and openly admitted that while the strongly independent Molly, who stood for truth, justice, and the American way, was an amalgam of her mother and maternal grandmother, many of the show's other characters were based on those she had observed in the Catskills. (On the show, the Goldbergs summered in the mountains, at the thirty-room Pincus Pines, whose chief competitor was Weissinger's.)

In real life, the Bergs, who had two children, Cherney and Harriet, didn't live in the Bronx but in Manhattan, on Park Avenue, and the gifted Gertrude was as elegant and cultured as she was prolific.

Eventually, the media pioneer, whose influence later could be seen on just about everything from *The Adventures of Ozzie and Harriet* to *The Cosby Show* to *Modern Family*, returned to Fleischmanns. Upon her death in 1966, Tillie Edelstein Berg was buried in the family plot in Clovesville Cemetery.

preted as meaning deeper-pocketed and Americanized German and Sephardic Jews, rather than those just off the boat from Eastern Europe.

"Eventually, the Silver Age begins to collapse," said John Conway. "The hotels and boardinghouses that had grown up during this period began to close or struggle, and they are sold cheaply. In many cases they're purchased by Jewish families who were moving to the mountains. This was a phenomenon that was noted in the local papers for years. You'd see an article—'Smith Farms sold to Hebrews, pay twelve thousand dollars, expect to take in summer boarders'—articles of that

nature. At first, it was kind of a novelty that these Jewish families were coming up and populating the area. But as soon as we moved into the twentieth century, it's pretty evident that the Silver Age has ended. Nineteen fifteen is really the official end, but 1914 is an important year. The Wowanda, which [opened in 1896 and] had been the premier Silver Age resort with three hundred rooms and its own golf course, and bicycle trails, and, really, just the most elaborate architecture of all the Silver Age resorts, burned in 1914 after struggling for several years. And that officially signaled the beginning of the end of the Silver Age.

"Ironically," added Conway, "1914 also marked the year that the Grossinger family arrived in Sullivan County."

II

In 1870 tuberculosis of the lungs was responsible for about four thousand deaths in New York City; this figure rose steadily in the ensuing years until about 1890, when almost fifty-five hundred deaths were reported.

—JOHN DUFFY, "Social Impact of Disease
in the Late Nineteenth Century"

Between 1700 and 1900, tuberculosis, or consumption as it was commonly known, had killed more than one billion people worldwide. In the 1880s, New York City had the unwelcome distinction of claiming the highest number of tubercular deaths of any city in the world; entire sections of slums, where tenement rooms lacked windows or even the slightest ventilation, were written off as "lung blocks," given their alarmingly high concentrations of the disease. According to a New York City Board of Health map, one Lower East Side block, bordered by Catherine, Hamilton, Market, and Cherry Streets, contained virtually no dwelling uninfected by tuberculosis between the years 1894 and 1903.

Before antibiotics effectively tamed the disease in the 1950s (though a 2014 report cited an annual 1.3 million people worldwide still dying from it), tuberculosis had been claiming victims ever since ancient Egypt. Among the notables who suffered with it, often fatally, in America were Edgar Allan Poe, Ralph Waldo Emerson, Stephen Foster, Henry David Thoreau, Andrew Jackson, Ulysses S. Grant, Jay Gould, and Eleanor Roosevelt. At Washington Irving's house, Sunny-

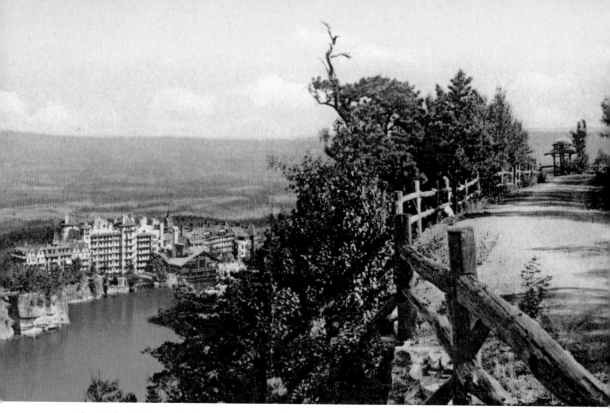

The Mohonk Mountain House maintained a Christians-only policy and shared information about guests with other Catskills hotels. By the end of World War II, however, the Jewish Theological Seminary was holding annual meetings there.

side, the author and those in the guest bedrooms slept sitting up every night, the belief of the time being that the position would ward off tuberculosis. It did not; Irving too succumbed to the disease, in 1859.

By the 1890s, the findings of Prussian microbiologist Robert Koch, who isolated the airborne bacillus that caused tuberculosis, proving that the disease was contagious rather than hereditary, helped earn him the 1905 Nobel Prize in Medicine. Still, a frightened public continued to grasp at nearly any exotic treatment that was placed on the market. From California to Washington, D.C., quacks concocted potions and curatives, some very profitable (for the quacks) but useless (to the patients).

Folk medicine also took on a renewed popularity. In the Catskills, a common belief was that the only way to whip TB was to ingest a rattlesnake's heart.

While it was still beating.

AMONG THE MORE LEGITIMATE MEANS of treatment was the popular "rest cure" at a clean-air sanitarium. The first of these was established in 1863 by a German botanist turned physician, Dr. Hermann Brehmer, who, having contracted tuberculosis in the 1840s, traveled to the Himalayas and was pleasantly relieved to find that the time spent at the high altitude had improved his condition. Returning to Germany, he founded a clinic in a small Silesian village eighteen hundred feet above sea level, where the treatment for tubercular patients involved a regimen of nourishing food, exercise, and constant medical monitoring—a radical departure from earlier remedies that usually involved shutting patients away in hot rooms and administering large doses of ineffectual medicine.

With success in curing some patients and limiting the progress of the disease

E stablished in 1869 on a nearly three-hundred-acre site where originally stood a tavern with ten rooms, the Lake Mohonk Mountain House was built adjacent to a small lake on Shawangunk Ridge, across the Ulster County countryside from the Catskills, and offered arresting views of the mountains from the entire front exterior of the hotel. Greatly expanded (though "Lake" has been dropped from its name), Mohonk is still in operation today as a year-round destination resort, conference center, and spa.

The lodge's founders, identical twins Alfred and Albert Smiley, were Quaker educators born in Maine in 1828 and graduates of Haverford College in Pennsylvania. Originally planning a summer residence, the Smileys, having only modest salaries as teachers, needed to take in paying guests to share their wonderland. Very soon, 251 rooms greeted the May-to-November crowd, while a Quaker boys school also operated on the site in the off-season.

Similar to the Catskill Mountain House, Mohonk offered room and board and pampered its guests in a grandly designed, turreted hotel. And, like the Catskill Mountain House, by the early twentieth century it too was completely restricted.

In February 1916, the secretary to the owner of Mohonk—whose management had been assumed in 1881 by the Smiley twins' younger (by twenty-seven years) half brother, Daniel Smiley—sent a letter to the manager of the Chalfonte Hotel in Atlantic City, discreetly inquiring about a guest of theirs, Mr. H. B. Houseman.

in others, Brehmer's treatment was soon applied in other sanitariums established across the Continent. This included Dr. Friedrich Jessen's nearly mile-high Waldsanatorium in Davos, Switzerland, credited with inspiring the fictional Berghof Sanatorium in Thomas Mann's 1924 masterwork *The Magic Mountain.*

Although the United States was slow to adopt these advances, Dr. Alfred Loomis, a prominent New York City physician whose entire family, except for one member, was wiped out by the disease, devoted his life to battling tuberculosis from the time of his 1853 graduation from the College of Physicians and Surgeons at King's College (later Columbia University). In 1866, at age thirty-six, he too began experiencing a cough, loss of weight and strength, night sweats, and other signs of incipient tuberculosis. "Now keep in mind that at this point in time this

"From the nature of the application we are just a little bit curious to know exactly how cordially to reply, although from the fact that the gentleman writes from your good house, we are very much inclined to assume that everything is all right," the secretary wrote. (The Chalfonte manager replied that Mr. and Mrs. Houseman were both practicing Christian Scientists.)

To keep the situation in check, every year Mohonk's house manager prepared a report describing "Undesirable Guests." During the First World War, this included Germans and those with pro-German sentiments.

An entry from 1917, however, read, "Wm. W. Cohen, a high-class Hebrew, rather insisted on coming, even after learning that he would probably be unwelcome. It took only three days for him to realize his mistake." Another update observed, "A few Jews crept in on over-night parties, but on the whole the Hebrew question gave no trouble."

This gentleman's agreement between hotels ultimately faded away, at least at Mohonk, which continues to be owned and operated by descendants of Daniel Smiley and his wife, Effie. As seen in hotel archives, from 1946 to 1968, Rabbi Louis Finklestein, leader of the Jewish Theological Seminary, held an annual conference at the Mohonk Mountain House, "in which he brought together eminent persons from the fields of business, philosophy, sciences, ethics, theology, and government to discuss the values and problems of contemporary civilization."

Dr. Schenck's Medicine, circa 1880, claimed to be "the best and most positive cure for Consumption, Coughs, Sore Throat, Hoarseness, Whooping Cough, and all other diseases of the throat, lungs and respiratory organs."

disease was befuddling the medical community," said Sullivan County historian John Conway. "In fact, most physicians assumed for centuries that tuberculosis had been an inherited disease—that it wasn't contagious."

Considering himself an invalid with barely months to live, Loomis went to the Adirondacks with no assumption that the setting might help restore his health. "He had always enjoyed the outdoors, and the Adirondacks, in particular," said Sullivan. "So he spent several weeks there in a tent, and was amazed by the physical recovery he made."

"I came out of the Adirondacks free from cough, with an increase in weight of about twenty pounds, with greater physical vigor than I had known for years," Loomis said. "My personal experience that summer convinced me that there was something in the air of this region especially adapted to diseased lungs."

A subsequent visit to the Adirondacks in 1873 helped connect Loomis with Dr. Edward Livingston Trudeau, who himself had come down with TB at the age of twenty-five, forcing his retirement from the practice of medicine. On his doctor's orders, Trudeau had spent the spring down south, "which was where most doctors at the time were sending their tubercular patients," said Conway. "He had an immediate relapse."

Wishing to spend his remaining months hunting and fishing, Trudeau arrived at Paul Smith's Hotel in the Adirondacks so emaciated that he had to be carried to

his room. Though Trudeau had been warned that the cold weather would surely prove fatal, Loomis successfully urged him to extend his time in the Adirondacks to the entire winter. Not only did Trudeau recover, but he was able to resurrect his medical practice and tout the benefits of the Adirondacks as "a natural sanitarium."

In 1885, with the assistance of Loomis and some affluent friends, Trudeau founded the Adirondack Cottage Sanitarium in New York's Saranac Lake, the first sanitarium in the United States devoted solely to the treatment of tuberculosis. Besides conditioning patients to withstand constant exposure to inclement outdoor weather, Trudeau, following the teachings of Dr. Brehmer, also prescribed their following a program of "good and abundant food and rest and discipline." Among the first to be treated was Robert Louis Stevenson, whose celebrity helped publicize the facility, giving it the reputation as the American Davos.

"Loomis continued to practice in New York City," said Conway, "where he saw the disease continue to ravage the population. But he realized that sending people to the Adirondacks was not a good solution. It was just too far away, and the Adirondack sanitarium could only handle a few people at a time, so he began to experiment with other geographic areas."

One suggestion came from Bethel native Daniel Bennett St. John Roosa, an 1860 graduate of New York University's Medical College and a founder of the Manhattan Eye, Ear, and Nose Hospital, in 1869. "On the recommendation of [Roosa]," said Conway, "Loomis began sending people to Liberty," which research showed to have the lowest death rate from tuberculosis in New York State.

Here, at twenty-two hundred feet above sea level and only a four-hour train ride from New York City, Loomis chose a 190-acre site to build a sanitarium that would treat both the poor and those with the means to afford treatment.

Manhattan's Dr. Alfred Loomis spent his entire career seeking to cure the disease that had wiped out most of his family.

With an $85,000 initial contribution from J. P. Morgan, whose first wife, Amelia, died of tuberculosis only three months after their wedding, construction began on the Loomis Sanitarium in 1894.

That same year, his system already weakened from his bouts of TB, Loomis contracted pneumonia. He died January 25, 1895, eighteen months before the doors opened at the Loomis Memorial Sanitarium for Consumptives.

"IT OPENED IN June of 1896 and this brand-new protocol for treating tuberculosis was practically an immediate success," said John Conway. "It was a kind of holistic regimen that included living outdoors as much as possible while also participating in the normal functions of everyday life. The patients at Loomis were allowed to housekeep their own cottages. They went to dinner. They put on shows. There was a library. They were active. One of the tenets of treating tuberculosis, according to Loomis—the sanitarium followed his vision, even though he had died—was, 'Send these people to a hospital and they die.'"

After the first seventy patients were admitted, the *Boston Medical and Surgical Journal* reported, "The statistics at the end of the first six months show a remarkable improvement in sixty percent of the cases, and there have already been nine discharged in which the disease was regarded as arrested or controlled."

"The sanitarium went from five buildings in June of 1896 to over twenty buildings by 1901," according to Conway. "They pioneered many of the new methods of treating tuberculosis and diagnosing the disease, including the use of X-rays."

The community of Liberty—"home to dozens of rambling wood-framed Victorian hotels that catered to summer boarders," said Conway—benefited from the new health facility, which "became a major force in the economy of Sullivan County of the Catskills." The summer trade expanded to

Dr. Edward Livingston Trudeau, dying of tuberculosis, was convinced by Alfred Loomis to spend the winter in the Adirondacks, where he would miraculously recover and open a sanitarium on Saranac Lake.

The Loomis Sanitarium "opened in June of 1896 and this brand-new protocol for treating tuberculosis was practically an immediate success," said John Conway.

year-round, and hotel and boardinghouse owners leapt upon the chance to promote their lodgings to consumptives in newspapers and magazines. The O&W Railroad ran a series of notices in *Summer Homes* quoting "What medical experts say," which was, "The immediate neighborhood of Liberty, New York, is one of the best regions for consumptives. Doctors Say Go To the Mountains." The railroad also began publishing a cold-weather-months supplement called *Winter Homes* to sell Sullivan County as "A Winter Health Resort [with] Climatic Treatment for the Throat and Lungs."

"Noted for its healthfulness," said a Liberty brochure, "[the climate] has been well described as 'delightful in spring, restful in summer, charming in autumn, and invigorating in winter.'"

"Initially everyone loved it," Conway said of the sanitarium. "Money was being made. Lots of boardinghouses. And then, suddenly, the other side showed up. The good and the bad."

Little did the hotel owners and railroad management anticipate that their perceived bonanza would backfire.

In addition to a barn that supplied patients and staff with milk and eggs, the Loomis Sanitarium also provided a golf course and casino on its handsomely landscaped grounds.

The final owner of the Loomis Sanitarium was the brash publisher, nudist, nutritionist, and physical-culture proponent Bernarr Macfadden, who had lost his mother to tuberculosis and feared that he too would be stricken.

"It's important to understand what was going on in Sullivan County at the time this sanitarium opened in 1896. The southern Catskills had just really begun to gain some notoriety as a tourist destination. People were coming up to enjoy the fresh air and clean water during the summer months. But an interesting phenomenon was occurring in the medical profession. As the nineteenth century came to a close, the medical profession suddenly became aware of the fact that tuberculosis was not inherited, but was a contagious disease."

Passenger traffic on the O&W ground to a standstill. Within the town of Liberty—where the sight of weakened men and women with flushed cheeks, unnaturally gleaming eyes,

The centerpiece of the Loomis Memorial Sanitarium was its barn, which, to the specifications of patients' regimens, produced fresh milk and eggs at a time when refrigeration was unknown. For recreation, in addition to frequenting the casino, patients could play croquet and golf, with the greens helping to further distinguish the facility from a hospital.

Chief among the benefactors of the sanitarium was the socially connected philanthropist Mary Irvin, the wife of the Manhattan banker Richard Irvin and the sister-in-law of Alfred Loomis. It was she who reached out to J. P. Morgan and then selected two of New York's more celebrated architects, J. Russell Pope and Bruce Price, to design the facility.

"Pope later designed the Railroad Building, the largest building at the 1939 World's Fair," said John Conway. Price's best work could be found in the wealthy vacation community of Tuxedo Park, in Orange County, New York, though he was also responsible for many of the Canadian Pacific Railway's château-style stations and hotels.

"Despite an impressive body of work," said Conway, "he is perhaps best known today as the father of Emily Post, the queen of etiquette and good taste in the early twentieth century."

and gaunt bodies coughing and spitting into sputum flasks on hotel porches had become commonplace—the healthy visitors couldn't check out fast enough.

"So what started as an economic boom," said Conway, "began to adversely affect the resort industry here."

To curb the desertion, front desks tried turning away anyone who looked sickly, and in the unfortunate event of an actual death in the middle of the night, hotel managers would smuggle the body into a funeral parlor that would be in on the dirty little secret. The next morning, hotel guests would learn that the suddenly absent visitor had been called away "on business."

As precautionary measures, laws were enacted against spitting in public, and in 1901 Liberty's Board of Health passed an ordinance barring any building within village limits from being used as a hospital, pest house, or sanitarium, with penalties ranging from fifty to one hundred dollars.

Only these regulations did little: the Loomis Sanitarium and many of the guesthouses stood outside village limits. "Ironically," said Conway, "the resort owners' opposition would soon bring an end to their own industry, while Loomis would continue to thrive into the 1940s."

In the end, enforcement of health laws proved ineffective. Consumptives moved in and guests moved out, vowing never to return. Property values, already having taken a hit from the presence of Eastern European Jews in the Protestant playground, plummeted. "For Sale" and "Closed" signs went up. Hotels went under. Fortunate owners got out at a loss. Unfortunate owners lost everything.

Eventually, Loomis's monument disappeared too. The Great Depression gutted the fortunes of most professional medical facilities in the nation, including the sanitarium in Liberty. In 1938, having expanded to 780 acres but its staff down to a skeleton crew and the number of patients greatly diminished, the Loomis Sanitarium was purchased by the flamboyant physical-culture faddist Bernarr Macfadden, who with his characteristic bluster and enthusiasm ran it for four years, before the property closed for good on July 31, 1942.

Today, of what remains, Loomis's overgrown chalet-style main building, whose design served as the prototype for the area's large boardinghouses that followed, as well as the sanitarium's domed, Monticello-inspired adjacent structures, stand derelict amid patchy, neglected lawns. In better days, they had been adorned by manicured floral gardens that looked as if they had been designed by Thomas Cole.

Planting the Seeds

> For eight months in the year [the Jewish farmer] is forgotten . . . but
> with the oncoming of the summer, a host of friends appear on the
> scene. . . . These friends are not unlike friends everywhere. They like to
> visit you at your summer home and dine with you, and some of them
> bring their baggage along with them for an extended stay.
> — "A VOICE FROM THE GHETTO," *The American Hebrew*, August 1903

F amily separations were not unusual for the Grossingers. The first took place
in 1897, when Selig, the head of the household, left his wife and two daugh-
ters in their native Galicia, then part of Austria, and sailed to the United
States. Pressing coats with a twenty-pound charcoal-filled iron on New York's
Lower East Side twelve hours a day, six days a week, for three years finally enabled
Selig, at thirty-three, to send for Malke, his wife, and their girls, Jennie, now aged
eight, and Lottie, five.

Immediately prior to their departure aboard the SS *Potsdam,* Malke went to
say goodbye to her father, a country innkeeper in a neighboring village. Among
the promises, Malke vowed to her father that she would never become so Ameri-
can as to remove her *sheitel,* the wig worn by married Orthodox women over their
own hair as a sign of their modesty.

AFTER A TEARFUL REUNION on Ellis Island, Selig escorted his wife and daugh-
ters to the ferry to Battery Park, where Jennie Grossinger took her first step on

the American continent. The wide-eyed arrivals then climbed the stairs to board what looked like a locomotive on stilts, and despite their father's assurance that "the train will not fail," the jerky contraption scared the girls as it wended its way to the Allen Street station. From there, the Grossingers walked through the busy streets to a cousin's tenement apartment, where in the middle of the two rooms was a table piled high with food, including a sausagelike something that Jennie had never tasted before, a frankfurter.

The welcoming party with the cousins having concluded, Selig took his family to their new home, three simple but clean rooms at 158 Ridge Street, only six or seven blocks from the public baths where the Grossingers would go once a week. Among the pushcarts, makeshift playground, and even an organ grinder with his monkey, the child Jennie adapted to life on Manhattan's Lower East Side.

A second prolonged family separation began in June 1904, three years after the birth of the Grossingers' son, Henry, who had been born deaf. When doctors in New York saw no hope for the boy, Malke, with money Selig raised from relatives in New York, whisked Henry and Lottie back to Europe to seek medical and rabbinical help. During their three-and-a-half-year absence, Selig and Jennie fended for themselves in a cold-water flat on Houston Street; given their struggling circumstances, the New World wasn't seeming that much different from the Old. Seeking a fresh start, Selig, flush with family loans, especially from Malke's relatively deep-pocketed uncle Joe Grumet, took a stab at running his own butcher shop, only to lose everything within two months because there were so many other butcher shops in the neighborhood. Next was a dairy shop on East 5th Street, only this fared no better. Given the family's impoverished state, Jennie, despite being an attentive student with a sharp memory, dropped out of school in the fourth grade to go sew buttonholes into garments eleven hours a day. Her pay was two dollars a week.

INFORMED BY SPECIALISTS in Europe that Henry's best prospects were to be found in a school for the hearing-impaired on Manhattan's Upper East Side, Malke returned with the two younger children to find Selig still determined to prove himself an independent businessman. Grossinger's Dairy Restaurant opened on Columbia Street on the Lower East Side with Malke cooking in the kitchen, Jennie, now a teenager, out front hosting and waitressing, and Selig once again going belly-up. The problem this time was Malke's food. Customers may have adored it,

Accompanied by their mother, Malke, eight-year-old Jennie Grossinger and younger sister Lottie were reunited with their father, Selig, at the Immigration Station on Ellis Island (shown here) in 1900, after a three-year separation.

but her portions were so generous that the restaurant couldn't manage to squeeze out a profit. Jennie at least reaped two benefits from the failed enterprise: as hostess, she learned to hone her social skills, and she got a break from buttonholes.

Other young women in the neighborhood were not as fortunate. Many worked at the Triangle Shirtwaist Company, up on Washington Place and Greene Street. When the fire that was to be the deadliest workplace incident in New York City history—146 fatalities in all, 129 women and 17 men—broke out on March 25, 1911, Jennie ran to the factory in Greenwich Village to see about her girlfriends.

Their charred corpses had been laid out on the street.

BY 1912, Selig's fatigue might have been psychosomatic, but his cough was genuine, and, fearing tuberculosis, his doctor prescribed a break from the city.

A few weeks' rest in a boardinghouse in Colchester, Connecticut, returned

**HUNDRED AND FIFTY PERISH IN FACTORY FIRE;
WOMEN AND GIRLS, TRAPPED IN TEN STORY BUILDING,
LOST IN FLAMES OR HURL THEMSELVES TO DEATH**

Jennie Grossinger was ten years out of school by the time she was nineteen, yet managed to avoid the fate of many of her girlfriends. They worked at the Triangle Shirtwaist Factory.

him to his family with renewed vigor and a surprising announcement: "I have bought a farm." The deal was sealed with a twenty-five-dollar deposit.

Both bits of news were met in the Grossinger household with stone-cold silence, except from a nosy neighbor, who scoffed, "Connecticut? You will raise nothing but rocks in that part of the world. Terrible storms come in from the ocean, the winters are long and miserable. . . . Everything is expensive in Connecticut. Ask [Malke's] Uncle Joe!

"Better still," insisted the neighbor, "ask him about the Catskills. Things are much cheaper there."

The icing on the cake? "The climate is just like Galicia."

"So he went up to Sullivan County and bought this big place on a brook," Jennie's daughter, Elaine Grossinger Etess, recalled of her grandfather Selig nearly a century after he first settled in the Catskills. The thirty-five-acre site he had chosen for his new home, which the previous, non-Jewish owners had christened Longbrook, was in the Sullivan County town of Ferndale, and the purchase price was $3,500.

For their introduction to the mountains, Malke and Jennie, according to the latter's biographer, "had to cross the Hudson River to Weehawken on a ferry and

then board an Ontario and Western train which left early in the evening. The train seemed to stop every few moments. Occasionally, they dozed off on the hard benches, but always the jerking of the railway car as it stopped and started woke them up. It was eight in the morning when the train pulled into the tiny Ferndale station."

As anticipated, Malke's uncle Joe provided the $450 loan for the down pay-

Feeding the proliferation of Jewish immigrant farmers on American soil was the philanthropy of the German court financier Baron Maurice de Hirsch de Gereuth, whose banking fortune had been further enriched by his financing the Oriental Railway's link between Constantinople and Europe.

Born near Munich in 1833 and known for saving a franc by condensing his message whenever telegramming a school or hospital with the news that he was generously endowing them, the baron, starting in 1891 (five years before his death), assisted Jews fleeing pogroms in Russia and Poland with a fund bearing his name.

A friend of royalty, especially the Duke of Windsor, Hirsch was himself a nonpracticing Jew—his two adopted sons, in fact, were raised Christian—but he remained acutely aware of the persecution of his people in Europe, and personally sent emissaries to assess the situation in Russia. Sensing that the czar would never be dissuaded from attacking the Jews, Hirsch's solution was to spend considerable sums moving the inhabitants of entire villages out of Russia and into safe colonies in North and South America.

Under the Hirsch Fund's umbrella, trade and English-language schools were established, financial relief was offered to new arrivals to the United States, and $1 million went to help resettle immigrants into areas less crowded than the Lower East Side—Sullivan and Ulster Counties among them. With the majority of Jewish immigrants working as garment workers or teachers, Hirsch believed "what was needed was to wean Jews away from urban occupations and intellectual preoccupations and get them back to the land."

In the reports of his death that praised his life and works, it was said that the baron's total contributions to charity were impossible to calculate, as he handled them as quietly as he possibly could. The enormity of what he had done for Russian refugees, however, was something that could never be kept secret.

ment, only the investment—which was on top of the abandoned twenty-five-dollar nonrefundable deposit Selig had made in Connecticut—quickly seemed to be as ill-fated as the Grossinger patriarch's other ventures. The Longbrook farmhouse was so dilapidated that while Malke and Jennie made whatever cosmetic patch-ups they could, Selig tended to the roof, which looked as if it might have been pelted by a meteor shower. Still, as a symbol of his resolve to become a successful farmer, he bought himself a horse, albeit a scrawny nag.

"Jennie," said her father, pointing to the barren soil on their property, "just wait till next year and you'll see what we are going to grow out there."

"When springtime came," said Etess, "lo and behold, the property was not any good for farming." Salvation was delivered thanks to a shopkeeper in Ferndale, who advised, "The sooner you find out the most important crop in these parts is boarders, the better off you're going to be."

By this time, Jennie, now twenty-two, was two years into her marriage to her first cousin, Harry Grossinger, a production supervisor in a garment factory back in the city. Lending a collective voice of reason, Jennie and Harry calculated the assets and liabilities for a prospective transition into the boardinghouse business.

Pros: The farmhouse had seven rooms, more than enough for the Grossinger clan as well as boarders. Boardinghouses in the area charged up to twelve dollars a week for room and board. "Everyone knew my grandmother was an excellent cook," said Etess, also noting that others in the family had their special talents. "My mother had this warm personality, and my grandfather could take care of the grounds, because he had been an overseer on an estate in Austria."

Cons: Boardinghouses had to advertise in the New York newspapers, a financial drain that the family could ill afford.

Still, son-in-law Harry, to demonstrate his faith, anted up $200, all the money he and Jennie had saved, and promised he would spread the word about the boardinghouse among the tradesmen he knew. Harry's proved the only bankable contribution. Lottie and her fiancé, Louis Grau, declined to invest, although once the family hotel business was later off and running, Grau did loan Selig money, at the going interest rate of 6 percent. As Selig kept up the argument that he would only consider taking in boarders until such time as his crops started sprouting, Malke declared she would simply place her faith in God.

One morning while feeding the chickens, Jennie observed her mother being approached by a stranger, who turned out to be a Romanian émigré named Mrs. Carolyn Brown, of the Bronx. After voicing dissatisfaction with her present

early half a century after collaborating with Jennie Grossinger on her memoir, *Jennie and the Story of Grossinger's*, Joel Pomerantz was still able to single out Jennie's "qualities as a greeter. It was her personality. Warm. Congenial. People wanted to meet her and shake her hand." And her mother, Malke, he said, "was certainly a presence." But it was Jennie's husband, Harry, "who really ran the day-to-day nitty-gritty of the hotel. Very smart businessman, though not at all educated. And he stayed in the background."

Originally the Grossinger story was to be entrusted to the former *Collier's* writer, sports journalist, and author Quentin Reynolds, who as a World War II correspondent was as widely read as he was prolific. After being contracted by the publisher Grosset & Dunlap to work with Jennie, "Reynolds came up to the hotel and went straight to the bar," said Pomerantz. "He was a legendary boozer, and this made Jennie uncomfortable. She didn't drink a drop. She was a very proper lady from Europe."

After finishing the first two chapters by 1965, "He died, of drinking," said Pomerantz. "The publisher then suggested a number of writers, but Jennie didn't know any of them. So she said, 'Joel, why don't you write it?'"

Asked how accurate he found the doyenne of a $20 million empire to be in the telling of her story, Pomerantz awarded his subject high marks. "Very good memory," he said of Jennie, especially when it came to dredging up details of her early life. "I was amazed by her recall."

accommodations, Mrs. Brown inquired if she and her husband might possibly stay at the Grossingers' farm. Curious, Jennie asked Mrs. Brown why she was making such a request.

"My husband and I have passed your farm several times," Mrs. Brown answered, admitting she took special notice of Malke.

"When I saw the *sheitel*, I knew yours must be a truly kosher household."

THE GROSSINGERS' LONGBROOK FARM operated as a family affair, with everyone putting in eighteen-hour days. Malke worked the kitchen; Selig on his horse-drawn buggy greeted guests at the railroad station; Jennie and the as yet unmarried Lottie helped their mother cleaning chamber pots and plucking chick-

Jennie Grossinger (left) on her hotel's private airfield, greeting entertainer Eddie Cantor and his wife, Ida.

ens. When he came up from his job in the city on weekends, Harry made a bee-line for the kitchen, where he "did everything but actually cook. He made salads, carved the meat, and waited on tables. He was also bellboy, porter, bed-maker, plumber, and general handyman," said Jennie biographer Joel Pomerantz.

By the end of their first summer, the new landlords "had eighty-one dollars, which was a lot of money," said Etess. The sum was all the more impressive because rather than the going rate of twelve dollars, the Grossingers charged only nine, a concession to the lack of indoor plumbing. By the end of the second summer, on the strength of their establishment's reputation for friendly service and Malke's cooking, "they had been so successful that they had to pitch tents" in order to accommodate the overflow of guests, Etess said. Not only were six rooms added, but a first employee was hired, a chambermaid.

Equally important, the Grossingers had officially joined an established tradition, of Jewish immigrants welcoming other Jewish immigrants to the Catskills. "Eventually," said Sullivan County historian John Conway, "the hotels and boardinghouses that had grown up during the Silver Age began to close or struggle. They were sold cheaply, and in many cases they were purchased by Jewish families who were moving to the mountains."

By the time of the Grossingers' arrival in 1914, several Jews had already put down roots in the Catskills: "Abraham Brickman in South Fallsburg; Charles Slutsky, who started what was to become the Nevele Hotel in Ellenville [1901]; Louis and Max Kutsher in Monticello [1907]; 'Pop' Weiner in Livingston Manor; Louis Nemerson, also in South Fallsburg; Isaac Sussman in Woodridge; and Emanuel Paul in Swan Lake," according to Pomerantz.

The first of this new breed of hotelier was Yana "John" Gerson, who in 1892 built a boardinghouse in Sullivan County's Glen Wild, near Woodbridge. Originally from Vilna, Lithuania, he emigrated to the United States when he was thirty-four, in 1888. At first leaving wife Annie and their four children in the Old Country, Gerson briefly ran a small farm on Pitkin Avenue in Brooklyn. Greater ambitions brought him to the Catskills, where he realized that rooming, feeding, and entertaining guests could be more profitable than working the soil. And while the farmhouse bedrooms offered by Gerson and his wife were tiny, their house did have the advantage of two porches. Even more impressive, in the O&W Railroad's publication *Summer Homes,* Gerson ran what was the first advertisement for Catskills room and board ever to include the word "Jewish":

CENTERVILLE STATION–Glen Wild Post Office Rock Hill Jewish Boarding House. 5 miles; accommodates 40; adults $6, children $3, transients $1; discount to season guests; transportation free; new house, newly furnished; prepare our own meats; raise our own vegetables; scenery unsurpassed; Jewish faith and customs throughout; ¼ mile from Post Office; good road to station; fine shade; good airy rooms.

"We weren't the first boardinghouse in the area," recalled Dave Levinson, whose parents, Max and Dora Levinson, arrived in Greenfield Park on January 3, 1900, "but there weren't too many others when we came." Originally from Minsk, the Levinsons had spent fifteen years in New York City, where Max worked as a tailor. On the fifty Catskills acres they shared with twenty-five cows and four horses–one, according to their son, "past retirement age"–the couple opened their farmhouse to boarders.

"In 1903," said Dave Levinson, "Pop saw that his neighbors were making a living by catering to boarders, so he built six bedrooms, added on to the little house that they had, and went into the boardinghouse business."

The weekly rate was three dollars and fifty cents, "for all the milk you could

drink, all the eggs you could eat, plus whatever meat you got fed. Whatever little profit he made went into more rooms."

The pattern soon became familiar. After five years, in 1919, the Grossingers sold Longbrook for $10,000, then invested every penny of it, along with another $17,000, in the formerly restricted Terrace Hill House and the Nichols Estate, which brought with it one hundred wooded acres and a lake.

Their first year in the new location, the weekly room rate was hiked to eighteen dollars, in part due to inflation, but also because the new boardinghouse contained indoor plumbing and round-the-clock hot water. The family named it Grossinger's Terrace Hill House, and, as run by Jennie, Grossinger's, as it simply came to be called, would become legendary.

WHILE THE EARLY JEWISH ROOMING HOUSES such as Grossinger's could barely stop expanding, the established Protestant ones were sealed up, or burned down, or, in an even more common scenario, were taken over by the new arriv-

Postmarked Catskill, New York, October 30, 1908, this penny postcard's message, to Miss Gertrude Harry of Syracuse, read, "This is the way we spent our summer at least 13 weeks of it and enjoyed it so much."

In 1919, the Grossingers sold their original farmhouse and, for $27,000 (nearly $365,000 today), bought a formerly restricted hotel, which they called Grossinger's Terrace Hill House. Eventually it was simply called Grossinger's.

als. The first Christian-only hotel in the Catskills to become Jewish-owned was the Sha-Wan-Ga Lodge, in Wurtsboro, whose new proprietors kept the old signage and brochures but replaced the phrase "No Hebrews Accommodated" with "Dietary Laws Observed."

Surrounding what became the Levinson and the Grossinger properties in Liberty had been the strictly non-Jewish Victorian hotels, the Lenape, the Mecca, the Ye Lancashire Inn, and the flagship of the cluster, the Flagler House. "While at first they offered their guests simply fresh air, clean water, farm fresh vegetables, and milk, and plenty of shade," said Conway, "by 1895 lawn tennis had become an attraction, and by 1897 golf was offered. The county's first golf course was opened

that year at the Trout Valley Farm on the Beaverkill, and several more, including three official nine-hole courses, followed by 1901."

According to Conway, "The story of the Flagler probably best illustrates the phenomenon that went on." Built as a small boardinghouse in 1872, the establishment was run by Carrie Flagler Angel, the daughter of Fallsburg tanner Nicholas Flagler (the family, of Palatine German origin, first arrived in the Hudson Valley in 1709, having been sent by Queen Anne). The boardinghouse–completely restricted–grew to about thirty-five rooms, "which Carrie Flagler Angel ran until the early 1900s, until the influx of Jewish immigrants began in earnest," explained the historian. In 1908, "Carrie Flagler Angel sold the Flagler House to a couple of Jewish salesmen," Asias Fleisher and Phillip Morganstern ("former door-to-door peddlers," said Alf Evers), "who immediately became aware that many of the guests for some reason assumed the Flagler House was owned or operated or somehow affiliated with Henry Morrison Flagler, a very rich American and, with John D. Rockefeller, a founder of Standard Oil."

Henry Morrison Flagler, a Dutchess County native who had made his money

Built in 1872, the original Flagler Boarding House grew to thirty-five rooms under the watchful eye of Carrie Flagler Angel, daughter of a Fallsburg tanner. She kept it restricted until the early 1900s, when she sold it to a couple of Jewish former door-to-door salesmen.

in grain, had in fact bankrolled Rockefeller's first oil refinery. The tycoon, next becoming interested in railroads and hotels, then developed two Florida holdings starting in the late 1880s: Palm Beach and Miami.

The truth was, said Conway, in the Catskills "Henry Morrison Flagler had nothing to do with the Flagler House, but Fleisher and Morganstern were smart enough businessmen to realize they shouldn't dissuade their guests of this notion, so they encouraged it. When they began their new main building in 1919, they decided it should look like something Henry Morrison Flagler would have constructed. So, because most of the hotels that he built years before in Florida had a Spanish influence, Fleisher and Morganstern copied that architectural style. Then, because the Flagler became the most prominent of all the Sullivan County resorts, soon every hotel wanted to look like the Flagler. And this new style of architecture, which today is called Sullivan County Mission, was born when that main hotel opened in 1920. This style included stucco [which at least made the façade look fireproof], Palladian windows [Alf Evers likened them more to Versailles], parapets, and, usually, the name of the hotel prominently displayed in the center of the hotel front."

The new, improved Flagler, three miles from the New York and Oswego Midland Railroad station, featured such upgrades as in-room telephone service and hot and cold running water, as well as a few more subtle changes.

Where "Lawn tennis, croquet, first class in every respect" (and "References exchanged") had been played up in advertisements during the hotel's first incarnation, under its new ownership other assets of the Flagler were emphasized. "Strictly kosher," proclaimed the new notices, along with "special rates for families for the season."

HOTEL CONVERSIONS WERE NOT the exclusive domain of the southern Catskills. In the north, the Overlook Mountain House, originally designed and built in 1871 by Lewis B. Wagonen of Kingston before the Kiersted brothers of Saugerties reopened it in 1878 (three years after its destruction by fire), was eventually purchased in 1917 by Morris Newgold, a New York City hotel operator.

In other transformations, the elegant, middle-class Laurel House at the rim of Kaaterskill Falls became a Jewish hotel in the 1920s; the Fried Chicken Wars by then were a distant memory, George Harding died in 1902 (as did his great rival, Charles Beach), and Harding's thousand-room Hotel Kaaterskill was sold to

By 1908, a single, easily navigable auto-trail linked together a number of roads that ran from New York City through the heart of the southern Catskills before continuing on to Cleveland. Its formal designation was Route 4, but people usually referred to it as the Liberty Highway, after the town of Liberty, the most significant town along the way.

"It was dubbed the Liberty Highway by a man named R. H. Johnston, an official with the White Motorcar Company, which was based in Cleveland," said historian John Conway. Johnston was so prominent that in 1908 President Theodore Roosevelt appointed him to "a country life commission . . . charged with the duty of examining into the conditions of rural life and of making such recommendations for its improvement and general 'up-lift,'" Johnston wrote in an essay titled "The Auto a Good Road Producer."

"Johnston wanted to route his cars from the Cleveland assembly plant to New York City, where they could be dispersed to market, through the most direct route he could find," said Conway. "He chose the route that brought him through Sullivan County, and dubbed it Liberty Highway because he thought it was a very patriotic name, and because the village of Liberty was kind of dead center along the route."

The Liberty Highway became something of a national phenomenon, said the historian, when "Johnson himself hired a film crew to travel along with his vehicles as

Harry Tannenbaum of Lakewood, New Jersey, who ran it for Jewish guests until a kitchen fire claimed the entire structure in 1924.

Nor was the Catskill Mountain House immune from change. By 1930 it was the last redoubt of Protestant vacationers in the northern Catskills—that is, until it was leased to Jewish owners who changed its name to Andron's Mountain House and ran it as a kosher hotel. By that time, it was but one of at least a hundred such establishments in the region.

Those lacking the resources to check into a boardinghouse could opt for the inexpensive *kuchalayn*, Yiddish for "cook for yourself." This Catskills hospitality staple became increasingly popular in the 1920s, only to see its market share greatly boosted once the extreme pinch of the Depression settled in.

For as little as fifty dollars a month (slightly more than $700 today), with a five-dollar discount for the following year if you booked before the end of the

they were transported to New York, and this was later released as a promotional vehicle in theaters throughout America."

The car ride from New York City to the northern Catskills up the western side of the Hudson River lengthened the time of the trip, given the steep hills and the fact that Kaaterskill Clove Highway, a strategic early connection between the Hudson Valley and the northern Catskills' interior, wasn't fully equipped to handle heavy automobile traffic until 1918.

Along with better roads to deliver weekend vacationers to the Catskills, in 1927 Ford introduced the Model A to replace the Model T, enabling drivers to bypass roadside creeks for cooling down burning brake linings as they motored into the mountains.

Two more transportation advancements appeared in 1927 and 1931 with the respective openings of the Holland Tunnel and the George Washington Bridge, connecting Manhattan to New Jersey and reducing the eleven-hour car ride from the city along Route 17 to a manageable three hours—that is, assuming the absence of traffic jams.

That was no easy assumption, either. A traffic study conducted over twelve hours on Saturday, August 13, 1932, counted more than eighty-eight thousand cars barreling along Route 17 into Sullivan County—which was clearly the place to go.

current summer, the *kuchalayn* offered its guests only the simple basics of a room, with cooking and cleaning left to the renter. The arrangement also freed its proprietor from the responsibilities of running a full-scale boardinghouse, so he could work his farm or tend to his dairy cows with the assistance of his wife, who was no longer burdened with the daily indoor domestic chores. Bringing their own food from the city or purchasing it from the farmer, renters shared a common kitchen, as well as outhouses and bathtubs, normally found behind the barn with separate hours for men and women—although many *kuchalayners* preferred nearby rivers and streams to the communal tubs.

"You had to take everything with you, from pillows, mattresses, heavy quilts, and linens to pots, pans, dishes, silverware, hammocks, and toilet paper," said the comedian Joey Adams, claiming that the only amenities to be found in the *kuchalayn* were those already offered by Mother Nature: "sun, air, and trees.

Nothing that cost money." Landlords, he said, "offered nothing but a roof and the use of the kitchen and tables." Journalist Stefan Kanter, in his buoyant 1989 book *A Summer World: The Attempt to Build a Jewish Eden in the Catskills, from the Days of the Ghetto to the Rise and Decline of the Borscht Belt*, offered an addendum to Adams's claim, observing that there was a lone convenience provided at a *kuchalayn*—refrigeration, provided you were willing to haul up your own chunks of ice from the lake.

Pantry pilfering was common, as was battling for a burner because of a shortage of stoves. "Each woman sought to establish a beachhead at one of the two sinks," said Adams. "Armed with Brillo pads and scouring powder, each lived by the motto, 'Take the sink . . . and hold it.'"

Initial arrivals were also planned and timed with the precision of military maneuvers. Families coming by train usually shipped their household goods ahead by Railway Express, while buses were sometimes hired to carry both the families and their belongings. Loading and unloading for the journey was a tedious all-day affair; the trick was to be the last family to be picked up in the city and the first to be let off when the bus reached the Catskills.

Those fortunate enough to own a car needed to manage some way to pack everything on top of it, along with mattresses strapped to the roof. The usual time to leave New York City for the Catskills was the middle of the night, to arrive at the *kuchalayn* the very second the lease took effect the next morning.

Once there, the recreational opportunities, like the accommodations, were strictly bare-bones: a river for swimming and the countryside for walking and collecting blueberries. Some children found excitement in helping on a farm after a year in the city, while entertainment for the entire family needed to be improvised, with dining room tables pushed aside on Saturday nights for someone to play an instrument or tell jokes.

What the individual *kuchalayn* may have lacked in comfort, it often made up for in the sentiment that attached itself to the particular institution. Families returned to the same *kuchalayn* every year as if coming home to an extended family, ensuring a warm sense of community similar to what had typified life in the shtetls of Eastern Europe.

"Time worked differently in the Catskills," said professor of Jewish history Jonathan D. Sarna. "Your schedule was entirely different than it would have been in the city. In the Catskills, food was different. How you spent your evenings were different. In many ways, the Catskills gave people a sense of what it would

Kuchalayns and bungalow colonies (pictured, Kurt's Kottages, on Route 17, Exit 102, in Ferndale) occupied the social-echelon rungs between campgrounds and hotels.

be like if you could rest and get away from work. All you had to do was eat and play."

The same atmosphere to an even greater extent also pervaded the next step up the social ladder, the bungalow colony, originally a group of small cottages or shacks arranged in a semicircle or oval around a common green. "Where a *kuchalayn* in the 1930s might cost fifty dollars for the summer, a bungalow in the same place would go for ninety dollars," said *Catskill Culture* author Phil Brown. The price difference wasn't the only dividing factor; the word "bungalow" was used by architectural magazines as early as the 1890s to suggest upward mobility when describing the better class of mountain or seaside summer homes. In the same way many Catskill hotels later would add "country club" to their names—as in Kutsher's Hotel and Country Club—the term "bungalow colony" was typical Catskills

hyperbole, meant to increase the appeal of what were often nothing more than a handful of rudimentary two- and three-room living units.

The bungalow itself consisted of a kitchen and bedroom, no living room but often a screened-in porch. The colony provided recreational facilities for children (such as a playground) and adults (a social hall), as well as a small store for groceries and daily necessities, although the inclination was to bring from home rather than pay the extra pennies the on-premises store would charge for an item.

"Our bungalow colony had twenty-nine bungalows," said Shelly Altman, whose experience in the mountains served as the basis for her screenplay for the 1987 movie *Sweet Lorraine*, which starred Maureen Stapleton as a veteran Catskills innkeeper. "I come from a very large family, so a minimum of six of them were occupied by family members. I often wondered how my grandmother made a living, but she did."

While the surroundings were so safe that there were no locks on the doors, there was also no heat, "and Catskills mornings could be very cold," Altman

Recalling the 1960s childhood she and her siblings spent at their parents' Frank's Cabins and Diner, Joanne Stefanatos told Hudson, New York's, *Register-Star* in 2011, "We had to work, as far back as we can remember; mowing lawns, pulling weeds, cleaning cabins and working in the diner. Summers were spent working half days, swimming at Slippery Rock, and hiking the back roads and birch forests."

remembered, "so mothers would turn on the gas jets on the stove, and that would be how we warmed each other." The bungalows themselves were minuscule. "I would share a room with my brother, and [outside] we had a swimming pool, which was a social center during the day. Everyone was down at the pool." Beyond that, not much existed in terms of formal recreation. "We had nothing but our own resources and a lot of green lawn. And blueberries." For the women, Altman recalled, there was "a lot of mahjong. A lot of them played cards, as well. And

The Jewish experience in the Catskills, let alone leisure life in general, came under heavy criticism from Old World scholars, alarmed at what they perceived to be factors contributing to the growing acculturation and deracination of Jews in America.

Expressing the general sense of disappointment and outrage, Zionist intellectual and *belletrist* Maurice Samuel published in the *Menorah Journal* of 1925 a prose poem titled "*Al Harei* Catskill" ("In the Catskill Mountains"). In it, he contrasted the values of an Old World grandfather with the depths to which his descendants had sunk in the New World.

As one part of the poem decried:

> And here in Catskill, what do Jews believe?
> In Kosher certainly; in *Shabbos*, less.
> (But somewhat, for they smoke in secret then.)
> In *Rosh Hashonoh* and in *Yom Kippur*,
> In charity and in America,
> But most of all in Pinochle and Poker,
> In dancing and in jazz, in risqué stories
> And everything that's smart and up to date.

Reprinting the poem in 2004, *The Jewish Daily Forward* editorialized, "Samuel wonders as he contemplates an American Jewry more at home on the golf links than with Torah, more conversant with the latest fads than with its Old World heritage. What will become of us?"

Prospect House, Forman Bros., Proprs.,
Mountain Dale, N. Y.

Harry Forman's Manor in Mountaindale, New York, opened around 1920, with wife Ida in the kitchen. Granddaughter Janet Forman recalls her horror at seeing photographs of games that were played in the old days, such as mock marriage (complete with cross-dressing). She preferred playing in the pool.

then they would go down to the pool and sun themselves. Some might even get in the water."

Small hotels were the next step up, with some of them eventually morphing into grand resorts, explained Janet Forman, a contemporary travel writer whose grandparents, Harry and Ida, opened Harry Forman's Manor around 1920. Known, according to their granddaughter, "for setting a bountiful table" that kept the establishment in business for nearly forty years (until Harry's health declined), "in her paprika-smeared chef's apron, straps gathered with an enormous safety pin to accommodate her four-foot-nine, eighty-pound frame," Ida "was the keystone of the hotel's delicate chemistry. . . . [S]he rose at three a.m. to stoke the ovens and pack coffee into the industrial-size percolator—along with a few raw eggs to clarify the brew."

When retirement was finally forced upon her, Ida never completely adjusted, said Janet, who went into travel writing, she said, because "it's in my DNA how a guest should be treated." That was something she would continue to witness

from Ida. "For years after my grandfather died and the grandchildren went off to college," Janet continued, "Ida could still be found in front of her stove churning out stuffed chickens, boiling cauldrons of soup, and filling blintzes for the ghostly cadres still hungry for a piece of the *shtetl*."

The comedian Phil Foster, who used to advertise himself as "Brooklyn's Ambassador to the United States," also wasn't about to forget the small hotels, where, besides telling jokes, he was hired to dress in a white suit and, because he was single, be attentive to the customers' daughters. "If a guest checked out, the boss would kill you," he remembered. One hotel owner "was a very frugal man . . . and he always went around turning out lights. If you were a guest, reading in bed at two o'clock in the morning, the door would open, and a hand would reach in and turn off the light."

Starting in the 1920s and surviving the '30s before hitting the jackpot in the '50s, the destination of choice, and by no means available to everyone, was the Catskills resort hotel, which ideally encompassed about "two hundred acres, a main building with a porch, and a dining room. Across the road a swimming pool and the playhouse," said Robert Towers, a Madison Avenue executive who handled advertising for the Concord and the Nevele at their postwar peak. (Despite its sound, the name Nevele was neither Native American nor Italian, but "eleven" spelled backwards—to honor, it was said, the eleven picnicking schoolteachers who discovered a nearby waterfall in the 1800s.) Recreation consisted of sitting in rocking chairs anticipating the next meal, horseshoe pitching, gossiping in the dining room, and awaiting the evening show.

"There was a humor, an escape, a special feeling. It was a club, a sorority, a fraternity, a lodge," said Towers. "I'm talking about the Grossingers, the Slutskys with the Nevele, the Levinsons with Tamarack Lodge in Greenfield Park."

The hotels also gave the Jews the exact same thing the Protestants had had before them but had kept under lock and key: a playing ground all their own.

Above the Law

✦━━◆━◇━━✦

I

The reign of tears is over. The slums will soon be a memory. We will turn our prisons into factories and our jails into storehouses and corn-cribs. Men will walk upright now, women will smile and children will laugh. Hell will be forever for rent.

—THE REVEREND BILLY SUNDAY, at the start of Prohibition, 1920

In some respects, the attitude that we later came to associate with Las Vegas first took shape in the mountains: 'Whatever happens in the Catskills stays in the Catskills,'" said history professor Jonathan D. Sarna. "There were certainly all sorts of stories about men who had mistresses in the Catskills, who engaged in hanky-panky in the Catskills, but who were very upstanding citizens in the city. Certainly there was a sense that you could let your hair down in the Catskills. You could bet on boxing, you could partake in various indulgences of the flesh, and it would stay in the mountains. There was a code of silence. I think that may well be why certain Jewish criminals were attracted to the Catskills."

Emboldened by Prohibition, which took effect January 17, 1920, men with names like Otto "Abbadabba" Berman, Abe "Kid Twist" Reles, Albert "Tick-Tock" Tannenbaum, and Philip "Little Farvel" Cohen—all with connections to the enforcement arm of the mob, known as Murder, Inc.—graduated from earning comfortable livings shaking down fearful shop owners and robbing unsuspecting marks to making a killing from bootlegging and owning speakeasies. In New York City alone, an estimated thirty-two thousand illicit drinking establishments were up and running

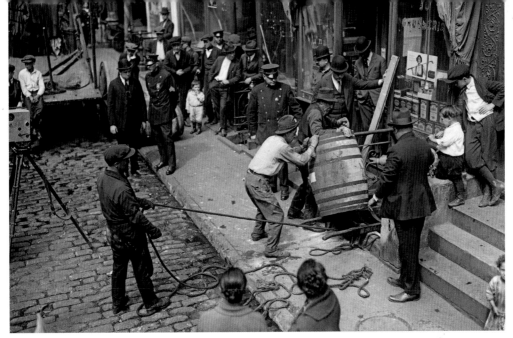

"The anti-alcohol movement divided rural and urban Americans and native-born from immigrants," said *The Jewish Daily Forward* after the fact. "Prohibition forced Jews to forge a new identity for themselves."

soon after enforcement of Prohibition began; in Rochester, the number of bars doubled with the Eighteenth Amendment; in New Jersey, it multiplied by ten.

Given the untamed nature and remoteness of Catskills roads, ponds, and caves, the underworld had found its Eden. "To this day," said Alf Evers, citing author Manville Wakefield's 1970 account, *To the Mountains by Rail*, "Sullivan people say that many undiscovered bodies wired to concrete blocks or scrap metal still lie on the bottoms of lakes as invisible memorials to the Prohibition Era." Then again, criminals were cautious, even creative about avoiding any federal agents who might be on their trail. One house in the town of Catskill sat back from the highway, accessible only by a small, rickety bridge that at first glance appeared too fragile to support trucks weighed down by cases of illegal hooch. Agents keeping a watchful eye on the residence witnessed no out-of-the-ordinary activity—until a flyover by a federal plane after a heavy winter's snowfall. What was revealed was the roof of an outer building so warm that it melted the snow.

Raiding the compound, the lawmen uncovered a still, then made a closer inspection of the rickety bridge. It had been surreptitiously strengthened with railroad ties so it could support the weight of a ten-ton truck.

"THE MOUNTAINS WERE a good place to hide, and so the bootleggers, who had established stills and other kinds of distribution operations throughout the Catskills during the twenties, began to divvy up territories," said historian John Conway. "Legs Diamond was along the Hudson River. Dutch Schultz was in the Ulster County Catskills. Waxey Gordon had a lot of activities in Sullivan County. Though Waxey Gordon was not an owner of record in any way, I feel pretty strongly that he was an investor in the Mansion House at White Lake." Hailing from the Lower East Side, Irving Wexler—"Waxey" came about because he was such a smooth thief that the wallets seemed to slip out of his victims' pockets as if they'd been wax-polished—specialized in bootlegging and gambling, though it was narcotics trafficking that finally sent him to Alcatraz. "And these men would often fight gun battles against one another if one or the other was trying to move in on another's territory."

Among hotels, the President at Swan Lake and the Ambassador in Fallsburg came across as especially gangster-friendly, while the Plaza in South Fallsburg served as the de facto summer home to the mother of Murder, Inc., kingpin Louis "Lepke" Buchalter. (It was she who gave her son his nickname, "Lepke" being her Yiddish diminutive version of Louis; the Plaza staff treated her like a queen.) Lepke himself mostly kept to his palatial Catskills hilltop estate, with its Tara-like white colonnades, nearly a quarter mile from Ratners Hotel, again in South Fallsburg. Like Buchalter with his mother, Lepke's henchman, the Odessa-born Brooklynite Jacob "Gurrah" Shapiro, kept his wife and children at the Plaza during the season, while he and his mistress shacked up at a country club in Loch Sheldrake.

An associate of Arnold Rothstein's, Waxey Gordon was believed to be an investor in the Mansion House at White Lake.

"The Hotel Evans in Loch Sheldrake always seemed to be involved in one way or another in these mob hits, though the mob would stay at other hotels as well," said John Conway. "The interesting thing about these very despicable murderers was that throughout their stays in Sullivan County the hotel owners who recognized them also remembered them as being perfect gentlemen during their stays at the hotels."

"At dinner they introduced themselves to other guests as labor organizers or said they were in the garment industry, or trucking, or importing," wrote Rich Cohen, author of *Tough Jews*.

Evans Hotel. Loch Sheldrake, N. Y.

"The Hotel Evans in Loch Sheldrake always seemed to be involved in one way or another in these mob hits," said historian John Conway.

"Away from the dining hall, the respectable clientele must have whispered 'Guess what he does in the city?'"

Most of the Jewish hotels "had concessions of one sort or another," said Conway, "something as simple as renting out boats, or they could be a little more sophisticated. They might be card games, and eventually they would include pinball and primitive slot machines."

Once "these millionaire gangsters" appraised the situation, said the historian, "they demanded payment on a regular basis from the concessionaires. Even at a place as established as Grossinger's, these gangsters would demand a slice of the concession pie, so to speak.

"Interestingly, once the activities of these gangsters became known in Sullivan County, raids on these slot machines became a regular thing. Oftentimes, these raids would take place before the season, or immediately after."

Moreover, Conway observed, opening the door to the suggestion that authorities might somehow have been convinced to work within the parameters of the crime bosses' timetables, "Rarely did you see a hotel raided at the height of the tourist season."

ries" had been lobbying to outlaw drinking since before the Revolutionary War. Colonial Georgia banned alcohol as early as the 1730s, and Maine became the first state to prohibit spirits outright, in 1851.

Early in the history of the Catskill Mountain House, which boasted a lucrative liquor concession, the otherwise financially fragile hotel stood in determined opposition to the proposals set down by the newly formed Greene County Temperance Society, which made the claim that if only the county were to go dry, all crime would be eradicated, the jails would close (at a dramatic savings to the taxpayer), and poverty would be vanquished. As the group decreed, "The tax upon good morals should also be taken into account."

One out of every seventeen persons in the village of Catskill (population 2,200) was a chronic alcoholic, the society claimed, and three hundred others lived under the imminent threat of addiction to the bottle. Worse, with the constant arrival of strangers, especially those from the city, the cocktail lounges of the Mountain House contributed to this scourge.

According to the "Facts showing the Evils resulting from the use of Intoxicating Liquors," as compiled by the Catskill Temperance Society, February 26, 1833, a year-long sobriety campaign was having an effect, or what the society termed "happy results."

"Eight merchants, who were formally engaged, and many of them extensively so, in the traffic of ardent spirits, have from principle abandoned the traffic. A large population of the best families in the village have discontinued the use of ardent spirit as a drink altogether," said the report, which also considered such places as the Mountain House and other watering holes "fountains of sin . . . pouring forth rivers of pollution and death upon the community."

One-third of all residents of Catskill signed the pledge to swear off booze, but the society saw it as "the duty of all entirely to abstain from the use . . . which has done more than any thing else to overspread the civilized world with crime and lamentation and wo [sic]."

As for the owners of the Mountain House, they instructed their bartenders just to keep pouring. The guests were not heard to complain.

With dark eyes, a narrow mouth, and a prominent, off-kilter nose, Bronx native Arthur Flegenheimer, better known as Dutch Schultz, looked like Bing Crosby with his face bashed in, according to one girlfriend. Born in 1902 to German-Jewish parents, the Dutchman was fourteen when his saloonkeeper father abandoned the family and left Arthur as chief provider—a responsibility the boy met by leaving school and holding up neighborhood crap games.

At seventeen, he moved up to home burglaries and a prison stretch on bleak Blackwell's Island (now Roosevelt Island). His old gang from Bergen and Webster Avenues nicknamed him Dutch Schultz—which "had a blunt sound, like a couple of whacks with an axe," said the journalist Pete Hamill—after an earlier and notoriously brutal gangster, Dutch Schultz, of the old Frog Hollow Gang from the Bronx. "He loved this name," said John Conway. "He said it was small enough to fit in the headlines." As Schultz himself reputedly said, "If I'd kept the name Flegenheimer, nobody would have ever heard of me."

Like many a local hood who graduated to the big time when America went dry, Schultz did a brief stint driving alcohol trucks for Arnold Rothstein, the courtly "Moses of the Mafia" credited with bribing members of the Chicago White Sox to throw the game and allow the Cincinnati Reds to win the 1919 World Series. Rothstein, a mentor to both Jack "Legs" Diamond and Charles "Lucky" Luciano (to whom Rothstein taught etiquette and the advantages of bespoke tailoring), is

Dedicated Prohibitionist Agnes Cole was known for destroying a fair share of saloons in Margaretville.

said to have inspired F. Scott Fitzgerald's Meyer Wolfsheim in *The Great Gatsby* and Damon Runyon's incorrigible gambler, Nathan Detroit, for the classic Broadway musical *Guys and Dolls*. But this was no sentimental song-and-dance man; it was the cunning A.R. who, in developing the mob, recognized the urgency of structuring it in the duplicate image of American big business.

"Look out for Number One," Rothstein is credited with having said. "If you don't, no one else will."

"Waxey Gordon, Dutch Schultz, and Legs Diamond were in fact all protégés of Arnold Rothstein," said Conway, "but they all went their separate ways. Probably, of all of them, Dutch Schultz was the most interesting."

By the late 1920s, Schultz had laid claim to his own bootlegging network, which from modest beginnings in the Bronx had spread to Manhattan's Upper West Side and into Washington Heights, Yorkville, and Harlem, territories that put him in direct competition with a rival organization run by Legs Diamond.

Supplying watered-down booze to speakeasies throughout New York, Schultz eliminated competitors through any means necessary. "You can insult Arthur's girl, spit in his face, push him around, and he'll laugh, but don't steal a dollar from his accounts," said Schultz's lawyer, J. Richard "Dixie" Davis. "If you do, you're dead."

"He was a very colorful guy," said Conway, "but he grew up to be very stingy and penny-pinching. He was known to pay less money to his henchmen than any other major gangster, so it was always difficult for him to buy the loyalty of his men. But, again, he was very adept at making money."

When a speak owner named John Rock tried to stiff him, Schultz's goons kidnapped Rock, hung him on a meat hook and tortured him, then sheathed his eyes with gonorrhea-infected gauze that eventually blinded him—and solidified Schultz's reputation for ruthlessness throughout the underworld.

Prohibition brought Schultz to the Catskills, where he kept a home and operated a number of stills near the Ulster County village of Phoenicia. Local papers reported the shoot-outs along backcountry roads where the Dutchman's men battled Diamond's for control of upstate New York's lucrative market for booze, although the more seriously premeditated murders took place in Manhattan. After Diamond fatally shot Schultz's business partner Joey Noe outside the Chateau Madrid nightclub on 54th Street near Sixth Avenue in October 1928, the following month Schultz's men gunned down Diamond's mentor Arnold Rothstein at the Park Central Hotel just two blocks away. Rothstein died two days later.

Nearly a year later, Schultz's goons went after Diamond in his chorus-girl mistress's room at the Hotel Monticello on 64th Street, near Central Park West. Legs was sprayed with bullets but survived. The chorus girl disappeared.

For Schultz, a permanent link to the Catskills began to take hold once Prohibition was rolled back in 1933, by which time the Dutchman had already safely cushioned himself in the Harlem numbers racket, union management, and Tammany Hall, the corrupt New York City Democratic machine that controlled the courts and the cops.

"When Prohibition ended," said Conway, "the former bootleggers had to find new ways of making money. One of the ways they devised was to form a syndicate, an alliance between Sicilian and Jewish gangsters—really the first time that those two groups of gangsters had formally worked together, largely through the efforts of Lucky Luciano and Meyer Lansky."

Prohibition brought Dutch Schultz, né Arthur Flegenheimer, to the Catskills, where he kept a home and oversaw stills in Phoenicia.

Because of his Tammany connections, the New York police refused to arrest Schultz, so the federal government stepped in, and the Dutchman was indicted in 1933 for income-tax evasion. Named Public Enemy Number One by FBI director J. Edgar Hoover, Schultz allegedly made $481,000 (with no overhead expenses) from 1929 to 1931 from his beer enterprise alone, exclusive of what he was reaping from his numbers and protection rackets.

Before the trial, his lawyers secured a change of venue to the small upstate New York town of Malone. Schultz moved there temporarily and posed as a model citizen—buying dinner and drinks for others at every opportunity, granting interviews to the local press (who found him surprisingly erudite), presenting toys to sick children, attending a local baseball game as the personal guest of the mayor, and successfully convincing many townspeople he was being unfairly persecuted by a vengeful government.

"By the time the jury was asked to deliberate, Schultz had fooled or bribed the entire town," said Rich Cohen. "There is a picture of him just after the acquittal, the broad smile of a kid who has stolen a student council election."

The smile quickly faded. Fiorello La Guardia, the newly elected reform mayor of New York City, threatened to have the Dutchman arrested the moment he set foot in town. At the same time, Manhattan-based mobsters, including Lucky Luciano and the cartel's enforcer, Albert Anastasia, sensing Schultz's vulnerability, were closing in on his territory and his rackets. From the other side, Thomas E. Dewey, then the fierce federal special prosecutor (and later governor of New York State and the 1944 and 1948 Republican candidate for president), stepped up the pressure on Schultz, harassing him at every turn.

His back to the wall, Schultz summoned a meeting of the syndicate, where he called for the murder of Dewey. "In fact," said Conway, "he had already decided he needed to get rid of Dewey, but as a good soldier, he went to the board of directors before he carried this out and told them he wanted to kill Dewey. Well, these guys were a little bit smarter than Schultz and a lot less impetuous. Lucky Luciano and Meyer Lansky, especially, realized that killing someone of Dewey's stature would be a big mistake and bring a lot of heat down on their organization. They discouraged Schultz from following through on his plan, but Dutch was outraged that they wouldn't listen to his reasoning, and he basically stormed out of the meeting, saying, 'I don't need your permission, I'll do it myself.' So that left Luciano and Lansky with a dilemma. Should they allow Schultz to kill Dewey and destroy what they wanted to build, or do they kill Schultz themselves before he can carry out the plan? This turns out to be a very attractive option for them because they had designs on Schultz's territory anyway. So they decided to have Schultz killed."

Albert Anastasia was ordered to arrange Schultz's assassination and assigned Lepke to handle it. (While the cartel was composed mostly of Jews and Italians, when it came to dispensing justice, the board left each group to take care of its own.) "Now, Schultz had already put his plan in motion and had Dewey followed on a regular basis," said Conway. "And, if not for a fluke in Dewey's schedule, the hit probably would've been carried out."

Instead, on Wednesday, October 23, 1935, Schultz and three of his confederates were gunned down by Charles "Bug" Workman in the bathroom of the Palace Chop House, a dingy restaurant a few blocks from Newark's Penn Station. "He was there because he's a wanted man and can't show his face publicly in New York

State, and it's here that Luciano and Lansky's men find him," said John Conway, although the story by now sounds more like something from Mario Puzo.

"Schultz excused himself from the table and used the men's room at just the moment that the hit men entered the tavern and began shooting. One of the hit men entered the men's room and saw someone they didn't bother to identify and shot him and left him for dead. After the shooting, they left, assuming they had killed everyone. Schultz, who was the man in the men's room, didn't die right away. But he was mortally wounded."

Hit in the spleen, stomach, colon, and liver, the thirty-three-year-old Schultz was taken to the Newark City Hospital. "He lingered for twenty-four hours, lapsing in and out of consciousness," said Conway. As he lay dying and ranting deliriously with a fever of 106, Schultz had his bedside words taken down by a police stenographer as a detective asked if he could identify who shot him and possibly speak about his crime operation.

Among Schultz's bizarre ramblings:

Oh, mama, mama, mama . . . How many shots were fired at me? . . . John, please, did you buy me the hotel for a million? . . . I'll get you the cash out of the box . . . there's enough in it to buy four, five more . . . Lulu, drive me back to Phoenicia . . . Don't be a dope Lulu, we better get those Liberty bonds out of the box and cash 'em . . . sure, it was Danny's mistake to buy 'em, and I think they can be traced . . . Danny, please get me in the car . . . Kindly take my shoes off, they're not off . . . there's handcuffs on 'em . . . Wonder who owns these woods? . . . he'll never know what's hidden in 'em . . . My gilt-edge stuff and those rats have turned in . . . What did that guy shoot me for?

The mob kingpin lasted until eight-thirty Thursday evening, and it was from these and other disjointed mutterings that a legend was born.

That of Dutch Schultz's lost Catskills treasure.

"PART OF SCHULTZ'S PREPARATION if he had to go on the lam after Dewey's murder, or if he were to be captured and sent to prison, was to hoard some money to fall back on and bury it," said Conway.

Further fueling the story, Schultz commissioned the construction of an airtight, waterproof safe into which, it was rumored, he placed $7 million in cash

and bonds. "Five or seven million dollars, depending on whose story you believe," said Conway. "It's believed he buried it, either in a steel suitcase or a specially made safe, around the Phoenicia area, where during Prohibition he operated some stills and became a fairly well-known presence." The burial supposedly took place with Schultz accompanied by his chief lieutenant, Bernard "Lulu" Rosencrantz. "Schultz was definitely wealthy enough to have hoarded away millions of dollars," said Conway, "and he was stingy enough not to have spent that money and to actually have it available to bury somewhere."

Rosencrantz scrawled out a map documenting the loot's location, but here too legend has taken over. It was buried between two pine trees, or by the railroad tracks, or under a boulder by the banks of the Esopus River. One version had Schultz and Rosencrantz stopping for lunch at the Phoenicia Hotel, leaving by one o'clock, then driving half a block before turning right on Route 214. From there they proceeded about eight miles north along Stony Clove Creek, eventually burying the money underneath a skull-shaped rock formation known as the Devil's Face. By three o'clock that same afternoon they were back in Phoenicia before heading down to Newark for their fateful encounter at the Palace Chop House.

Some accounts have Rosencrantz entrusting the treasure map he drew to Marty Krompier, one of Schultz's lieutenants. Jacob "Gurrah" Shapiro, the long-time associate of Lepke's, heard that Krompier had the map and figured that if he got his own hands on it the $7 million could be his. "Shapiro's not a real bright guy," said Conway. "He's a gangster largely because of his brawn. He's the brawn to Lepke's brain. But he understands that there's a treasure to be had." By the same token, the keeper of the map, Marty Krompier, "wasn't too bright either," said Conway. "Krompier was told to keep the map in a safe place. And Marty's idea of a safe place was to carry it around in his wallet wherever he went."

That was all the information Shapiro needed. He gunned down Krompier in a barbershop in a subway arcade at 47th and Broadway, then retrieved the map from Krompier's wallet, tossed its cash contents in the barber's face, and snapped, "Here's Marty's last tip. It's a big one."

As a habitué of Sullivan County, Shapiro studied the map but could make no sense of it. While familiar with the areas around Monticello, South Fallsburg, and Loch Sheldrake, he could not make out Rosencrantz's markings about Phoenicia and Mount Tremper in Ulster County. In frustration, he reputedly tore the map to pieces, bellowing, "These ain't the Catskills!"

Whatever fate befell the alleged map, the story of Dutch Schultz's buried treasure persisted, at times setting off a quest every bit as obsessive as Henry Hudson's for the Northwest Passage. "It's become a legend that has fed the economy of the area," said Conway. "Treasure hunters come from all over the country, many of them even have maps. Some say they got them from someone who knew Schultz personally. Others say they knew someone who had been in prison with someone who knew Schultz, or else they purchased it at a garage sale where someone who knew Schultz had died."

Even E. L. Doctorow, whose 1989 *Billy Bathgate: A Novel* tells of a young errand boy and surrogate son to Schultz, bolstered the belief that Schultz's loot might still be in them thar hills. "Mr. Schultz's whole missing fortune which to this day and until now people have believed was never recovered," said Billy after he returned from service in World War II, when he took the money for himself. "It was in the form of bundled Treasury certificates and crisp bills, and it was stuffed in a safe, packs in mail sacks . . . like pirate swag, [a] monument to ancient lust." As for its location, Doctorow's hero would only reveal that "it was just where I knew it would be."

While conceding that the Dutchman "was kind of elusive," Doctorow himself said, "There are a lot of guys of that generation who did this sort of thing. Stashing away cash in the Depression was not such a stupid idea, whether you were a criminal or not."

Several of the fortune hunters who still flock to the Catskills every spring are convinced Schultz left the stash along Route 28, between the roadway and the Esopus Creek, although most of the digging today is done within Phoenicia. "I don't believe there's anything to it, but they keep coming," Hillary Gold, the librarian in the town's tiny public library, told *The New York Times* in 1997. "The second a stranger comes in and asks for an old map, I know what they're here for."

When the railroad to the hamlet was still in operation, one prospector kept digging along the tracks until he was ordered to stop, as his excavations were undermining the ballast support. In another effort, a motel owner in Phoenicia let fortune seekers dig on his property in return for a share of the treasure should anything be found. This continued until one of them showed up with a backhoe, dug dozens of holes, then disappeared without filling them back in. (Conway told a similar story, but the property was a motel, the proprietor was a woman, and the treasure hunter showed up with heavy equipment.)

Gary Bennett, a Holyoke, Massachusetts, resident, was inspired to search for Schultz's millions after seeing the story on television's *Unsolved Mysteries* in 2005. Speaking to the Associated Press, Bennett said he had made at least a half dozen treasure-hunting trips to the Catskills, sometimes with his wife and two sons, and that he had also read up on the story in search of every clue.

To this day, neither Bennett nor anyone else has found a penny.

II

Diamond was found not guilty Thursday in Rensselaer county supreme court at Troy of kidnapping James Duncan, 20-year-old Green[e] county farm boy. The verdict was reached five hours and 31 minutes after the jury received the case.

—Associated Press, December 18, 1931

How Jack Moran, alias "Gentleman Jack," got the name "Legs" Diamond was widely disputed, though it was said, like Jimmy Cagney, the guy could dance, and he certainly could run. An Irish-American gangster born in Philadelphia in 1897, Diamond has also been called America's first antihero, from an era in which the true villains were the American government for legalizing Prohibition and the law for enforcing it. Or at least pretending to.

Baptized Jack Nolan and motherless at sixteen, Diamond moved with his bereft father to New York City, where the teen joined the Hudson Dusters street gang and quickly developed a taste for fancy clothes and fast women. At seventeen he served a prison stretch for burglary and narcotics smuggling, and at twenty-one was jailed again for deserting the army. By the time his life played out in its thirty-fourth year, Diamond had become to New York what Al Capone was to Chicago, though the charismatic "gangster, gunman, and bootlegger," as *Time* labeled Legs in May 1931, seven months before enemies finally laid him to waste, could also claim another seat of power: the Catskills hamlet of Acra, from which he controlled eighteen different counties around New York State, had on his payroll sheriffs who brought down booze from Canada, and ran Greene County's lucrative beer and applejack industries.

"He had the rhythm and strut of a star," said the author Jerome Charyn, "and became, in the 1920s, a creature of the American imagination, larger than his own

Jack "Legs" Diamond's mug shot, September 22, 1930; as the incident was reported by the *New York Sun* on December 18, 1931: "He went back to his old home town, Philadelphia, and they arrested him as a suspicious character. However, after he promised never to set foot in his native city again, he was turned loose and he went up to the Catskills for a rest."

miserable roots." Newspaper reporters relished his flamboyant exploits, including how he visited the Cotton Club following his release from Bellevue Hospital after yet another attempt on his life. Arriving with his girlfriend, the redheaded *Follies* dancer Kiki Roberts, Legs asked Duke Ellington to play "St. Louis Blues," and the bandleader cheerfully obliged—earning a thousand-dollar tip from Gentleman Jack.

"Thanks, kid," Diamond told Ellington. "Buy yourself a cigar."

HIRED AS THE PERSONAL BODYGUARD for bootlegger and racketeer Jacob "Little Augie" Orgen after Arnold Rothstein had introduced them, Diamond was shot twice trying to protect his charge from Louis "Lepke" Buchalter, who was determined to move in on Orgen's Garment District contacts. Following Orgen's death at age twenty-six in a Lower East Side shoot-out—Lepke and Gurrah Shapiro had him triggered—Diamond handled bootleg whiskey, including shipments he hijacked from rivals. His base of operations was a second-floor Manhattan speakeasy called the Hotsy-Totsy Club, at 1721 Broadway, between 54th and 55th Streets (now the site of an apartment high-rise and a street-level coffee shop named, aptly enough, the Applejack Diner). Despite Diamond's personal flamboyance, his Hotsy-Totsy was emblematic of how speaks had degenerated from the onetime watering holes of the smart set to what New York district attorney Joab Banton

considered "hangouts of criminals who watch for women with jewelry and men with money, follow them when they leave, and rob them or blackmail them."

It was inside the Hotsy-Totsy Club one stifling July night in 1929 that two brothers, William "Red" and Peter Cassidy, and their companion, an ex-convict named Simon Walker, became too boisterous for Diamond's liking. Signaling the orchestra to play louder and drown out the din that would soon ensue, Legs and his partner, Charles Entratta, shot the trio, leaving Walker and Red dead and Peter seriously injured.

Twenty-five patrons witnessed the incident, though not one would dare testify. Entratta fled to Chicago, Legs to the Catskills, specifically, to Acra, where his younger brother Eddie Nolan already lived so he could handle his tuberculosis. Acra immediately became Legs's proud new home.

AS WITH his extravagant gesture with Duke Ellington, Diamond, unlike Dutch Schultz, never shied away from generously reaching into his pocket, and examples of his largesse were especially evident in the Catskills. Besides quietly slipping money to those flattened by the Depression, Legs fully funded the building of the red barn–like St. Edmund's Chapel in Acra. He also picked up the tab at the A&P in the adjoining hamlet of Cairo for Thanksgiving baskets to be given

As with Capone, the legend of Legs Diamond refused to die. In 1960, Warner Bros. released the low-budget *The Rise and Fall of Legs Diamond,* starring television actor Ray Danton in the title role. The script kept the names real, but in accepted Hollywood tradition, made up most of the story.

"A strange, cold, sordid movie about a strange, cold, sordid gangster," said *The New Yorker* in a capsule review.

Despite its flaws, the film became a lifelong obsession for Australian composer-entertainer Peter Allen, who in 1988 used it as the basis for the dressed-up Broadway musical *Legs Diamond,* starring himself as the tap-dancing bootlegger.

Unlike Legs, who made a habit of surviving real bullets for most of his brief life, the ill-conceived show, massacred by critics, died a quick death.

to the neediest cases, handed cash and candy to local kids, and had a clothing shop in Catskill replenish the wardrobe of a woman who had lost every stitch in a fire. And while he was unquestionably ruthless and undoubtedly sociopathic, Diamond spared the life of Catskills truck driver Grover Parks, whom Legs was torturing, possibly out of admiration for how the loyal Parks refused to name the bootlegger who had hired him to drive a truck loaded with barrels of applejack—local cider distilled into potent liquor.

The incident, as described by *Legs* author William Kennedy, took place on April 18, 1931, with Legs and his henchmen commandeering Parks's truck, taking him to the Acra compound, stringing him up to a tree, beating him, then putting lit matches and cigarettes to his bare feet. Still, Parks refused to talk. Finally, Legs held a gun to the driver's head. Again, not a word.

So Legs patted Parks's cheek and let him go. Parks ran to the police and then got a gun to protect himself, and Diamond got into the applejack business.

DIAMOND DISTILLED his main product at the floodlit Acra compound and also produced beer in the old Barmann Brewery in nearby Kingston, dispensing the suds through an elaborate series of rubber hoses running through the city sewers to a warehouse several blocks away. There the beer was kegged and loaded onto waiting trucks so it could be shipped to speakeasies in New York City and Albany. The rubber hose was discovered only in the late 1970s, although it was said that during Prohibition townspeople were fully aware of its existence but didn't speak of it, fearing retribution.

Earning the reputation as the clay pigeon of the underworld after having survived numerous attempts on his life that nonetheless left him wounded and hospitalized, but always still breathing, Diamond in early 1931 was targeted by Schultz's henchmen, who opened fire with machine guns at the Aratoga Inn near Cairo in Greene County. They missed Legs but killed two bystanders. After the failed attempt, Schultz was quoted as saying, "Ain't there nobody who can shoot this guy so he don't bounce back?" Even Diamond's doctor was amazed at his patient's recuperative powers. "He's lead proof," said the physician. "They can't kill him off."

But Diamond's luck was about to run out. New York governor Franklin D. Roosevelt, prior to sailing to Paris to visit his flu-stricken mother, Sarah, appointed state attorney general John James Bennett Jr. to supersede the presumably cor-

rupt local prosecutors and clean up the Catskills gangster colony. In short order, two Diamond goons were arrested, the Acra house was raided, and Diamond was slapped with another charge after weapons were discovered in his car. Coupled with a previous conviction for burglary and the old sentence for deserting the army, he was as good as convicted in Bennett's eyes. On top of that, the state had stumbled upon Legs's central liquor dump, where they discovered $5,000 worth of whiskey, wine, and beer hidden in an outhouse behind the Aratoga Inn, near Cairo, where Diamond played host.

Before he could be tried on any past charges, another trial was held in Catskill, in December 1931, for the kidnapping and torture of Grover Parks. Legs was acquitted, but on the verge of his next trial he stole away from a party he was attending with his devoted wife, Alice, to visit his old girlfriend, Kiki Roberts.

At around five-thirty in the morning, December 18, 1931, following a night of drunken revelry with Kiki, Jack "Legs" Diamond was shot in the back of the head three times at point-blank range. Whether it was Dutch Schultz or another enemy who ordered the hit remains an unsolved mystery.

William Kennedy, in *Legs*, proposes that Diamond's murder was ordered by the Democratic political establishment in Albany, eager to rid the city of the syndicate, and that the deed was carried out by the Albany police.

III

A Sullivan County jury, deliberating an hour and a half, tonight acquitted Irving (Big Gangi) Cohen, Hollywood bit actor, of the ice-pick slaying of Walter Sage in July, 1937. The killing was one of 57 attributed to a Brooklyn "murder-for-cash" syndicate.

—Associated Press, June 22, 1940

Anyone out for an stroll along the shores of Sullivan County's Swan Lake on the morning of July 31, 1937, would have noticed a strange object floating in the deep glacial pond: the body of a man named Walter Sage, who had been missing for nearly two weeks. Stabbed thirty-two times in the neck and upper chest with an ice pick, his bloated corpse was still lashed to a slot machine that had accompanied him, along with a large rock, to the bottom of the lake.

The Noble Experiment, as President Herbert Hoover called Prohibition, may

Strollers along Sullivan County's Swan Lake on the morning of July 31, 1937, encountered an unexpected sight: the corpse of Walter Sage, strapped to a slot machine.

have ended in 1933, but the mob found other ways to keep their coffers filled, and this included slot machines. Sage, a young member of the syndicate from Brooklyn that would evolve into Murder, Inc., had been assigned the job of overseeing the slot operations at the Catskills hotels for his boss, Louis "Lepke" Buchalter, the short-fused mobster who had gained his foothold in the crime world by seizing control of the garment industry unions before he extended into protection racketeering and narcotics trafficking.

"It was Sage's job to collect the money and pay it to the syndicate," according to historian John Conway. "Only, before too long, the boys realize that they're coming up short–they're not making as much money as they should." Abe "Kid Twist" Reles, also known as "the blustering badman of Brownsville," wisecracked at the time, "It looks like Walter figures all the nickels and quarters that stick to the ceiling belong to us, and he takes the rest."

As related by Conway, "Lepke decided that Sage must be taught a lesson, a permanent one." Sage's best friend, Irving "Big Gangi" Cohen, a 230-pound hulk, was dispatched to lure his pal to the Evans Hotel, in Loch Sheldrake, and then

invite him for an evening car ride. "In fact," said Conway, "Sage and Cohen are roommates—they live together at the Ambassador Hotel in Fallsburg." In the car, Sage sat in the front passenger seat, Big Gangi in the back, and behind the wheel, Jack Drucker, a Catskills local from Hurleyville with a long criminal record.

At one point, Drucker slowed down, and Big Gangi, who was reputed to be practically capable of performing brain surgery with an ice pick, took out the instrument and, with an assist from Drucker, stabbed Sage thirty-two times. As the wounded Sage struggled, he grabbed the steering wheel from Drucker and "actually managed to pull it off the road and into a ditch, wrecking the car," said Conway.

When one of Drucker's stabs accidentally missed Sage and struck Gangi instead, the big guy took it as a sign that the jab had been deliberate and he was the next to go simply for knowing too much *and* being Sage's friend. Gangi "let out a primal scream," said Conway, "and left the car in a beeline for the woods and disappeared."

In the car trailing them, Abraham "Pretty" Levine, Harry "Pittsburgh Phil" Strauss (considered the most prolific of all Murder, Inc., hit men), and Albert "Tick-Tock" Tannenbaum, whose father owned the Loch Sheldrake Hotel, watched in amazement as the bulky Big Gangi streaked off into the darkness. Then, along with Drucker, they carried Sage's dead body to the follow-up car and the group of them drove to Swan Lake, "which is one of the deeper lakes in the county," said Conway. "'Pittsburgh' always had a flair for murder and a sense of irony, and so he decided to tie Sage's body to a slot-machine frame, since it was the proceeds of the slot-machine operation that led to Sage's demise." Added to the package was "a thirty-pound rock," said Conway, "and they rowed out to the middle of Swan Lake and dumped the body overboard, thinking it won't be found for months."

Ten days later the body surfaced, still tied to the gaming machine. The gases generated by the decomposition of the corpse had not been sufficiently released by the puncture wounds, causing the jabbed remains to surface—in full view of the dozens of hotel guests out for a leisurely walk around Swan Lake.

"This is in July of 1937," said Conway, "the height of the tourist season."

IN THE TIME it took the law to pin the murder on a suspect, Big Gangi had hopped a train to California, where he took the name of Jack Gordon and became a bit actor in movies, usually playing a tough guy or a cop. Two years after the stabbing, a Sullivan County policeman went to a local movie theater to see Bar-

bara Stanwyck and William Holden in the boxing drama *Golden Boy* and recognized Big Gangi among the extras in a fight scene.

Enforcement officers contacted their counterparts in California, who jailed Big Gangi on a fugitive warrant, then extradited him to Sullivan County for trial, the anticipation for which was covered in *Time* magazine's April, 1, 1940, issue:

> Murder indictments were handed up last week in Sullivan County against five men, including Big Gangi Cohen, who was promptly arrested in California. Lesser crimes were added to the gang's midden-heap record: loan-sharking, extortion for "protection" of prostitutes, bookmakers, merchants, laundries, even women's afternoon small-stakes card games all over Brooklyn. Nothing, apparently, was too picayune if it could turn a dishonest dollar.

The only snag: came the time of the trial, the leads were cold and the witnesses were either "unavailable" or of questionable character. To quote Lepke's "bombproof technique" for resolving such matters, "All investigations collapse when there are no witnesses around." For his part, Big Gangi cried on the stand, the United Press reported. "This man is lying. I wasn't there, honestly," the tearful defendant testified when Abraham "Pretty" Levine accused him in court of participating in Sage's fatal stabbing.

Finally, not only was Big Gangi acquitted for lack of evidence, but according to the Associated Press he "was calm when the jury, including seven farmers and a housewife, returned its verdict. His wife, Eva, rushed sobbing to his side and then the defendant began to cry. He thanked the jury and said he would return to Hollywood immediately." There, he resumed his acting career, racking up more than thirty impressive credits before his death in 1976. Besides a bit part in *It's a Wonderful Life*, with Jimmy Stewart, he also landed roles on television's *The Untouchables*, *Perry Mason*, *Gunsmoke*, and *Bonanza*.

In 1943, six years after Walter Sage's murder, Jack Drucker, the driver of the car in which Sage was offed, was arrested. Star witness for the prosecution "Tick-Tock" Tannenbaum told the court that he had discussed Sage's murder with Drucker and that Drucker told him he had killed Sage under direct orders from "Pittsburgh Phil" Strauss.

Drucker, desperate to save himself, claimed it was Strauss who had actually committed the murder, but Strauss had an alibi for his whereabouts on the night of the killing—something Drucker did not.

Drucker was convicted and sentenced to twenty-five years of hard labor. He died in Attica State Prison in 1962.

THE SAGE MURDER WAS one of the last acts of gang-related violence to disturb the calm of the Catskills in the years following the First World War. All told, from Prohibition's enactment to repeal, at least eight gangster-related killings occurred in Sullivan County. As the 1930s wound down, most of the flamboyant characters who had operated illegal stills, run truckloads of whiskey down back roads, and deposited bodies in lakes were either behind bars or dead.

Murder, Inc., hit man Abe "Kid Twist" Reles said he found God and became a government informer, and in 1941, at the age of thirty-five, after implicating several members of the mob, including his old boss Louis "Lepke" Buchalter, he either fell or was thrown out of a window at the Half Moon Hotel in Coney Island. "Abbadabba" Berman, always respected for his math ability, was forty-six and Bernard "Lulu" Rosencrantz thirty-three when they were both shot to death along with Dutch Schultz at the Palace Chop House. Legs Diamond had only been thirty-four, and the Dutchman no older. "Little Farvel" Cohen held on longer. He was sixty-three when he was murdered after serving a ten-year stretch for narcotics trafficking.

It was Lepke who met the most ceremonious demise. Taking it on the lam in the mid-1930s to escape federal narcotics charges, the old shakedown artist eventually believed he could strike a deal with J. Edgar Hoover, whom he surmised might go easier on him than would the unflinching racket-buster Thomas Dewey. The special prosecutor for the state had been on a two-year manhunt for Lepke, posted a $25,000 bounty on his head (dead or alive), and branded him "probably the most dangerous criminal in the U.S." But in an incident meant to humiliate Dewey, in the summer of 1939 Lepke was introduced to Hoover at a private Manhattan summit arranged by the omnipotent *Daily Mirror* columnist and radio personality Walter Winchell, who knew the FBI director personally.

"Hoover wanted Lepke badly," wrote Hoover biographer Curt Gentry, "but even more, he wanted to upstage Dewey."

Practically an equal to Hoover in terms of ego and power, Winchell proved a formidable front man for the director. "Attention Public Enemy Number One, Louis 'Lepke' Buchalter," the famously nasal commentator bellowed across the nation's airwaves on his Sunday news program that August. "I am authorized by

John Edgar Hoover of the Federal Bureau of Investigation to guarantee you safe delivery to the FBI if you surrender to me or to any agent of the FBI."

For three weeks after the announcement, a representative of Lepke's made a nightly call to Winchell. During that same period, Winchell met Hoover at the Waldorf-Astoria to glean, on behalf of the mobster's rep, what sort of sentence Lepke might expect. Twelve to fifteen years, if convicted, said Hoover. Lepke was expecting only ten, though unbeknownst to him, the fix was already in. As Gentry reported, "[T]he only reason Lepke had surrendered to Hoover (and Walter Winchell) was that Lepke's associates had decided to sacrifice him to relieve the pressure on their own activities."

Louis "Lepke" Buchalter lived in a palatial Catskills hilltop estate, with Tara-like white colonnades, in South Fallsburg.

The three met on August 24, 1939, around 10:15 p.m. inside a parked car at the corner of Fifth Avenue and 28th Street. Two weeks later, Hoover escorted Lepke into the Federal Building, where he was indicted on ten counts of narcotics smuggling–not on the murder rap Dewey wanted to pin on the criminal for ordering the 1936 hit on Brooklyn candy store owner Joseph Rosen, who had failed to follow the racketeer's orders.

The drug charges earned Lepke fourteen years in Leavenworth, in addition to another sixteen for union racketeering. While Lepke served his time, Dewey steadily built his case. In November 1941, a New York jury convicted Lepke of first-degree murder, for which he received the death sentence.

Fighting extradition from Leavenworth, Kansas, to New York for his execution, Lepke was finally sent to Sing Sing in January 1944.

That March 4, he was electrocuted.

He was the only major mob boss ever to receive capital punishment.

All That Glitters

I

> If Rip Van Winkle, that old pizza lover, ever came back to the Catskills, he'd be stunned. The Mountains are still barely as high as the Highlands of Scotland, but they now shelter the largest concentration of summer vacationers in the U.S.—in hundreds of resorts whose facilities, food, and flavor are unique.
>
> —*Sports Illustrated*, July 2, 1962

Although Malke took her time turning over control of her kitchen to others, the reins of the Grossingers' business once the family made the 1919 move from Longbrook to Terrace House were handed over from Selig and his son-in-law (and Jennie's husband) Harry to Jennie herself.

"When people speak about Grossinger's," said Jennie and Harry's daughter, Elaine Grossinger Etess, "the person they really speak about is Jennie. Jennie was the lady of the house. Jennie was full of hospitality. She had a way with people that was second to none." With her remarkable memory and commanding presence, it was Jennie who, in an offer of congratulations that was akin to a benediction, would greet every guest by name, remember who among them had welcomed a new baby or grandchild, or had recently sold his business.

Described by Leo Lerman of *Vogue* as possessing a "tight profusion of blond hair, a plump face," generous lips, and smiling blue eyes, Jennie, from her daughter's perspective, may have lacked a formal education, but "was able to hold her own with the first ladies of the United States. Eleanor Roosevelt was a dear friend of hers."

Etess credited her mother's special "ease with people. There wasn't anything pretentious about her. She was as comfortable sitting at a head table as she was sitting in a chair in her living room."

UNSURPASSED AT FEEDING its customers, Grossinger's Terrace Hill House, which became simply Grossinger's—or, even better, the G—would survive the Great Depression and the shortages during World War II, then spare no effort in maintaining its hard-won position as the gold standard of the Catskills for accommodations, service, recreational facilities, and entertainment, all under one roof.

Not unexpectedly, this engendered some envy, if not downright enmity, among other hotel owners. Henrietta Lichtenbaum recalled how her grandfather, George Barrack, owner of the Excelsior Hotel in Liberty, nurtured the idea of its becoming another Grossinger's, "but he expanded at the wrong time, 1929 to be exact. . . . We were keenly aware of our competition—hence, the casino, the clay tennis court, the handball court, and the serious thought of a swimming pool."

While the Great Depression cut sharply into the number of Jewish vacationers, the consumer's need to scrimp not only helped spur the growth of *kuchalayns*, the cheapest of Catskills accommodations, but even compelled some families to open their summer homes to paying guests. Waging their own struggle to keep business alive, Grossinger's and other hotels announced "rates in step with the times," offering reduced travel fees and three meals a day.

Eleanor Roosevelt and her hostess and "dear friend," Jennie Grossinger, enter Grossinger's dining room.

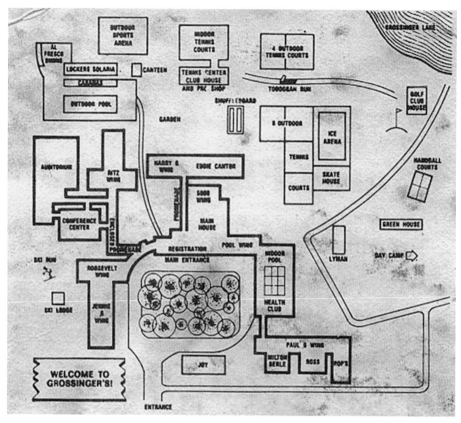

Grossinger's grew from one hundred acres in 1919 to twelve hundred acres by the time of Jennie's death in 1972. This map is from 1986, the year the family sold the property.

The cutbacks by the railroads, as much a result of highway improvements and the popularity of the automobile as they were due to the national economic downturn, actually began with a shutdown of service in the north as early as 1920, affecting the short-haul lines of the Catskill Mountain Railway, the Otis Elevated Railway, and the Catskill and Tannersville lines. Passenger traffic on the Ulster and Delaware, the major rail carrier in the north, also began a steady decline, and by 1932 the railroad had gone bankrupt. Once the pride of the southern Catskills, the Ontario and Western saw its trains taken out of service, its repair work languish, and its very name, the O&W, become an acronym for "Old and Weary." In 1937 the line filed for bankruptcy, even though it would continue to operate in a limited way for another twenty years.

Catskills tourism also benefited from the imperious political collusions of Robert Moses, the "city-transforming Faust," as Charles McGrath of *The New*

York Times called him in 2012, thirty-two years after the urban planner's death. Rising to power in the 1920s, Moses ended up controlling all road and bridge construction in New York City for the next four decades. Intent on preventing those who rode buses—primarily New York City African Americans—from gaining inexpensive access to his beaches on Long Island, Moses ordered all bridges on his new parkways to be built so low as to prevent buses from passing under them.

"Bus trips therefore had to be made on local roads, making the trips discouragingly long and arduous," Robert Caro wrote in his definitive 1974 biography of Moses, *The Power Broker.* The maneuver also forced an increase in car traffic, with those families inside the private vehicles generally able to afford an escape to the Catskills.

"The end result is another period of great prosperity based on tourism, which

Charles and Lillian Brown opened Brown's Hotel in 1944, in Loch Sheldrake; during the 1950s and '60s, it was considered the third most popular resort, after Grossinger's and the Concord. In addition to an Olympic-sized pool, it boasted "the beautiful Redwood cocktail lounge."

The Nevele, in Ellenville, had existed since 1903 and was more of a family destination than the other Borscht Belt resorts, although it still included the requisite Olympic-sized pool and what then passed for designer interiors.

today we call the 'Golden Age,'" said John Conway, "the era of the great hotels—the Concords and the Grossinger's, and the very popular Jewish resorts."

These same "great hotels" could also claim another distinction, as the precursors of the Las Vegas resorts of the postwar years, which offered their customers everything from swimming pools to dress stores to top-name entertainment all within the confines of the same property. Forty and fifty years after that, the same design principle was applied to cruise ships, which offered just as many recreational activities, and just as much food, as the bygone era of the Borscht Belt.

In the tradition of a matriarchy, where the Jewish mother was revered, women served as the trademark representatives of most large Catskills resorts. Just as they counted on being greeted upon arrival by Jennie at Grossinger's, so did customers expect to find Helen Kutsher playing hostess in the lounge of Kutsher's Hotel in Monticello, or the flamboyant Lillian Brown at Brown's Hotel near Liberty. At the Concord, where the proprietor's wife, Jean Winarick, was active in philanthropy,

it was husband Arthur who, in possession of his own remarkable memory for guests' names, was left to serve as unofficial greeter, though he also took advantage of the anonymity that allowed him to query guests on their likes and dislikes of the hotel.

"In small resorts, husbands and wives split the responsibilities," said Esterita "Cissie" Blumberg, who ran the Avon Lodge in Woodbridge. "The hotel was more or less divided into 'front of the house' (reservations, advertising, entertainment, hosting) and 'back of the house' (kitchen, purchasing, maintenance)." Still, "Even if a woman had the 'privilege' of working in the front office," she said, "it was inevitably the male member of the family who represented the hotel at the board table of the insurance cooperative, credit union, hospital, and Hotelmen's Feder-

M idway to the mountains, a stop at the Red Apple Rest on Route 17 in South-fields, New Jersey, was all but compulsory.

A product of the Depression, the Red Apple was born after Russian émigré Reuben Freed lost his Garment District women's coat and suit business to the stock market crash. Accompanying a cousin on a delivery outside the city to Tuxedo, New York, Freed spotted a combination gas station/refreshment stand on State Route 17, then only a dirt road, and with $3,000 of borrowed money (for silverware) began operations in May 1931, reputedly naming the place for his cook, a redhead named Red Appel.

The first season Freed nearly lost his shirt, but with the October 1931 opening of the George Washington Bridge, the customers started arriving, in droves. By the Second World War the Red Apple was running twenty-four hours a day, seven days a week.

While customers especially loved the hot dogs, performers took advantage of the locale to meet their agents for last-minute instructions, or else for a switch in bookings.

Comics held court at the Red Apple on their way back to New York after their performances, bragging about how they had "killed" at their last gig or inflating the amount of money they had received.

In 1965 alone, when the Red Apple Rest hit the thirty-four-year mark, it served one million customers. But who's counting?

ation." As Blumberg pointed out, "In every hotel there was a woman who was an integral part of the operation, but the trade organization was called the Hotel-*men's* Federation."

"Jennie Grossinger and some of the other women who opened up these hotels were really the most successful of the great Catskill matrons," said Jonathan D. Sarna, who saw these groundbreakers as having "taken some of the values of the wonderful *balaboosta* [perfect homemaker], as we might say, and marketed those values. There weren't many businesses open to women in those days, and the values and virtues that made you a good hostess and someone who people wanted to entrust their summers to made you a very successful matron of the hotel." Jennie, he said unequivocally, "was truly able to build this hotel into the great success that it was."

By having invested in physical improvements to her enterprise rather than in the stock market, as Lottie's husband, Louis Grau, had advised, the Grossingers—and the G—survived the 1929 crash. By 1931, the same year as Selig's death (Malke made it to 1952), Grossinger's guests enjoyed tennis courts, an eighteen-hole golf course, a dining room that seated four hundred, and a theater. Over time further additions included a post office (so correspondence could be stamped "Grossingers, N.Y."), a newspaper (*The Grossinger Tatler*), a fire department, a *schul* (albeit small, necessitating the extra use of the showroom or ballroom for High Holy Day services), a toboggan run, a ski slope, a riding academy, and, eventually, an airfield mostly served by Mohawk Airlines but also accommodating private planes, so that VIPs from Nelson Rockefeller to Rocky Marciano would no longer have to land on the golf course.

Along with upgrading the structure and gardens, in 1929 Jennie hired Milton Blackstone, a Manhattan-based publicity specialist with a tight-lipped, lawyerlike demeanor. (Later on, his other accounts included the Copacabana, Toots Shor's, and Billy Rose's Diamond Horseshoe.) In 1934 Blackstone "got the idea of having lightweight champ Barney Ross train at Grossinger's," remembered comedian Joey Adams. Entrusted with making Grossinger's a household name, Blackstone also initiated the concept that couples who wed after they had met at the hotel would then receive a free honeymoon there. As for bringing Barney Ross up to train in his upcoming bout against Jimmy McLarnin, Adams recalled, "Jennie went for the idea, but her mother wouldn't hear of it. 'A fighter on my grounds? Never!' she said. But when Blackstone explained that Ross was an Orthodox Jew, ate strictly kosher, and didn't work on the Sabbath, she agreed."

Kutsher's, in Monticello, specialized in welcoming sports-minded guests as well as staff members; hostess-proprietor Helen Kutsher was a Jewish mother figure to one of her bellhops, future basketball great Wilt Chamberlain.

"A resort isn't buildings and kitchens and lakes or nightclubs," said Jennie Grossinger. "The real hotel is the people who work here." Still, when the 1950s turned into the '60s, modern expansions included an outdoor pool and cabanas, all-weather tennis courts, an indoor swimming pool, an outdoor winter sundeck, and a boxy residential tower, called the Jennie "G."

The Concord, its lobby and outdoor and indoor pools pictured here, was an ever-growing monument to chrome and concrete. According to Mordecai Richler, its owner, Arthur Winarick, once asked entertainer Zero Mostel, "What else can I do? What more can I add?" Replied Mostel, "An indoor jungle, Arthur. Hunting for tigers under glass. On *shabbos* the hunters could wear *yarmulkas*."

Accompanying Ross to the Catskills training camp was nearly every sports columnist from New York, as well as Damon Runyon, who arose at dawn to witness Jennie milking the cows. The celebrated newspaperman, whose short stories about the Manhattan demimonde would later provide the basis for the classic Broadway musical *Guys and Dolls*, some of whose scenes were set in the fabled Times Square deli Lindy's, nicknamed Jennie's resort "Lindy's with trees."

"Because of Blackstone, Grossinger's got a running start on all the other hotels," conceded Milton Kutsher, whose family-named Catskills resort featured a sports bent—Boston Celtics legend Red Auerbach coached the Kutsher's summer basketball team—and, in 1954, employed a veritable beanpole of a bellboy barely out of high school: Wilt Chamberlain, who was so tall he could push a suitcase through a second-story window from the driveway.

"He was like a member of the family," said Milton's mother, Helen Kutsher, who, with her then new groom, Milton, a sports enthusiast, started the resort in 1946. Recalling Milton's advising her to get this Chamberlain kid to bulk up by

drinking a full quart of milk a day, Helen told *The Wall Street Journal* in 2010, "It was nothing to him. He could swallow it down in one gulp."

Fifteen miles to the southeast of Grossinger's, at Kiamesha Lake, was the Gimbel's to Grossinger's Macy's: the Concord, formerly the Ideal Plaza. Taken over in 1935, the Concord became the plaything of its owner, Arthur Winarick, a bald Russian émigré who made his fortune with the unmistakably aromatic Jeris Hair Tonic, a mainstay of the nation's barbershops. To Winarick, bigger was better. He built fifteen hundred guest rooms on his two thousand acres, with a nine-story modern main building described as "Jet Airlines Terminal Contemporary"–until, in response to a cool reception from guests, he redid the stark white marble with dark wood paneling to make it more homey, like Grossinger's.

Winarick's dining room seated three thousand, and while the Concord wasn't the first resort in the world to create artificial snow for summer skiing–that distinction, expectedly, went to Grossinger's, in 1952–it was the first to offer its icecaps tinted hot pink.

In 1959, when Winarick inaugurated the Concord's coliseum-sized Imperial Room nightclub, the opening-night headliner, "Mr. Television" Milton Berle, told the packed house, "You think this is something? Next year they're going to build an indoor mountain."

Resort aficionados (and everyone who went became one) took special delight in feeding the feud by comparing the G and the Concord. Families and Orthodox Jews tended to frequent the former, where dietary laws were strictly observed and where every Sabbath eve the Grossingers, on the advice of a Talmudic scholar, signed a lease turning the hotel over to a gentile employee, so as not to violate the Orthodox proscription against working on the Sabbath. When Sunday rolled around, the lease was terminated and the Grossingers again assumed control of their hotel.

"The Concord was more Reform, and flashier," one Manhattan furniture dealer recalled decades after she visited Winarick's resort with her parents. The hotelier would have appreciated the observation. After the Miami Beach Fontainebleau opened and attracted attention in 1954, Winarick hired its architect, Morris Lapidus, to redo the Concord in similarly ornate overstatement.

Because Jennie Grossinger's pool cost $1.5 million, Arthur Winarick's cost $2 million–and claimed former Olympian and *Tarzan* star Buster Crabbe as its swimming instructor. How many holes was the Grossinger's golf course? Eighteen, Winarick was told. "Then," he replied in his broken English, "build me a fifty-hole course." "The nine-hole Challenger came first, then the eighteen-hole

International," wrote *New York Times* sports columnist Mike Strauss, "then in 1962, the 7,672-yard Monster championship course."

In the twenty-first century, long after the abandoned Concord had taken on the sad appearance of a bombed-out relic, the Monster still survived, prompting this 2005 assessment in *Sports Illustrated:*

> From the back tees, this par-72 course is indeed a monster at 7,650 yards. Monster features a par 5 that measures 632 yards and has water running the entire length of the hole. Built in 1964 in Kiamesha Lake, N.Y., this course touts a slope of 137. If you're a boomer off the tee and can keep the ball in the fairway more times than not, this course is for you—slay the monster!

WHILE SOME FIVE HUNDRED HOTELS and an equal number of bungalow colonies, the majority of them Jewish, were estimated to be operating during their 1950s peak, at least two decades before then about two dozen other ethnic groups, including Greeks, Armenians, Hispanics, and Chinese, had staked their claim to their own resorts in the region.

Germans stayed at the Bavarian Manor, in Purling, and in Lake Huntington at the Sagamore or else Kraack's Hotel, which specialized in beer and summer dances. Ukrainians had the Soyuzivka Resort, in Kerhonkson; Italians, the Villa Roma, in Calicoon, and the Villa Vosilla, in Tannersville; and the Irish, Gavin's Irish Country Inn and the Shamrock House, both in East Durham.

The Shamrock came into being in 1938, when Patrick Kellegher, a Long Island Rail Road worker and a part owner of the Three Musketeers bar in Jamaica, Queens, visited his sister Mary and her husband, George Sullivan, who had recently purchased Erin's Melody Hotel in East Durham. Taking a drive, Kellegher noticed that the Central Hotel on the town's main street was for sale and, according to the Shamrock's account, "was so taken with the beauty of the area and its likeness to his native County Longford that he purchased the Central," which he then renamed.

The Kellegher family kept the Shamrock running until 2009, when it was sold to John and Sue Quirk of East Durham, who promised to keep the long-standing tradition of Shamrock hospitality alive.

————

The year-round Hofbrau Hotel, on Route 28 in Phoenicia, promised "attractive rooms, excellent food," hunting, and free parking.

KERHONKSON WAS ALSO HOME to the first successful African-American resort in the United States, which opened in 1951 under the ownership of the popular one-legged dancer Clayton "Peg Leg" Bates. "Everybody went at least once or twice," said June Terry, who, then in her thirties, took day trips there in the 1960s. "Some people went three times. You'd catch a bus up in Harlem, and those were the days of hard drinking. Nobody drank wine in those days. They drank liquor. So you'd ride in the bus and drink and it could get pretty rowdy. People would sing, all the Motown stuff. It was one big party. You'd have a wonderful time. And when you got there, Peg Leg would have all this delicious food laid out for you, all under tents, and everybody would drink and party some more. Peg Leg would walk around and he'd dance for us. Oh, he was a wonderful man, a beautiful performer. The women all loved and kissed him."

According to most of his biographies, when Bates was twelve years old, in 1919, still living in his native Greenville, South Carolina, and only three days into his job at a cottonseed gin mill, his left leg was mangled by a threshing machine.

(A *New Yorker* "Talk of the Town" piece from 1943, done when Bates was performing morale visits to army and navy hospitals and camps, however, blamed the loss on a car accident that dragged him fifty feet after impact.) The amputation, above the knee, took place on the kitchen table at home, and Bates's mother, a sharecropper raising cotton on a white farmer's land, was inconsolable. She and her son had often butted heads, including the time young Clayton refused to do farm work and instead ran off to perform a buck-and-wing for customers' coins in the white barbershop. "Right off," Bates told *The New Yorker* about the accident, "my mother started cryin' and thinkin' I was through, and I said, 'Ma, stop wailin', I'll earn you a living.'" (He eventually bought her a house in Greenville.)

Upside-down broomsticks served as Clayton's first crutches, until his uncle carved him a wooden leg and attached a rubber tip, which is how the nickname developed. Undeterred by his setback, Bates, who had always had a musical inclination, forged a dance career, learning to leap nearly five feet into the air and delivering the most challenging of tap steps: cramp-roll turns, pullbacks, and Maxie Fords, as well as his own riffs.

A performance at Harlem's Lafayette Theatre served as entrée to Broadway's *Blackbirds of 1928,* and the following year he accompanied the show to Paris before returning to America and appearing on the leading vaudeville

"The food is good, the show is good; it's a nice and quiet place, and they get respect," was Peg Leg Bates's explanation as to how his eponymous hotel/country club continued to draw visitors.

circuits—sometimes having to don blackface along with the white tap dancers so it would not be known that an actual African American was in the line. In the 1930s he gained notoriety dancing with the big bands of Jimmy Dorsey, Duke Ellington, Count Basie, Louis Armstrong, and others, often, while tapping, reciting a jingle he wrote himself:

> *Don't look at me in sympathy*
> *I'm glad I'm this way*
> *I feel good*
> *Knockin' on wood*
> *As long as I can say—*
> *I'm Peg Leg Bates,*
> *The one-leg dancing fool*

In the 1950s and '60s, his routines on television's *The Ed Sullivan Show* made him a household name. His final performance on the program was in 1965, as he was approaching sixty, a challenge dance with a tap dancer named Little Buck.

The Peg Leg Bates Country Club, on the site of a sixty-acre former turkey farm, contained 108 guest rooms to accommodate 240 guests, a parking lot that could hold nearly fifty buses, and a picnic area for four thousand. "We used to spend the day," said June Terry, who at the time of her first visit was recently out of nursing school, though, as she was quick to point out, "nobody did just one job in those days. You had several to make ends meet, so I also sewed and made clothes." (In her eighties, Terry still teaches arts and crafts at a Manhattan senior citizens center, among other jobs.) "Some spent the weekend, but I'd like to go for the day. I think it cost about twenty-five dollars. You'd take the bus at five, six in the morning, then leave to come home at six o'clock at night, because you'd have done all you wanted to do—go in the pool, lie in the sun. Then there'd be drinking on the bus on your way home, and everybody would party some more. People would fall asleep. You'd hear snoring, and you'd try to get away from that. It was all about having fun, and it was. Even churches had bus rides there. We were okay with that. One churchwoman sat next to me on the bus one time and she wanted me to give her some of my coffee, but I wasn't going to do that, it had liquor in it. She said, 'Let me have some of that coffee,' but I said, 'Oh, no. You wouldn't want this coffee. I didn't put any sugar in it.'"

"You'd go and you would meet the right people," recalled Ruth Inniss, who

today is a publicist for recording artists. Much to her mother's dismay, right out of high school she would go to Peg Leg's with Roy Inniss, who was twenty years her senior and in real estate. (They eventually married and had a son.) She described the resort as "top-notch. The facilities were gorgeous, the food was soul food, and at night, the entertainment was superb. It attracted a lot of famous people from show business. And him dancing on that peg leg was something. He was not a small man. As a matter of fact, he was kind of chunky."

The buttoned-down 1950s also saw the rise of another vacation colony, this one in the tiny town of Jewett, five miles south of Hunter.

Originally called Silver Springs, by mid-decade it was renamed Casa Susanna and "repurposed drastically," according to a 2007 account in the Hudson Valley cultural magazine *Chronogram*. At a time when homosexuality was illegal in the United States, Casa Susanna, which stood behind an inconspicuous hand-painted sign nailed to a shade tree, was nevertheless an open secret.

"For twenty-five dollars per weekend, visitors—mostly Manhattan business-men—were fed three squares and taught the finer points of 'passing'; that is, developing a feminine masquerade that escaped detection," wrote the publication's columnist Jay Blotcher, introducing, as the "headmaster of this finishing school," Tito Valenti, who by day served as a translator in the New York court system. But by night "he preferred the name Susanna when wearing wigs and evening frocks, which did little to soften his gangster-like mug."

At first, Valenti confined his lessons to the Manhattan apartment he shared with his wife, Marie, who owned a Fifth Avenue wig shop. As the customer base expanded, however, so did the need for room to roam.

The wig-store profits financed the Catskills compound, and there, Blotcher reported, Casa Susanna quietly survived "as both a safe harbor and a playground" for the better part of the next ten years, only to reemerge in the spring of 2014, when Tony-winning playwright Harvey Fierstein captured its essence, and added a message about acceptance, for a Broadway play titled *Casa Valentina*.

As *Entertainment Weekly* observed before its premiere, "We've seen the standup and the dirty dancing, but this certainly sounds like a side of the Catskills we haven't seen before."

Tito Valenti, who preferred to be called Susanna, created a 150-acre Catskills refuge for men who "talked about fashion, and passing, and how and if they'd told their wives or girlfriends," one regular from the 1950s recalled for *The New York Times* in 2006. Broadway playwright Harvey Fierstein dramatized its situation for 2014's *Casa Valentina*.

Bates estimated that 5 percent of his clientele was white, and, like the better Jewish resorts, his country club survived a healthy run until it closed in 1987. (And, as had been the case with the Jews, Bates opened his own resort in large part because while traveling as an entertainer throughout the country he had been denied access to many hotels.) Of coming to the Catskills with his wife, Alice, and changing the racial makeup of the area–Sammy Davis Jr. was also a frequent guest–Bates said, "At first the natives were resentful. But now everything is kosher."

His Catskills spread, where summers were spent with his family as he oversaw the operation, also allowed him to satisfy his penchant to perform. "I would miss [show business] if it weren't for my own business," he told *Ebony* magazine in 1973, when his and wife Alice's daughter, Melodye Ann, was thirteen. "But every time I walk out of my door, I'm on stage because someone is always asking me for my autograph or telling me where they saw me on some television show."

The dauntless dancer and innkeeper died in 1998, aged ninety-one, and was buried in the Palentown Cemetery in Ulster County. In his honor, a portion of U.S. Route 209 was named the Clayton Peg Leg Bates Memorial Highway.

The cult of celebrity, if not born in the Catskills, was fine-tuned there, and guests, whose word of mouth was key to maintaining the reputation of the resort,

were quickly alerted when a personality from the world of sports, entertainment, politics, or even religion–Cardinal Spellman was a Grossinger's regular–visited Jennie at Joy House, the home she and Harry built on the grounds of the hotel. Boldfaced names were routinely invited by publicity maven Blackstone to enjoy the facilities free of charge, so customers could go home with bragging rights to "having coffee with Whitey Ford," "schmoozing with Jackie Robinson," or spotting Floyd Patterson, Ingemar Johansson, and Emile Griffith jogging on hotel trails or sparring in professional-size rings.

The drama and humor of Catskills resort life inspired many a story, perhaps most notably, in its time, novelist Herman Wouk's 1955 *Marjorie Morningstar*, whose Bronx–to–Upper West Side title character summers in a vacation compound called South Wind.

In 1938, RKO adapted the 1937 Broadway romantic comedy *Having Wonderful Time*, which onscreen starred Ginger Rogers as a wisecracking stenographer from the Bronx who goes to the mountains and slowly falls in love with a law-student waiter, played by the aristocratic Douglas Fairbanks Jr. (Besides exorcising every Jewish character name from the play, the movie also cast the non-Jewish Red Skelton as the ubiquitous tummler.)

In its next incarnation, *Having Wonderful Time* was adapted into the 1952 Broadway musical *Wish You Were Here*, directed by Joshua Logan. Besides presenting a functioning Grossinger's-like swimming pool onstage, the show was accessorized with a largely male chorus stripped down to bathing suits and a lilting score by Harold Rome.

And while Warner Bros.' melodramatic 1958 screen adaptation of *Marjorie Morningstar*, with a miscast Natalie Wood and Gene Kelly, drew a crowd at the box office, the most successful movie to tip its hat to Grossinger's was *Dirty Dancing*.

Set in 1963 at a fictive vacation camp called Kellerman's Mountain House (and actually shot in North Carolina), the quasi-musical starred Patrick Swayze and Jennifer Grey and contained a plotline involving a class clash, a botched abortion, and a steamy mambo. The movie unexpectedly proved a sensation in 1987, a year after the real Grossinger's had fallen to the wrecker's ball.

"*Dirty Dancing*—what a great title!—is such a bubbleheaded, retro vision of growing up in the sixties (or any other time) that you go out of the theatre giggling happily," film critic Pauline Kael wrote in *The New Yorker*. Here, Catskills camp dance instructor Johnny Castle (Patrick Swayze) faces Frances "Baby" Houseman (Jennifer Grey).

Jennie also cultivated her own celebrity, after first undergoing a thorough self-improvement. Once time and money permitted, she had her accent hammered out of her and hired "an English professor, a Spanish teacher, a piano teacher, an elocution teacher, a literature teacher, a painting teacher—she even learned how to guide a motorboat in the canals in Miami Beach," said her daughter, Elaine, who, along with her brother, Paul, referred to their mother's lessons in ongoing refinement as "the University of Jennie."

The grande dame of the G also had her own way of doing business. "To the dining room staff, Jennie was untouchable, aloof," Ernie Haring, who worked as a busboy, still remembered years later for Myrna Katz Frommer and Harvey Frommer's oral history, *It Happened in the Catskills*. Toward summer's end, the staff petitioned "the empress," as they called Jennie, for "better living conditions," said Haring, whose own accommodations were "just horrible. I had much better living conditions in the Army."

Terming such defiance as "taking the bread out of her mouth," according to

the former employee, Jennie promised that in return for the staff's not striking she would give them whatever they desired, so long as they returned to work, which they did.

"But," Haring noted, "we were never asked back to work at Grossinger's after that summer."

<div align="center">

II

</div>

> Grossinger's, on first sight, looks like the consummate kibbutz. Even in the absence of Arabs, there is a security guard at the gate.
> —novelist MORDECAI RICHLER, on the Catskills

To survive, a Borscht Belt resort lived by three cardinal rules: Never let the guests go hungry. Never let them get bored. And see to it that romance lurked around every corner. The top priority came at mealtime.

"There's an old joke," Woody Allen says at the fade-in of his 1977 Oscar winner *Annie Hall*. "Two elderly women are at a Catskill mountain resort, and one of them says, 'Boy, the food in this place is really terrible.' The other one says, 'Yeah, I know. And such small portions.'"

"The food was of primary importance," acknowledged screenwriter (*The Magnificent Seven*) and producer (*The Front*) Walter Bernstein. "That you could get all you could eat and the portions were big. To somebody like my father, who had come to this country from Russia, [whose] family was very, very poor, he never got enough to eat. Ever. And leaving food was a sin. If we were at a restaurant I would be very embarrassed, because if I couldn't finish what was on my plate, he would finish it."

"To understand the emphasis on food, one has to understand hunger," said Jonathan D. Sarna. "Immigrants had memories of hunger, and in the Catskills, the food seemed limitless. There was a sense that 'too much was not enough.' At a deep level you were demonstrating how far you'd come from those days when you didn't know where your next meal was coming from."

"For breakfast," recalled Jackie Horner, a Grossinger's dancing instructor, "there were seven varieties of herring alone: baked, pickled, kippered, marinated, fried, tomato, *matjes* [mild on the salt]." At the Concord, one room was entirely devoted to a single purpose: the pickling of herring.

LONGTIME *NEW YORKER* CARTOONIST Mort Gerberg, reminiscing about the dairy lunches he served during his summer as a waiter at the Midwood Hotel on Loch Sheldrake in Fallsburg, winced when he recalled, "Sour cream on everything. Strawberries and sour cream. Blueberries and sour cream. Bananas and sour cream. Blintzes and sour cream. Pot cheese and sour cream." The Concord alone claimed it served twenty tons of sour cream a year.

"People check into the hotel as guests, they check out as cargo," joked the comedian Mal Z. Lawrence. Calories and sodium and cholesterol levels weren't counted; piling on the plates was part of the experience—and the show. When someone once asked Sylvia Lyons, the wife of the *New York Post* columnist Leonard Lyons, how to lose weight at Grossinger's, she responded, "Go home."

"To be fat," said Sarna, "was interpreted as a sign of health, especially for children. Chubby babies stood a better chance of making it out of infanthood. For an adult, extra pounds also represented prosperity, and for women of the era being Rubenesque even had a sense of the erotic."

The most popular spot at Grossinger's: the main dining room. In the Catskills, said the comedian Billy Crystal, "Jews ate like Vikings."

Luncheon

GOOD AFTERNOON

Chilled Apricot Nectar
Hearts Delight Grapefruit Juice
D.le Pinea ple Juice

SOUP

Cream of Tomato Soup
Cold Borscht w Boiled Potato

LUNCHEON

Broiled Mushroom Saute
Cheese Blintzes and Sour Cream
Garden Vegetable Plate
Onion Omelette

Whipped Potatoes Whole Beets

COLD SUGGESTIONS

Smoked White Fish Salad Combination
Blueberries and Sour Cream
American Cheese and Crackers

DESSERT

Victory Cake
Raisin Cake Plain Pound Cake
Marble Slice

BEVERAGE

Coffee Tea Milk

Friday June 4, 1954
Harry K Lowenthal
Maitre D'Hotel

Laurels HOTEL and COUNTRY CLUB, SACKETT LAKE, N. Y.

The luncheon menu at the Laurels Hotel and Country Club, which by the 1960s was considered the hippest resort in the Catskills, as well as the largest. It was also the first Jewish hotel to serve lobster.

Guests at the Laurels Hotel, 1955

"You get a menu when you sit down, and the menu lists seven juices, choice of four soups, four appetizers, seven main courses, and eight desserts," recalled Freddie Roman, dean of the New York Friars Club. "And if you want one of each, you can have them."

"These are not for now," intoned Mal Z. Lawrence, mimicking a matronly Catskills customer's faux finishing-school accent as she explained to a waiter (as if he's a backward child) why there's a pyramid of sweet rolls carefully balanced on her bread plate. "We have for *now*. These are for *later*. We'll have these with coffee February twenty-third."

For the soup course, Grossinger's guests were offered matzo ball, noodle, or kreplach–a close cousin to wontons or ravioli. "I would say ninety-five percent of the guests would order the *kreplach*," Etess reminisced for the *Palm Beach Post* just before the 2010 High Holy Days. (She also provided her mother's recipe.)

"The Catskills, by having kosher food," said Sarna, "gave Jewish immigrants a kind of sense of being at home. You knew what to expect. Friday night you had chicken soup. And there were many other delicacies from home that you could enjoy in the Catskills. The fascinating fact is that many of these places would serve foods all summer that many Jews associated only with particular holidays

[the rest of the year]—for example, blintzes, which you might have had only on the holiday of *Shavuot*, when traditionally you eat dairy food. If you liked blintzes, which are hard to make, you could have them every day in the Catskills."

In the mountains, even fasting marked an occasion to eat. "After the [Yom Kippur service] ended and people came out of the playhouse, which had been turned into a house of worship, there would be a sweet table with honey cakes and date-and-nut cakes and sponge cakes and fresh fruit and everything that you might want just for a nibble," remembered Tania Grossinger, a younger cousin of Jennie's. The guests would then return to their rooms en masse for the next ritual, the changing of the wardrobe, before heading back to the dining room, this time for their dairy course, all in preparation for changing clothes upstairs again, this time for their nine o'clock meat meal.

"Then the nurses and the doctors got into action," said Tania. "Even as a kid I didn't understand this. I would say, 'How can you eat so much?' And I remember one lovely lady looking at me. She said, 'Someday you'll understand, dear,' as she pinched my cheek. 'We paid for it!'"

At fifteen, Sheila Nevins, who later became president of HBO Documentary Films, lied and said she was a year older so she'd meet the age requirement to clear tables at Grossinger's. Before greeting her public, she was carefully instructed on how to recognize when a guest was ready to have his or her place setting removed.

"It had to do with the positioning of the knife and fork on the plate, only Jews don't do that," Nevins said half-kiddingly, "because they never put down their forks."

"The table is *gemakht*, ready, with barely a centimeter to spare," was essayist Elizabeth Ehrlich's recollection of the Catskills meals shared in a modest bungalow colony with her mother-in-law, a Holocaust survivor. "Here is a plate of sliced melon, blueberries, strawberries, and a bowl of sugar for the berries. There may be ripe tomatoes cut

Jennie's resort was so associated with food that she compiled a cookbook; also on grocery store shelves could be found Grossinger's rye bread—seeded or unseeded.

into chunks with raw Spanish onion, oil, and wine vinegar. Perhaps a herring in cream sauce, or a tin of smoked sardines. . . . There are fresh little *challah* rolls, or heavy slices of corn rye bread festooned with caraway seeds. Cream cheese with scallions."

To keep the guests fed, Marvin Welkowitz, whose parents owned the Ridge Mountain Hotel in Parksville, would hop into the family pickup truck every two weeks and "drive in with my father to the Washington Market in New York City, like Paul Grossinger did with his father." First order of business, "fruits and melons. Then we'd go to the Fulton Fish Market." Later they would hit the Hunts Point Market before heading back to the mountains, having made the entire round-trip journey between breakfast and lunch.

"It was exhausting," said Welkowitz, who once out of curiosity took a tour of the Grossinger's kitchen. "The figures were staggering," he admitted. "On a

From *The Art of Jewish Cooking*, by Jennie Grossinger (1958):

CHOPPED CHICKEN LIVERS

1 pound chicken livers
4 tablespoons rendered chicken fat
2 onions, diced
3 hard-cooked egg yolks
1 teaspoon salt
1/4 teaspoon freshly ground black pepper

Wash the livers and remove any discolored spots. Drain.

Heat 2 tablespoons fat in a frying pan; brown the onions in it. Remove the onions. Cook the livers in the fat remaining in the skillet for 10 minutes. You can grind or chop the onions, livers and egg yolks, but be sure you have a smooth mixture. Add the salt, pepper and remaining fat. Mix and taste for seasoning.

Serve cold with crackers as a spread or on lettuce. Serves 6 as an appetizer or 12 as a spread.

summer day, three thousand rolls, four thousand pounds of meat and poultry, fifteen thousand eggs, two hundred fifty gallons of soup, seventy-five hundred cups of coffee, four hundred quarts of juices, and two thousand pieces of melon."

Luncheon

"To be a busboy or on the wait staff of a Catskill hotel was the dream of many young people," said Sarna. "Not because the work was fun—the staff routinely worked twelve- and even fifteen-hour days and had to deal with the infamous 'culture of complaint.' The food was too hot or too cold, too spicy or too bland, overcooked or undercooked. And what's more, 'Why can't we have the table near the window?'"

Although they carped, the customers also tipped generously. Between Memorial Day and Labor Day, it was not unusual for a waiter to clear $1,000 in gratuities, enough for a year of college or graduate school. Moses Shapiro, who, going by the name of Monte Shaw (like Artie Shaw, because Monte also moonlighted in the resort's big band when he wasn't waiting tables), long remembered being awakened with the other young male workers by the hotel proprietor's early-morning ritual cry of, "Doctors, lawyers, dentists—get up, you sons of bitches."

"My station had fifty people," remembered the film writer and director (*Bob & Carol & Ted & Alice, An Unmarried Woman*) Paul Mazursky. "My real name is Irwin, [and] it was, 'Irwin, where are the pickles? Irwin, I have no sour cream.' People wanted their money's worth. Just before they opened for breakfast, you could see guests with their faces pressed again the French doors, waiting impatiently to come in for their prunes and hot water. Before you turned around it was lunch."

"Dinner at Grossinger's was a mob scene, breakfast and lunch, too," said the food writer Diana Foote, who as a child would be taken to the Catskills by her aunt Helen (described by her loving niece as "a Roman Catholic drama queen from Yonkers who stood out at the resorts because she enjoyed dressing for dinner more than eating it"). "The Concord was a slight bit better, because the women took more time getting dolled up and would rather make an entrance than be first. But once seated, everybody ate like there was no tomorrow."

The comedian Robert Klein, another veteran of the Catskills nourishment patrol, recalled, "A woman at my station beckons me over, grabs me by the bow tie, and pulls my head down to her face. 'Listen, dolling, I like my cawfee burning hot, so hot it burns my lips. You undahstand? This cawfee is ice cold.' Then she

gives me instructions. 'First you pour hot watah in the cup and throw it out. *Then* you paw the hot cawfee into it. Now go get me a cup of hot cawfee.' Then . . . at last . . . she lets go of my bow tie."

Women encountered different obstacles. "This guy, he hired each of us separately," said New York–based writer Vivian Gornick. "He explained the dining room, which I knew already. So then he took my arm between his fingers and he said, 'Kid, you take care of me and I'll take care of you.' And I thought he was asking me to be a good waitress. So I said, 'Sure, absolutely.' It was clear that I was so obtuse and so young and stupid that I didn't even know what he was talking about."

Then there was the work. "I served a woman who was all bosom from neck to knee, tiny feet daintily shod, smooth plump hands beautifully manicured, child-ish eyes in a painted face." When Gornick delivered the woman's three-minute eggs, exactly as ordered, the customer delivered a not-so-delicate command.

"Open them for me, dear. The shells burn my hands."

III

You were very good, for a Tuesday.

—BUNGALOW COLONY GUEST, to a young Mel Brooks

After dinner came the formal entertainment, which had evolved far beyond the limited array of genteel hobbies pursued by hotel guests in the nineteenth century. "Vacations then included sketching, writing poetry, strolling . . . and other focused activities which emphasized a refined passivity—not only because this kind of passivity was a sign of privilege, but because it positioned the tourist as a vessel to receive the greatness of God through His landscapes," wrote Samantha Hope Goldstein in her far from passively titled study *Don't Mind Me, I'll Just Sit Here in the Dark: Illuminating the Role of Women in Catskills Performative Culture.*

In 1899, *The New York Times* noted that Protestant vacationers took hikes in the countryside, sometimes entertaining themselves by working on farms, while "hunting for four-leaf clovers is one of the industries of lady guests."

Early entertainment in the Jewish Catskills was equally simple, though mark-edly different in terms of both variety and decibel levels: boardinghouse and hotel employees—the wait staff and bellboys—would double as performers, having

Loch Sheldrake, N. Y.

The Hotel Evans in Loch Sheldrake began as an overgrown farmhouse early in the twentieth century. As the years progressed it began advertising, "Live, Laugh, and Enjoy the ultimate in Vacation Happiness! Golf—Swimming—Tennis—Boating—Baseball—New Indoor Basketball Court—Volleyball Badminton—Ping Pong—Solarium—Sun and Health Club—New 5-mile Bridle Path."

been encouraged by the management to make the customers laugh and sing along with them, usually in the abandoned barn that would also double as the place to play cards. Some guests would ignore the employees' attempts and totally hog the stage themselves.

A few were even talented.

"ONE OF THE THINGS that the Flagler House pioneered in the Sullivan County tourism industry was the idea that entertainment could be a major attraction for guests," said John Conway. "In 1928, [owners] Fleisher and Morganstern built as a primary amenity a fifteen-hundred-seat, state-of-the-art theater that rivaled Broadway. This was one of their chief attractions."

When it came to nontheatrical entertainment at Jewish resorts, there were

Members of the Group Theatre spent the summer of 1934 in Ellenville at an old hotel picked out by group founder Cheryl Crawford. The August stay kicked off with two lectures by Stella Adler on her work with Stanislavsky.

masquerade balls, with prizes for best costumes, as well as farmer or cowboy theme nights and dance marathons. Poetry readings took place in the more intellectual enclaves, as did political lectures and literature discussions.

Among the first professional Jewish entertainers to come to the mountains, in the early 1920s, was Boris Thomashefsky, who, along with fellow actors from the Yiddish stage, brought the classics from Manhattan's Second Avenue to a captive Catskills audience.

When Jennie Grossinger, during the same period, added a playhouse to her property, she hired Don Hartman, an actor and director with Broadway credentials, to produce shows for her guests. Before a weekend, Hartman would pull up to the stage door of the Palace Theatre in Times Square and offer room and board to actors and chorus girls in exchange for their appearances at Grossinger's. (In

an equal swap, many hotel managers swept the Bowery for weekend dishwashers who'd work for room and board and a few dollars to replenish their liquor supply.)

Onstage, English would be sprinkled with Yiddish, and over time the shows grew increasingly less ragtag and more polished, complete with scenery. When Hartman pulled off a successful production of *Hamlet*, Jennie not only congratulated him but admitted that most of her guests had never heard of the play before.

With Jennie, who made it a habit of visiting the eastern seaboard's first-class hotels and collecting new ideas for her place (which accounted for jackets on men becoming mandatory in the Grossinger's dining room), Hartman approached the young social director at the Flagler, by then known for staging extravaganzas so tantalizing that they drew crowds from the surrounding hotels in the area. The director's name was Moss Hart, and while he declined the offer to become Hartman's assistant, he did suggest another young social director for the job. This fellow—Isadore Schary, but everyone called him Dore, pronounced "Dory"—worked at Cedar Lake and was annoyed that he had to double as a lifeguard, particularly because he couldn't swim.

While Hart would go on to become a celebrated playwright (often with George S. Kaufman, with whom he collaborated on *You Can't Take It with You* and *The Man Who Came to Dinner*, among other stage comedies) and director (*Lady in the Dark, My Fair Lady*), Schary advanced to the heights of chief production executive at RKO and MGM (where he replaced the long-reigning, omnipotent Louis B. Mayer) and became an accomplished playwright whose *Sunrise at Campobello* dealt with the family repercussions of Franklin Roosevelt's contracting polio.

Schary lasted only one season at Grossinger's, but he made his mark. Writing in the in-house newspaper, the *Tatler*, he suggested that Hartman as Hamlet should never wear tights. Eventually heeding the advice, Hartman left the G and went on to become production head of Paramount Pictures.

"Not one of us would have believed this to be in the realm of even remote possibility in that summer of 1929," Hart wrote in his timeless 1959 memoir, *Act One*, "though we were, all three of us, not inclined to be modest of what the future held in store."

To keep the atmosphere spirited, and the competition at bay, the big hotels hired social directors to entertain between meals. Always male and called tummlers, as in "tumult makers," they originated in Eastern Europe with "the *shtetl 'badkhn*,' the itinerant Jewish funnyman who was hired to amuse guests at weddings."

As defined by Mel Brooks, the tummler was "a resident offstage entertainer

at a Jewish mountain resort, mostly after lunch." The first one in the Catskills, according to Stefan Kanfer, worked at a gathering of garment workers in Pine Hill, in a house that had been rented for the summer by the International Ladies' Garment Workers' Union.

By the 1920s, every big hotel had a tummler; Mel Brooks, né Melvin Kaminsky, began his rise to success in 1940 as a fourteen-year-old "pool *tummler*," he told *Playboy* in 1975. "A pool *tummler* is a busboy with tinsel in his blood. For eight bucks a week and all you can eat, you do dishes, rent out rowboats, clean up the tennis courts, and, if you beg hard enough, they let you try to be funny around the pool."

Brooks's bungalow colony shtick was to "walk out on the diving board wearing a black derby and a big black alpaca overcoat. I'm carrying two suitcases filled with rocks. 'Business is terrible!' I yell. 'I can't go on!' And I jump in the pool. Big laughs–the Jews love it. But I don't laugh–because the suitcases weigh a ton and like a shot I go to the bottom."

Pulling down possibly $250 and his room and board for the entire summer, the tummler worked from breakfast until the last guest retired in the evening. He organized entertainment, did tricks, told jokes, mingled with the guests. "During daylight he doubled as sports and activities director," explained Joey Adams, and, at night, after playing onstage and acting as stagehand, "he was the *shadchon*, or marriage broker."

Adams also admitted it was the tummler's task to find the unattractive, unescorted women and dance with them. Most of all, it was his job to convince the guests that they were having a good time and getting their money's worth–a practice later continued at very pricey American amusement parks.

While singers and dancers and the occasional magician rounded out the bill, comedy formed the bedrock of Catskills entertainment. Seizing upon life's hilarious imperfections, humor born in the shtetls of Eastern Europe migrated to America, where greenhorns ran smack up against jokes about their Old World habits and awkward English as delivered by more assimilated earlier arrivals. The irreverent observations quickly graduated from the streets of New York to the vaudeville stage, then up to the Catskills, where, relying on wordplay and a theme of things never going right, the jokes defined the gap between the Jews' expectations and the reality of what America was providing them.

Catskills humor also impudently played up the differences between groups of people. As Borscht Belt comedian Jackie Mason said, earmarking this "otherness" in one of his most-quoted routines (Lenny Bruce, who'd try out material at the

Comics referred to fur wraps as "Jewish security blankets"; here they are on display inside the fully air-conditioned Fan-Fare Theatre Nite Club at the Hotel Evans.

resorts in the wee small hours, also fingered the great divide, but in far edgier terms): "It is easy to tell the difference between Jews and Gentiles. After the show, all the Gentiles are saying, 'Have a drink? Want a drink? Let's have a drink!' While all the Jews are saying, 'Have you eaten yet? Want a piece of cake? Let's have some cake!'"

That the Borscht Belt tummlers would progress into polished comedians with scripted routines seemed inevitable. When vaudeville died, the Catskills provided a refuge for older Jewish comics cut off from the variety circuit or else unable to adjust to radio, a medium that failed to provide them with a live audience. The mountains also served as a boot camp for an entire generation of young comedians who grafted slapstick, horseplay, physical humor, and practical jokes onto the traditional Jewish staple of caustic verbal wit.

Two neophytes who cut their teeth in the Catskills were Henny Youngman (formerly Henry Yungman), who began as a bandleader in the 1920s before perfecting his rapid-fire one-liners, and master of patter Danny Kaye (né David Dan-

With a deceptively simple philosophy—"I don't take myself too seriously, I just laugh at myself a lot and call myself a dummy"—Isaac Sidney Caesar began eliciting laughs during the Great Depression, when he mimicked the accents of customers who came into his Russian-Jewish parents' luncheonette in his native Yonkers.

But comedy wasn't primarily on Sid Caesar's mind; he was determined to make it as a saxophonist. Fate conspired otherwise.

When he was seventeen, in 1939, Caesar was playing in bands in the Catskills, but by the summer of 1942 he was already an experienced entertainer, working at a miniature Grossinger's-like spread called the Avon Lodge in Loch Sheldrake. It was there that he first developed a following for his comic routines, which included his impersonating an airplane.

"People would leave other hotels and the acts they had paid to see and would come to the Avon Lodge to get a glimpse of this brilliant young comedian" who played to overflow crowds forced to peek through the lodge windows in order to catch Caesar onstage, said Phil Leshin, a talent manager.

That same season Caesar also met a Hunter College student from the Bronx, Florence Levy, who was a children's counselor at the lodge, which her uncle owned. Of Sid, Florence recalled in 2009, after the two had been married to each other for sixty-six years, "I thought he would be just a nice boyfriend for the summer. He was cute-looking and tall, over six feet."

Describing their yearlong courtship, she said, "We were still dating when Sid went into the service, the Coast Guard. Luckily he was stationed in New York, so we were able to continue seeing each other, even though my parents weren't too happy about it. They never thought he would amount to anything."

How wrong they were. The nation came to hail Caesar as the golden boy of TV's golden age, beginning with his hugely popular *Your Show of Shows* in 1950, when the brilliant, albeit temperamental artist—along with rubber-faced sidekick Imogene Coca and Caesar's cadre of young cowriters, among them Neil Simon, Carl Reiner, Mel Brooks, and, later, Larry Gelbart and Woody Allen—delivered a ninety-minute platter of Borscht Belt–style satire, slapstick, and skits on NBC.

And, a full quarter century before the advent of *Saturday Night Live,* it was live from New York every Saturday night.

iel Kaminsky), from Brooklyn, who first worked as a busboy in a Loch Sheldrake hotel in the early 1930s. "Even Van Johnson, who became a major Hollywood star, started his acting career in Sullivan County, working at a small hotel called Paul's Resort in Swan Lake," said John Conway. "Danny Kaye, who worked at the White Row Inn at Livingston Manor for six years, perfected his comedy routine that he later used to become a major movie star."

The same year Mel Brooks sank to the bottom of the pool, 1940, another fourteen-year-old, Joseph Levitch, from Newark, was busing tables in Fallsburg at the Ambassador Hotel, which was owned by the Merl family and managed by Charles and Lillian Brown, who four years later would buy the Black Appel Inn in Loch Sheldrake and rename it Brown's.

While it is true that the Browns acted like surrogate parents to young Joey, whose vaudevillian parents, who called themselves Danny and Rae Lewis, played the Borscht Belt (and largely ignored their son), the myth surrounding the scrawny busboy's launch into professional show business is more the product of a publicist's imagination. The legend holds that Joey accidentally dropped an entire stack of dishes during the hotel's Yom Kippur services and exclaimed, "Oh, God, I'm sorry," which made even the rabbi break up. Closer to the truth, according to John Conway, was that during the summer of 1941 the Browns' daughter, Lonnie, helped Joey develop his elaborate pantomime act, in which he would act crazy and lip-sync to records.

"Throughout the summer of 1941," said Conway, "Joey Levitch and His Hollywood Friends" was booked into "the Nemerson, the Laurel Park, the Waldemere, Young's Gap, and the Flagler." By the following summer, said the historian, "sixteen-year-old Joey Levitch quit school to pursue a full-time career in show business, adopting the professional name of Jerry Lewis."

Conway confirmed that Lewis was never a tummler, another popular misconception, but the point to be made is that the Catskills were never at a loss for yuk-meisters. The entire list could fill a book (and has), and to be counted among them were the impish Red Buttons; the fast-talking Phil Silvers; shlubby (and "blue") Buddy Hackett; sharp-tongued Alan King; weight-joke queen Totie Fields; insult artist Don Rickles; unflappable Bill Cosby; sarcastic but embraceable Billy Crystal; Kutsher's crazy guy Andy Kaufman; and, as the old resorts were in eclipse, Jerry Seinfeld, who, besides a mullet, brought something new to the mix, a hip dryness–packaged in a nice Jewish boy you could still take home to Mother.

The Stardust Room at the Nevele, which in 1969 was advertising, "Of course the Nevele is wonderfully chic . . . but don't let that worry you!"

Captive as they may have been within their all-inclusive resorts, this was no audience of pushovers. At the time she was trying to light a match under her new career, Joan Rivers encountered "a field of blank faces, empty of any emotion beyond boredom and mystification," she remembered, along with "[t]he pale disk of a face tilt downward to check a watch."

In the Catskills, a hotel guest's ultimate status symbol was not only the number of big names he had seen–such as Barbra Streisand, provided it was *before* she did *Funny Girl*–but also how many he had walked out on.

"They would brag, 'Oh, I walked out on Sammy Davis.' And the other guy would say, 'Me? Harry Belafonte,'" said Dick Capri, a comedian who played Brown's in the 1960s and '70s.

Russian-born Jewish folklorist Immanuel Olsvanger (1888–1961) homed in on what was in people's DNA that triggered these reactions:

When you tell a joke to a peasant, he laughs three times, once when you tell it to him, the second time when you explain it to him, and the third time when he understands it.

The landowner laughs twice. Once when you tell it to him and again when you explain it, because he never understands it.

The policeman laughs only once when you tell it to him, because he doesn't let you explain it so he never understands it.

When you tell a Jew a joke, he says, "I've heard it before. And I can tell it better."

"The Concord was famous for having four doors in the back" of its three-thousand-seat showroom, veteran comedian Stewie Stone told CBS's *Sunday Morning* correspondent Richard Schlesinger for a February 2013 feature titled "Did You Hear the One About the Borscht Belt?" (pinned to the current Off-Broadway show *Old Jews Telling Jokes;* several of those jokes, incidentally, got their start in the Catskills too).

"Now, while you're onstage," Stone said of the old days, "if [the Concord audience] didn't like you, they'd walk out in the middle of your act. And you'd see the door open and the light would come in–like there was the light from above.

"And, then if they hated you, two doors would open. So that's how we'd judge an act . . . 'How was the act?'

" 'Four doors. It was the worst act in the world.' "

There were only forty-four thousand television sets in American homes in 1947. By 1951, that number had jumped to twelve million, and four years after that, half of all American households had Catskills class clowns Milton Berle, on NBC's *Texaco Star Theater,* and Sid Caesar, on the same network's *Your Show of Shows,* in their living rooms. Those in their writing armies, Caesar's especially, if they hadn't been Catskills-trained, like Mel Brooks, then they had sharpened their skills at the Tamiment Playhouse in the Pocono Mountains of Pennsylvania, where Woody Allen learned to hash out sketch material on deadline.

As he did with African-American singers and other breakthrough acts for television, Ed Sullivan never shied away from presenting Borscht Belt comics on his CBS Sunday-night variety program, including Myron Cohen, a Polish-born former clothing salesman who delivered his jokes in a pronounced (and put-on, as he also did Italian and Irish dialects) Garment District accent. To wit: Three men

walk into a coffee shop and order glasses of milk. One man says, "Be sure it's in a clean glass." Waitress returns with the order and says, "Which one ordered the clean glass?"

Although often some of the ethnicity of Jewish humor was watered down for television, the rhythm and the spirit confidently remained intact. (Knock on the door. Husband: "Who is it?" Voice: "The Boston Strangler." Husband, to wife: "It's for you, dear.") And while some jokes retained their Jewish specificity, the national audience could still get it. ("A Jewish boy comes home from school and tells his mother he has a part in the class play. 'What is it?' she asks. 'It's the part of a Jewish husband.' The mother scowls and says, 'Go back and tell the teacher you want a speaking part.'")

Small-time entertainers, who might have started piecing together their acts in the Catskills, Atlantic City, Miami Beach, and Las Vegas in the 1940s, could fully deplete their entire joke arsenals with one three-minute spot on *Sullivan*. By the same token, the more popular entertainers could build up their reputations thanks to television exposure and command large salaries and vast audiences in live venues, even arenas.

One definitive early example of Catskills/television synergy occurred in 1946. Eddie Fisher, a singer from Philadelphia, was not yet eighteen and therefore too young to work the Copa in New York. Instead, Grossinger's publicist Milton Blackstone, operating out of his West 57th Street office, sent the slender boy with the wavy hair sticking up from the top of his head up to the G to accompany the band in the Terrace Room, where he bowled over the crowd with the Gershwins' "Love Walked In."

Later, his popularity mounting, his voice maturing, and the ladies returning for more, Fisher was booked for a week's solo engagement in the Terrace Room. From there the publicist went into overdrive. "My discovery by Eddie Cantor was manufactured and manipulated by Blackstone," said Fisher. "It was on September 2, 1949, the Labor Day weekend." Cantor, by then solidly established on stage, screen, and radio, was vacationing at Grossinger's and, by all accounts, wishing to be left alone. Furthermore, he was not impressed by Fisher's voice.

Still, said Fisher, "It was like a setup."

As Tania Grossinger recalled, "I'm a teenager, and my mother is the social director of the hotel, and Milton comes to my mother and tells her that he wants me and my friends to help out. 'This is what is going to happen,' he says. 'Eddie

Fisher will sing the warm-up, then when it's Eddie Cantor's time to perform, he comes out and says, "Ladies and gentlemen, I'm sure you heard that wonderful young crooner, Eddie Fisher. I fell so much in love with him, he is going to be a star. But it depends on you. If you agree with me by your applause, if you show how wonderful you think he is, I'm going to take him on tour with me. He's going to be my protégé." ' "

Cantor brought out Fisher for an encore, "and all us kids," said Grossinger, "we're whistling, we're running back and forth, screaming on cue . . . 'Eddie Eddie, Eddie!' . . . and, lo and behold, a star is born."

The tour took place, Fisher knocked 'em dead, and Cantor wanted to sign him at $500 a week, but as Milton Blackstone sagely advised the boy, "Don't sign anything." Instead, Fisher sealed a $1 million deal with Coca-Cola to star on NBC's *Coke Time with Eddie Fisher,* which went on the air in 1953. At this point, Fisher's star outshined Eddie Cantor's.

Two years later, Fisher married Debbie Reynolds—at Grossinger's—and he was there again in 1959, this time to take another wife, Elizabeth Taylor.

"Later I came up so many times when I was on my ass," said Fisher, only by then Jennie was gone.

And not long after that, so were the customers.

IV

[The singles] weren't looking for someone to sleep with in the country. They were looking for someone to go out with in the city.

—TANIA GROSSINGER

Playing Howard Prince in scenarist Walter Bernstein and director Martin Ritt's 1976 *The Front,* Woody Allen checks into a Catskills hotel and is asked by a young woman what he does. "I'm a writer," he answers—prompting her to run away as fast as her legs can carry her. Later, another young woman poses the same question, only this time Prince is all the wiser. "I'm a dentist," he replies, as she pulls her chair in closer and thoughtfully inquires, "Staying long?"

Beyond the eating and laughing yourself silly in the Catskills, there existed the genuine possibility for making a match—not a temporary hookup, but some-

The Terrace Lounge at Grossinger's, where headwaiter David Geivel observed of the matchmaking ritual, "They've only got two days . . . so they've got to make it fast. After each meal they're always wanting to switch tables."

thing permanent. Matrimony. Even those not looking for themselves might be persistently looking for their children, or for their sister, or their aunt, especially from among the pool of available medical and law students.

"The issue for Jews was that it was very important to marry young people to other young people who were Jewish," said Jonathan D. Sarna. "Intermarriage was a significant taboo. And the truth was that not so many non-Jews wanted to marry Jews in those days. So the question was, how were you going to introduce girls and women of a certain age to young men of a similar age in a setting where they would be able to enjoy one another's company and see one another in a relaxed atmosphere?

"In many ways, the Catskills served as a kind of theater of mating.

"We know that many women came up with vast trunks of clothing precisely in order to show themselves off."

OF EQUAL CONSEQUENCE WAS to marry *up,* which further enhanced the effort to produce an important sense of show in the mountains. Reputations were also built up to augment a prospective bride's appeal, although many of these were based on nothing more than idle gossip—or wishful thinking.

"You have to remember that in the thirties all the great department stores were Jewish-owned: Macy's, Gimbels, Bloomingdale's, Sterns," one observer told Stefan Kanfer. "And the rumor was that every young woman was a relative of someone who owned one of these emporiums." In that pre-Google age, said the source, "To find out the truth you tried to listen to her vocabulary, see the way she carried herself, how she acted with her friends. When you were satisfied you made your move."

"Many people came as families," said Sarna. "It was not so common to send a young woman there on her own, and therefore you could see the kind of family a young boy or girl came from, and the fact that they were at the Catskills at a hotel with their family suggested that they must be people of means. And that, of course, made them even more desirable."

The precedent for making matches went as far back as the Jews' entry into the Catskills. "The girls are bored and try to find boys; when a young man wanders onto a farm they do their utmost to hold him there." That was from *The Jewish Daily Forward,* in 1904.

The article also underscored the fact that despite the uninhibited atmosphere prevalent in the mountains, "the girls remain honorable"—or, as they were known, "nice" Jewish girls. Herman Wouk seized upon this notion in *Marjorie Morningstar,* when he wrote of his free-spirited heroine's summer experience, which involved a resort called South Wind, before she settled for a disappointingly bourgeois existence.

"Marjorie did notice a lot of necking in canoes and on the moonlit porch outside the social hall, but there was nothing startling in that," Wouk wrote in the novel. "Perhaps terrible sins were being committed on the grounds; but so far as her eyes could pierce there was nothing really wrong at South Wind."

Among those committing the terrible sins, or at least aiming to, were the married women left to their own devices during the week. "You'd see a change in these women on Sunday afternoons when the husbands went back to the city, leaving them for the week," said New York television journalist Marvin Scott, who'd been a bellhop at the Raleigh Hotel after his grandmother put in a word

on his behalf. "Suddenly, they became swingers. They were looking for the young guys, and they became hip. But come Friday night, the husbands would come up and they'd turn back into nice, doting, lovely housewives again."

"Romance was a major theme of every summer in the Catskills," acknowledged *Sweet Lorraine* screenwriter Shelly Altman. "I know that I fell in love for the first time in the Catskills at the age of ten, with an older man of the age of twelve. My older cousins were constantly meeting guys every summer."

Given the reputation of the Catskills as a marriage magnet (hotels routinely erected makeshift arbors, which they labeled "Flirtation Walk" or the "Kissing Arch," and which could also serve as wedding *chuppahs*), "When I called my parents to tell them that my husband and I were splitting up," said Altman, "my father's first response was, 'We're taking you to the Catskills!'–apparently just to have a nice, relaxing time. But I'm sure at the back of his mind was, 'I bet there's a nice divorced man for my daughter up there.'"

Tania Grossinger's mother, Karla, served as the resident matchmaker-psychologist at cousin Jennie's hotel, introducing couples with practiced skill– and a standard line if no successful match was made by the time the weekend wound down. According to Tania, "If a woman came up and hadn't met somebody, my mother would go over and hug her and say, 'Darling, please–this weekend there was no one here good enough for you.'"

As Joey Adams observed of the selection process, "the law of survival goes into effect." At the outset, the woman "is looking for Cary Grant on the white charger, but after a few lonely nights," he said, "she'll settle for . . . Peter Lorre with sinus."

Just how many matches were made was a matter of record. "The weekly Grossinger's newspaper (delivered to more than 100,000 alumni) proudly reports all marriages that can be traced back to a romance at the G," reported *Time* magazine in 1959. At the rival Concord, the maître d'hôtel, Irving Cohen, kept tabs on guests so he could efficiently arrange proper seating in the three-thousand-person dining room. As *Time* uncovered, "A wooden pegboard records who is sitting where–pink pegs for women, blue for men. Lighter and darker shades indicate relative ages."

"You got to pair them by states and even from the same cities," Cohen, who was known as King Cupid of the Catskills, told New York's *Daily News* in 1967. "If they come from different places, the doll is always afraid the guy will forget her as soon as he gets home."

Himself a product of the Lower East Side, Cohen began as a waiter at the hotel in the late 1930s before rising to the position of maître d' in 1943–and facing an

immediate avalanche of requests that he assist in making matches. At his death at ninety-five, he claimed he'd have continued his job had the Concord not closed in 1998. Shortly after his retirement, the *Boca Raton News* estimated that he'd paired ten thousand couples.

Three decades earlier, he had already confidently told the *News* that he never feared being replaced by a machine. "Can a computer get to the human element?" Cohen posited. "I ask you, can a nice widow, maybe a little on the plump side, but nice, can she tell all her aches and dreams to a computer? Never!"

"For making matches, Mr. Cohen relied on his keen ability to suss out subjects at a glance," *The New York Times*, paying tribute to Cohen's gift for combining "Holmesian deductive skill with Postian etiquette and a touch of cryptographic cloak and dagger," stated in a particularly affectionate obituary, by Margalit Fox, on October 3, 2012.

"Age, sex and marital status were of crucial concern, of course, but so too were occupation, tax bracket, and geography," wrote Fox.

Whether or not sparks flew over the chopped liver, the practice of making matches perfectly suited the general atmosphere of the mountains in their heyday. Some called it the original JDate.

"The Catskills were full of miracles, after all," recognized *Catskills Culture* author Phil Brown. "To make a place for the Jewish working class to get some fresh air, that was a miracle. To turn a little boardinghouse into a first-rate hotel, that's a miracle.

"To find romance . . . well, why not?"

Utopia's Outposts

※━◦━◦━◦━※

I

Behold the turtle. He only makes progress when he sticks his neck out.

—JOHN BURROUGHS

Having originated in England in the 1860s as a means to protest constricting Victorian sensibilities and the monotony of capitalism, the Arts and Crafts movement established its American foothold in the Ulster County village of Woodstock, in 1902, under the guiding principle that good design would result in a good society.

Ralph Radcliffe Whitehead, whose financial support brought Arts and Crafts to the Catskills, was an Oxford-educated disciple of the two anti-industrialists whose writings served as the basis for the movement: John Ruskin, a London-born art critic and social thinker, and William Morris, a textile designer and socialist.

Born in Yorkshire in 1854, the tall, sandy-haired Whitehead, scion of a wealthy mill-owning English family, was an artistic aesthete with a total lack of interest in the family business, despite how the felt pads the Whitehead mills produced for piano keys provided him with stately homes in Sussex's Borden Wood, the Austrian state of Styria, Venice, and Avignon. Explaining his philosophy in his 1892 treatise *Grass of the Desert,* Whitehead wrote, "A society is not healthy which is composed of a few rich idlers, a few rich workers, many of whom do useless work, and a great many poor, whose sole aim is . . . to get into a richer class."

Determined to find the proper setting for his artists' utopia, which Ruskin and Morris insisted could exist only in a rural environment, Whitehead abandoned

Europe for the United States—at the same time divorcing his Austrian wife and, in 1892, marrying the American socialite Jane Byrd McCall, daughter of the mayor of Philadelphia and, in her own right, a watercolorist and ceramist. After a wedding in New Hampshire, the bride and groom set off for Maine, where, in a literal demonstration of having money to burn, they set fire to their honeymoon yacht to keep it from ever being put to frivolous use.

Settling in California's Montecito, the couple established an art school near their Italian villa–styled home, Arcady, where their circle included the Harvard-educated social worker and writer Hervey White. In his early thirties, White was a shaggy-haired charmer from Iowa who went on the Whitehead payroll with the assignment to find a suitable location for their long-imagined artists' colony. Initially a site was found in western Oregon, except before a deal was struck, a domestic dispute arose over Whitehead's mistress, with whom he took up shortly after the birth of his and Jane's son. By then Whitehead had met another utopian dreamer, Bolton Coit Brown, the founding head of Stanford University's art department and whose furniture designs Whitehead deemed perfect for his colony. With Brown on board, thought was given to erecting the artists' settlement on the East Coast, with Whitehead and Hervey White favoring the mountains of Virginia or the Carolinas. Brown, however, had another suggestion: the Catskills.

Whitehead agreed to give the furniture designer permission to explore the mountains, but with one major stipulation. A staunch anti-Semite, Whitehead had visited the Catskills one summer, encountered Jews, and refused to consider locating his dream child in any town where they should reside. Duly warned, Brown combed the Catskills for three weeks to find a spot that would fulfill John Ruskin's precept that an ideal artists' environment should be at least fifteen hundred feet above sea level. Any higher, Ruskin cautioned in his *Modern Painters,* would prove too harsh; any lower, debilitating.

A native Iowan, Harvard-educated social worker and writer Hervey White was entrusted by Ralph Radcliffe Whitehead to find a suitable location for an artists' colony on the American continent.

Finally, one mid-May morning in 1902, Brown stood atop the southwest side of Overlook Mountain near Mead's Mountain House, a rambling summer hotel affording a watering station for horses and a refreshment stand for visitors. Looking down on a cluster of small buildings in the narrow valley below— it would be practically another decade before Jewish farmers started coming to the region—Brown was overwhelmed by what he called "that extraordinarily beautiful view. Amazing in extent, the silver Hudson losing itself in remote haze, those furthest and faintest humps along the horizon being the Shawangunk Mountains."

Turning to a white-bearded man who happened to be picking apples from a nearby tree, Brown casually asked the name of the town.

"Woodstock," replied George Mead, the hotel proprietor.

PART OF THE ORIGINAL HARDENBERGH PATENT, the village of Woodstock was surrounded by woods so dense and packed with wolves that its residents, already convinced that the glowworms they saw at night were evil spirits, rarely ventured from one house to another. During the Revolutionary War, Woodstock's population was divided in its loyalties, although the majority favored independence and the town claimed two American military outposts, at Little Shandaken and Great Shandaken.

Above Woodstock, in Bearsville, a Tory had reputedly buried his treasure along with a slave to guard it, giving rise to tales of haunted apparitions. When the site was finally excavated years later, an antique snuffbox was uncovered, along with a silver spoon and a pair of handmade scissors, but no skeleton.

After the War of 1812, when glass from Europe was no longer being imported, five glassmaking companies operated in and around Woodstock, along with a tanning mill and a number of bluestone quarries, the latter staffed from a community of Irish families who lived at the edge of town in Lewis Hollow. It was also believed the devil once appeared there, in the form of a fetid-smelling, crowing black rooster, to claim the souls of those playing cards on the Sabbath.

At the time Brown hiked down from Mead's Mountain House, the quarries, tanning factory, and glassworks were abandoned shells, and life in sleepy, charming Woodstock "was very quiet with little excitement," said former town historian Edgar Leacraft. "Children could roam freely everywhere. The mountainsides were largely cleared in an effort to increase crops; a few boardinghouses and the hotel on the green attracted some summer visitors. Water powered sawmills along the Sawkill

and other streams did cut lumber, but the glass factories and tannery had left nothing but second-growth timber to cut."

Telegraphing news of his discovery to Whitehead and White, Brown soon met and shared a steak dinner with them in Washington, D.C., where he presented his case for Woodstock. Brown's sales pitch continued on the train to Kingston, where a carriage delivered the trio to Mead's Mountain House. There, on May 31, 1902, the men surveyed the town of Woodstock from the same promontory that had provided Brown his first view.

Whitehead was so strongly seduced by the site that he put to rest his earlier prejudice against the Catskills, writing his wife, Jane:

It was the founding head of Stanford University's art department, Bolton Colt Brown, who deemed the Catskills suitable for Whitehead's colony when his benefactor and Hervey White preferred the mountains of Virginia or the Carolinas.

> We have found a country with a sky—such beauty of sky I have not seen except in France, I mean of Northern skies. Such a sky for any painter, a transparent blue with wonderful gradation towards the horizon and such beauty of cloud forms & of distant blue landscape as I never expected to see in N.Y. State. . . . Here is an atmosphere for you, dear, which I did not hope for and the beauty of the landscape is very great.

In a separate letter to his son, Whitehead expressed a relief over earlier concerns about Woodstock, saying there were "no Jews at this season and even in the summer they are confined to the railroad and the district where the big hotels are."

To ensure privacy, Whitehead set about purchasing, for $10,000, all twelve hundred acres to the west of Mead's, down the slope of Overlook Mountain and inclusive of seven farms.

"There," wrote travel writer T. Morris Longstreth, whose 1921 *The Catskills* tells of his personal encounter with Whitehead on his Woodstock compound, the benefactor "intended that the families who had caught the flame of his ambitions were to live. There they were to weave by hand, to fashion out their pleasure in

pottery, and to work in metals. Their children were to be taught to use their hands until they had reached college age. Health and simplicity, and the genuine riches of life were to be the rewards for all."

Construction of the Byrdcliffe colony, named with a syllable from Whitehead's middle name and another from that of his wife's, began in the autumn of 1902, and by the following March, Ralph and Jane Whitehead and their two sons, their cars, horses, books, and artwork were situated in White Pines, their new, fifteen-room home. Over time, thirty residential cottages, artists' studios, a metalworking shop, a pottery, a woodworking shop, a library, and an inn would go up within the sprawling compound, while the adjacent dairy farm would help feed the expected residents.

To attract artists and craftsmen, Whitehead published "A Plea for Manual Work" in the June 1903 issue of *Handicraft*, spelling out the communal nature of the colony and the atmosphere of creative nourishment it intended to provide, along with Byrdcliffe's classes in painting, jewelry crafting, furniture making, and rug weaving. Free easels were to be offered to students who couldn't afford them, just as there was a blanket invitation "to any true craftsmen who are in sympathy with our ideas and who will help us realize them."

Whitehead's vision struck a chord, attracting both craftsmen and the curious,

The Woodstock post office and general store furnished the telegraph for Bolton Coit Brown to signal Ralph Radcliffe Whitehead and Hervey White of his discovery.

In creating their furniture, Byrdcliffe artisans followed the assembly-line methods already in use by the Shaker religious communities and those of Buffalo's Charles Rohlfs and the Roycroft Furniture Shop, in East Aurora, New York, which was founded in 1895 by the philosopher Elbert Hubbard.

Byrdcliffe's furniture—distinguished by its simple, straightforward shape, hand-carved panels, and natural wood surfaces finished with transparent stains in nature's colors—was marketed commercially through McCreery's Department Store on Manhattan's 23rd Street, near Sixth Avenue.

The problem was, the pieces were not competitively priced like those produced by Gustav Stickley, another Arts and Crafts advocate, whose studio was farther north in Syracuse. So while Stickley sold to the middle class (the furniture brand survives to this day), the Byrdcliffe pieces were marketed only to the very wealthy, which made hash out of one principle upon which the colony had been founded: of producing art *for* the people.

As a result, after only a year, Whitehead shut down Byrdcliffe's woodworks—a heartbreak made all the more wrenching given that a "Lily" chair, named for Byrdcliffe's trademark and featuring a carved polychrome panel by painter, potter, and designer Zulma Steele, sold at Sotheby's in 2011.

It fetched $42,000.

who included John Burroughs, John Dewey, the painter George William Eggers, the photographer Eva Watson-Schütze, and Ellen Gates Starr, who cofounded Chicago's Hull House with Jane Addams in 1889.

"Unlike the vernacular architecture specific to the Hudson Valley, with its tidy white clapboard farmhouses," read a historical description by the Woodstock Byrdcliffe Guild, "Byrdcliffe buildings resembled low rambling Swiss chalets characterized by their dark stained indigenous pine siding, gentle sloping roofs with wide overhangs, and ribbons of windows painted Byrdcliffe blue." The structures were christened with imaginative names, such as Morning Glory, Fleur-De-Lys, Lark's Nest, and Camelot.

Bolton Brown's influence was evident in the sturdy, elegant examples of dark-toned furniture produced from rugged-looking oak or poplar, while painters seeking inspiration for their canvases needed only to gaze at the symbol of the colony, Overlook Mountain.

Pottery continued at Byrdcliffe even after the woodworking shop had closed, and enjoyed a long tradition with Jane Byrd Whitehead, who had taken lessons in California from the influential potter Frederick Hurten Rhead.

"The lily was the symbol of the colony and was to be found . . . on chests, sideboards, lamp stands, footstools, tables, and chairs," read a 2013 Sotheby's catalog for the auction of a midwestern collection of pieces from Byrdcliffe.

Harmony prevailed, but only until festering resentments got the better of Hervey White. Having once been Whitehead's partner, the social reformer had, to his mind, devolved into a mere hired hand confined to recruiting and overseeing the farm. Frequently arguing with Whitehead, White complained, "He would only employ people he could dictate to, and no self-respecting artist would ever stand for his dictation." White's resignation was tendered in 1905.

Hoping to rectify what had gone wrong by starting a commune of their own, White and his much younger wife, a color printmaker named Vivian Bevans, along with Swedish-born painter Frits van der Loo (although he was soon to sail to China, where he successfully sold British patent medicines), found a property suited to their needs three miles southeast of Byrdcliffe, on the outskirts of Woodstock. Called Maverick, the one-hundred-acre colony took its name from White's 1911 epic poem *The Adventures of Young Maverick*, in which he praised a wild horse "free from ownership of any master."

Dedicated to the principle of providing "young talent a chance to earn its living until its recognition," the Maverick colony was bohemian and permissive, unlike the regimented Byrdcliffe. "We are not revolutionaries," White, easily recognized by his signature purple Russian blouse, wrote in the Maverick publication, *The Plowshare*, "we are but harmlessly tinged with radicalism; we are not the wild anarchists that onlookers might judge us from the freedom exhibited in our clothes."

Byrdcliffe and Maverick were too far removed from the center of Woodstock to alarm the locals, unlike the Art Students League, which started a summer painting branch in the heart of town in 1906. Here, the corner of Avery Avenue and Ulster Street.

Socialist as their ideologies might have been, Byrdcliffe and Maverick were too far from the village green to alarm the staid citizenry of Woodstock. Such isolationism would abruptly change in 1906, when Manhattan's well-regarded Art Students League started a branch right in the heart of town. Like the Byrdcliffe and Maverick colonists, the art students philosophically opposed the money and machine culture, but far more grating to the conservative locals was their irregular habit of sleeping in open fields, dressing outlandishly, and hanging out on the village green. As one old-timer unburdened himself to *Time* magazine in 1930:

> Wall, to tell the truth we thought they was a bunch of wild Indians and maybe some of them still is. In those days they'd take a canvas out into the field and begin painting on it. First, they'd put a dab of paint of one color and take about ten steps back to see how it looked . . . and by the time that picture was finished what with all the walking back and forth to look at it–there wasn't nothing left of the vegetable garden the artist was tramping on.

"You could say these were the first hippies to hit Woodstock," said Richard Heppner, town historian. "Some of the students had shaved their heads or cut

their hair in patterns such as stripes or checkerboards. Every kind of creativity was celebrated, and a few of the local people were able to take advantage. If you were a farmer and put a large window in the north wall of an outbuilding, however ramshackle, you could be sure of renting it as a studio. But a lot of people who weren't making money off them disliked them intensely."

In 1915, the serially unfaithful White, having been abandoned by his wife and two young sons, attempted to meet the mounting costs of running his frequently debt-ridden colony by organizing a carnival-like fund-raiser to mark the August full moon. Barely breaking even the first year, the Maverick Festival nevertheless would become an annual extravaganza, decreed an optimistic White, who, true to his prediction, saw the event grow in popularity.

In 1929, six thousand revelers showed up. The following year there were even more, as well as a correspondent from *Time* magazine. "The colonists," he reported, "sell their batiks, paintings, arty gadgets. In the evening the campfires glow and a pageant is enacted. As the night wears on, tippling, done at first covertly, becomes rowdy." This was still during Prohibition.

By 1931, the Maverick Festival was history, thanks mostly to generous supplies from bootleggers that caused the crowds to become just *too* rowdy, though there

Hervey White launched the Maverick Festival in the 1910s to celebrate creative expression, and it continued through the 1920s, until it became too rowdy for Woodstock.

were physical problems with the Maverick's venue too. As Alf Evers remembered in 1975, on the fiftieth anniversary of the Woodstock Playhouse, "Plays had occasionally been given in Hervey White's open-air 'quarry theater.' . . . The quarry theater was romantic and picturesque, but rocks tumbled down its sides every now and then and disturbed performers."

Still, few who attended ever forgot its programs, whether it was an opera by Maverick resident Edna St. Vincent Millay or the 1917 festival production of *Catskills' Rip Van Winkle*. That one was replete with nude nymphs.

IN 1907, five years after its founding, Byrdcliffe obviously bent its rules when, on the suggestion of Clarence Darrow, the German-Jewish progressive leader and economist Walter Weyl and his new bride, the former Bertha Poole, herself a labor organizer, writer, and settlement house worker from a wealthy Christian Chicago family, spent their honeymoon at the colony. It was not reported that the walls caved in. This, however, was still during the period before the great Catskills Jewish influx, which when it did take place noisily revealed that Whitehead was not alone in his bias.

Referring to the rabidly bigoted Henry Ford and his "international weekly" newspaper, which in the 1920s the automaker demanded be circulated to all Ford dealerships in the country, Alf Evers wrote, "Ford's anti-Semitic *Dearborn Independent* had many readers among the Catskills and did much to excite mountain people."

With the Great War in its third year and nearby mountain resorts struggling financially, worries arose among residents that Woodstock's faltering, and restricted, facilities might soon be converted into Jewish resorts. Their worst fears were realized when, in 1917, Morris Newgold, the owner of the Times Square Hotel in New York City, bought the Overlook Mountain House, perched like a beacon high over town and long a bastion of polite Protestantism. Among the private parties to lease the hotel soon after the Newgold takeover was the International Ladies' Garment Workers' Union, which in one fell swoop sent hundreds of young women in the needle trades, most of them Jewish, strolling arm in arm down Woodstock's Main Street. Further antagonism developed when in 1920 Newgold added the Irvington Hotel in the center of Woodstock to his holdings. Around one o'clock in the morning on September 4, 1922, three loud young men, well oiled on bootleg liquor, entered the Irvington and awakened hotel guests by

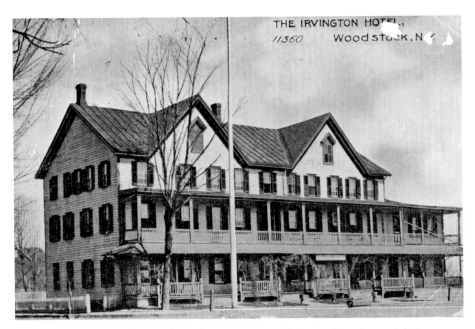

THE IRVINGTON HOTEL.,
//360 WOODSTOCK, N.

Drunken local boys broke into the no longer restricted Irvington Hotel one night in 1922 and beat up its manager, Gabriel Newgold. Among those arrested was the elder Whitehead boy, Ralph Jr., whose mother was quoted in the press as proudly saying her son "wouldn't touch a Jew with a ten-foot pole."

demanding the use of the telephone. When manager Gabriel Newgold, stepson of Morris, ordered them off the premises, they knocked him down and beat him up.

Of the three arrested, one turned out to be Ralph Whitehead Jr., the son of the founder of Byrdcliffe. Local newspapers had a field day, with the *Kingston Daily Freeman* inflaming citizens with reports of what transpired when the case went before a judge, including the testimony of Jane Byrd Whitehead, who stated, "I hope it is not irrelevant of me to say that the men in my family never lose their heads when they drink, and [Ralph Jr.] wouldn't touch a Jew with a ten-foot pole."

Eventually a settlement was reached, but not before Hervey White circulated a poem that went, in part, "[T]he invasion of Belgium by the Germans, us by the Jews,/Which is the worse, I leave you free to choose."

Making hay of the opportunity, the Ku Klux Klan, which had been resurrected nationally in 1915, increased its foreboding presence in Woodstock. Subsequently, less than a year after the Irvington Hotel altercation, news spread that the American Communist Party had been organized in secret meetings held at the Overlook Mountain House.

Not long after, the structure suspiciously burned to the ground. Arson was presumed, but no concrete evidence was ever produced.

DURING THE DEPRESSION, "There was a whole artists' colony from New York that would stay in Woodstock, because one could live really cheap. The men would hunt and fish, barter artwork for milk, corn, and vegetables, maybe do a quick picture of a farmer's house or prized pig or chicken, and come away with a gallon of milk, eggs, maybe some bacon," Dorothy Sanson, who was about ten years old when she and her parents moved there, recalled eight decades later. Her father, Edwin O'Hanlon, was a struggling writer, and her mother, Connie Gilchrist, at the time a Brooklyn-born stage actress who later became a contract player in Hollywood, where her many supporting roles included those opposite Clark Gable and Judy Garland. In 1958's *Auntie Mame*, Gilchrist's Norah Muldoon delivers her young charge, Patrick, to his eccentric New York relative, played by Rosalind Russell.

Describing her own unorthodox household during her Woodstock days, Sanson said,

During the Depression, "there was a whole artists' colony from New York that would stay in Woodstock, because one could live really cheap," recalled Dorothy Sanson in 2014, eighty years after she'd lived there as a child.

Everyone had a fireplace, there was plenty of wood in the forests, and there were rabbits, squirrels, and deer. Applejack was cheap, and my father made a potent wine from raisins. There was some experiment with beer making. Some worked, some didn't. The living was much better than in the city, where you had to use money. Even the houses were free, or very cheap in winter. The schools just asked the parents to help with the upkeep of the buildings. Bearsville was a one-room schoolhouse—first grade in the first row, on up to the eighth grade in the eighth row, which was always empty in the spring and fall, because the children, both the boys and the girls, were needed for planting or harvesting. Just one teacher for all. There was also, among the artists' community, some lesbian experimenting and wife swapping. Free love was quite popular. The mother of [actor] Efrem Zimbalist Jr., Alma Gluck [a noted operatic soprano, married to the equally celebrated violinist and composer-conductor Efrem Zimbalist], came to Woodstock to see my mother. They had been "friends" in Paris. Alma had given my mother a valuable pendant, and my father was very jealous. Another part of "the group" was Madame [Ernestine] Schumann-Heink [a renowned German Bohemian operatic contralto], who kept going back and forth from Woodstock to Paris. Morton Gould was the piano player for my dance teacher, and though he couldn't have been more than seventeen, he wanted to marry my mother—as did [the artist Yasuo] Kuniyoshi, who actually asked my father for her hand. My father nearly killed him, but that didn't deter him. He ended up marrying Katherine Schmidt, who was a better-known artist than Kuniyoshi, and she looked a lot like my mother. [Realist painter] George Bellows's widow, Emma, and two daughters lived in Woodstock also. Jean, the youngest, maybe seventeen, was an [acting] understudy and my babysitter. [Broadway and silent film actress] Lenore Ulric was one of the [stage] stars one summer, as was [actor] Howard Da Silva. [African-American singer and social activist] Paul Robeson was also popular in Woodstock. I remember at a party at our house he and my mother danced a tango while someone kept the old Victrola wound up. He was trying to put together a production of what became a movie about the Haitian dictator whose men marched off a cliff to prove how loyal they were to him. Raymond Duncan, Isadora's brother, was up there too. He had some kind of new religion and formed quite a group that followed him around in white gowns, sandals, and carrying staffs. He preached a diet of brown rice and boiled vegetables, free love for all, and down with all government.

It was quite a time, really.

MAVERICK SURVIVED until Hervey White's death at age seventy-eight, in 1944, although the concerts he first organized continue to this day. "It was the irony of fate that the books I had for years been making sacrifice should never be read," complained White in his senior years. "Whereas [the festivals], a plaything, a painted toy I had created to pay my living[,] should be thought of as the outcome and aim of my whole life."

Bolton Coit Brown broke from Whitehead in 1903 (only one year after Byrdcliffe's founding, and two years before White's departure), although he stayed on in his house, Carniola, on the Byrdcliffe property, and applied himself to oil painting and lithography. "His skill was marvelous, his industry prodigious, and his pursuit of the perfect Beauty enthusiastic and tireless to the end of his life," said his sister Ellen. Nevertheless, having been arrogant, argumentative, and completely lacking in social graces his entire life, when Brown died in 1936, at seventy-one, he was estranged from his children, friendless, and penniless.

"For people interested in lithography, the work and writings of Bolton Brown are essential," wrote religious and social historian Herbert A. Wisbey Jr. "Unfortunately, too few people were interested in lithography in his lifetime to enable him to earn a living from his work."

When Ralph Radcliffe Whitehead died in 1929, he left Byrdcliffe to his wife, Jane, who ran it as an artists' refuge until her own death in 1955, at the age of ninety-three. Among those who paid visits in the intervening years were Isadora Duncan and Thomas Mann. While much of its land ended up sold for taxes, the colony stayed in the family until the 1975 death of Ralph's son Peter Whitehead.

In his will, Peter bequeathed the remaining acreage and buildings to the Woodstock Guild, which opens Byrdcliffe for tours on summer Sundays. Art classes continue to be offered there.

I went to hear Father Divine, and he had a sermon and his subject was,
"You got to accentuate the positive and eliminate the negative." And I
said, "Wow, that's a colorful phrase!"

—JOHNNY MERCER, lyricist of
"Ac-Cent-Tchu-Ate the Positive," 1944

God arrived in the Ulster County village of High Falls during the depths of the
Depression, in 1935. "He was wearing a rumpled suit that looked heavy from per-
spiration," recalled Charles R. Barnett, who was seven at the time, "but he didn't
seem to mind. On his head was a fedora as cool as a summer cloud."

God, as he liked to be called, was the almighty Father Divine, whose more
than thirty racially integrated Catskills communities in the 1930s were an outreach
of his charismatic ministry, the Universal Peace Mission Movement. Bald, pot-
bellied, and standing all of five foot two in his exquisitely tailored $500 silk suits,
Divine was charismatic himself. "The two principal candidates for Mayor of New
York called on him at one of the nightly meetings in his Harlem heaven in 1933,"
the New Yorker issue of June 13, 1936, reported in the first in a series of three articles
on Divine. "'I came here tonight,' said Mr. LaGuardia, 'to ask Father Divine's help
and counsel. Whatever he wants, also I'll do it for him.'" As such, Father Divine,
or God, was also one of the most powerful, to say nothing of elusive, characters to
emerge from the Depression era—heralded, criticized, sometimes both. Harvard
scholar Henry Louis Gates Jr. referred to him as "that historic con man of the
cloth."

Little verifiable information ever existed about Divine's origins, beyond his
likely being born in 1879 (some accounts said 1865), either in Maryland or near
the Savannah River on a Georgia rice plantation. His mother may have been an
ex-slave, and his likely given name was George Baker, although a magazine clip-
ping from the 1930s may have shed a new light on his origins when it reported:
"Father Divine's mother is what Mrs. Eliza Mayfield claims to be. When reporters
went to her rickety little house they found an old Negro woman with big gold
earrings."

She told these reporters that though her son, who, according to her, was born
Frederick Edwards near Hendersonville, North Carolina, claimed to have been

Father Divine, leading his flock, with the first Mother Divine following to his right, at his five-hundred-acre "Heaven" on the Hudson River, 1938

dropped from heaven, "I know better." She also said he had a wife and five children he had deserted. From his Harlem headquarters, a clench-fisted Divine is quoted in this story as responding, "You know God has no mother."

What is verifiable is that he worked as a gardener in Baltimore before becoming a disciple of itinerant evangelist Samuel Morris. After taking the name "The Messenger," Baker/Edwards/Divine started spreading the Gospel on his own. Wending his way to Georgia, he preached celibacy and, in bold defiance of southern practice, worked to bring whites and blacks together. His strong belief in integration landed him sixty days on a chain gang, and when released he renewed his sermonizing, only to be arrested again, this time for what local authorities branded "lunacy." In court, he was tried under the name "John Doe, alias God."

Moving to Brooklyn in 1914, he established a small African-American congregation and adopted the name Reverend Major Jealous Divine, from Exodus 34:14: "For the Lord whose name is Jealous is a jealous God." His flock, many of them having moved north to seek a better life, called him simply Father Divine. Organizing his congregants into a cooperative, he found them places to live, bought them food and secondhand clothing, and through an employment agency found them jobs, usually in domestic service. Unlike Marcus Garvey, who encouraged African Americans to return to their ancestral lands, Father Divine preached self-sufficiency and salvation within the United States. His marriage to Peninniah, a follower many decades his senior, helped dispel rumors that he was having affairs with a number of his young female congregants. For the rest of their lives together, Father and Mother Divine, as Peninniah was formally addressed, would claim their union had never been sexually consummated.

Taking his congregation to Long Island's all-white community of Sayville in 1919, Father Divine bought a house that served as the base of his ministry. "By September, 1931, it was said that an average of one thousand persons, of a variety of races, were partaking of the free Sunday banquets at the house," according to historian Carleton Mabee. "Such quantities of free food being served during the Depression kept raising the question as to how Divine could afford them, adding to the neighborhood's uneasiness with him." There was resentment too; Divine wasn't shy when it came to displaying his brand-new Cadillac or keeping up noisy late-night prayer services.

Arrested and tried in December 1931 for disturbing the peace, Divine received a one-year jail sentence—and reams of publicity for having claimed he was the Almighty himself. When Judge Lewis J. Smith dropped dead of a heart attack shortly after pronouncing sentence, newspapers took additional delight in reporting the unsubstantiated claim that Divine had boasted, "I hated to do it."

Using supporters' funds and never keeping books, Father Divine's Universal Peace Mission developed a coast-to-coast following, a lot of it white middle-class, and his empire, which he called Heaven, became the largest landholder in Harlem. Looking to expand into the Catskills, where Divine found land reasonably priced (due to the Depression) and desegregation a necessity (only 1.7 percent of Ulster's census was listed as "Negro," a smaller average percentage than in the rest of New York State or even nearby counties), Divine inspected Ulster and Orange Counties "in an old Ryan monoplane of the type Lindbergh used on his first transatlantic flight," reported *The New Yorker*.

The first acquisition in the Catskills was made on behalf of the Universal Peace Mission on July 27, 1935, when parishioner Clara Budds, a Harlem domestic worker, bought a thirty-two-acre farm in New Paltz for about $5,500. The four-story house that rested on the property had previously taken in summer boarders—after the church purchase, Mother Divine took up residence—and was so conspicuously situated that it could even be seen from the "Mohonk Hotel's famous Sky Top watchtower on the Shawangunk Ridge," according to Mabee. And though vegetables, chickens, and cows were quietly raised on the farm, and overlooked by the people of New Paltz, the 125 African Americans who visited in the first month, and the many who followed later, were not. Those turning a cold shoulder included the owner of the town drugstore, who in November 1935 bodily shoved Divine out of his emporium after the minister came in, planning to pay the farm's electric bill.

Over the next five years Divine's church purchased twenty-five more parcels of land, which collectively were called the Promised Land. Among the enterprises developed were farms and boardinghouses, garages, gas stations (whose fuel sold for three or four cents a gallon cheaper than that of their competitors), and a hotel, all of which brought more than twenty-three hundred followers to Krumville, Lloyd, High Falls, New Paltz, Elting Corners, Stone Ridge, and Kingston—which disciples pronounced "King's Town," in a nod to their leader.

The Kingston Mansion, as it became known, sat on four acres at 67 Chapel Street, off Wilbur Avenue, and was the former residence of the Sweeney family, who dealt in bluestone and, more recently, a fifty-guest hotel. Purchased by four of his followers on December 21, 1935, the home (and it was a home, not a farm, with a swimming pool rather than a chicken coop) was used by Divine as his administrative headquarters for the Ulster branch of the movement. According to Mabee, Divine delivered twenty-six sermons there in 1936 alone and preached that "racial prejudice is not either 'true Americanism' or 'true Christianity.' Instead, he said, 'true Americanism' and 'true Christianity' are the racial mixing 'you observe in this dining room.'"

Rooms in interracial hotels run by the Universal Peace Mission went for as little as five dollars a week, meals for a nickel, and those without money stayed and ate for free. Still, Divine's message was not well received by all. "News that the county was going to be used as a lab for a negro collectivization experiment in camp meeting tempo was received with wrath by the Ulster County farmers and businessmen," *The New York Times* reported.

Collectively, the Ulster County land purchases made by Divine's church (never in his own name) came to be known as the Promised Land, and brought more than twenty-three hundred followers to the area.

Constant harassment by local officials over the slightest health or building-code violation did nothing to deter Divine. Slowly, hostility gave way to cautious acceptance, especially once Divine's operations pumped much-needed cash into local economies.

In August 1936, Divine's movement acquired the hamlet of High Falls, where forests had been depleted and quarries abandoned, and church ventures were credited with financial salvation and noticeable gentrification (Divine favored pastel-colored buildings and storefronts). In 1939, the *New York Herald Tribune* reported that because mission residents had shown themselves to be "hardworking" and "quiet," the opposition toward the Divine movement's Ulster property acquisition "has diminished steadily.... Whatever revelry or song occurs on these hidden estates is almost invisible and absolutely noiseless a short distance away." In addition, the *Tribune* noted, several of Divine's followers, "white and colored, show ecstatic happiness verging on insanity. Divine pulls their strings of

emotion making them dance." Divine, the newspaper concluded, "had complete domination over them."

While maintaining his Harlem command center, Father Divine frequently preached in the Catskills, where he infused his informal religious services with songs and improvised sermons, mostly about self-respect, and no readings from scripture. To his Depression-weary disciples starved for a savior, Divine's message was simple: those who lived righteously would be prosperous, healthy, and never die, thanks to reincarnation. And while congregants were to address Father Divine as "God," what distinguished his communities from cults was that his members were free to join or leave as they desired. Within the communities, however, members were to follow what Divine called his "International Modest Code" and not smoke, drink, use obscene language, wear makeup, gamble, see plays or movies, or engage in "undue mixing of sexes." Children were raised separately from their parents—who also were asked to sleep apart (Marcus Garvey accused Divine of encouraging race suicide)—and followers were persuaded to forgo their family names in favor of such monikers as Positive Love, Angel Flash, Bunch of Love, and Holy Quietness.

"I don't have to say I'm God, and I don't have to say I'm not God," Divine said by way of clarifying his creed. "I said there are thousands of people call me God. Millions of them. And there are millions of them call me the Devil, and I don't say I am God, and I don't say I am the Devil.

"But I produce God and shake the earth with it."

TO CREATE "a divine, modern, mystic standard of living" for those of "all creeds and colors," Father Divine assumed possession of a five-hundred-acre estate near Highland on the west side of the Hudson. The location was no accident; it was directly across the river from President Franklin Roosevelt's Dutchess County family estate at Hyde Park. Divine believed such proximity would put pressure on Roosevelt to push antilynching legislation through Congress and step up the president's support of civil rights as called for by Walter White, the executive secretary of the National Association for the Advancement of Colored People. While the president may have shown reluctance in dealing with racial issues, Divine soon learned that Mrs. Roosevelt did not. When in August 1937 about twenty-five hundred members of Divine's congregation gathered on Divine's estate for what

The New York Times called "two days of jubilation such as this Rip Van Winkle country never saw before," Eleanor Roosevelt wrote approvingly in her "My Day" newspaper column that it must "be pleasant to feel that in future this place will be 'heaven' to some people."

Divine at this time was clearly a force even the president had to reckon with. In 1939, *Time* magazine claimed his ministry had more than two million followers worldwide, while in *The Atlantic Monthly*, the conservative columnist George Sokolsky called the Universal Peace Mission the nation's "most successful religious movement." Writing in the *Amsterdam News* after visiting one of Divine's Catskills communities, the African-American sociologist and historian W. E. B. DuBois claimed that the movement "does do a great deal (just how much no one knows) of charity in feeding people and giving them work. It is (and this is the most curious of all) interracial among people of the laboring and middle class."

With about one hundred thousand followers in residence, the Universal Peace Mission communities in Ulster County survived the Depression and the outbreak of World War II (as an advocate of nonviolence, Father Divine pressed for pacifism). Their numbers, however, began to dwindle after their leader encountered a continuing series of brushes with the law, including a 1937 charge of dealing in bootleg coal. Under fire from authorities in New York State, Divine was forced to relocate his headquarters from Harlem to Philadelphia's Main Line, and could visit New York State only on Sundays, when, by state law, subpoenas could not be served. Without his presence, the interracial communities in Ulster County began to fall apart. In 1942, twenty-five of the original thirty-one remained in operation. By 1950, there were only nine, and by 1985 the last property in the Catskills, in Kingston, had been sold. Some believe that while Divine's message and works might have been relevant during the Depression, their potency weakened as the nation prospered. What could not be argued was that once he left the Catskills, his star descended.

Father Divine died of lung congestion aggravated by diabetes in 1967, which would have made him eighty-eight. His much younger second wife, Edna Rose Ritchings, a white Canadian stenographer known as Sweet Angel and then Mother Divine, took over the movement, whose real estate holdings at the time of Divine's death were valued at $10 million, about $70 million today.

As of 2013, the Universal Peace Mission Movement, having retained a few hotels, missions, and estates, was still carrying on Father Divine's mission for a devoted but diminishing congregation—all under the spiritual and business guidance of Mother Divine.

III

"The first time I went to the Catskills was with my father, at age twelve, to climb Slide Mountain," recalled Pete Seeger, one of the iconic figures of American folk music. Seeger, along with Woody Guthrie, had been an original member of the Weavers and an unabashed left-wing protester who was blacklisted during the McCarthy era. "Another time," Seeger remembered, "we climbed Overlook and slept up there on a cliff." Still able to picture the "sunrise over the valley," Seeger, at age ninety in 2009, described the origins of Camp Woodland, arguably the first interracial camp in America. "Many of the teachers in New York in the 1930s were lefties of one sort or another, and a group of them decided to pool their resources and found they could buy an old church camp that was for sale near Phoenicia, up Woodland Valley. And they called it Camp Woodland."

Woodland's goal was to instill a democratic spirit in its campers by inviting city children of different ethnic, racial, and religious backgrounds to live together and learn from one another and their counselors. At the same time, they would be steeped in the rich cultural and sociological history of the Catskills.

As in a 2010 exhibition presented by the Historical Society of Woodstock, titled "The Spirit of Camp Woodland":

Just as there is a Hudson River School of Painting, whose artists like Thomas Cole, Frederic Church, and Jasper Cropsey sought to capture and preserve an idyllic view of the Hudson River Valley, so too is there a lesser known, unofficial Hudson River School of Folk Music, among which Pete Seeger, Eric Weissberg, and Joe Hickerson can be counted as some of its students. Like those painters who created sweeping vistas of Catskill Mountain landscapes and majestic views of Hudson River scenes, they too are creating an image with lyrics and melodies of the lives and stories of the people who dwelled and settled in this region long ago.

SEEGER, who worked on an early version of what was to become his signature song, "Where Have All the Flowers Gone?" at Camp Woodland, was a regular summer visitor who first came in the late 1930s, at a time when he and three others were appearing in a traveling puppet show. "I remember being struck by the wonderful spirit of the children and the fact that they took the older kids out in station wagons to visit people in the local towns," Seeger recalled. "At the general store, they'd ask, 'Is there anybody here who knows what it was like back in the days when the tanneries were going?' [And they'd be told,] 'Oh, go see Mrs. Johnson. She'll talk your ear off.' And they would go find her."

Seeger also said "the camp had one big room that could be used for square dances and a performance. I'd sing for the whole camp for an hour or so, get them singing with me. And every year I looked forward to learning new songs."

The camp's founder was the educator Norman Studer, who, with his codirectors, Norman Cazden and Herbert Haufrecht, set about documenting and conserving the fast-disappearing traditional folk and music culture of the Catskills. Counselors would ferry carloads of campers to visit and talk with old-time Catskills mountain folk, then drive them all back to Woodland so the locals could continue to share what they knew.

"Camp Woodland's musical traditions included a weekly square dance called by Catskill resident George Van Kleek, who was always accompanied by his wife Clara, and sometimes the youngsters themselves," according to the New York Folklore Society. What the old-timers sought to pass on were "traditional skills in logging, bark stripping, blacksmithing, hoop-shaving, shingle splitting, square dance calling, and . . . the stories of their lives, the tall tales and songs from the region."

In 1982, years after this information was first amassed, Studer, Cazden, and Haufrecht published *Folk Songs of the Catskills: A Celebration of Camp Woodland*, an invaluable collection of songs and ballads that chronicled the entire span of Catskills history, from those crooned by the first pioneers to ballads about the Catskills during the Revolutionary War, and songs about lumbering and quarrying, the Anti-Rent War, steamboat pilots and railroad wrecks, and the hoboes and tramps who rode the Catskills rails during the Depression.

The high point of every summer at Woodland was a folk festival that brought together campers and residents to perform songs, put on plays, and tell stories, all to celebrate, maintain, and pass on Catskills culture to the next generation.

By the early 1960s, Woodland was gone, but not before Pete Seeger had picked up a song he learned from the children, who insisted they teach it to him.

The melody of "Guantanamera" came from the Spanish composer Julián Orbón, and the lyrics from a poem by Cuban nationalist poet and independence hero José Martí, who in 1860 had been advised by doctors in New York City to take a rest in the country.

"They sent him up to Haines Falls, in the Catskills," said Seeger. "He rented a room somewhere and went walking in the woods, and, at the end of the summer, had composed about 150 little quatrains. It's a song, about a Guantanamera . . . a woman of Guantánamo . . . the kind of song that arises all over the world wherever there's an American army base, satirizing the girls who are going out with the American servicemen and making a little money. And it became a tradition in a bar when men got drunk to see what scandalous verses they could make up. 'Where were you last night, what were you doing, huh, Guantanamera?'"

Over the years those who have sung it have included Joan Baez, José Feliciano, Celia Cruz, Tito Puente, Julio Iglesias, Jimmy Buffett, and Wyclef Jean, although it was Seeger who first heard it from the children of Woodland, around 1962.

Camp Woodland "was part of a widespread movement of reform that was not new to American life, but which grew to special importance in the late 1930s and 1940s," said educator and folklorist Norman Studer.

"I got there almost every year except for World War II," Seeger recalled. "Camp Woodland kept on going after the war, until the Cold War was too much for it."

After a twenty-three-year run, Camp Woodland closed in 1962.

A HIGHLY REGARDED WRITER of scripts for television and film, Walter Bernstein penned the 1976 *The Front,* in which Woody Allen plays a practically illiterate bar cashier and part-time bookie who during the McCarthy era in the 1950s poses as a "front" for blacklisted television writers. "There were a bunch of us in New York in the entertainment business that were writers and directors and musicians and producers who were blacklisted as a result of *Red Channels,*" said Bernstein, who in the 1950s was only in his early thirties. "There were eight or nine listings for me, all true. Supporting Republican Spain. Some Russian friendship thing. African-American civil liberties. Writing for the *New Masses,* a couple of times. They were all accurate. You were blacklisted unless you went and cleared yourself. And that meant going down and testifying before the House Committee on Un-American Activities. . . . You could go there and say, 'I'm sorry I did this. I would never join the organizations again. You know, they're all terrible people.' But unless you gave names—that was the mark of your sincerity—you stayed blacklisted."

For Bernstein, who did not name names, this meant being out of work "for about eight or nine years in movies, and another year in television before it ended. It was not easy making a living. It was harder for the actors and directors than it was for the writers, because we could try to find ways to survive. We stuck together," he said.

"One of the things that was very nice was that several hotels in the Catskill Mountains, the smaller ones in particular, would invite blacklisted artists to come for a free weekend. And in return for which they would ask us if we would conduct seminars or panels or give speeches or lectures on our particular subjects. The hospitality was very open. There was either a swimming pool or a lake. And lots and lots of food, all you could eat."

Bernstein found refuge in "one small hotel that I went to several times . . . Chester's. The full name was Chester's Zunbarg, that's Yiddish for Sun Hill." Located down the road from Grossinger's and started during the Depression by Anne Chester and her family when their real estate business collapsed, the 120-guest-capacity hotel catered to an intellectual crowd, offering chamber music, workshops, discussion groups, and meditation sessions. African-American entertainers like Josh

Paul Robeson was a frequent guest of Anne Chester and her family, who owned Chester's Zunbarg, down from Grossinger's. It was at Chester's that Robeson, who was hanged in effigy by residents of Oregon Corners, took refuge when he became the storm center of riots in Peekskill.

White and Paul Robeson stayed there as guests of the Chester family. Robeson, who frequented Chester's, was taken there in 1949 after the notorious Peekskill riots, when a crowd of racists and anticommunists stoned his car before he was to perform a concert on the Lakeland Picnic Grounds at Cortlandt Manor in Westchester County.

Long a figure of controversy for his social and political stance, Robeson had been targeted on this particular occasion for expressing his gratitude toward the Soviet Union (about which he said, "Here I am not a Negro but a human being") and for his belief that African Americans should not serve in the military of a racist Western democracy. During the melee, Robeson escaped by quickly climbing from one car to another to conceal his exit amid a seven-car convoy. "He was told to lie on the floor in case somebody tries to kill him on the way out," remembered Pete Seeger.

Seeger also vividly recalled how the Klan surrounded the dirt road leading out of the country club as if it were a battlefield and that signs had gone up throughout Peekskill reading, *Wake Up, America: Peekskill Did.* "The very moment of the

evening of the attack, [the signs] went up," said Seeger. "They were on bumpers of cars. In gas stations. In windows. In houses. In stores. And, in Europe, they were horrified. They said, 'Don't you know that's the same sign that went up in Germany after *Kristallnacht*? They said, *Wake Up, Germany: Munich Did.*'"

"Chester's Zunbarg was a small hotel," Bernstein said. "The woman who ran it, Anne Chester, was warm and very hospitable. What I remember mainly was the warmth. 'Kinderlach, darlings, children, come, eat, eat!' You know you were constantly trying to cut that sense of isolation that was forced on you by being blacklisted. You knew you were the pariahs. There were people who I knew who would cross the street when they saw me coming." This was not the case at Chester's. "We went up there several times. Go up on a Friday, come back Monday morning. And we entertained. Some of the actors did comic routines."

One of them was Zero Mostel. "I remember going up there once with Zero. He was the big star of the weekend. They knew him from his nightclub work. He had played the Borscht Belt. One time Zero asked if I would drive him up to a hotel in the Catskills called the Concord. Big hotel. He had been promised five hundred dollars to appear. Before he was blacklisted, he was pulling down something like two thousand dollars a night. But he needed the five hundred very badly."

So badly that when Mostel showed up, the manager informed him that the fee had been sliced in half. "Even the two-fifty at that time was more than rent money, and he needed it," said Bernstein. Mostel took to the stage as planned, before an audience of at least fifteen hundred. "And he was wonderful. He did his act in a rage. He was so angry at what was going on. And he insulted the audience in Yiddish. He called them names. And the more he did that, the more they laughed. The more they liked him. He was a big hit. They called him back several times, and he cursed out everybody."

Bernstein wound up putting Mostel to bed that night, though not before the actor had downed half a bottle of whiskey. When it became time to shoot *The Front* more than two decades later, Bernstein wanted Mostel, who played a blacklisted TV star in the movie, to re-enact the entire real-life episode, only Mostel would have none of it.

"It was still too painful for him to re-create that. And so we just show a snippet of his thing and then he does get angry afterward and attacks the manager. But he wouldn't do that thing which was so awful and extraordinary to see, of him performing his comic act on the stage in such anger."

"Raise Your Hand," "As Good as You've Been to This World," "To Love Somebody," "Summertime," "Try (Just a Little Bit Harder)," "Kosmic Blues," "I Can't Turn You Loose," "Work Me, Lord," "Piece of My Heart," "Ball 'n' Chain"

—JANIS JOPLIN's ten-song set at Woodstock

Except for its sylvan setting and dairy farms, where Holsteins outnumbered the seven-thousand-plus residents two to one, Woodstock in the early 1950s resembled most other Eisenhower-era small towns. Manufacturing was represented by the Woodstock Typewriter Company on North Seminary Avenue, where it had existed since 1913. On Clay Street, Woodstock Die Casting, the town's largest employer, was home to twenty-two hundred workers producing auto parts for Ford and Chrysler. A Montgomery Ward and a Woolworth's anchored a small but solvent shopping district in Town Square, along with "five food stores, two long-established banks, four meat markets . . . two bakeries, a Sears Roebuck order office, two hardware stores, three drug stores and Wes Pribla's fur shop," according to the *Woodstock Independent*.

For those seeking an antidote to the grinding hustle of New York City, the rustic charms that had so captivated poets, potters, and painters for half a century still remained to attract a new generation of artists to Woodstock. As travel writer T. Morris Longstreth observed in 1921:

The village of Woodstock is the sort of charming, delicious place that a guide-book would call a community, the inhabitants a town, and New Yorkers a spot. It is in reality a hamlet, which is short for hamelet, a place of little houses. And the hame countree never gathered together prettier cottages on its own green hills than cluster about the bridges over the little Sawkill or are sandwiched in the folds of green pastures. Sandwiches, I insist, are appetizing.

IN THE LATE 1940S, folk musicians moved in, and in the ensuing decades the town served as home to Joan Baez and the harmonic trio of Peter, Paul and Mary. In the mid-1960s, Bob Dylan bought an out-of-the-way mountaintop retreat,

where he lived reclusively following a motorcycle accident. Members of the Band rented a house in nearby West Saugerties that they called Big Pink, and it was in its basement in 1967 that Dylan, accompanied by the Band, recorded what became known as *The Basement Tapes*. Later in the same rented house, the Band made its first solo recording, *Music from Big Pink*. At the same time, Jimi Hendrix lived in an eight-bedroom house on the outskirts of town, while Van Morrison wrote the songs for his album *Moondance* in Woodstock.

"With all these music superstars in the vicinity, an avalanche of hippies descended," said town historian Richard Heppner. "There were communes organized around the sale of clothing, handmade jewelry, drug paraphernalia, and such." Not since the days of Byrdcliffe had such an emphasis on crafts existed. "People started driving in from all over the area to look at the hippies and flower children. Traffic jams every weekend," said Heppner. "These kids smoked their drugs while hanging out on the village green. Some were weirdly dressed in granny dresses and hats with big ostrich plumes, the guys often with bushy, unkempt beards."

The business community, determined to fashion Woodstock into an upscale,

In the 1950s, the only traffic jam one expected to encounter in Woodstock was on the crosstown horse trail from Byrdcliffe to the Riding Club. Here, the village green at the junction of Mill-Hill Road and Tinker Street.

When the flower children arrived in Woodstock, police retaliated by arresting them for such infractions as carrying trace amounts of drugs, vagrancy, trespassing, even playing a flute in a tree.

family-oriented town—and fearful that the hippie influx would cause property values to drop—instructed police to begin a program of petty harassment aimed at driving away the flower children. Every week the front page of the local paper printed lists of the young people arrested for trace amounts of drugs, for vagrancy, for trespassing, and, in one especially bizarre case involving a young man, for playing a flute while sitting in a tree.

"It was just inevitable," said Heppner, that "the local town fathers, conservative businessmen, declared war against the hippies."

Nationwide, the hippie era "was at its height from 1965 to 1970," said cultural historian Morris Dickstein. "Nineteen sixty-seven was the year of these first gatherings, the so-called human be-in in San Francisco, where Allen Ginsberg read his poetry and so on. Poetry and music were the more likely things to happen at these be-ins than social protest."

The be-in imagined for Woodstock was not to be political but commercial, billed as "Three Days of Peace and Music." The snowball began to roll when

pharmaceutical heir John Roberts and musician Joel Rosenman placed an ad in *The Wall Street Journal* identifying themselves as "young men with unlimited capital." Hooking up with record-label artists-and-repertoire man and songwriter Artie Kornfeld, and Michael Lang, a former head-shop owner who had promoted concerts in Miami, Roberts and Rosenman wanted to take advantage of the musical talent in Woodstock by building a recording studio there. To launch it, they planned a rock concert, something small but impressive, along the lines of the folk-rock concerts called the "Woodstock Sound-Outs" held for several years across the city line in Saugerties—where performers and audiences were free from the harassment of the Woodstock police.

As the four men continued to meet, their plans grew bigger, into something they envisioned to be a rock concert to end all rock concerts; if the 1968 Miami Pop Festival could attract a crowd of forty thousand, they reasoned, then perhaps their proposed Woodstock Music and Art Fair could attract fifty thousand, maybe even one hundred thousand.

Given how the town hated and hassled hippies and lacked a suitable venue, any thought of locating the Music and Art Fair in Woodstock was out. Focus shifted instead to the two-hundred-acre Mills Industrial Park in nearby Wallkill, a town even sleepier than Woodstock despite being home to the Orange County Speedway and, since 1857, the annual summer Orange County Fair. When word

Max Yasgur made his dairy farm in Bethel available to the organizers of the Woodstock rock festival because, he said, "if the generation gap is to be closed, we older people have to do more than we have done."

of the proposed rock festival leaked out, however, a Wallkill Concerned Citizens Committee was formed, and hundreds of signatures were soon attached to a petition demanding that local authorities ban any such gathering, for fear of overtaxing the town's security and sanitation facilities. In retaliation, Woodstock Ventures, the organization that had been formed by Roberts, Rosenman, Kornfeld, and Lang to run the festival, announced that it intended to sue Wallkill for "millions of dollars."

In late July 1969, after a week of scrambling for a site and sixty thousand tickets already sold, a new home was announced for the "Aquarian Exposition," as the Woodstock Music and Art Fair was also called. The place was Bethel, a tiny village (population 2,366), forty-three miles southwest of Woodstock. The venue was a six-hundred-acre farm belonging to dairy farmer Max B. Yasgur.

"He was a Republican, he was pro–Vietnam War, he was the antithesis of everything we stood for," Lang recalled forty years afterward. Yet despite Yasgur's leanings, "He was our hero." The festival organizers paid him $75,000.

While the Bethel town fathers were demanding a $3 million bond to ensure that the festival would not cost taxpayers a penny, agitated citizens erected a two-and-a-half-by-four-foot sign reading, *Stop Max's Hippie Music Festival. No 150,000 hippies here. Buy no milk.*

Pointed as its message was, one single billboard could not possibly compete with a barrage of commercials on rock radio stations and the power of word of mouth. With advance tickets having been available by mail or from local ticket brokers, hundreds of thousands of young people—often in direct defiance of their parents' ultimatum that they not attend—headed up to the Catskills on the weekend of August 15, 1969.

"A lot of the kids who came to Woodstock were not nineteen, twenty, twenty-one. They were fourteen, fifteen, sixteen. They were not kids living in the East Village. They were kids living at home, and this was their way of getting away and reaffirming the identity that was counter to their parents' identity," said Morris Dickstein. "And so the ingredients of a counterculture revolution were there."

Estimates placed the crowd that weekend at somewhere between four hundred thousand and half a million. "There was so much grass being smoked last night that you could get stoned just sitting there breathing," a nineteen-year-old student from Denison University in Ohio told a reporter, whose newspaper felt compelled to explain to its readers the meanings of "grass" and "stoned" and "busted" (all in quotation marks).

Woodstock Music and Art Fair	Woodstock Music and Art Fair	Woodstock Music and Art Fair	THREE
FRIDAY	**SATURDAY**	**SUNDAY**	**DAY**
August 15, 1969	August 16, 1969	August 17, 1969	**TICKET**
10 A. M.	10 A. M.	10 A. M.	
$6.00	**$6.00**	**$6.00**	Aug. 15, 16, 17 1969
Good For One Admission Only	Good For One Admission Only	Good For One Admission Only	**$18.00**
60207 NO REFUNDS	60207 NO REFUNDS	60207 NO REFUNDS	60207

"What the young promoters got was the third largest city in New York State, population 400,000 (give or take 100,000)," reported *Life* magazine. "On those almost instantly legendary three days," said music critic Greil Marcus, "there were nearly as many Americans at Woodstock as there were in Vietnam."

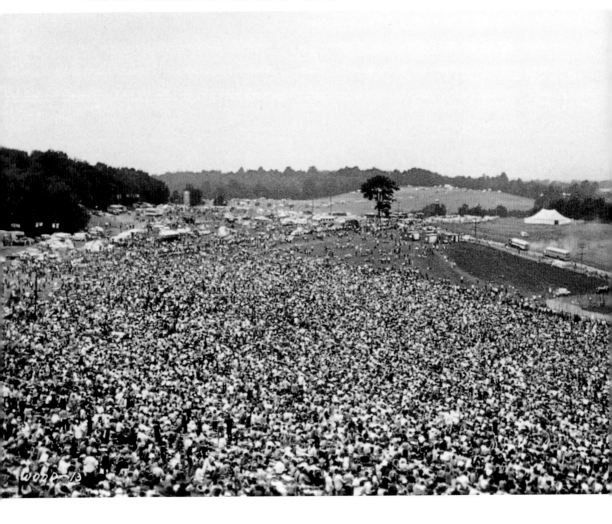

In alphabetical order, the complete list of the festival's thirty-one performers: Joan Baez; the Band; Blood, Sweat and Tears; the Paul Butterfield Blues Band; Canned Heat; Joe Cocker; Country Joe McDonald and the Fish; Creedence Clearwater Revival; Crosby, Stills and Nash [and Neil Young]; Grateful Dead (Jerry Garcia pictured, with joint); Arlo Guthrie; Tim Hardin; the Keef Hartley Band; Richie Havens; Jimi Hendrix [and the Gypsy Sun and Rainbows]; the Incredible String Band; Jefferson Airplane; Janis Joplin; Melanie; Mountain; Quill; Santana; John Sebastian; Sha Na Na; Ravi Shankar; Sly and the Family Stone; Bert Sommer; Sweetwater; Ten Years After; the Who (Roger Daltrey pictured); and Johnny Winter

In her essay "Voodoo Child: Jimi Hendrix and the Politics of Race in the Sixties," critic Lauren Onkey wrote of the musician's instrumental rendition of "The Star-Spangled Banner" at Woodstock, "[A]ccompanied only by Mitch Mitchell's psychedelic jazz drumming, he played the first few verses of the song, adhering closely to its familiar form. When he got to the line 'and the rockets' red glare,' Hendrix let loose with a carefully orchestrated sonic assault on the audience in which his shrieking, howling guitar riffs, modulated and distorted with feverish feedback, attained the aural equivalent of Armageddon."

"On those almost instantly legendary three days, there were nearly as many Americans at Woodstock as there were in Vietnam," said the music critic Greil Marcus. In fact, during that long weekend, Yasgur's farm became the third largest city in New York State, after New York City and Buffalo.

"One of the things that so many people said at the time," remembered Marcus, "[was,] 'I had no idea there were so many of us,' so many people who cared about this sort of thing. Who would go to the trouble to travel, to be in the presence of Janis Joplin. Sly Stone. Jimi Hendrix. So many other people."

Outside the Bethel compound came reports of doom and gloom. Under the

headline "Bethel Pilgrims Smoke 'Grass' and Some Take LSD to 'Groove,'" *The New York Times* struggled to deal with the seismic political and cultural shifts occurring in America. The paper editorialized against those who went to the festival as having "little more sanity than the impulses that drive the lemmings to march to their deaths in the sea."

Barnard Law Collier, the one reporter from the *Times* assigned to cover the entire festival, remembered, "Every major editor said the tenor of the story must be a social catastrophe in the making. I had to resort to refusing to write the story unless it reflected my on-the-scene conviction that 'peace and love' was the actual emphasis, not the preconceived opinions of editors sitting in Manhattan."

James Reston, executive editor of *The New York Times,* finally gave Collier the go-ahead to write the story as he saw fit, "although," the reporter noted, "the nuts-and-bolts matters of [traffic] gridlock and minor law-breaking were put close to the lead of the stories."

As the weekend went on, Marcus would come to say in retrospect, "there was a sense [of], we have to cooperate to make this work. But also a sense of defiance. They say it's going to be a disaster. And we're going to show them it's going to be great."

Richie Havens launched the first day's program at 5 p.m., with an evening of mostly folk music from Arlo Guthrie, Joan Baez, and Ravi Shankar. Saturday's concert began at noon in a deluge. Though the farmland turned into a sea of mud, few left. The kids stayed to listen to the giants of their generation: Canned Heat, Creedence Clearwater Revival, Grateful Dead, Janis Joplin, Jefferson Airplane, Santana, the Who, and all the others. During one of the downpours, crowds of people raised their hands and shouted, "Stop the rain! Stop the rain!"

"What could be more stupid than 'Stop the Rain'?" Greil Marcus recalled. "It was this mass expression of frustration that went on for a while. And then Country Joe and the Fish . . . got up [and] unplugged their instruments. They didn't want to be electrocuted. And they performed. Nobody could hear them when they were unplugged and there was no microphone. But what they did was they pantomimed their whole show. And the crowd is watching this . . . and everybody is laughing and saying, 'You know, if it wasn't raining, they would just be playing ordinary songs in an ordinary way. But this is something absolutely incredible. No one's going to believe this.'"

"It wasn't a rebellion, or even rebellious," Marcus continued, "but, rather, citizens of a city doing as they pleased–taking off their clothes, staying up all

night—for the pleasure of it. It was a raised finger to no one. Dreams of revolution were replaced by ordinary realities of freedom. The bands people had come to hear responded in kind; from the stage, you could feel musicians straining to reach people sitting hills and hills away, to bring them close enough to touch."

John Lennon wanted to perform but was stuck in Canada, denied a U.S. entry permit visa. Dylan was waylaid by a sick child of his in the hospital. To feed the hungry crowds, who at night slept in tents, nuns distributed provisions, including two gallons of pickles donated from a local Jewish community center. Wavy Gravy, a former beatnik comic, donned a Smokey the Bear costume and warned that anyone caught breaking the law would be hit by a custard pie.

Joplin, who brought along a full complement of musicians, didn't perform until around two in the morning on Sunday, followed by the Who, around five. The original intention was to have the festival close at midnight Sunday with the legendary "King of the Cowboys" Roy Rogers, with whom the baby boomers on the field had all grown up, singing his signature sign-off, "Happy Trails to You," as the crowds were to disperse. Rogers's manager nixed the appearance, and the cowboy hero himself admitted years later, "I would have been booed off stage by all those goddam hippies."

Hendrix insisted on closing the festival, except his designated Sunday midnight slot didn't open up until nine in the morning Monday. Hendrix ended up playing to a dwindling crowd of about thirty-five thousand.

"It didn't faze him at all," said Michael Lang. In those two hours, he performed "Voodoo Child/Stepping Stone," "The Star-Spangled Banner," "Purple Haze," "Woodstock Improvisation/Villanova Junction," and "Hey Joe." Of all the numbers, his guitar "Star-Spangled Banner" left the most lasting impression, as he interpreted the images of the violence and triumph in the War of 1812, with "the bombs bursting in air," into an indelible declaration of his generation's belief in the power of peace—one that in his Vietnam War memoir, *Born on the Fourth of July*, Ron Kovic remembered as blasting in his ears and those of his comrades in arms.

Said Kovic, "The soldiers listened to the music and they grew their hair long and they painted peace symbols on their helmets and they refused to go out on patrol."

"OUT OF THE MUD and hunger and thirst, despite the rain and the end-of-the-world traffic jams, beyond the bad dope trips and the garish confusion, a new nation

had emerged into the glare provided by the open-mouthed media," *Rolling Stone,* then a relatively new voice, said after the throngs had gone home. *Time* magazine, speaking for the American Establishment since 1923, summed up Woodstock as follows:

> The baffling history of mankind is full of obvious turning points and significant events: battles won, treaties signed, rulers elected or disposed, and now seemingly, planets conquered. Equally important are the great groundswells of popular movements that affect the minds and values of a generation or more, not all of which can be neatly tied to a time or place. Looking back upon the America of the '60s, future historians may well search for the meaning of one such movement. It drew the public's notice on the days and nights of Aug. 15 through 17, 1969, on the 600-acre farm of Max Yasgur in Bethel, N.Y.

Greil Marcus also reflected upon the meaning of Woodstock. "Halfway through an era of bad news, in the middle of a horrible war, barely a year after the wrenching, terrifying assassinations of Martin Luther King Jr., and Robert Kennedy, an entire, desperately-wished-for era of good feeling was compressed into a single place and time. It was 450,000 people trapped in an elevator, making the best of it, and in some weirdly mythic way, not forgetting once the elevator came unstuck, to keep in touch," he said.

"It was a magnificent accident."

A New Leaf

I

The hardest thing was the loss of a sense of possibility . . . the anticipation that, when the snows melted and next summer came around, the region would come back to life again, the way it always had.

—JOHN CONWAY, historian

Thomas Cole himself could not have imagined a more emblematic tableau. Standing before a small army of reporters and photographers, Eddie Fisher, whose career had sprung from Grossinger's and whose singing appearances and honeymoons there with Debbie and Liz had served to help keep the landmark on the map, now leaned over to push a plunger that would dynamite the sixty-five-year-old Grossinger's Playhouse off the face of the earth forever. Lou Goldstein, who since 1948 had spent most of his adult life as the tummler at Grossinger's and led generations of devotees in countless rounds of Simon Says, watched as the storied Swiss-chalet-style structure imploded. "It was something like watching my mother-in-law go over a cliff in my Cadillac," he said, attempting to get the last laugh.

The year was 1986 and the thirty-five buildings that had once comprised the Catskills' gold standard had been sealed shut since 1982. By the time the final guest had consumed the last herring, Jennie Grossinger had been dead and lamented for ten years. Having privately battled chronic depression for decades, the queen of the Catskills was forced to remove herself from the day-to-day operations of her namesake hotel before she succumbed to the effects of a stroke on November 20,

The indoor pool at Grossinger's; first padlocked in 1982, the property has been neglected for decades.

1972. Governor Nelson Rockefeller, long a devoted friend, had paid her tribute in 1968, declaring June 16, her seventy-seventh birthday, Jennie Grossinger Day, the first time a proclamation honoring a living woman had ever been issued in New York State.

Posthumously, Jennie received further accolades, though perhaps none quite so ambitious as a stage musical titled *Saturday Night at Grossinger's,* charting the family's journey from Ellis Island to the mountains. "Loving but labored," critiqued *Variety* when the show played Los Angeles in 2005, before journeying on to Texas, Florida, and Long Island, though, in another sign of changing times and tastes, perhaps, never the full distance to Broadway.

WITH OR WITHOUT the likes of Jennie, and with their core clientele rapidly aging, the once-flourishing playgrounds that defined the region were ignomini-

In an effort to woo jet-setters in the late 1960s, hotels worked with airlines to offer package deals.

ously slipping into their graves. Immune to their parents' values, including those formed by tragic memories of Europe that might have discouraged them from visiting there, a younger generation—cameras cocked and passports valid—sought different outlets for spending their leisure time, with the jet-age mantra of flying now and paying later an easy new option. Also not to be overlooked was the fact that the Civil Rights Act of 1964 legally put an end to restricted hotels (anti-Semitism in America had already become less acceptable after the atrocities of Nazi Germany had been fully exposed), while air-conditioning and the urban flight to the suburbs no longer made a summer escape to the mountain resorts a necessity.

"It's too bad no one wrote songs about them—we were probably too limited a demographic: kids in the Catskills making out in abandoned hotels," the jour-

nalist Joyce Wadler reminisced about what she did when she was seventeen. She was also describing the new landscape. "Around 1966, articles started appearing about the number of hotels in Sullivan County that are closing down or changing from traditional resorts to campgrounds, entertaining people in campers or recreational vehicles," said John Conway. "With the end of the Golden Age in 1965, several of the large hotels evolved into what we called 'fortress hotels,' where the guests checked in and then everything that they could want during their stay was provided by the hotel itself, and they never left the hotel grounds until it was time to go home. This was a death knell for the surrounding area, because the local economy was no longer being fed."

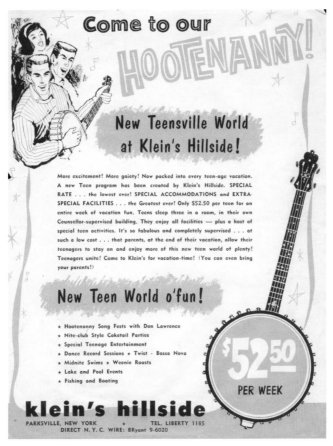

Attempts to attract the next generation proved hopelessly square. "It's so fabulous and completely supervised," Klein's Hillside in Parksville promised parents about the resort's "new teen world of plenty!" Woodstock had none of that.

Societal and economic shifts also generously contributed to the demise of "the Catskills" as generations had known them. With large numbers of women entering the workforce, few were able or even inclined to spend summers in the mountains minding the children while their husbands toiled in the sweaty city. Liberated young women with their own money were also now free to find suitable mates without the intrusion of parental chaperones. Many of the established hotels, meanwhile, were now more than half a century old and expensive to maintain. Staffing also posed a problem; college-age students who once worked the dining rooms to pay their tuitions were no longer available, or interested, leaving owners to pay rising wages as they also struggled to find enough foreign workers to meet their demands.

As vacancies rose, competition intensified. Clinging to the old adage that bigger was better, restaurants and nightclubs were enlarged, and tennis courts, handball courts, and indoor swimming pools added. "In some cases, the smaller hotels bankrupted themselves trying to keep up," said Phil Brown, of Brown's, which his parents originally bought for $70,000 in 1944. John Weiner, whose parents owned the White Rose Hotel in Summitville, observed, "A lot of the owners were dying off or retiring and leaving the hotel business to their kids. And the kids just weren't that good at it, they didn't want to work that hard."

In a final dance of desperation to fill the more than twelve thousand rooms available every night, new tricks were tried and traditions shattered. After more than seventy years of adhering to kosher dietary laws, the Nevele started serving bacon at breakfast, shrimp cocktails at lunch, and a creamy lobster thermidor at dinner. Grossinger's booked Jefferson Airplane in 1968, to a mostly bewildered crowd. In 1984, to mark the fifteenth anniversary of Woodstock (the festival took place twelve miles from there), one resort hosted a Rit Dye company party to demonstrate how to tie-dye. Widely promoted singles weekends sprouted up with diminishing returns, as did spring-break specials with discounted rates for college kids.

Throughout the region, dozens of bungalow colonies were shuttered and abandoned, leaving only moss and weeds to fill derelict swimming pools, ice rinks, and toboggan runs.

"The Catskills melted away from the bottom up. The bungalow colonies were the first to go, then the smaller hotels, with some of the large and fanciest hotels hanging on the longest," remembered Jeremy Jacobs, who grew up at the Delmar Hotel, opened by his grandfather the summer before the crash of 1929 and later run by his parents, Max and Claire.

The Red Apple Rest was sold by its original owners in 1985, and by 2007 was demolished.

The death rattle could be heard clear down Route 17. The Red Apple Rest continued to thrive for only as long as the Catskills resorts did too. The Freeds sold the property in 1985, and in early 2007 the structure was demolished. The eulogy in the local paper, the *Times Herald-Record*, read, in part:

> For the kids and grandkids of the Polish immigrants who grew up in the tiny
> community around Southfields in Tuxedo, the restaurant was a place of work
> for their family members, as well as a place for awakening adolescence, where
> the small-town kids got their first significant glimpse of the diversity of life as
> it flowed up in an endless stream of humanity from New York City.

As for the Concord, it managed to outlive its great rival Grossinger's by a dozen years, only to die a slow, natural death. Arthur Winarick, age seventy-five, had succumbed to a heart attack in 1964, and his family bowed out of the business. After various reincarnations and different owners, the mountains' glitziest hostelry locked its doors for good in 1998.

For a time, in what seemed another highly symbolic gesture, New York City used the facility to train its firefighters, who set the solid concrete and steel structures ablaze and practiced their drills there. Finally, in 2000, plans were unveiled

The Concord's staying power rested solely on its Monster golf course, though the hotel would close for good in 1998.

for a half-a-billion-dollar redevelopment. More than a dozen years later, those plans remained just that, plans.

FOR MOST OBSERVERS, the thought of the Catskills ever reemerging as a destination resort appeared to have gone the way of dressing for dinner. Some owners managed to convert lodgings into drug treatment and rehabilitation centers, or else into residences for patients with special needs, while others sold their properties at bargain prices to Orthodox Jewish or New Age groups. A few resolute believers, however, remained convinced that a comeback rivaling the glory days was still possible. Their perceived white knight was the Jack of Diamonds, and as 2014 approached, it looked like at long last he was ready to play.

Except for clandestine poker games masquerading as pinochle and the odd illegal slot machine that would turn up at even the swankiest resorts, gambling had virtually vanished from the Catskills. By the time the resorts were starting to feel the pinch in the late 1970s, efforts were already under way in Sullivan

County to introduce legalized gaming. Business analysts confirmed the economic soundness of the plan; with the mountains closer to New York City than either Atlantic City or the two proposed Connecticut casinos, developers would be wise to snap up failing properties such as the Concord and convert them into hotel-casinos.

Three thousand jobs, six million annual visitors, and new revenue of up to $1 billion were foreseen—as was, to New Jersey's consternation, a formidable financial drain on Atlantic City. But conservative-minded New Yorkers, and those who argued that casinos only sucked in money for themselves and did nothing to feed local economies and existing businesses, weren't ready to approve casino gambling, and it would not be until the 1988 congressional passage of the Indian Gaming Regulatory Act, permitting Native American tribes to open, own, and operate casinos on reservation land, that casinos could even become a possibility in the Empire State.

The next big step didn't arrive until 2013, when Governor Andrew M. Cuomo stepped up his effort to bring full-scale casino gaming to New York. His plan called for a maximum of seven resort-casinos in the state, although, against the strong desires of gambling companies, not one would be within the borders of New York City.

The Catskills faced no such prohibition in the Cuomo plan. With three casinos targeted for upstate, one would end up in the Catskills.

But where?

FOR THE MORIBUND GROSSINGER'S PROPERTY, a corporate savior appeared in the form of thirty-five-year-old William Meyer. A graduate of Wharton, the London School of Economics, and Georgetown Law School, Meyer was president of Servico, Inc., a small, publicly traded hotel company. In late 1985 it bought the hotel and all the surrounding real estate from the Grossinger family for $9 million. In its redevelopment plans, Servico projected the first phase of redevelopment to open on July 4, 1987, with a new lobby and three hundred renovated guest rooms, as well as a conversion of the abandoned recreational facilities into a world-class spa, a dining hall, and a deluxe "action lounge." Blueprints also called for the later addition of two hundred more guest rooms and $125,000 two-bedroom condominiums. "The kosher and non-kosher kitchens will be separate, so there will be no chance of mixing," Meyer professed to the *Times Herald-Record* in 1986, right

before Eddie Fisher blew up the old Playhouse. "We still hope to attract the traditional Grossinger's guest."

By the time of the promised 1987 opening, Servico was gone, replaced by a triumvirate of new owners who by the summer of 1989 were looking at an opening of late 1990. With an eye still focused on the property's heritage, one of the trio, Glenn Chwatt, a twenty-nine-year-old real estate developer with a degree in business administration from the University of Miami, informed the Jewish publication *Moment*, "Before we bought the hotel, one of my partners . . . lit a cigarette in the lounge on a Saturday morning. He was almost mauled and killed by the patrons for smoking on the Sabbath."

Chwatt also played down the Chapter 11 filing in early 1990 that had halted construction, but used the publicity surrounding the bankruptcy protection plan to play up the revitalized look of the proposed new Grossinger's. The developer envisioned a salmon-colored southwestern-style lodge with "a lot of slate and marble, and we've maximized some of the spectacular views. We want to be all things to everyone and create a little city of our own." To whisk patrons to the premises, Chwatt promised helicopter service from New York City.

Before a helipad could be laid, an alliance was forged with the St. Regis Mohawk tribe to secure a gaming license, although obtaining permission to build

Over the years, plans to revive the Concord have surfaced, only to disappear again.

an Indian casino on the site proved a challenge. Local opposition came from those who feared that a casino would bring traffic congestion, crime, prostitution, and higher taxes, while competing gambling interests in New Jersey and Connecticut also fought any proposal to bring casino gambling to the Catskills.

Ultimately, the biggest obstacle was geographical; the St. Regis Mohawk reservation happened to be located on New York State's Canadian border, hundreds of miles from Jennie Grossinger's old kingdom. In filing for a gaming license, the tribe insisted that they be allowed to exchange their right to own and operate a casino on their ancestral lands for the right to own and operate a casino in Liberty, New York. Briefs and counterbriefs were filed, and the matter dragged on in the courts for years.

What materialized in due course was not a new Grossinger's, but a Chapter 7 bankruptcy filing. Chwatt and his partners abandoned their dreams of casino riches, and in May 1993, Soung Kiy Min, a Japanese entrepreneur born in Korea, bought Grossinger's with his own plans for redevelopment. Under new management, Japanese and Korean tourists played golf at the hotel and drank sake at a refurbished karaoke bar.

"Forget the sumptuous eight-course meals of yore," a chagrined Tania Grossinger reported. "Miso soup has replaced borscht, and bacon is served with bagels at breakfast."

The hotel soon floundered into bankruptcy court. By the time a sale of fixtures and other assets was ordered, shattered highball glasses littered the floors and Tudor-style banisters stood rotting. Mattresses and fixtures, from toilet seats in assorted pastel colors to stockpots labeled "milk" and "dairy," went on the auction block, along with alarm clocks, nightstands, track lights, fire extinguishers, benches, and even a Zamboni ice resurfacing machine.

Still, no one was willing to raise a white flag just yet. In 1999, another buyer surfaced with even more grandiose plans. This time it was New York–based real estate entrepreneur Louis R. Cappelli, who was credited with revitalizing the downtowns of New Rochelle and White Plains. Cappelli acquired Grossinger's for $6 million and optioned to buy neighboring Kutsher's Hotel and Country Club for an additional $35 million. He then placed plans for these two resorts on hold, while, in partnership with Empire Resorts, Inc., he went and picked up the bankrupt Concord Hotel for $10.5 million. His vision: a billion-dollar Concord Entertainment City.

The goal was to relocate the nearby Monticello racetrack and its slot machines

onto the old Concord property–throughout this period, the Monster golf course had remained intact and functional–and then construct several hundred hotel rooms, along with a convention center and five hundred vacation homes. Believing that the state would eventually authorize table games for resort hotels, with the trifecta of Grossinger's, the Concord, and Kutsher's under his control, Cappelli would become the emperor of casino gambling in the Catskills.

"It's bittersweet," Town of Thompson supervisor Anthony P. Cellini said of the fate of the Concord. "It's sad to see history going down in a big pile. But we have to move on and bring economic development back to Sullivan County. If anyone can do it, Louis is the guy. His track record is proven."

Years passed and nothing happened. Then, in 2007, some thirty years into the fight to gain federal approval for gambling in the Catskills, New York governor Eliot Spitzer finally approved plans for the St. Regis Mohawk tribe to build a $600 million Las Vegas–style casino at the Monticello Raceway. This wasn't exactly what Cappelli had been hoping for, but a casino at the racetrack was better than nothing at all, and with Empire Resorts as one of his partners, he would receive 70 percent of the net revenues in exchange for building and running the casino on behalf of the Mohawk tribe.

Again there arose attempts by opponents to slam on the brakes. No sooner had Spitzer posed for photos as he signed the agreement with the three governing chiefs of the Mohawks than an activist consortium comprised of the Natural Resources Defense Council, the Sullivan County Farm Bureau, and others filed suit in Manhattan federal court to challenge the state proposal on environmental grounds.

"We simply don't know the likely impacts in increased traffic congestion, air-quality deterioration, and dangerous sprawl that a major development like this would have on the Catskills," said Richard Schrader, speaking on behalf of the Natural Resources Defense Council. Working in the group's favor was the requirement that final approval was necessary from the secretary of the interior, because the casino would be built and operated under the provisions of the Indian Gaming Regulatory Act.

At the time, the secretary was the former governor of Idaho, Dirk Kempthorne, whose long-held position was to oppose any Native American casino on non-reservation land–and Monticello Raceway stood a good four hundred miles from the Mohawks' Akwesasne reservation on New York's Canadian border. While awaiting word from Kempthorne's office, Governor Spitzer told *The New York*

Times, "I will do everything I can to encourage expeditious review and approval. The objective here is economic development. One casino, at a minimum, is good for the economy, good for the region."

In January 2008, nearly a year after Spitzer's approval and two months before the governor's unceremonious resignation from office over a sex scandal, Kempthorne rejected both the St. Regis Mohawk tribe's proposal for the Monticello Casino and that of the Stockbridge-Munsee tribe to build a casino in nearby Thompson. It wasn't the proximity of one casino to the other that ruled his decision, but the distance that the holdings would be from their respective owners' reservations. The Stockbridge-Munsee tribe was from Wisconsin.

"The departure of a significant number of reservation residents and their families could have serious and far-reaching implications for the remaining tribal community and its continuity as a community," Secretary Kempthorne wrote in a letter to the tribal chiefs. The night that the news of the vetoes had spread, the Natural Resources Defense Council declared a major victory. Even distant observers couldn't help but be fascinated by the twists and turns in this chapter of Catskills history. "I don't know what's going to come first—gambling or the messiah," posited Tania Grossinger. "It's been so many years, and there's been so many promises, so many false hopes, and nothing has happened."

Cappelli still held out hope. "When the secretary of the interior rejected outright the Indian gaming proposal, it focused us on the fact that we had to take this by the horns ourselves and do something with the property," said the developer, who described the 1,750-acre Concord site as "a beautiful alternative to going four hours on the expressway to the Hamptons. It's an undiscovered jewel that has to be pulled out of the box."

Demolition of the Concord finally began in 2009 after originally being halted in the aftermath of the September 11, 2001, attacks. Speaking to *The New York Times,* which reported that state financial assistance would be required in this time of tight bank lending, Cappelli said, "Table games aren't in the cards right now, but you have to walk before you run."

Yet even as the demolition dust settled, there still had been no progress toward construction. In April 2011, efforts by Empire Resorts and Cappelli to move ahead on the Concord resort project fell apart, and the partners went their separate ways. Empire announced it was now working with another company, Entertainment Properties Trust, and looking into plans to build a hotel next to the existing Monticello racetrack and "racino," which offered electronic gambling devices, includ-

Late 2013 brought another proposed Catskills development to the table from Chinese investors wishing to create a $6 billion "China City" within the 874-square-mile Thompson, New York (2010 population, 15,308). Likened to a combination Epcot, Las Vegas, resort village, and college town, the city would include condominiums, a hotel, a museum, a casino, a college, an amusement park paying tribute to zodiac signs, and a shopping mall modeled after the Forbidden City. Skeptics called it "Chinatown on steroids" and foresaw little hope for its future.

ing video poker. (By 2013, it was also promising the addition of roulette and craps to its "electronic table games [on] our casino floor . . . all the excitement of table games without the dealer and the newest way to win BIG!")

In a court settlement, Entertainment Properties Trust "acquired roughly fifteen hundred acres around the Concord, basically all of Cappelli's land except the former hotel site in Kiamesha Lake," reported the *Times Herald-Record*. Lost, at least for the time being, was the fabled Monster golf course, ripped apart by Cappelli to accommodate construction that never went beyond breaking ground.

What Entertainment Properties Trust promised in place of a hotel and casino was an amusement park.

AS NATIONAL PUBLIC RADIO'S *Planet Money* cofounder Adam Davidson said in 2013 about the inevitability of gambling in Sullivan County, "There just isn't a Plan B." And then, after so many years, Plan A finally went into effect. "For 50 years, the Sullivan County Catskills have sought gaming as a way to grow our tourism-based economy. And now that moment is here," said Republican state senator John J. Bonacic a day after New York governor Andrew Cuomo's December 17, 2014, announcement that the Catskills would receive a state casino license.

More than one skeptic noted that just as the roulette wheel would at last be rolling into the Catskills, gambling–or, rather, the failure thereof–already had nearly laid to rest Atlantic City. So while the old school Empire Resorts was erecting the $630 million Montreign Resort Casino on the site of the old Concord for a scheduled spring 2017 opening, new school entrepreneurs were seeing how better to shape their own visions for the Catskills.

"This new generation is interested in renewing the healthy lifestyle, eating good local food, and getting out of the city," Randy Lewis, a founder of the Catskill Brewery in Livingston Manor, told the *Daily Beast* in January 2015. "It's a natural fit for them."

"The cheap real estate in the area is really compelling. There's space for a dream project and plenty of fertile ground to explore your passions," said Sims Foster, a thirty-eight-year-old native of Livingston Manor, although he did concede, "At the end of day it's really not about the money, but about the energy people want to invest. When people see the local bakery, café, and brewery they think, 'Hey, there's a foundation for me to build upon.' I have friends in finance who could have a mansion in Bridgehampton but choose the Catskills instead."

As confirmed by Roberta Lockwood, president of the Sullivan County Tourism Association, "People eager to establish a second home in the Catskills are again searching."

Foster, who with his wife, Kirsten, owns the Arnold House, a stylish ten-room inn with spa on Shandelee Mountain, added, "The Catskills is becoming a new brand. We've swapped gefilte fish with locally cured bacon."

"Dude, there are so many Jews here," shouted the man, Ari Dicker, 20, a long-lost yeshiva friend from Queens. "This place rocks."

—*The New York Times*, September 2, 2005

As the Golden Age faded into memory, the scenarios playing out in the region started to sound eerily alike.

In 1969, a group of investors bought the Flagler, changed its name to the Fountains of Rome, and sought to convert it into a casino resort. Once gambling failed to be legalized in the foreseeable future, they abandoned the site, which was left vacant until 1973, when it was occupied by the 150 students and staff of the Crystal Run School, a center for the developmentally disabled. When Crystal Run outgrew the facility and moved to larger residences in the communities of Orange, Rockland, and Sullivan Counties in 2002, the site was sold to a Hasidic sect. The Alpine-inspired main building, declared unstable, had to be torn down. Today, virtually nothing remains of what had once been the jewel of South Fallsburg.

In 2009, heated issues arose over health and safety problems at the 450-acre former Homowack Lodge, which had been taken over by members of the Skver sect.

Jennie's grandson Mark's interest in the family business was evident from childhood. "I'll tell you one thing, Grandma," the young boy said as the two strolled among several tree stumps near the lake on the Grossinger's property. "We ought to cut some away and make more walks people can use in the summer."

The Grossinger family's contribution to the hospitality field continued to survive well after the resort folded, with Jennie's two grandsons, Mark and Mitchell Etess (the sons of Elaine and her husband, Dr. David A. Etess), both putting their stamps on the business.

As an adult, Mark Grossinger Etess became president of the Trump Plaza and the Trump Taj Mahal in Atlantic City, only to perish in a 1989 helicopter crash that also claimed seven others involved in the building of a mega-casino in Minnesota. (Jennie's biographer, Joel Pomerantz, said that Donald Trump was also set to be on board but ended up canceling the trip.) Mark was thirty-eight.

The multipurpose, five-thousand-seat Mark G. Etess Arena at the Trump Taj Mahal was dedicated to him in 1990.

Younger brother Mitchell Grossinger Etess has been with the Mohegan Sun Casino in Connecticut since 2002, serving as its president and chief executive officer, as well as CEO of the Mohegan Tribal Gaming Authority.

The Laurels Hotel and Country Club, once Sullivan County's largest hotel, was padlocked in the 1970s by the sheriff during the Passover holidays as a result of a foreclosure action. Sold to new owners who were then unsuccessful at reviving it, the Laurels fell victim to a devastating fire of suspicious origin in 1980. In 1995, the property was again seized, for nonpayment of real estate taxes, and in 1999 the lakefront property was sold for slightly more than $1 million. But instead of the Las Vegas–style hotel and entertainment complex envisioned by the new backers, the acreage serves as home to several species of wild migratory birds.

Brown's was sold at a foreclosure auction in 1988, and within a few years was converted into condominiums called Grandview Palace. Facing fire-code and other building safety violations that threatened to condemn the complex, Grandview went up in smoke on the night of April 14, 2012. No one was injured, but one

hundred people were evacuated to the Sullivan County Community College, and seven of the nine Grandview structures were destroyed.

The Tamarack Lodge, where Herman Wouk waited on the children's tables in the 1930s (when the Tamarack was still a boardinghouse, before its expansion into a hotel in 1947), fell into the hands of S. Robert Parker, a former owner of the Concord, and Ron Roberts, a former actor, evangelist, and self-proclaimed Native American chieftain, under the name "Chief Golden Eagle." Even so, the federal government questioned his heritage and his grandfather's death certificate that visibly altered "white" to "Indian," which led to his conviction on charges of submitting false documents and perjury. That pretty much put the kibosh on his own multimillion-dollar lawsuit against New York State for two hundred years of rent past due on public property that he claimed was owned by his tribe.

According to Robert P. Storch, the assistant U.S. attorney who prosecuted the perjury case, before "Chief" Roberts pleaded guilty halfway through his 2004 trial in Albany, the former actor had persuaded a group of Chicago investors to sink $3.5 million into the defunct Tamarack Lodge, under an agreement to build a casino there. Prosecutor Storch sought a stiff five-year prison sentence for Roberts, who instead received six months of house arrest, five years' probation, and a fine of $200.

Where Thomas Cole once communed with Mother Nature, today can be found "an increasing number of nonbelievers who are seeking stress-free, spiritual, and often inexpensive weekend breaks at [Catskills] ashrams," *The New York Times* reported.

As for the old Tamarack Lodge, on April 7, 2012, that too fell victim to a blaze, which completely destroyed the pool house, clubhouse, and whatever else remained. No one was hurt, because the bungalows had been "abandoned many moons ago," said the *Times Herald-Record*, even though "some were occupied by members and friends of the unrecognized Western Mohegan Tribe, owners of the 255-acre property since 2001." The newspaper added, "The tribe filed for bankruptcy March 9, staving off a sheriff's sale of their property. Chief Ron 'Golden Eagle' Roberts, a truck driver, was in Pennsylvania Saturday, according to son Ron Roberts, Jr."

When suspicion arose that the fire may have been intentional, Roberts Sr. replied, "Why would I destroy something I tried to save?"

By seeking solace instead of slot machines, some special-interest groups managed to transform the Catskills in their own special ways. As early as 1976, Hindu guru Swami Muktananda Paramahamsa, known for popularizing meditation in America, established a modest operation that he ran out of rented rooms in an old hotel in South Fallsburg.

Paying cash, because he disapproved of borrowing, the sixty-eight-year-old swami soon acquired three run-down hotels—the Brickman, the Gilbert, and the Windsor—for the Siddha Yoga Dham of America Foundation, or SYDA. Disciples' days began at five-thirty with Sanskrit chants. "Since the beginning of time there have existed on earth great souls who live immersed in the highest Reality, and who manifest the power to pass that experience on to others," SYDA says of its historical origin. "Such beings are known as Siddha Gurus, perfected Masters. The path they teach is Siddha Yoga, the path of perfection."

By 1980, freshly painted signs pointed out the path to the old Winter Hotel in Sullivan County, a transcendental meditation center headed by the Maharashi Mahesh Yogi, who also operated a second facility at the former Waldemere Hotel at Shandelle Lake. In Roscoe, the Tennanah Lake House became the home of the Foundation for a Course in Miracles, a group that studied a scripture believed to have been a correction to the Bible, preaching forgiveness as dictated by Jesus and channeled through a middle-aged Jewish woman.

On a hilltop near Woodbourne, a sign that once read *Haywire Dude Ranch* was replaced by another reading *Sivananda Ashram Yoga Ranch*. "Enjoy the view from our Russian style sauna," a brochure touted. At the ashram, decisions are left to others, activities—be they silent prayers or choral chants—are strictly regimented, and self-contemplation is given free rein. Meals are mostly vegetarian,

grown on premises, and served buffet-style. And, in another Catskills tradition, there's plenty of it, even if pastrami has been replaced by pineapple-and-vegetable stir-fry. "Close to home," remarked one contented attendee, "but it feels way off and gives you a feeling that you've disconnected from everything."

In all, there are monasteries, mosques, yoga retreats, ashrams, and meditation centers in a dozen Catskills communities, including a Vietnamese Buddhist monastery, in Pine Bush; the Dau Bosatu Zendo, a Zen retreat, in Livingston Manor; a Zen Mountain Monastery, in Mount Tremper; and the Ananda Ashram, in Monroe, where in 2008 *The New York Times*, reviewing "Ananda's high school–like dining hall," lauded a lunch that "featured six varieties of breads, including spelt and sprouted, roasted herbed potatoes, a vegan tomato bisque, orzo salad, pineapple-and-vegetable stir-fry, lemon bars, and apples and pears from a nearby farm. Nearly everything is made from scratch, including the ketchup, salad dressings and even tempeh."

Elsewhere on the spiritual spectrum, a Hare Krishna colony settled onto the town of Lake Huntington, and the Unification Church of the Reverend Sun Myung Moon bought land in Accord. Initially havens for the devout, these retreats have also been embraced by nonbelievers seeking what the Catskills have always provided: a fresh-air antidote to stressful workweeks in town. Some visitors even become full-time adherents of Eastern religions.

As stated on a sign in a window on Tinker Street in Woodstock: *If you lived here, you'd be Om now.*

"THE NEW CULT GROUPS are quite a contrast with the old resorts," novelist and onetime South Fallsburg English teacher Andrew Neiderman said in 1981, after a decade that saw a precipitous decline in Borscht Belt vacationers but a 23 percent rise in the overall Sullivan County population, thanks largely to cheap land that made second homes affordable to a wide new variety of residents.

"The fluxing that is going on here is exciting," said Neiderman, "to see Orthodox Jews talking to guys in togas."

Thirty years on, the outlook amid the locals was not necessarily so embracing. Rather than "exciting," the operative word seemed to be "polarizing."

Up until the end of the Second World War, Jewish vacationers in the mountains were predominantly secular. While the truly Orthodox had stayed in the Old Country, after the war, aware that nothing existed for them in Europe, many

left for the United States. "At that point," said Jonathan D. Sarna, "it was what they would've called *pikuach nefesh* [saving a life in jeopardy]—you're saving yourself by coming to America." Once here, determined to preserve their traditional Hasidic customs, they had no desire to integrate themselves into the American mainstream, a principle to which they have tenaciously clung ever since.

"They see themselves as operating on a different moral plane, on a different social plane," said sociology professor Samuel Heilman, referring to those who have moved, either seasonally or permanently, into such Sullivan County towns as Woodbourne, Monticello, Fallsburg, and Liberty. "To put it in the most general way, they see themselves as inhabiting a world apart."

Given this attitude, they remain apart, engaging only with their own kind. "What the Catskills offered them," said Heilman, "was a place to go where there were other Jews like them, insulated and separated from the world around them. They don't know the Catskills in the way that locals or people who were vacationing there in the past might know them. To these Hasidic Jews, the forests, lakes, and streams of the Catskills are incidental benefits."

Their entire view of the Great Outdoors, in fact, "really conflicts with a growing ecological consciousness about preserving nature," said Heilman, underscoring another point of contention between the ultra-Orthodox and their adopted communities. "They haven't absorbed these values because, besides their insularity, they don't operate by the same rules. For example, what has to be kept clean and what doesn't. In the Haredi [ultra-Orthodox] view of cleanliness, the home will be immaculate. The kitchen will certainly be immaculate—strictly separating the milk and meat, and all of that. But the outdoors is not viewed with the same kind of ontological importance. This, by the way, is not unique to Jews. You find this very often in the Middle East, the idea of throwing your garbage out the window. That's fine, because you don't want to keep the garbage in your home. But outside belongs to everyone."

Aggressively buying up old Catskills hotels and bungalow colonies—more than 250 of the latter, as of 2011—the Hasidim and ultra-Orthodox then manage to petition successfully for their removal from tax rolls by designating many of their properties as schools. At the same time, in Hasidic enclaves in Rockland County near the Catskills, "ultra-Orthodox Jews . . . control the local school board," *The Jewish Daily Forward* reported in late 2009. "[P]eople who send their kids to public school are not happy about the school board being controlled by people who send their kids to private religious schools and who seem to be primarily inter-

ested in lowering their own taxes and increasing the amount of money going to special-education programs."

In late September 2013, the prospect of a Satmar Hasidic Village being built in the Sullivan County village of Bloomingburg led to a planning board meeting so disruptive that it brought out the police, according to the *Times Herald-Record*. "Left unresolved . . . amid the din was the issue that brought the crowd to Village Hall in the first place—a private school for girls that will serve developer Shalom Lamm's 396-unit, townhouse project, Chestnut Ridge on Winterton Road, which has been approved but not yet built," wrote reporter Michael Randall.

The reader-supported website FailedMessiah.com, whose slogan is "Covering Orthodox Judaism since 2004," further noted, "Bloomingburg has 420 residents, none of whom appear to be Hasidic or Orthodox. . . . Lamm is also developing a large townhouse complex in the tiny village[,] which has been illegally marketed in a 16-page insert in a Satmar-controlled Brooklyn Yiddish language newspaper as a Satmar-only Hasidic village to be called Kiryas Yatev Lev."

Speaking to the *Times Herald-Record*, Lamm, while denying any responsibility for the sales insert, did assert, "But I'm a developer and I'm here to sell homes. I'm not going to say someone can live or they can't live here."

According to a September 24, 2013, FailedMessiah.com report by Shmarya Rosenberg, "Satmar has a long history of allegedly violating fair housing law to exclude non-Hasidim from its housing developments—some of which have been built with government funding. Kiryas Joel, Satmar's first Hasidic village, is 99.9% Satmar and is run by politicians handpicked by one of the two rebbes (grand rabbis) of the Hasidic sect. State and New York City officials are reluctant to take on Satmar, which has a large voting bloc which votes at the direction of its rabbinic leaders."

After an earlier planning board meeting which also ended prematurely (this time because attendance in the village hall exceeded its maximum legal capacity), residents expressed their outrage, according to *Hudson Valley Your News Now* reporter Jessica Chen. "How much of a tax base is it going to bring to the community? We don't know," said Brenda Giraldi, vice president of the Rural Community Coalition Board. "Is it going to be weighing on the community? We have no idea." Village trustee Joseph Gotthardt concurred. "There are a lot of questions that are unanswered and no matter who you ask, whether it's the builder, the developer or village officials, they will not answer those questions," he said.

For Catskills towns already dealing with large Hasidic populations that demand

compliance to their dietary laws, holidays, and religious observances—at the same time joining welfare rolls and evading tax rolls—the economic consequences have been dramatic. According to Assemblywoman Aileen Gunther, whose 98th District represents all of Sullivan County and parts of Orange, more than 40 percent of Ellenville became tax-exempt, in Fallsburg 48 percent, thus leaving the already overburdened taxpayers the additional burden of paying for local heath-care, fire, and police services that the ultra-Orthodox also use.

"If you put it all together," said Heilman, "the insularity, the differentness, the unfamiliarity, the temporariness—that adds to tension. And, finally is the fact that they have very large families, and lots of children, and children take up a lot of space. They take space outside. In the summer they're very often much more outside, and the kids are all over the place."

This has led to some confrontation. In the summer of 2009, a standoff arose between the State Department of Health and the Hasidic Congregation Bais Trana over the former Homowack Lodge, off Route 209, where officials determined that about 265 campers and thirty-five families were living there, despite the lack of an occupancy permit. Compounding the problem, "The sect, based in Rockland County," according to the *Times Herald-Record*, "continues to ignore requests to evacuate voluntarily in spite of warnings the buildings are firetraps."

As reporter Victor Whitman wrote on July 29, 2009, "The owners have been 'very elusive' about who is in charge and who owns the properties, [a] source said. This has made dealing with the situation even more difficult." The state Department of Health's district director, Mark Knudsen, told the paper, "We have never received an accurate accounting of their population," and it took a year of often frustrating proceedings before a solution could be reached. After several inspections and court dates, the elusive Congregation Bais Trana was fined $12,000 for being in violation of a series of state environmental laws that included operating a sewage system without proper supervision.

"I suspect that one of the reasons that local politicians are very careful about not publicly saying anything negative or even doing something about this community is that the Catskills are an economically depressed area," Heilman said in 2010, "and this is a very large bloc of people who, in spite of their insularity, are bringing money into the area. Maybe not as much as some locals would like, but they're buying gasoline.

"You don't want to alienate them."

Harbingers

I

The State of New York, in tandem with the development, intends to make 74 million dollars worth of improvements to the current ski area—that will link with the new golf course and hotels—acting as a huge public subsidy to the private investors and compounding the negative impacts to the surrounding community.

—SIERRA CLUB ATLANTIC CHAPTER,
in a July 17, 2013, solicitation letter

Ridiculous, isn't it?" said Brooke Alderson, referring to the $33,000 she and her husband, Peter Schjeldahl, paid in the early 1970s for 120 acres in Bovina, which they bought from a farmer. At the time, Alderson said four decades later, it was a lot of money. On the land, the Manhattan couple built their second home in Delaware County, which Alderson described as "a real poverty pocket since the late nineteenth century."

Retiring in 1996 from an acting career with credits that included the John Travolta and Debra Winger movie *Urban Cowboy* and television's *Murder, She Wrote*, Alderson opened what she called "a little shop in Andes, New York, Brooke's Variety, selling antiques and home furnishings."

It was a time of growth in the area. "So many families were moving up here, every year we added business," said Alderson, who, with the other proprietors in the tiny shopping district—"two guys, one was a designer, then two restaurants came in"—formed a small-scale business development group. "Every shop was

unique," said Alderson, "to create a destination where people would want to go. We were selling the town, not the individual businesses. It worked beautifully."

Best of all, said Alderson, "We didn't alienate the community, and it was all done with private money." Still, when it came to planning any kind of future economic development, there was a contingent of what Alderson called "the others," those who "only thought in terms of getting grants from Albany." High on their list, she said: have the state build a prison.

Alderson sold Brooke's Variety in 2008, although the shop is still there. (She travels and does antique shows.) Besides keeping an active interest in the social and economic welfare of her community, she and her husband, a poet and the chief art critic for *The New Yorker*, have since 1989 hosted an annual Fourth of July party that has attracted the attention of *The New York Times*, *Town & Country*, the *New York Observer*, and, depending on the particular year (and who's counting), anywhere from six hundred to fourteen hundred guests, including Steve Martin, Ben Stiller, and Adam Horovitz, better known as the rapper Ad-Rock of the Beastie Boys.

Alderson, however, doesn't require fireworks to see a rocket's red glare. When a friend sent her an email containing a mass-mailing message signed by "Susan Lawrence, Conservation Chair, Sierra Club Atlantic Chapter," seeking donations for a movement to prevent from being built in Shandaken and parts of Middletown "a mega-resort next to the State-owned Belleayre Mountain Ski Center that would see massive forest-clearing for construction of 2 hotels, 2 spas, an 18-hole golf course, a conference center, new ski slopes, retail shops, restaurants, parking lots, additional resort homes, outbuildings, streets and their lighting," Alderson was quick to fire back.

"Where does this person live?!?" she emailed. "She hasn't a clue what goes on here. The naysayers have been a stumbling block for years. This development is a very good thing for this area. Upgrading the ski center is much needed and a godsend for businesses trying to stay alive during the winter. Tourism is the most logical and greenest way to sustain and grow the economy, so I don't think any of these people have done half as much research as the business community. This has been going on for over 15 years with knee-jerk negative thinkers looking to put the kibosh on a perfectly viable and much needed plan for this area. DON'T GET ME STARTED!"

In a later phone conversation, a perfectly calm Alderson couldn't help but remark upon the tone of the Sierra Club letter, "the superiority of it all," she said,

"and the horror that private money might be used." She also cited a long list of concessions made to the community that had been made by the developer, Dean Gitter. "It's very green," she said of the project.

Indeed, the developer, Dean Gitter, born in 1935 and who grew up outside of Boston, does not fit the stereotype usually associated with those in his profession. A graduate of both the Harvard Business School and the London Academy of Music and Dramatic Art, in his former career in the music business Gitter produced records for the folksinger and civil rights activist Odetta, and more recently he was a teacher of meditation in Big Indian, New York. A profile—highly flattering—in the Hudson Valley lifestyle magazine *Chronogram* ("Arts. Culture. Spirit" is its subtitle) from May 2002 not only verifies that a three-thousand-page environmental impact report regarding the proposed ski-resort property was submitted to the New York State Department of Environmental Conservation, but goes on to say, "Even though the start of construction on the Belleayre Resort is a few years away, a foundation, called Crossroads Foundation, which will receive a third of Belleayre Resort at Catskill Park's profits, was already set up last year [2001]. The foundation's purpose is to benefit community health and cultural and environmental purposes of Middletown and Shandaken."

Furthermore, a quarter of a million dollars went into establishing that foundation, with the money already having been donated to "the Margaret Dill Hospital, in Margaretville, the Belleayre Conservatory, and the Neil Grant Youth Foundation, which provides financial assistance for youths in Shandaken and Middletown in the form of scholarships and recreational programs," according to *Chronogram*. (A cursory check of available sources produced no evidence to dispute this.)

The website for the Belleayre Resort, whether hyperbole or not, lists "541 permanent, fulltime jobs," "$400 million in development money for the local area," and an "organic-managed golf course" foreseen for the project, and further states, "For over twelve years, The Belleayre Resort has been studied, analyzed, and reviewed. In that time, the area has seen businesses close, families forced to move away to pursue better jobs, schools closing due to lack of students and taxes rise due to fewer revenue-generating businesses."

Alderson considers the antidevelopment tack "a last-minute grenade—who thinks this is a good idea? The Catskills are back, and it's tourism that's driving it. But businesses die up here in winter. How can you oppose a ski resort?"

To the argument, as expressed in a letter to the editor of *Chronograph* a month

On a steamy July day in 2013, *The New York Times* featured a front-page photo of an inviting swimming pool jutting out from a modern, $2 million residential aerie on an Ulster County hilltop with unobstructed views of the Ashokan Reservoir.

The homeowners, said the newspaper, were investor-activist Sean Eldridge and his husband, Facebook cofounder and *The New Republic* owner Chris Hughes, and though the story was ostensibly about Eldridge's political ambitions, another message was clear: not only had new blood arrived in the area, but new money. The deep pockets belonged to the congressional aspirant's campaign contributors—"billionaire financier" George Soros and Sean Parker, "the tech entrepreneur behind Napster and Spotify"—as well as Eldridge himself, who "quietly moved an investment firm he owns to the small city of Kingston," ten minutes from his Catskill home with Hughes, according to a similar article by *New York* magazine.

With the push of a Manhattan-based publicity agency, said the *Times,* prospective candidate Eldridge was making it known that his firm "has provided at least $800,000 in loans to businesses in the district," including two with the very hip names of Bread Alone (a bakery) and Prohibition Distillery (pretty self-explanatory).

In addition, Eldridge personally donated a quarter of a million dollars "to build a 3-D printing technology center at SUNY New Paltz." And while the news story suggested that the twenty-six-year-old's candidacy might pose a challenge for the region's long-time conservative constituency (Eldridge ended up losing the election), it also made clear that those same old-timers were not taking kindly to something else new to the region: the sudden rash of "gourmet coffee shops, boutiques, organic grocery stores—and liberal politics."

after the 2002 Gitter profile appeared, that the developer's "environmentalism starts by clear-cutting five-hundred trees off a mountaintop and replacing them with ornamental shrubs," Alderson, in 2013, had an answer.

"It's the Catskills. You can't kill off trees."

"WE LOVE THE AREA so much that we left the hustle and bustle of the Big Apple to start a new life up here," raved Gregory Henderson and Joseph Massa, owners of the delightfully over-the-top Roxbury Motel, on County Highway 41. Offer-

ing specialty-themed accommodations—from an "Archeological Digs" cottage right out of *Raiders of the Lost Ark*, complete with various bullwhips, to man-caves inspired by *The Jetsons* and *I Dream of Jeannie* (the former having been named one of *Forbes* magazine's Favorite Hotel Suites of 2012, and the latter giving the illusion of sleeping inside a bottle)—the Roxbury might elicit a serious case of the giggles, but, in season, just try booking a room there.

Equally theatrical, though purposely so, the Forestburgh Playhouse (with its adjoining Forestburgh Tavern), the oldest continuously operating summer theater in New York State, boasts roots that reach back to the mid-1940s. Fearing the loss of their Provincetown Playhouse when New York University began quietly buying up property in their Greenwich Village neighborhood, John Grahame and Alexander Maissel hunted for alternative space, which they found at a Sullivan County farm. Their first production there, in 1947, was Noël Coward's *Blithe Spirit;* the playhouse's 2015 schedule, under new producer Franklin Trapp, included the evergreen baseball musical *Damn Yankees* and, continuing Mel Brooks's everlasting connection to the Catskills, the humorist's monster musical *Young Frankenstein*.

Specialty accommodations at the Roxbury Motel include an Indiana Jones–inspired "Archeological Digs" cottage and an *I Dream of Jeannie*–like suite that's like sleeping in a bottle. Some showers and living rooms feature a built-in aquarium.

Over in the quiet village of Tannersville (population barely five hundred) the town has made a welcome spectacle of itself thanks to local artist Elena Patterson, who reimagined her once-staid gray-and-white house in Technicolor hues of orange, purple, yellow, and green. She started by using her mudroom as her canvas.

"It looked so terrific that it just migrated into the other rooms," Patterson told the *Today* show. Then it spread to the outside of her house. Eventually, others in town followed suit, and Tannersville, all aglow, now attracts curious weekenders enchanted by their surroundings.

For those still wishing to get back to nature, gay travel web pages and word of mouth commend the pond at Stony Kills Falls to hikers and nude swimming enthusiasts, just as naturalists from the city head up to the Mohonk Preserve, below Split Rock and the Coxing Trailhead, weather and sunscreen permitting. By the summer of 2013, even *The New York Times* was jumping into Catskills swimming holes under Fawn's Leap Falls, near Palenville, and Big Deep and Millstream in Woodstock, just as the newspaper was checking out the weed-scented scene in the hundreds of secluded spots along the nearly twenty-six-mile-long Kaaterskill Creek.

Train buffs have something to whistle about too: the ongoing rehabilitation of the former Catskill Mountain Branch Railroad Line. Something less earthbound? On Hunter Mountain, New York Zipline Adventure Tours offer "SkyRider," which, at speeds approaching fifty miles per hour, can propel the brave of heart across thirty-two hundred feet at up to dizzying heights of nearly seven hundred feet. "The majesty of the Catskills sucks me in so much, one of the guides has to shake the line to remind me to open up my body, to slow down," Tim Donnelly, commenting on the "pants-wetting potential" of "the fastest[,] longest[,] and tallest zipline in all of North America," reported in the *New York Post* in the fall of 2013.

Clearly—especially with former bungalow colony units in Ellenville, Lake Huntington, and Woodbourne being updated into co-ops and sold as affordable second residences to traditional and nontraditional middle-class New Yorkers—these are no longer your aunt Rivka's Mountains.

Witness Hazel, the brazenly off-kilter NBC page (Kristen Schaal), in her 2013 come-on to *30 Rock* heroine Liz Lemon (Tina Fey): "Say, I bought a Groupon for a couples massage at a resort in the Catskills where Henny Youngman used to take his mistresses.

"Whaddaya say?"

Our two chief economies in New York State are tourism and agriculture. Those two things can't happen in a gas field.

—JOSH FOX, filmmaker (HBO's 2010 documentary *Gasland*)

"The Marcellus Shale extends deep underground from Ohio and West Virginia northeast into Pennsylvania and southern New York, including the Catskills and the West-of-Hudson portion of the New York City Watershed. New York's portion of the Marcellus Shale is approximately 18,750 square miles and is very deep—over one mile below ground," according to a recent New York City report.

And how much gas is down there? That depends upon whom you ask. Some think the estimates are inflated—or just so much hot air. In 2011, according to the New York Department of Environmental Conservation, "Geologists estimate that the entire Marcellus Shale formation may contain up to 498 trillion cubic feet of natural gas throughout its entire extent. To put this into context, New York State uses about 1.1 trillion cubic feet of natural gas a year."

In February 2012, however—one month after President Barack Obama said in his State of the Union address that the United States was sitting on a nearly one-hundred-year supply of natural gas—the Energy Information Administration in Washington, D.C., revised dramatically *downward* its own 2011 estimates of the nation's natural gas resources, including those in the Catskills.

The sharply lower measures, anywhere between 40 and 66 percent less than the original approximations, were based on data made available to the EIA from more recent drilling for natural gas in Pennsylvania, the agency said.

"The Marcellus Shale is wildly overestimated, with the gas industry and New York State really overstating it," an activist with an academic pedigree stated emphatically in the autumn of 2013—though, like the United States Geological Survey (a federal agency that studies the American landscape and its natural resources), the person was unable to determine a specific measure. "Nobody can say that it's easy to get off the top of our heads," said the academician. "But it's not nearly as much gas as the USGS says."

So why not officially revise the estimates downward?

In another observer's opinion, it's because of Wall Street. "Energy investors have embraced the gas shale phenomenon," reported the Pittsburgh-based writer

"I've never had anyone say to me, 'I believe fracking is great.' Not a single person in those [upstate] communities. What I get is, 'I have no [economic] alternative but fracking,'" New York governor Andrew Cuomo said in his landmark December 2014 announcement that the practice would be banned in his state.

Dave Cohen, whose field of expertise encompasses energy, the economy, and climate. "In fact," said Cohen, "if producers don't have gas shale acreage to highlight in investor presentations—suggesting reserve and production growth—they are ignored in the marketplace."

Still, the threat—or, depending on one's point of view, the opportunity—to tap whatever is down there continues to loom large.

Facing a potential windfall should he permit a fuel company onto his property in Callicoon, Catskills dairy farmer Pete Diehl told the *Los Angeles Times* in February 2012, "Once you lease the land, they can do what they want on it. They can drill wherever they want."

That thing they wanted to do is introduce hydraulic fracturing, or "fracking"—the high-pressure injection of millions of gallons of chemical-and-sand-treated water into shale formations—to tap the region's supply of natural gas and fuel America's energy needs. Despite loud assurances to the contrary from fuel companies, the drilling process remained what most considered a high-risk proposition.

As *New York Times* op-ed columnist Joe Nocera, who identified himself as a supporter of fracking because of its "economic and foreign policy blessings," wrote on October 4, 2013:

> Ever since April 2011, when Robert Howarth, Renee Santoro, and Anthony Ingraffea of Cornell University published a study that purported to "evaluate the greenhouse gas footprint" of fracking, there has been an additional fear: that the process of extracting all that gas from the ground was creating an emissions problem that made coal look good by comparison.

Ingraffea, the Dwight C. Baum Professor of Engineering, Weiss Presidential Teaching Fellow at Cornell University, and president of Physicians, Scientists and Engineers for Healthy Energy, Inc., sharing a *Huffington Post* byline with actor-activist (and Catskills family man) Mark Ruffalo, stated in an April 2013 posting that "fracking itself is not the biggest problem." The problem is what comes with it:

> The trouble starts with wellpad construction. Each wellpad—and shale gas and oil extraction requires thousands—chews up five to nine acres of land. The wellpad's attendant technologies—pipelines, processing units, and compressor stations—chew up even more. This clear-cutting of forests and destruction of farmland sends topsoil into rivers and streams. Meanwhile, the relentless noise, light, and dust pollution during the many months of 24/7 drilling and fracking destroys quality of life in small towns.

It was such "troubling data," in the words of Igraffea and Ruffalo, that, the *Albany Times Union* reported in March 2013, New York governor Andrew Cuomo "has stopped the clock on hydraulic fracturing for natural gas in order to give his health commissioner more time to study its potential problems [and so that] medical professionals in other states where fracking has arrived have a chance to weigh in."

Faced with the hard questions before them, several Catskills residents, along with ecological watchdogs such as Ruffalo, strongly voiced their doubts when it came to permitting drilling to take place on their land. Weighing the potential hazardous environmental fallout against the economic benefits in the region—as

Publicly, Rex Tillerson, chairman and CEO of Exxon Mobil Corporation, has defended fracking, but privately, the executive and some of his neighbors in Texas filed a lawsuit in 2013 against the Bartonville Water Supply Corporation to halt construction of a water tower, *The Wall Street Journal* reported in February 2014. The plaintiffs were concerned that the utility company would sell some of the stored water to energy concerns for fracking, and hauling away the water would create a "noise nuisance and traffic hazards." A lawyer representing Tillerson told the *Journal* that the CEO's primary concern had more to do with property values than traffic.

well as elsewhere, and exacerbated by the fact that the safety of the New York City watershed may be threatened—fueled an argument that understandably was not only heated but divided neighbors, even families.

Pete Diehl, like his brother Jack—who openly favored drilling, provided, he said, strict controls were in place to protect his farm's water supply—grew up in a clapboard house built by his German immigrant ancestors in 1842. And it was for that very personal historic reason alone that, where Pete Diehl was concerned, no argument in favor of fracking could possibly exist.

"It's about the future," he said. "It's the landscape. It's the Catskills."

A HYDRAULIC FRACTURE IS formed by pumping three to eight million gallons of chemically treated water down a single well at pressures that exceed the rock strength, a process that breaks up the shale and releases the gas. Once the resources in the Catskills were identified, energy companies that had previously ignored the region suddenly started buying up gas leases for prices of up to $3,000 an acre. For residents in economically distressed areas of the Catskills, "the concept of gas drilling seems to be their only way out," admitted Sullivan County historian John Conway. For New York State, the stakes were even greater, with early estimates that the future extraction of natural gas from the Marcellus Shale could conceivably add as much as a billion dollars a year to the state's economy.

Conservationists and the City of New York, however, did not foresee potential dollar signs, only impending disaster. Of greatest concern was that some of the chemicals used in hydrofracking–which drilling proponents usually referred to simply as "trace chemicals"–were believed to be toxic.

As passed by Congress, the Energy Policy Act of 2005 allowed gas companies to inject unknown materials directly into, below, or adjacent to underground sources of drinking water without reporting the chemicals or their quantities to the government or to the public, forcing some states to take up their own action.

As fracking increased in Ohio, its lawmakers legislated in September 2013 that "[a] list of toxic chemicals used by Ohio shale drillers must be made available locally to governments, first responders and residents," the Associated Press reported. "Among chemicals used in the process that may be listed are: ethylene glycol, which can damage kidneys; formaldehyde, a known cancer risk; and naphthalene, a possible carcinogen."

Of the ruling, the *Columbus Dispatch* reported, "The decision . . . marks a victory for environmental advocates, who have long demanded that more light be shed on the chemicals used in fracking." Still, said the paper, "Oil and gas companies won't have to disclose everything, however. The right-to-know law allows companies to list some chemicals as trade secrets."

Energy companies insisted that fracking poses no danger when done properly, and that the drilling would be safe because the gas deposits in the Marcellus Shale were located well below the aquifers. In addition, because the well shafts would be sheathed so that both the chemically laced water going down and the gas coming back up would be under constant monitoring and control, environmental concerns were overblown, ExxonMobil CEO Rex Tillerson told *Fortune* for its April 30, 2012, issue.

"Faulty Wells, Not Fracking, Blamed for Water Pollution," read the headline of a pro-fracking *Wall Street Journal* feature on March 13, 2012, quoting Mark Boling, executive vice president and general counsel of Southwestern Energy Co., a major natural gas producer, about incidents in which gas drilling caused gas to get into drinking water, "Every one we identified was caused by a failure of the integrity of the well, and almost always it was the cement job."

Furthermore, said the gas companies, all drilling activity would have been governed by strict state environmental regulations. As a final precautionary measure, the companies guaranteed that the chemically charged wastewater drawn back to the surface would have been discharged into collection pits and disposed of so as not to contaminate the surface water or the land around the wells in any way, ensuring the avoidance of leaks or spills. The *New York Post*, in a March 1, 2013, op-ed piece by Greg Lancette, the political director of the New York State Pipetrades Association, stated, "When the Ground Water Protection Council reviewed more than 10,000 wells, it found only one complaint about groundwater quality—and the [Environmental Protection Agency] found that the problem wasn't the result of fracking." The same article further claimed, "Nor do we have evidence that well-constructed, well-operated fracking wells contaminate the air."

In his *Times* piece, Nocera wrote, "The primary problem [with extracting all that gas from the ground], according to Howarth and his colleagues, was the amount of [the powerful greenhouse gas] methane—somewhere between 3.6 and 7.9 percent of the natural gas produced, they estimated—that escaped into the atmosphere. . . . Howarth's study, however, was purely an estimate."

Bolstering their position, energy companies advertised to the public that gas was cleaner than coal and unleashes a less harmful effect on the climate and in the air we breathe than other sources of power. And while natural gas was not a substitute for oil, advocates of drilling insist that the extraction of the gas reserves in the Marcellus Shale would have ultimately encouraged the development of vehicles running on natural gas and reduced the nation's dependence on foreign oil.

WERE DRILLING to have been approved in New York State, the number of wells developed per year could have ranged from 413 to 2,462 and generated between 4,408 and 26,316 full-time construction jobs, according to a study commissioned by the New York State Department of Environmental Conservation. The report also suggested that an additional 1,790 to 10,673 new jobs in production would

have been created along with added employment in retail and other areas. The State of New York also stood to benefit from any fees collected from the drilling companies and from an increase in the taxes from individuals and companies benefiting from an improved economy.

Opponents of drilling disputed every claim. "There is an entire portfolio of bad impacts," warned Robert F. Kennedy Jr., chairman of the Waterkeeper Alliance, a worldwide clean-water protection organization. Spills and air contaminates from closely clustered wells had been recorded with increasing frequency in states where fracking was allowed, and some who lived near current drilling sites needed only turn on their bathroom or kitchen taps to find flammable drinking water. Skin rashes and nosebleeds had developed among those living in close proximity to wells.

Added *Gasland* documentary filmmaker Josh Fox, whose 2013 *Gasland 2* highlighted the fuel companies' strong-arm tactics in dealing with opponents (including those who had leased their land to them), "With all the leasing that's been going on in the Southern Tier, the amount of gas wells would be between fifty thousand and a hundred thousand, throughout 50 percent of New York State. This is the greatest environmental and economic issue facing the state in its history."

The approximately 250 undisclosed but largely toxic chemicals used in hydraulic fracturing contain such carcinogens as benzene and formaldehyde. Halliburton, one of the drilling-service companies, is credited with the provision in the Energy Policy Act of 2005 known as the "Halliburton loophole," which prevented the Environmental Protection Agency from demanding disclosure of the chemicals used in the fracking process.

"If your water gets polluted, the companies say you have to prove they did it," cautioned Ruffalo, who lives in Sullivan County along with neighbors and fellow actors (and fracking opponents) Michelle Williams and Debra Winger. "And the only proof is naming the chemicals they're using, which they don't have to release."

Also joining the opposition to fracking, and in January 2013 taking their protest to the Albany offices of Governor Andrew Cuomo, were Yoko Ono and her son, Sean Lennon. With them, Pete Seeger, age ninety-three, led a rousing rendition of "This Land Is My Land."

"Fracking kills," said Ono, "and it doesn't just kill us. It kills the land, nature, and, eventually, the whole world." Speaking of his father, John Lennon, who had bought a Catskills farm, Sean Lennon said, "He loved it up there because we had our own well water."

"Unfortunately, the industry's response too often has been just to argue that

"At least 15.3 million Americans live within a mile of a well that has been drilled since 2000," *The Wall Street Journal* reported in October 2013. "That is more people than live in Michigan or New York City."

hydraulic fracking can't possibly cause any problems," said Fred Krupp, president of the Environmental Defense Fund and a member of the Energy Department's shale gas advisory board subcommittee in 2011. "When that kind of denial meets real and actual issues, the disconnect results in a lot of anger. And it erodes trust."

Environmentalists insisted that fracking would inevitably contaminate the aquifers from which the entire Catskills region, as well as New York City, draws its water. The city gets more than 50 percent of its water from the Catskills watershed, and for more than one hundred years this supply has remained so pure that no filtration has been needed. Should this water ever become polluted as a result of fracking, virtually every community in the Catskills would be required to build a filtration plant. For New York City alone, the cost would be staggering. One estimate put it at $20 billion.

Also questioned were the economic benefits fracking would have delivered to the region. While restaurants, stores, gas stations, and motels would have seen an uptick in business, few local residents would have been hired for the new jobs on the drilling rigs, which would have gone instead to experienced hands from out of state. The same would have been true for the purchase of equipment and supplies before the drilling, and the costs of cleanups after—including the repair of roads

and bridges damaged by the high volume of truck traffic servicing the sites, a vast expenditure that could conceivably offset any economic gains in the region. The only real beneficiaries, opponents claimed, would have been the oil and gas companies and their drilling partners.

In 2011, public records revealed, companies that drilled for natural gas spent more than $4 million lobbying the administration of Governor Andrew Cuomo and New York State legislators, prompting *The New York Times* to report on November 25, 2011, "The hydrofracking issue has created a cottage industry for paid lobbyists." Chesapeake Energy, a major gas driller, spent more than $1.6 million on lobbying from 2008 to 2011. In 2007, it only spent $40,000.

Additional millions were poured into newspaper and television advertising campaigns to convince the public that fracking is safe and economically beneficial. The broader natural gas industry gave hundreds of thousands of dollars to the campaign accounts of lawmakers and the governor, while environmental groups, lacking such deep pockets, mounted homegrown and social media campaigns to convince Cuomo, the legislators, and the public that hydrofracking could poison the water supply and cause an environmental disaster.

Opposing gas drilling in the Catskills, the National Resources Defense Council led a large group of other organizations with the goal of demanding that all proper environmental reviews be conducted and officials be required to prove that fracking would not jeopardize public health or the environment. In September 2012 the Council launched the Community Fracking Defense Project, to provide legal and other assistance to those who wished to ban the natural gas companies from their communities. Towns like Dryden and Middlefield that lie on the edge of the Catskills have filed lawsuits to prohibit fracking, and in a landmark decision in February 2012, the New York State Supreme Court upheld their right to bar fracking within their boundaries.

Joining them, in late March 2012, was the Preservation League of New York State, which sought to declare areas around proposed drilling sites as endangered historic and cultural resources. Speaking to the press, officials for the groups said they were saving structures and scenery dating back to the eighteenth century. On an aesthetic level, the damage from drilling would have been incalculable, with hundreds and possibly thousands of derricks, miles of muddy construction roads, and wastewater pits marring the countryside.

Then came the dawn. After a five-year study of the potential environmental, economic, and public health effects of fracking, the Cuomo administration, cit-

ing the extreme health risks, on December 17, 2014, announced that hydraulic fracturing was prohibited in New York State. Except no sooner was one environmental challenge diffused than another presented itself, that very same month, when federal energy regulators approved the $700 million Constitution Pipeline project for the Tulsa-based Williams Partners LP and Houston-based Cabot Oil & Gas Corporation to bring Marcellus Shale fracked gas from Pennsylvania's Susquehanna County into markets in New England and New York. The 126-mile pipeline, scheduled to begin construction in the summer of 2015, was to wend through forests and waterways in New York's Broome, Chenango, and Delaware Counties, to connect with existing Tennessee and Iroquois pipelines in the Schoharie County town of Wright.

Among those opposing the plan was the Center for Sustainable Rural Communities, with environmental attorney (and founding member of the group Stop the Pipeline) Anne Marie Garti telling the Albany *Times Union*, "The pipeline simply cannot be done without violating laws that are meant to protect us." Arguing that the pipeline would devastate people who live in its path, Garti urged the New York Department of Environmental Conservation to reject it.

Mirroring the events surrounding the Catskills land grab for water of more than a century before, in late February 2015 U.S. district judge Norman Mordue granted the Constitution Pipeline eminent domain rights to use property whose owners had been resisting right-of-way agreements. "We appreciate the action of the court in affirming well-established case law granting parties, such as Constitution, the right of possession, which is critical for us to move the project forward so that we can meet the conditions necessary to begin pipeline construction," said Christopher Stockton, a spokesman for Williams Partners. Surveying the land and the cutting of trees was expected to begin immediately.

Only perhaps not so fast. Opponents claimed Constitution Pipeline had failed to obtain a 401 water quality certificate from the state Department of Environmental Conservation. "There is not a single case where eminent domain proceedings have occurred without obtaining a 401 water quality certificate," said Garti, citing how the omission violates federal laws.

Of the personal price to property owners should the pipeline go through, the attorney further stated to the Public News Service, "They're losing what their land means to them, because once this pipeline goes through it—in some cases very, very close to people's homes—nobody will ever want to buy this land again.

"Who wants to live next to a ticking time bomb?"

And there is a Catskill eagle in some souls that can alike dive down into the blackest gorges, and soar out of them again and become invisible in the sunny spaces. And even if he for ever flies within the gorge, that gorge is in the mountains; so that even in his lowest swoop the mountain eagle is still higher than other birds upon the plain, even though they soar.

—HERMAN MELVILLE, *Moby-Dick*

Catskill Park, founded in the late 1880s, is a 700,000-acre mixed-use recreational preserve that first came into the possession of Ulster County when the logging companies that had previously owned the land literally skipped out of town without paying taxes.

While prosperous businessmen snapped up some of the land for private fishing and hunting clubs, most of the vast acreage, which includes ninety-eight peaks standing more than three thousand feet tall, was deeded to the state in

A Catskill Mt. Eagle and its captor.

The Catskill Mountain eagle is "still higher than other birds upon the plain," wrote Herman Melville.

The town of Callicoon, circa 1890s. It was originally called Collikoon, from the Dutch word *Kollikoonkill,* meaning "cackling hen," a name given by the Dutchmen who came from the Hudson Valley and hunted the wild turkeys in pursuit of the plentiful beech tree nuts. The town of Callicoon, originally established in 1842, is comprised of the hamlets of Youngsville, Callicoon Center, and North Branch; the community of Shandalee; and the village of Jeffersonville.

exchange for the promise to establish a park and pay local taxes to the towns and villages on the property—guaranteeing economic survival for the fifty thousand permanent residents who live within the 287,000-acre "forever wild" park-within-a-park, the Catskill Forest Preserve.

Part of America's first frontier—and also home to bobcats, bears, weasels, and minks—the preserve that once inspired nineteenth-century writers and artists and welcomed pioneering travelers to the region is today under the protection of the New York State constitution; none of its land can be logged, leased, sold, or exchanged without the approval of both the state assembly and the senate in two successive sessions of the legislature.

For New Yorkers, there are carefully guarded recreational facilities amid extensive stands of still-pristine forest meadows, lakes, rivers, wetlands, waterfalls, and cliffs. The preserve is also home to four reservoirs, to supply what former New York City mayor Michael R. Bloomberg called "a healthier, more sustainable New York City."

THE UNCONVENTIONAL BUT INDOMITABLE nature of the region also happily survives. The Bethel Woods Center for the Arts, a $70 million arts and performance center, opened in 2006 on what many might consider hallowed ground: the site of the 1969 Woodstock Festival. The brainchild of venture capitalist and Cablevision founder Alan Gerry, the center features an immersive multimedia museum dedicated to that ultimate be-in, seats five thousand people in its open-air pavilion and another twelve thousand on its sloping lawns, and can count a wide variety of performers, from the New York Philharmonic and the Boston Pops to Bob Dylan, Willie Nelson, Tim McGraw, Lady Antebellum, and the Beach Boys, among those who have graced its stage. The autumn also brings an annual wine festival, where local vintners are spotlighted. Established at its founding, the guiding principle behind Bethel Woods is "to advocate for issues that make Sullivan County, and the world at large, a better place."

Only fifteen miles from Bethel Woods, in the Sullivan County village of Callicoon, originally settled by the Dutch in the 1600s, an effort is afoot to save the 1852 Western Hotel, a yellow four-story structure with a mansard roof. Once home to Chautauqua lectures, melodramas, concerts, and roller skating, the Western has been compared to the set of *Gunsmoke* and is supposedly haunted by the ghost of Laura Darling, whose parents owned the hotel in 1921, when she was fatally shot on the hotel's front steps by her husband, the bartender.

The hotel's owner since the late 1960s, Joe Naughton, was accidentally responsible for another death on the premises, in 2008, when he was playing with his unregistered semiautomatic .25-caliber handgun and it went off and shot his barmaid, local actress Lori Schubeler. Naughton served six months, only to be arrested again in May 2011 for violating his parole by selling alcohol to a minor, a $9.29 bottle of Merlot. At trial, Naughton's attorney, Joseph Ruyack III, said the twenty-year-old customer looked older than his age and appeared knowledgeable about wine.

The *Sullivan County Democrat* newspaper expressed surprise that Naughton, "known for running a genteel establishment," could have done such a thing. "His tap room was a place where patrons knew better than to swear," said the paper, "lest they be escorted out the door, and where they made sure they kept a napkin beneath their drink."

"We have a little town," Karen Zadabura, a neighbor of Schubeler and her

The $70 million Bethel Woods Center for the Arts opened in 2006 on the site of what used to be Max Yasgur's dairy farm, home to the Woodstock Festival.

Dating back to 1852, Callicoon's Western Hotel managed to remain in business despite scandals, murders, and even reported sightings of a ghost.

longtime beau, told the *Democrat* after the shooting. "These things aren't supposed to happen here."

Callicoon resident Lee Hartwell, a former Manhattanite who arrived in 2006, opened an antique store on Main Street, and, as he told the *New York Post,* "got to know a whole bunch of people from the city—ex–chefs, ex–theatre people who were fun to cook and eat with, and to tell stories with. That's why I never left."

He also promised that during the incarceration of Naughton, who in May 2011 was sentenced for up to four years, "[t]he Western Hotel will not fall into disrepair. I can guarantee that won't happen because we've already got people talking about how to bring this hotel back to life."

And while aiding in the rescue of the historically colorful hotel might prove as elusive for the town as finding the Northwest Passage was for Henry Hudson, Hartwell's determination and the potential for the Western, along with other cherished regional institutions like it, show, in the words of *Making Mountains* author David Stradling, "that American romanticism is alive and well, and that Americans have a very strong connection to the natural landscape and the increasingly historical landscape of the United States."

Or as John Burroughs so bluntly, and no doubt contentedly, put it, "Where the cow is, there is Arcadia."

Acknowledgments

Through interviews (both formal and informal), emails, texts, telephone conversations, and even chance meetings, the following thoughtfully lent their rich voices to the text: Brooke Alderson, Shelly Altman, Carolyn Bennett, Walter Bernstein, Phil Brown, John Conway, Henry C. Cooper, Jeremy Dauber, Morris Dickstein, Elaine Grossinger Etess, Joe Farleigh, Linda S. Ferber, Diana Foote, Janet Forman, Diane Galusha, Mort Gerberg, Robert A. Gildersleeve, Vivian Gornick, Tania Grossinger, Richard Heppner, Ruth Inniss, Elizabeth Jacks, Franklin Kelly, William P. Kelly, Mal Z. Lawrence, Steve Lawrence, Mary Lewis, Greil Marcus, Mia Navarro, Sheila Nevins, H. Daniel Peck, Joel Pomerantz, Tad Richards, Freddie Roman, Thane Rosenbaum, Dorothy R. Sanson, Jonathan D. Sarna, Pete Seeger, Bob Steuding, David S. Stradling, June Terry, Franklin Trapp, and Jeff Walker.

Several people also generously contributed time, introductions, and assistance as the book developed. They include Alice B. Acheson, Judith Bass, Estée Bauernebel, Joan Bloom, Joan Brower, Dale Burg, Marcia Calicchia, Carol Carey, Fran Carpentier, Barbara Carroll, Mary Corliss, the late Judith Crist, Charlotte Crowe, Barbara Cutler, Peter Derby, Yvonne Durant, Marshall Efron, Susan Garfield, Judith Gerberg, Tamara Glenny, Eric Herskovic, L. Clifton Hill Jr., Tom Houghton, Carmen Johnson, the late Howard Kissel, Sally Koslow, Diane Krausz, Anne and Ivan Kronenfeld, Howard and Ron Mandelbaum, Eve and Sidney Mayer, Isabel Mitchell, Carol Morgan, David Nemec, Alfa-Betty Olsen, Duncan Peterson, Barbara Pflughaupt, Nina Pinsky, Gladys Poll, Maria Pucci, Don Rath, Diane Reid, Evelyn Renold, Beatrice Rich, the late Martin Richards, Katie Rosenberg, Roy Schecter, Gail Clott Segal, Audrey Silverman, Jo Anne Simon, Michael M.

Thomas, the late Mary Travers, Mike Treanor, Judy Twersky, Annemarie van Roessel, and Sherman Yellen.

Special acknowledgment is also due to Victoria A. Wilson, senior editor, vice president, Alfred A. Knopf. It is often asked what an editor is, exactly. In the case of the prolonged gestation process of this particular book, and this particular editor, many labels apply. Among them initiator, facilitator, prime source, referee, talent scout, activist, environmentalist, friend, critic, and, above all, voice of reason. No author could ask for a finer collaborator, and this author is profoundly grateful. What I owe her is beyond evaluation.

Notes

INTRODUCTION

xii *"About two weeks":* "Our Christmas Green: Where It Grows, How It Reaches the New York Market, Varieties Used," *New York Times,* December 16, 1880.

xiii *To Richler:* Mordecai Richler, "The Catskills: Land of Milk and Money," *Holiday,* July 1965.

THE DAWN

5 *While little is known:* Peter C. Mancall, *Fatal Journey: The Final Expedition of Henry Hudson* (New York: Basic Books, 2009).

5 *By the time Hudson:* Russell Shorto, *The Island at the Center of the World: The Epic Story of Dutch Manhattan and the Forgotten Colony That Shaped America* (New York: Doubleday, 2004).

5 *"much trouble with fogges":* Robert Juet, *Juet's Journal of Hudson's 1609 Voyage,* trans. Brea Barthel, from *Purchas His Pilgrimes* (1625) (Albany, NY: New Netherland Museum, 2006).

6 *On the river shore:* Henry Hudson, *Henry Hudson the Navigator: The Original Documents in Which His Career Is Recorded, Collected, Partly Translated, and Annotated* (London: Hakluyt Society, 1860).

8 *"The sun soon dispelled":* John S. C. Abbott, *Peter Stuyvesant* (New York: Dodd, Mead, & Co., 1898).

9 *The Northwest Passage once:* Douglas Hunter, *Half Moon: Henry Hudson and the Voyage That Redrew the Map of the New World* (New York: Bloomsbury, 2009).

14 *"In 1690 Gerrit":* Myrtle Hardenbergh Miller, *The Hardenbergh Family: A Genealogical Compilation* (New York: American Historical Company, 1958).

15 *"Petition of Johannes Hardenbergh":* Alphonso T. Clearwater, *The History of Ulster County, New York,* vol. 1 (Westminster, MD: Heritage Books, 2001).

16 *He was also fascinated:* Ormonde De Kay Jr., "His Most Detestable High Mightiness," *American Heritage,* April 1976.

16 *The society tolerated:* Judith Klein, "History in the Making," *Columbia Magazine,* Winter 2011–12.

18 *"A stubborn and sometimes":* Carl Carmer, "The Lordly Hudson," *American Heritage,* December 1958.

19 *Aboard the fleet:* Ron Chernow, *Washington: A Life* (New York: Penguin Press, 2010).

19 *According to an 1879:* John Austin Stevens et al., eds., *The Magazine of American History: With Notes and Queries,* vol. 3 (New York: A. S. Barnes & Co., 1879).

22 *"Ulster County had":* Marius Schoonmaker, *The History of Kingston, New York: From Its Early Settlement to the Year 1820* (New York: Burr Books, 1888).

22 *"Its preamble incorporated"*: Gerald Benjamin, *The Oxford Handbook of New York State Government and Politics* (New York: Oxford University Press, 2012).

24 *Though the village:* Thomas Fleming, "Gentleman Johnny's Wandering Army," *American Heritage,* December 1972.

25 *"Handsome Jack"*: Reginald Hargreaves, "Burgoyne and America's Destiny," *American Heritage,* June 1956.

DRIVING DREAMS

27 *Hershel Parker, professor, author:* Hershel Parker, *Herman Melville: A Biography,* vol. 1 (Baltimore: Johns Hopkins University Press, 2005).

27 *Keeping them informed:* Patrick Bunyon, *All Around the Town: Amazing Manhattan Facts and Curiosities* (New York: Fordham University Press, 1999).

29 *"is written in a highly formal"*: Richard Freedman, *The Novel* (New York: Newsweek Books, 1975).

32 *From Washington Irving's:* E. Littell. *Littell's Living Age.* (Boston: E. Littell & Co., 1851).

33 *Financially supported by his:* Peter Irving, *Peter Irving's Journals,* ed. Leonard B. Beach, Theodore Hornberger, and Wyllis E. Wright (New York: New York Public Library, 1943).

33 *Under the name Jonathan:* Brian Jay Jones, *Washington Irving: The Definitive Biography of America's First Bestselling Author* (New York: Arcade Publishing, 2008).

33 *"I saw her fade"*: Andrew Burstein, *The Original Knickerbocker: The Life of Washington Irving* (New York: Basic Books, 2008).

34 *"The founders of the Hotel Gotham"*: "Gotham," *New Yorker,* "Talk of the Town," August 7, 1965.

34 *"the stream born"*: Charles M. Skinner, *Myths and Legends of Our Own Land* (Philadelphia: J. B. Lippincott, 1896).

36 *"quitted the breakfast"*: Robert Shelton Mackenzie, *Sir Walter Scott: The Story of His Life* (Boston: James R. Osgood & Co., 1871).

36 *The success of* The Sketch Book*:* Washington Irving, *Washington Irving: Three Western Narratives,* ed. James P. Ronda (New York: Literary Classics of the United States, 2004).

40 *"Irving not only realized"*: Curtis Dahl, "The Sunny Master of Sunnyside," *American Heritage,* December 1961.

42 *"What did Cooper dream"*: D. H. Lawrence, *Studies in Classic American Literature (The Cambridge Edition of the Works of D. H. Lawrence).* (Cambridge, UK: Cambridge University Press, 2003) (originally published 1923).

43 *"His father had determined"*: Thomas Raynesford Lounsbury, *James Fenimore Cooper* (Boston: Houghton, Mifflin & Co., 1883).

45 *"I loved her"*: Wayne Franklin, *James Fenimore Cooper: The Early Years* (New Haven, CT: Yale University Press, 2007).

51 *Cooper returned to the United States:* Jones, *Washington Irving.*

CAPTURING THE LIGHT

56 *"Apart from their work"*: Samuel Isham, *The History of American Painting* (New York: Macmillan, 1916).

59 *The Cole daughters ran:* Oswaldo Rodriguez Roque, "The Exaltation of American Landscape Painting," in *American Paradise: The World of the Hudson River School* (New York: Metropolitan Museum of Art, 1987).

60 *"What was now wanting"*: Louis Legrand Noble, *The Life and Works of Thomas Cole,* ed. Elliot S. Vessell (Hensonville, NY: Black Dome Press, 1997) (originally published 1856).

60 *Thomas, meanwhile, remained:* Barbara Babcock Millhouse, *American Wilderness: The Story of the Hudson River School of Painting* (Hensonville, NY: Black Dome Press, 2007).

60 *"The spring had arrived":* William Dunlap, *A History of the Rise and Progress of the Arts of Design in the United States*, new edition (Boston: C. E. Goodspeed & Co., 1918).

71 *Leaving home at fifteen:* Daniel Huntington, *Asher B. Durand, a Memorial Address* (New York: Century Association, 1887).

79 *"This book . . . addresses":* Nancy Siegel, Introduction to *Along the Juniata: Thomas Cole and the Dissemination of American Landscape Imagery* (Huntingdon, PA: Juniata College Museum of Art, 2003).

80 *The painting:* Franklin Kelly, *Frederic Edwin Church and the National Landscape* (Washington, DC, and London: Smithsonian Institution Press, 1988).

80 *"being a professional artist":* Judith H. Dobrzynski, "The Grand Women Artists of the Hudson River School," Smithsonian.com, July 21, 2010.

83 *Although the bidder:* Carol Vogel, "A Billionaire's Eye for Art Shapes Her Singular Museum," *New York Times,* June 16, 2011.

RICH MAN'S PLAYING GROUND

84 *"Bartram was essentially":* Nancy E. Hoffmann and John C. Van Horne, eds., *America's Curious Botanist: A Tercentennial Reappraisal of John Bartram, 1699–1777* (Philadelphia: Library of Philadelphia and John Bartram Association, 2004).

85 *"The two traveled":* Bill Birns, "A Catskills Catalog," *Catskill Mountain News* (Middletown, NY), April 7, 2010.

86 *"We now had a sight":* Dr. Alexander Hamilton, *Itinerarium; being a narrative of a journey from Annapolis, Maryland, through Delaware, Pennsylvania, New York, New Jersey, Connecticut, Rhode Island, Massachusetts and New Hampshire, from May to September, 1744,* ed. Albert Bushnell Hart (St. Louis: W. K. Bixby, 1907).

88 *By the time:* Cindy S. Aron, *Working at Play: A History of Vacations in the United States* (New York: Oxford University Press, 1999).

88 *"Luxury hotels began":* Kenneth T. Jackson, ed., *The Encyclopedia of New York City* (New Haven, CT: Yale University Press, 1995).

93 *"I've tugged up that steep mountain":* *New York Ledger* (reprinted on the Catskills Archive website).

93 *"With the loftiest":* *Christian Watchman,* 1828.

93 *"an illuminated fairy palace":* Harriet Martineau, *Retrospect of Western Travel,* vol. 1 (London: Saunders & Otley, 1838).

100 *"inhabitant of the village":* J. Van Vechten, *History of Greene County,* vol. 1, 1927 (Cornwallville, NY: Hope Farm Press, 1985).

101 *"The moment arrived":* "Robert Fulton," in *The Museum of Foreign Literature, Science, and Art,* vol. VI (Philadelphia: E. Little & Company, September to December 1838).

106 *The money would buy:* Morris A. Pierce, *Robert Fulton and the Development of the Steamboat* (New York: Rosen Publishing Group, 2003).

108 *"Shays and his followers":* Reeve Huston, *Land and Freedom: Rural Society, Popular Protest, and Party Politics in Antebellum New York* (New York: Oxford University Press, 2000).

LAST STAND

113 *"[I]t is unlikely":* John Conway, *Remembering the Sullivan County Catskills* (Charleston, SC: History Press, 2008).

122 *"One route for the carting":* Norman Cazden, Herbert Haufrecht, and Norman Studer, *Folk Songs of the Catskills* (Albany: State University of New York Press, 1982).

124 *"The bluestone belt":* Henry Balch Ingram, "The Great Bluestone Industry," *Popular Science Monthly,* July 1894.

124 *"Quarrying was a tricky"*: Robert G. Atkinson, "Harry Siemsen: A Traditional Singer in a Changing Society" (MA thesis, State University of New York College at Oneonta, 1969).

125 *"accordingly brought back"*: Dorothy Hurlbut Sanderson, *The Delaware and Hudson Canalway: Carrying Coals to Rondout* (Ellenville, NY: Rondout Valley Publishing Co., 1965).

126 *Surfaced in bluestone:* Robin Pogrebin, "Shaping a Plaza's Next Century," *New York Times*, June 24, 2013.

127 *"[T]hese refugees from famine"*: Alf Evers, "Bluestone Lore and Bluestone Men," *New York Folk Quarterly* 18 (1962).

128 *Siemsen collected and transcribed:* Susan B. Wick and Karl R. Wick, *Kingston and Ulster Townships* (Charleston, SC: Arcadia Publishing, 2009).

130 *By age twenty-eight:* United States National Park Service, *Final Environmental Impact Statement for the River Management Plan: Upper Delaware National Scenic and Recreational River, Delaware, Sullivan, and Orange Counties, New York, Pike and Wayne Counties, Pennsylvania* (1984).

130 *"and in March 1868"*: Allan J. Share, "William M. 'Boss' Tweed," *The Encyclopedia of New York City*, ed., Kenneth T. Jackson. (New Haven, CT: Yale University Press, 1999).

A CALL TO ARMS

133 *"The Sheriff was to Andes sent"*: From a broadside, Delaware County Historical Association.

133 *"stark social and political"*: Reeve Huston, *Land and Freedom: Rural Society, Popular Protest, and Party Politics in Antebellum New York* (New York: Oxford University Press, 2000).

134 *"Beginning in the 1730s"*: Reeve Huston, *The Encyclopedia of New York State* (Syracuse, NY: Syracuse University Press, 2005).

137 *"The farmers worked so"*: Henry Christman, *Tin Horns and Calico: The Story of the Anti-Rent Rebellion* (New York: Henry Holt, 1945).

140 *"The covering which concealed"*: Jay Gould, *History of Delaware County: And Border Wars of New York, Containing a Sketch of the Late Anti-Rent Difficulties in Delaware with Other Historical and Miscellaneous Matter Never Before Published* (Roxbury, NY: Keeny & Gould, 1856).

143 *"were simply an early"*: Joseph E. Persico, "Feudal Lords on Yankee Soil," *American Heritage*, October 1974.

144 *His father, Revolutionary:* Mary Robinson Siev, *Lost Villages: Historic Driving Tours in the Catskills* (Delhi, NY: Delaware County Historical Association, 2002).

146 *"Our husbands are driven"*: Dorothy Kubik, *A Free Soil—A Free People: The Anti-Rent War in Delaware County, New York* (Fleischmanns, NY: Purple Mountain Press, 1997).

147 *"included Edward O'Conner"*: Charles W. McCurdy, *The Anti-Rent Era in New York Law and Politics, 1839–1865* (Chapel Hill: University of North Carolina Press, 2001).

150 *"In the Revolutionary War"*: Robert LeFevre, *History of New Paltz, New York and Its Old Families (from 1678 to 1820) Including the Huguenot Pioneers and Others Who Settled in New Paltz Previous to the Revolution: With an Appendix Bringing Down the History of Certain Families and Some Other Matter to 1850* (Albany, NY: Genealogical Publishing Co., 1909).

150 *"Charles Hardenbergh's house"*: Carleton Mabee, with Susan Mabee Newhouse, *Sojourner Truth: Slave, Prophet, Legend* (New York: New York University Press, 1993).

150 *"She shudders"*: Sojourner Truth, *The Narrative of Sojourner Truth,* ed. Olive Gilbert (Boston: The Author, 1850.

151 *"To all those who think"*: Adele Oltman, "The Hidden History of Slavery in New York," *Nation*, October 24, 2005.

151 *"The Revolution had a"*: Michael E. Groth, "The African American Struggle Against Slavery in the Mid–Hudson Valley, 1785–1827," Hudson River Institute, 1993, www.hudsonrivervalley.org.

151 *"In the nineteenth century"*: Alan J. Singer, *New York and Slavery: Time to Teach the Truth* (Albany: State University of New York Press, 2008).

154 *"[a] woman of remarkable intelligence":* Nell Irvin Painter, *Sojourner Truth: A Life, a Symbol* (New York: W. W. Norton, 1996).

BOYS TO MEN

157 *"He was born":* Charles Burr Todd, *A General History of the Burr Family: With a Genealogical Record from 1193 to 1902* (New York: Knickerbocker Press, 1902).

159 *"Time is flying past":* Clara Barrus, *Our Friend John Burroughs* (New York: Houghton Mifflin, 1914).

159 *"a callow youth":* Clara Barrus, *John Burroughs: Man and Boy* (New York: Doubleday, Page & Co., 1920).

160 *"I said one day":* Jay Gould obituary, *Otsego* (NY) *Herald,* undated.

162 *"Just as there is more":* Edward J. Renehan Jr., *John Burroughs: An American Naturalist* (Delmar, NY: Black Dome Press, 1998).

162 *"never rated literary effort":* Julian Burroughs, in afterword to John Burroughs's *My Boyhood,* 1922.

162 *"Crosby, I'm going":* Maury Klein, *The Life and Legend of Jay Gould* (Baltimore: Johns Hopkins University Press, 1986).

164 *"three hearty cheers":* Letter from Jay Gould to Zadock Pratt, Gouldsboro, Pennsylvania, December 24, 1856, Ralph Ingersoll Collection, Boston University Library.

164 *"I've come to realize":* Edward J. Renehan, *Dark Genius of Wall Street: The Misunderstood Life of Jay Gould, King of the Robber Barons* (New York: Basic Books, 2005).

166 *"I loved him":* John Burroughs, *The Life and Letters of John Burroughs,* ed. Clara Barrus (New York: Russell & Russell, 1968).

167 *"This meant the government":* Ellen Terrell, "Robber Barons: Gould and Fisk," Library of Congress website, September 26, 2012.

170 *"a delighted Jay":* Edward J. Renehan Jr., "Jay Gould's Roxbury," *Guide Magazine,* Catskills Mountain Foundation, www.catskillmtn.org.

173 *He considered Gould:* John Steele Gordon, "Wall Street's Ten Most Notorious Stock Traders," *American Heritage,* Spring 2009.

173 *"[H]is genius was seldom":* John Steele Gordon, "Mephistopheles of Wall Street," *American Heritage,* December 1989.

175 *"Ford Field.":* "Burroughs Joins Edison Campers," *New York Times,* August 30, 1916.

WATER AND POWER

180 *"The destruction on the Schoharie":* Chester G. Zimmer, "Schoharie Valley Floods," *Schoharie County Historical Review,* Fall/Winter 1996.

183 *"Scientists estimated in 1830":* Charles H. Weidner, *Water for a City: A History of New York City's Problem from the Beginning to the Delaware River System* (New Brunswick, NJ: Rutgers University Press, 1974).

185 *"The powers asked":* Diane Galusha, *Liquid Assets: A History of New York City's Water System* (Fleischmanns, NY: Purple Mountain Press, 1999).

187 *"Three Hours Ride":* Wesley Gottlock and Barbara H. Gottlock, *Lost Towns of the Hudson Valley* (Charleston, SC: History Press, 2009).

188 *"If some of them":* David Stradling, *Making Mountains: New York City and the Catskills* (Seattle: University of Washington Press, 2007).

189 *"And so in the fall":* A. J. Loftin, "The Ashokan Reservoir," *Hudson Valley Magazine,* July 17, 2008.

191 *"The transformation":* Camilla Calhoun, "A Town Called Olive: A Perspective on New York City's Water Supply," Westchester Land Trust, 1997.

194 *"Within the space of one":* Bob Steuding, *The Last of the Handmade Dams* (Fleischmanns, NY: Purple Mountain Press, 1989).

194 *"very good farmland":* Alice H. Jacobson, *Beneath Pepacton Waters* (Andes, NY: Pepacton Press, 1988).

IRON-HORSE RACE

198 *In summer:* T. Morris Longstreth, *The Catskills* (New York: Century Co., 1921).

207 *"nothing but huge piles":* Timothy Dwight, *Travels in New England and New York* (London: W. Baynes and Son, and Ogle, Duncan & Co., 1823).

208 *"Diseases were greatly":* Bob Steuding, *The Heart of the Catskills* (Fleischmanns, NY: Purple Mountain Press, 2008).

209 *found one angler:* Ed Van Put, *Trout Fishing in the Catskills* (New York: Skyhorse Publishing, 2007).

213 *"to seek out":* Edward J. Renehan Jr., *John Burroughs: An American Naturalist* (Delmar, NY: Black Dome Press, 1998).

214 *"One day":* John Burroughs and Clifton Johnson, *John Burroughs Talks: His Reminiscences and Comments* (Boston: Houghton Mifflin, 1922).

214 *"some time to manage it":* Henry Ford and Samuel Crowther, *My Life and Work* (New York: Doubleday, Page & Co., 1922).

THE OUTSIDERS

215 *"The land was divided":* Leo Shpall, "Jewish Agricultural Colonies in the United States," *Agricultural History* 24 (1950).

216 *The Jewish pilgrimage:* Abraham D. Lavender and Clarence Steinberg, *Jewish Farmers of the Catskills: A Century of Survival* (Gainesville: University Press of Florida, 1995).

218 *"The mountains in Sullivan":* Phil Brown, *In the Catskills: A Century of the Jewish Experience in "The Mountains"* (New York: Columbia University Press, 2002).

221 *"[T]here were farmhouses":* Susy Clemens, *Papa: An Intimate Biography of Mark Twain* (Garden City, NY: Doubleday, 1988).

223 *"I was convinced":* New York Times, July 19, 1877.

224 *"The Fleischmann story":* P. Christiaan Klieger, *The Fleischmann Yeast Family* (Charleston, SC: Arcadia Publishing, 2004).

225 *"[M]any Jews were affected":* Joel S. Geffen, "Jewish Agricultural Colonies as Reported in the Pages of the Russian Hebrew Press," *American Jewish Historical Quarterly* 60 (1970).

230 *Established in 1869:* Robi Josephson, *Mohonk Mountain House and Preserve* (Charleston, SC: Arcadia Publishing, 2002).

230 *Very soon, 251 rooms:* "Alfred H. Smiley, A Sketch of His Life and Character," *The Citrograph* (Redlands, CA), February 28, 1903.

231 *The Chalfonte manager replied:* Cindy S. Aron, *Working at Play: A History of Vacations in the United States* (New York: Oxford University Press, 1999).

233 *"good and abundant food":* Charles Stanislaus Gill, "Birthplace of the Open-Air Cure in America," in *Good Health*, vol. XLII, ed. J. H. Kellogg, M.D. (Battle Creek, MI: Good Health Publishing Co., 1908).

PLANTING THE SEEDS

242 *"The climate is just like Galicia.":* Joel Pomerantz, *Jennie and the Story of Grossinger's* (New York: Grosset & Dunlap, 1970).

243 "what was needed": Judith Laikin Elkin, *Jews of the Latin American Republics* (Chapel Hill: University of North Carolina Press, 1980).

249 "Dietary Laws Observed": Irwin Richman, *Catskills Hotels* (Charleston, SC: Arcadia Publishing, 2003).

249 "While at first": John Conway, *Remembering the Sullivan County Catskills* (Charleston, SC: History Press, 2008).

252 "The Auto a Good Road Producer": R. H. Johnston, "The Auto a Good Road Producer," *New York Times*, January 17, 1909.

253 A traffic study conducted: David Stradling, *Making Mountains: New York City and the Catskills* (Seattle: University of Washington Press, 2007).

258 "For years after": Janet Forman, "The Borscht Belt's Culinary Thrill Ride," *Globe and Mail* (Toronto), March 15, 2008.

259 "If a guest checked out": "With a Comic to the Catskills," *New Yorker*, June 11, 1966.

259 "There was a humor": Myrna Katz Frommer and Harvey Frommer, *It Happened in the Catskills: An Oral History in the Words of Busboys, Bellhops, Guests, Proprietors, Comedians, Agents, and Others Who Lived It* (Albany: State University of New York Press, 2009).

ABOVE THE LAW

262 "At dinner they introducd themselves": Rich Cohen, *Tough Jews: Fathers, Sons, and Gangster Dreams* (New York: Simon & Schuster, 1998).

266 But this was no sentimental: Robert A. Rockaway, *But He Was Good to His Mother: The Lives and Crimes of Jewish Gangsters* (Jerusalem: Geffen Books, 2000).

266 When a speak owner: Allan May, "Dutch Schultz: Beer Baron of the Bronx," *TruTV Crime Library*, www.crimelibrary.com.

268 While the cartel: Burton B. Turkus and Sid Feder, *Murder, Inc.: The Story of the Syndicate* (Cambridge, MA: Da Capo, 2003).

273 "hangouts of criminals": Michael A. Lerner, *Dry Manhattan: Prohibition in New York City* (Cambridge, MA: Harvard University Press, 2009).

280 "Hoover wanted Lepke": Curt Gentry, *J. Edgar Hoover: The Man and the Secrets* (New York: W. W. Norton, 1991).

281 Two weeks later: "Crime: This Is Lepke," *Time*, September 4, 1939.

ALL THAT GLITTERS

283 "but he expanded": Phil Brown, *Catskill Culture: A Mountain Rat's Memories of the Great Jewish Resort Area* (Philadelphia: Temple University Press, 1998).

285 "From the back tees": Scott Wraight, "Inside Golf: The Front Nine, U.S. Golf Courses with the Most Terrifying Names," *Sports Illustrated*, March 3, 2005.

297 He eventually bought: "Peg-Leg Bates," *New Yorker*, November 20, 1942.

313 "the shtetl": Marcia Littenburg, "The *Tummler*: Carnivalian Laughter in the Catskills," *Jewish Folklore and Ethnology Review* 19 (1997).

316 "I don't take myself": "31 Years Later, New York Renders unto Sid That Which Is Caesar's–Laughter," *People*, July 10, 1989.

316 "I thought he": Greg Crosby, "Florence Caesar," *Tolucan Times* (CA), November 11, 2009.

319 "When you tell a joke": Ruth R. Wiesse, *No Joke: Making Jewish Humor* (Princeton, NJ: Princeton University Press, 2013).

320 "My discovery by Eddie Cantor": Myrna Katz Frommer and Harvey Frommer, *It Happened in the Catskills: An Oral History in the Words of Busboys, Bellhops, Guests, Proprietors, Comedians, Agents, and Others Who Lived It* (Albany: State University of New York Press, 2009).

328 *"that extraordinarily beautiful"*: Bolton Coit Brown, "Early Days at Woodstock," Publications of the Woodstock Historical Society, August–September 1937.

329 *"intended that the families"*: T. Morris Longstreth, *The Catskills* (New York: Century Co., 1921).

331 *"He would only employ"*: Nina Flanaghan, "Hervey White: Brief Life of a Maverick Impresario, 1866–1944," *Harvard Magazine*, July–August 2006.

332 *"free from ownership"*: Alex Ross, "Joyful Noise: Michael Tilson Thomas's 'American Mavericks' Festival," *New Yorker*, April 16, 2012.

339 *"His skill was marvelous"*: Herbert A. Wisby Jr., "Bolton Brown: Dresden's Other Famous Son," *Crooked Lake Review*, November 1995.

340 *"I went to hear"*: John Gilliand (producer), *Pop Chronicles of the 40's: The Lively Story of Pop Music in the 40's.* San Francisco: KSFO-AM, September 26, 1970.

340 *"The two principal candidates"*: St. Clair McKelway and A.J. Liebling, "Who Is This King of Glory?–I, II, III," *New Yorker*, June 13, 20, 27, 1936.

340 *"that historic con man"*: Henry Louis Gates Jr., "Whose Canon Is It, Anyway," *New York Times*, February 26, 1989.

342 *"By September, 1931"*: Carleton Mabee, *Promised Land: Father Divine's Interracial Communities in Ulster County, New York* (Fleischmanns, NY: Purple Mountain Press, 2008).

343 *"News that the county"*: Amity Shlaes, *The Forgotten Man: A New History of the Great Depression* (New York: HarperCollins, 2008).

345 *"I don't have to say"*: "Father Divine, Cult Leader, Dies; Disciples Considered Him God," *New York Times*, September 11, 1965.

347 *"When he emerged"*: "Mostel Remembered," *New York Times*, September 18, 1977.

352 *"It was still too painful"*: Ibid.

361 *"Every major editor"*: Pete Fornatale, *Back to the Garden: The Story of Woodstock* (Clearwater, FL: Touchstone, 2009).

A NEW LEAF

366 *"It's too bad"*: Joyce Wadler, "Every Teenager Should Have a Summer of '65," *New York Times*, July 14, 2013.

368 *"The Catskills melted away"*: Jerry A. Jacobs, "Reflections on the Delmar Hotel and the Demise of the Catskills," in *In the Catskills: A Century of the Jewish Experience in "The Mountains"* (New York: Columbia University Press, 2002).

377 *"There just isn't a Plan B."*: Adam Davidson, "The Least-Bad Bet," *New York Times*, July 14, 2013.

381 *"Ananda's high school-like"*: Shivani Vora, "Escapes: The Simple Life," *New York Times*, December 11, 2008.

382 *"The new cult groups"*: Richard D. Lyons, "Catskills Reawakening After a Long Sleep," *New York Times*, July 25, 1981.

383 *"ultra-Orthodox Jews"*: Nathaniel Popper, "Hasidic-Controlled School Board Roils Rockland County," *Jewish Daily Forward*, December 7, 2009.

HARBINGERS

387 *Besides keeping an active interest:* Josh Rippa, "Dean Gitter: The Catskills' Last Resort?," *Chronogram*, May 2002.

388 *a quarter of a million dollars:* Ibid.

389 *"quietly moved an investment"*: Raymond Hernandez, "Young, Rich and Relocating Yet Again in Hunt for Political Office," *New York Times*, July 11, 2013.

389 *ten minutes from his:* Joe Coscarelli, "Chris Hughes Buys $2 Million House in Husband Sean Eldridge's Dream District," *New York,* "Daily Intelligencer," February 27, 2013.

391 *By the summer of 2013:* Joshua Lyon, "Company in Eden," *New York Times,* July 25, 2013.

392 *"Our two chief economies":* Paul Hond, "The Gas Menagerie," *Columbia Magazine,* Summer 2012.

393 *"Once you lease the land":* Neela Banerjee, "Fracking Debate Divides New York Landowners," *Los Angeles Times,* February 19, 2012.

394 *"The trouble starts":* Tony Ingraffea and Mark Ruffalo, "Don't Frack Illinois (or North Carolina, Georgia, Maryland, New York, Virginia, or Florida)," *Huffington Post,* April 4, 2013.

394 *New York governor Andrew Cuomo:* David Brown, "Assessing the Risks of Fracking," *Albany Times Union,* March 9, 2013.

396 *"The decision . . . marks":* Spencer Hunt, "Shale Driller Must Report Chemicals," *Columbus* (OH) *Dispatch,* September 30, 2013.

401 *For New Yorkers:* Carol White and David White, *Catskill Day Hikes for All Seasons* (Lake Placid, NY: Adirondack Mountain Club, 2002).

MAP SHOWING
SUMMER RESORTS
AMONG THE CATSKILLS
REACHED BY DAY LINE STEAMERS

Selected Bibliography

In addition to those primary sources interviewed and cited in the text, background material was also provided by the following publications and productions.

BOOKS

Abbott, John S. C. *Peter Stuyvesant: The Last Dutch Governor of New Amsterdam*. New York: Dodd, Mead & Co,, 1898.

Antler, Joyce. *You Never Call! You Never Write!: A History of the Jewish Mother*. New York: Oxford University Press, 2007.

Aron, Cindy S. *Working at Play: A History of Vacations in the United States*. New York: Oxford University Press, 1999.

Atkinson, Robert G. "Harry Siemsen: A Traditional Singer in a Changing Society." MA thesis, State University of New York College at Oneonta, 1969.

Avery, Kevin J. "A Historiography of the Hudson River School." In *American Paradise: The World of the Hudson River School*. New York: Metropolitan Museum of Art, 1987.

Baker, Moses Nelson, ed. *Manual of American Water-Works (1888–91)*. New York: Engineering News, 1892.

Barasch, Lynne. *Knockin' on Wood: Starring Peg Leg Bates*. New York: Lee & Low, 2004.

Barrus, Clara, M.D. *John Burroughs: Man and Boy*. Garden City, NY: Doubleday, Page & Co., 1920.

———.*Our Friend John Burroughs*. New York: Houghton Mifflin Co., 1914.

Benjamin, Gerald. *The Oxford Handbook of New York State Government and Politics*. New York: Oxford University Press, 2012.

Birmingham, Stephen. *"Our Crowd": The Great Jewish Families of New York*. New York: Harper & Row, 1967.

Blond, Becca, and China Williams. *New York State*. 3rd ed. Melbourne, Australia: Lonely Planet, 2004.

Blumberg, Esterita "Cissie." In *Remember the Catskills: Tales by a Recovering Hotelkeeper*. Fleischmanns, NY: Purple Mountain Press, 1999.

Bone, Kevin, and Gina Pollara, eds. *Water-Works: The Architecture and Engineering of the New York City Water Supply*. New York: Monacelli Press, 2006.

Bradley, James W. *Before Albany: An Archeology of Native-Dutch Relations in the Capital Region, 1600–1664*. Albany, NY: New York State Museum Bulletin, 2007.

Brown, Phil. *Catskill Culture: A Mountain Rat's Memories of the Great Jewish Resort Area*. Philadelphia: Temple University Press, 1998.

———. *In the Catskills: A Century of the Jewish Experience in "The Mountains."* New York: Columbia University Press, 2002.

Bunyon, Patrick. *All Around the Town: Amazing Manhattan Facts and Curiosities.* New York: Fordham University Press, 1999.

Burroughs, John. *The Life and Letters of John Burroughs.* Edited by Clara Barrus. New York: Russell & Russell, 1968.

———. *My Boyhood.* New York: Doubleday, Page & Co., 1922.

———. *Signs and Seasons.* Boston and New York: Houghton, Mifflin, & Co., 1886.

Burroughs, John, and Clifton Johnson. *John Burroughs Talks: His Reminiscences and Comments.* Boston: Houghton Mifflin, 1922.

Burstein, Andrew. *The Original Knickerbocker: The Life of Washington Irving.* New York: Basic Books, 2008.

Caldwell, Mark. *The Last Crusade: The War on Consumption, 1862–1954.* New York: Atheneum, 1988.

Caro, Robert A. *The Power Broker: Robert Moses and the Fall of New York.* New York: Alfred A. Knopf, 1974.

Cazden, Norman, Herbert Haufrecht, and Norman Studer. *Folk Songs of the Catskills.* Albany: State University of New York Press, 1982.

Channing, Edward. *A History of the United States.* Vol. 2, *A Century of Colonial History, 1660–1760.* New York: Macmillan, 1908.

Charyn, Jerome. *Gangsters and Gold Diggers: Old New York, the Jazz Age, and the Birth of Broadway.* New York: Four Walls Eight Windows, 2003.

Chernow, Ron. *Washington: A Life.* New York: Penguin Press, 2010.

Christman, Henry. *Tin Horns and Calico: The Story of the Anti-Rent Rebellion.* New York: Henry Holt, 1945.

Clark, Willis Gaylord. *The Literary Remains of the Late Willis Gaylord Clark.* Edited by Lewis Gaylord Clark. New York: W. A. Townsend & Co., 1850.

Clearwater, Alphonso T. *The History of Ulster County, New York.* Vol. 1. Westminster, MD: Heritage Books, 2001.

Clemens, Susy. *Papa: An Intimate Biography of Mark Twain.* Garden City, NY: Doubleday, 1988.

Cody, Edward J. *The Governors of New Jersey, 1664–1974.* Edited by Paul A. Stellham and Michael J. Birkner. Trenton, NJ: The Commission, 1982.

Cohen, Rich. *Tough Jews: Fathers, Sons, and Gangster Dreams.* New York: Simon & Schuster, 1998.

Coke, Van Deren. *Andrew Dasburg.* Albuquerque: University of New Mexico Press, 1979.

Conway, John. *Loomis: The Man, the Sanitarium, and the Search for the Cure.* Fleischmanns, NY: Purple Mountain Press, 2006.

———. *Remembering the Sullivan County Catskills.* Charleston, SC: History Press, 2008.

Crockett, Davy. *The Life of Davy Crockett: The Original Humorist and Irrepressible Backwoodsman.* Philadelphia: Porter & Coates, 1865.

Defebaugh, James Eliot. *History of the Lumber Industry of America.* Vol. 2. Chicago: The American Lumberman, 1907.

Donzel, Catherine, Alexis Gregory, and Marc Walter. Preface by Paul Goldberger. *Grand American Hotels.* New York: Vendome Press, 1989.

Duncan, John M. *Travels Through Part of the United States and Canada in 1818 and 1819.* New York: W. B. Gilley, 1823.

Dunlap, William. *A History of the Rise and Progress of the Arts of Design in the United States.* New edition. Boston: C. E. Goodspeed & Co., 1918.

Dunlop. William. *History of the New Netherlands, Province of New York and State of New York, to the Adoption of the Federal Constitution.* Vol. 1. New York: Published by the author, 1839.

Dwight, Timothy. *Travels in New England and New York.* London: W. Baynes and Son, and Ogle, Duncan & Co., 1823.

Dyer, Alan Frank. *James Fenimore Cooper: An Annotated Bibliography of Criticism.* New York: Greenwood Press, 1991.

Eisenstadt, Peter, and Laura-Eve Moss, eds. *The Encyclopedia of New York State*. Syracuse, NY: Syracuse University Press, 2005.

Elkin, Judith Laikin. *Jews of the Latin American Republics*. Chapel Hill: University of North Carolina Press, 1980.

Elliott, Ellen Coit. *It Happened This Way*. Palo Alto, CA: Stanford University Press, 1940.

Ellis, Joseph J. *Revolutionary Summer: The Birth of American Independence*. New York: Alfred A. Knopf, 2013.

Evers, Alf. *The Catskills: From Wilderness to Woodstock*. Woodstock, NY: Overlook Press, 1972 (1982 edition).

———. *Woodstock: History of an America Town*. Woodstock, NY: Overlook Press, 1987.

Flavell, Julie. *When London Was Capital of America*. New Haven, CT: Yale University Press, 2010.

Ford, Henry, and Samuel Crowther. *My Life and Work*. New York: Doubleday, Page, & Co., 1922.

Fornatale, Pete. *Back to the Garden: The Story of Woodstock*. Clearwater, FL: Touchstone, 2009.

Franklin, Wayne. *James Fenimore Cooper: The Early Years*. New Haven, CT: Yale University Press, 2007.

Freedman, Richard. *The Novel*. New York: Newsweek Books, 1975.

Frommer, Myrna Katz, and Harvey Frommer. *It Happened in the Catskills: An Oral History in the Words of Busboys, Bellhops, Guests, Proprietors, Comedians, Agents, and Others Who Lived It*. Albany: State University of New York Press, 2009.

Galie, Peter J. *The New York State Constitution: A Reference Guide*. Westport, CT: Greenwood Press, 1991.

Galusha, Diane. *Liquid Assets: A History of New York City's Water System*. Fleischmanns, NY: Purple Mountain Press, 1999.

Gassan, Richard H. *The Birth of American Tourism: New York, the Hudson Valley, and American Culture, 1790–1830*. Amherst: University of Massachusetts Press, 2008.

Gates, Henry Louis Jr., and Evelyn Brooks Higginbotham, eds. *Harlem Renaissance Lives*. New York: Oxford University Press, 2009.

Gentry, Curt. *J. Edgar Hoover: The Man and the Secrets*. New York: W. W. Norton, 1991.

Gill, Charles Stanislaus. "Birthplace of the Open-Air Cure in America." In *Good Health*, vol. 42. Edited by J. H. Kellogg, M.D. Battle Creek, MI: Good Health Publishing Co., 1908.

Goldstein, Samantha Hope. *Don't Mind Me, I'll Just Sit Here in the Dark: Illuminating the Role of Women in Catskills Performative Culture*. San Diego: University of California Press, 2000.

Gottlock, Wesley, and Barbara H. Gottlock. *Lost Towns of the Hudson Valley*. Charleston, SC: History Press, 2009.

Gould, Jay. *History of Delaware County: And Border Wars of New York, Containing a Sketch of the Late Anti-Rent Difficulties in Delaware with Other Historical and Miscellaneous Matter Never Before Published*. Roxbury, NY: Keeny & Gould, 1856.

Grossinger, Jennie. *The Art of Jewish Cooking*. New York: Bantam, 1958.

Hamilton, Dr. Alexander. *Itinerarium; being a narrative of a journey from Annapolis, Maryland, through Delaware, Pennsylvania, New York, New Jersey, Connecticut, Rhode Island, Massachusetts and New Hampshire, from May to September, 1744*. Edited by Albert Bushnell Hart. St. Louis: W. K. Bixby, 1907.

Hart, Moss. *Act One*. New York: Random House, 1959.

Hoffmann, Nancy E., and John C. Van Horne, eds. *America's Curious Botanist: A Tercentennial Reappraisal of John Bartram, 1699–1777*. Philadelphia: Library of Philadelphia and John Bartram Association, 2004.

Howat, John K., et al. *American Paradise: The World of the Hudson River School*. New York: Metropolitan Museum of Art, 1987.

Hudson, Henry. *Henry Hudson, the Navigator: The Original Documents*. London: Hakluyt Society, 1860.

Hunter, Douglas. *Half Moon: Henry Hudson and the Voyage That Redrew the Map of the New World*. New York: Bloomsbury, 2009.

Huntington, Daniel. *Asher B. Durand, a Memorial Address*. New York: Century Association, 1887.

Hurst, Michael, and Robert Swope, eds. *Casa Susanna*. New York: Powerhouse Books, 2005.

Huston, Reeve. *Land and Freedom: Rural Society, Popular Protest, and Party Politics in Antebellum New York*. New York: Oxford University Press, 2000.

Irving, Peter. *Peter Irving's Journals*. Edited by Leonard B. Beach, Theodore Hornberger, and Wyllis E. Wright. New York: New York Public Library, 1943.

Irving, Pierre M. *The Life and Letters of Washington Irving*. 4 vols. New York: G. P. Putnam, 1862–64.

Irving, Washington *Washington Irving: Three Western Narratives*. Edited by James P. Ronda. New York: Literary Classics of the United States, 2004.

Isham, Samuel. *The History of American Painting*. New York: Macmillan, 1916.

Jackson, Kenneth T., ed. *The Encyclopedia of New York City*. New Haven, CT: Yale University Press, 1995.

Jacobson, Alice H. *Beneath Pepacton Waters*. Andes, NY: Pepacton Press, 1988.

Jones, Brian Jay. *Washington Irving: The Definitive Biography of America's First Bestselling Author*. New York: Arcade Publishing, 2008.

Josephson, Robi. *Mohonk Mountain House and Preserve*. Charleston, SC: Arcadia Publishing, 2002.

Juet, Robert. *Juet's Journal of Hudson's 1609 Voyage*. From *Purchas His Pilgrimes* (1625). Translated by Brea Barthel. Albany, NY: New Netherland Museum, 2006.

Kanfer, Stefan. *A Summer World: The Attempt to Build a Jewish Eden in the Catskills, from the Days of the Ghetto to the Rise and Decline of the Borscht Belt*. New York: Farrar, Straus & Giroux, 1989.

Kelin, Murray. *The Life and Legend of Jay Gould*. Baltimore: Johns Hopkins University Press, 1986.

Kelly, Franklin. *Frederic Edwin Church and the National Landscape*. Washington, DC, and London: Smithsonian Institution Press, 1988.

Kent, Henry Watson. *One Hundred Books Famous in English Literature*. New York: The Grolier Club, 1903.

Kessner, Thomas. *Capital City: New York City and the Men Behind America's Rise to Economic Dominance, 1860–1900*. New York: Simon & Schuster, 2003.

Klein, Maury. *The Life and Legend of Jay Gould*. Baltimore: Johns Hopkins University Press, 1986.

Klieger, P. Christiaan. *The Fleischmann Yeast Family*. Charleston, SC: Arcadia Publishing, 2004.

Kubik, Dorothy. *A Free Soil—A Free People: The Anti-Rent War in Delaware County, New York*. Fleischmanns, NY: Purple Mountain Press, 1997.

Lapthorp, Elise. *Early American Inns and Taverns*. Philadelphia: McBride & Co., 1926.

Lavender, Abraham D., and Clarence B. Steinberg. *Jewish Farmers of the Catskills: A Century of Survival*. Gainesville: University Press of Florida, 1995.

Lawrence, D. H. *Studies in Classic American Literature (The Cambridge Edition of the Works of D. H. Lawrence)*. Cambridge, UK: Cambridge University Press, 2003. Originally published 1923.

Leavitt, Judith Walzer, and Ronald L. Numbers, eds. *Sickness and Health in America: Readings in the History of Medicine and Public Health*. Madison: University of Wisconsin Press, 1997.

LeFevre, Robert. *History of New Paltz, New York and Its Old Families (from 1678 to 1820) Including the Huguenot Pioneers and Others Who Settled in New Paltz Previous to the Revolution: With an Appendix Bringing Down the History of Certain Families and Some Other Matter to 1850*. Albany, NY: Genealogical Publishing Co., 1909.

Lerman, Leo, and Stephen Pascal. *The Grand Surprise: The Journals of Leo Lerman*. New York: Random House, 2007.

Lerner, Michael A. *Dry Manhattan: Prohibition in New York City*. Cambridge, MA: Harvard University Press, 2009.

Lewis, Tom. *The Hudson: A History*. New Haven, CT: Yale University Press, 2005.

Littell, E. *Littell's Living Age*. Boston: E. Littell & Co., 1851.

Locke, Ralph P., and Cyrilla Barr, eds. *Cultivating Music in America: Women Patrons and Activists Since 1860*. Berkeley: University of California Press, 1997.

Longstreth, T. Morris. *The Catskills*. New York: Century Co., 1921.

Lounsbury, Thomas Raynesford. *James Fenimore Cooper*. Boston: Houghton, Mifflin & Co., 1883.

Mabee, Carleton. *Promised Land: Father Divine's Interracial Communities in Ulster County, New York*. Fleischmanns, NY: Purple Mountain Press, 2008.

Mabee, Carleton, with Susan Mabee Newhouse. *Sojourner Truth: Slave, Prophet, Legend*. New York: New York University Press, 1993.

Mackenzie, Robert Shelton. *Sir Walter Scott: The Story of His Life*. Boston: James R. Osgood and Company, 1871.

Mancall, Peter C. *Fatal Journey: The Final Expedition of Henry Hudson*. New York: Basic Books, 2009.

Marcus, Greil. *Mystery Train: Images of America in Rock 'n' Roll Music*. New York: Simon & Schuster, 1975.

———. *The Old, Weird America: The World of Bob Dylan's Basement Tapes*. New York: Picador, 2011.

Martineau, Harriet. *Retrospect of Western Travel*. Vol. I. London: Saunders & Otley, 1838.

Masquerier, Lewis. *Sociology, or, The Reconstruction of Society, Government, and Property upon the Principles of the Equality, the Perpetuity, and the Individuality of the Private Ownership of Life, Person, Government, Homestead and the Whole Product of Labor, by Organizing All Nations into Townships of Self-Governed Homestead Democracies—Self-Employed in Farming and Mechanism, Giving All the Liberty and Happiness to Be Found on Earth*. New York: Published by the author, 1877.

McCurdy, Charles W. *The Anti-Rent Era in New York Law and Politics, 1839–1865*. Chapel Hill: University of North Carolina Press, 2001.

McMurry, James. *The Catskills Witch and Other Tales of the Hudson Valley*. Syracuse, NY: Syracuse University Press, 1974.

Miller, Myrtle Hardenbergh. *The Hardenbergh Family: A Genealogical Compilation*. New York: American Historical Co., 1958.

Millhouse, Barbara Babcock. *American Wilderness: The Story of the Hudson River School of Painting*. Hensonville, NY: Black Dome Press, 2007.

Myers, Kenneth. *The Catskills: Painters, Writers, and Tourists in the Mountains, 1820–1895*. Yonkers, NY: Hudson River Museum of Westchester, 1988.

Noble, Louis Legrand. *The Life and Works of Thomas Cole*. Edited by Elliot S. Vessell. Hensonville, NY: Black Dome Press, 1997. Originally published 1856.

Noggle, Burl. *Into the Twenties: The United States from Armistice to Normalcy*. Urbana: University of Illinois Press, 1974.

Norcross, Frank W. *A History of the New York Swamp*. New York: Chiswick Press, 1901.

Padluck, Ross. *Catskill Resorts: Lost Architecture of Paradise*. Atglen, PA: Schiffer Publishing Ltd., 2013.

Paine, Albert Bigelow. *Mark Twain: A Biography*. New York: Harper & Brothers, 1912.

Painter, Nell Irvin. *Sojourner Truth: A Life, a Symbol*. New York: W. W. Norton, 1996.

Parker, Hershel. *Herman Melville: A Biography*. Vol. 1. Baltimore: Johns Hopkins University Press, 2005.

Pelletreau, William S., A.M. *History of Greene County New York with Biographical Sketches of Its Prominent Men*. Athens, NY: J. B. Beers & Co., 1884.

Pierce, Morris A. *Robert Fulton and the Development of the Steamboat*. New York: Rosen Publishing Group, 2003.

Pliny (the Elder) and John Bostock. *The Natural Elder of Pliny*. Vol. 5. London: G. Bell & Sons, 1856.

Pollack, Eileen. *Paradise, New York*. Philadelphia: Temple University Press, 1998.

Pomerantz, Joel. *Jennie and the Story of Grossinger's*. New York: Grosset & Dunlap, 1970.

Renehan, Edward J. Jr. *Dark Genius of Wall Street: The Misunderstood Life of Jay Gould, King of the Robber Barons*. New York: Basic Books, 2005.

———. *John Burroughs: An American Naturalist*. Delmar, NY: Black Dome Press, 1998.

Reynolds, Cuyler, ed. *Hudson-Mohawk Genealogical and Family Memoirs.* Vol. I. New York: Lewis Historical Publishing Co., 1911.

Richman, Irwin. *Catskills Hotels.* Charleston, SC: Arcadia Publishing, 2003.

"Robert Fulton." In *The Museum of Foreign Literature, Science, and Art.* Vol. VI. Philadelphia: E. Little & Co., September–December 1838.

Rockaway, Robert A. *But He Was Good to His Mother: The Lives and Crimes of Jewish Gangsters.* Jerusalem: Geffen Books, 2000.

Rockwell, Charles. *The Catskill Mountains and the Region Around.* New York: Taintor Brothers & Co., 1869.

Roque, Oswaldo Rodriguez. "The Exaltation of American Landscape Painting." In *American Paradise: The World of the Hudson River School.* New York: Metropolitan Museum of Art, 1987.

Sanderson, Dorothy Hurlbut. *The Delaware and Hudson Canalway: Carrying Coals to Rondout.* Ellenville, NY: Rondout Valley Publishing Co., 1965.

Schoonmaker, Marius. *The History of Kingston, New York: From Its Early Settlement to the Year 1820.* New York: Burr Books, 1888.

Seward, William H. *An Autobiography, from 1801 to 1834.* New York: Derby & Miller, 1891.

Shlaes, Amity. *The Forgotten Man: A New History of the Great Depression.* New York: HarperCollins, 2008.

Shorto, Russell. *The Island at the Center of the World: The Epic Story of Dutch Manhattan and the Forgotten Colony That Shaped America.* New York: Doubleday, 2004.

Siegel, Nancy. Introduction to *Along the Juniata: Thomas Cole and the Dissemination of American Landscape Imagery.* Huntingdon, PA: Juniata College Museum of Art, 2003.

Siev, Mary Robinson. *Lost Villages: Historic Driving Tours in the Catskills.* Delhi, NY: Delaware County Historical Association, 2002.

Singer, Alan J. *New York and Slavery: Time to Teach the Truth.* Albany: State University of New York Press, 2008.

Skinner, Charles M. *Myths and Legends of Our Own Land.* Philadelphia: J. B. Lippincott Co., 1896.

Skinner, Willa. *Remembering Fishkill.* Charleston, SC: History Press, 2008.

Smith, Anita M. *Woodstock: History and Hearsay.* 2nd ed. Woodstock, NY: WoodstockArts, 2006. Originally published 1959.

Steuding, Bob. *The Heart of the Catskills.* Fleischmanns, NY: Purple Mountain Press, 2008.

———. *The Last of the Handmade Dams.* Fleischmanns, NY: Purple Mountain Press, 1989.

Stevens, John Austin, et al., eds. *The Magazine of American History: With Notes and Queries.* Vol. 3. New York: A. S. Barnes & Co., 1879.

Stradling, David. *Making Mountains: New York City and the Catskills.* Seattle: University of Washington Press, 2007.

———. *The Nature of New York: An Environmental History of the Empire State.* Ithaca, NY: Cornell University Press, 2010.

Taylor, Alan. *William Cooper's Town: Power and Persuasion on the Frontier of the Early American Republic.* New York: Alfred A. Knopf, 1995.

Thomas, Lately. *Delmonico's: A Century of Splendor.* Boston: Houghton Mifflin, 1967.

Todd, Charles Burr. *A General History of the Burr Family: With a Genealogical Record from 1193 to 1902.* New York: Knickerbocker Press, 1902.

Truth, Sojourner. *The Narrative of Sojourner Truth.* Edited by Olive Gilbert. Boston: The Author, 1850.

Turkus, Burton B., and Sid Feder. *Murder, Inc.: The Story of the Syndicate.* Cambridge, MA: Da Capo, 2003.

Twain, Mark. *Autobiography of Mark Twain: The Complete and Authoritative Edition.* Vol. 1. Edited by Harriet Elinor Smith. Berkeley: University of California Press, 2010.

United States National Park Service. *Final Environmental Impact Statement for the River Management*

Plan: Upper Delaware National Scenic and Recreational River, Delaware, Sullivan, and Orange Counties, New York, Pike and Wayne Counties, Pennsylvania. 1984.

Van der Donck, Adriaen. *Description of the New Netherlands.* Ithaca, NY: Cornell University Library, 1841.

Van Put, Ed. *Trout Fishing in the Catskills.* New York: Skyhorse Publishing, 2007.

Van Zandt, Roland. *The Catskill Mountain House: America's Grandest Hotel.* Foreword by Brooks Atkinson. Hensonville, NY: Black Dome Press, 1997.

Vidal, Gore. *Burr.* New York: Random House, 1973.

Wadsworth, Ginger. *John Burroughs: The Sage of Slabsides.* New York: Clarion, 1997.

Warner, Charles Dudley. *Washington Irving.* Boston and New York: Houghton Mifflin, 1881.

Weidner, Charles H. *Water for a City: A History of New York City's Problem from the Beginning to the Delaware River System.* New Brunswick, NJ: Rutgers University Press, 1974.

Weisbrot, Robert. *Father Divine and the Struggle for Racial Equality.* Urbana: University of Illinois Press, 1983.

Wenger, Beth S. *New York Jews and the Great Depression: Uncertain Promise.* New Haven, CT: Yale University Press, 1996.

White, Carol, and David White. *Catskill Day Hikes for All Seasons.* Lake Placid, NY: Adirondack Mountain Club, 2002.

Whitehead, Ralph Radcliffe. *Grass of the Desert.* London: Chiswick Press, 1892.

Wick, Susan B., and Karl R. Wick. *Kingston and Ulster Townships.* Charleston, SC: Arcadia Publishing, 2009.

Wiesse, Ruth R. *No Joke: Making Jewish Humor.* Princeton, NJ: Princeton University Press, 2013.

Wilton, Andrew, and Tim Barringer. *American Sublime: Landscape Painting in the United States, 1820–1880.* London: Tate, 2002.

Zinn, Howard. *A People's History of the United States, 1492–Present.* New York: Harper & Row, 1980.

PERIODICALS, NEWSWIRES, AND WEBSITES

"Acra Acts." *Time,* May 4, 1931.

"Alfred H. Smiley: A Sketch of His Life and Character." *The Citrograph* (Redlands, CA), February 28, 1903.

"Al Harei Catskill: The Vacations of Yore." *Jewish Daily Forward,* August 6, 2004.

"Burroughs Joins Edison Campers." *New York Times,* August 30, 1916.

"Competition in the Catskills." *Time,* August 10, 1959.

"Father Divine, Cult Leader, Dies; Disciples Considered Him God." *New York Times,* September 11, 1965.

"Gotham." *New Yorker,* "Talk of the Town," August 7, 1965.

"Murder, Inc." *Time,* April 1, 1940.

"Natural Gas Drilling Overview." NYC.gov, 2012.

"New York v. Diamond." *Time,* May 11, 1931.

"Nightclubs: Competition in the Catskills." *Time,* August 10, 1959.

"Our Christmas Green: Where It Grows, How It Reaches the New York Market, Varieties Used." *New York Times,* December 16, 1880.

"Peg-Leg Bates." *New Yorker,* November 20, 1942.

"31 Years Later, New York Renders unto Sid That Which Is Caesar's—Laughter." *People,* July 10, 1989.

"With a Comic to the Catskills." *New Yorker,* June 11, 1966.

Al-Rikabi, Ramsey. "Tuxedo's Landmark Red Apple Rest Condemned." (Hudson Valley) *Times Herald-Record,* February 8, 2007.

Antrim, Doron Tyler. "Tailgunners and Bootleggers Return." *Daily Mail* (Catskill, NY), September 9, 2010.

Applebome, Peter. "Williamsburg on the Hudson." *New York Times,* August 5, 2011.

Appleton, Kate. "A Jewish Tour of the Lower East Side." *New York,* August 18, 2004.

Avery, Kevin J. "The Hudson River School." *Heilbrunn Timeline of Art History.* Metropolitan Museum of Art, 2000–2011. www.metmuseum.org/toah/.

Bagli, Charles V. "$500 Million Resort Planned on Concord Site in Catskills." *New York Times,* March 16, 2000.

Bahr, Lindsey. "Tony-Winner Harvey Fierstein Returns to Broadway with Cross-Dressing Play *Casa Valentina*." EW.com, September 9, 2013.

Balmaseda, Liz. "Grossinger Etess Recalls Wonderful Kreplach Served in Catskill Resort." *Palm Beach Post,* September 15, 2010.

Banerjee, Neela. "Fracking Debate Divides New York Landowners." *Los Angeles Times,* February 19, 2012.

———. "Spitzer Backs Indian Casino in the Catskills." *New York Times,* February 20, 2007.

Bell, Daniel. "Crime as an American Way of Life." *Antioch Review* 13, no. 2 (Summer 1953).

Berger, Joseph. "Lou Goldstein, Borscht Belt Master of Simon Says, Dies at 90." *New York Times,* April 16, 2012.

Biagli, Charles V. "New Plans for Casinos in the Catskills." *New York Times,* June 11, 2013.

Birns, Bill. "A Catskills Catalog." *Catskill Mountain News* (Middletown, NY), April 7, 2010.

Blotcher, Jay. "Man with a Mission." *Chronogram,* October 29, 2009.

———. "Queens of the Catskills: Casa Susanna." *Chronogram,* March 2007.

Bonomi, Patricia U. "Lord Cornbury Redressed: The Governor and the Problem Portrait." *William and Mary Quarterly*, 3rd series, vol. 51, no. 1 (January 1994).

Boyle, Robert. "The Sour Cream Sierras of New York." *Sports Illustrated,* July 2, 1962.

Brown, Bolton Coit. "Early Days at Woodstock." Publications of the Woodstock Historical Society, August–September 1937.

Brown, David. "Assessing the Risks of Fracking." *Albany Times Union,* March 9, 2013.

Calhoun, Camilla. "A Town Called Olive: A Perspective on New York City's Water Supply." Westchester Land Trust, 1997.

Carmer, Carl. "The Lordly Hudson." *American Heritage,* December 1958.

Chaban, Matt. "Borscht Belt Betting! Catskills Casino Just Two Hours from Home." *New York Observer,* November 23, 2010.

Chadwick, Ian. "The Life & Voyages of Henry Hudson," 1992–2007. www.ianchadwick.com/hudson/.

Cohen, Dave. "Shale Gas Shenanigans." *Energy Bulletin,* March 31, 2010.

Coscarelli, Joe. "Chris Hughes Buys $2 Million House in Husband Sean Eldridge's Dream District." "Daily Intelligencer," *New York,* February 27, 2013.

Crosby, Greg. "Florence Caesar." *Tolucan Times* (CA), November 11, 2009.

Dahl, Curtis. "The Sunny Master of Sunnyside." *American Heritage,* December 1961.

Darrach, Brad. "The Playboy Interview: Mel Brooks." *Playboy,* February 1975.

Davidson, Adam. "The Least-Bad Bet." *New York Times,* July 14, 2013.

Davis, Lisa Selin. "In Catskills, City Buyers Recolonize Bungalows." *New York Times,* August 4, 2013.

De Kay, Ormonde, Jr. "His Most Detestable High Mightiness." *American Heritage,* April 1976.

Dobrzynski, Judith H. "The Grand Women Artists of the Hudson River School." Smithsonian.com, July 21, 2010.

Donnelly, Tim. "Zip, Zip Hooray!" *New York Post,* September 28, 2013.

Dubos, Dr. Rene. "The Romance of Death." *American Lung Association Bulletin,* March 1982.

Duffy, John. "Social Impact of Disease in the Late Nineteenth Century." *Bulletin of the New York Academy of Medicine,* August 1971.

Duray, Dan. "No Sleep Till Bovina: Meet Peter Schjeldahl, Pyromaniac!" *New York Observer,* September 9, 2011.

Erikson, Chris. "The Season's Most Wanted." *New York Post*, November 28, 2012.

Evers, Alf. "Bluestone Lore and Bluestone Men." *New York Folk Quarterly* 18 (1962).

Flanaghan, Nina. "Hervey White: Brief Life of a Maverick Impresario, 1866–1944." *Harvard Magazine*, July–August 2006.

Fleming, Thomas. "Gentleman Johnny's Wandering Army." *American Heritage*, December 1972.

Foderaro, Lisa W. "New Vision for Catskill Development, Without Cards." *New York Times*, May 8, 2008.

Forman, Janet. "The Borscht Belt's Culinary Thrill Ride." *Globe and Mail* (Toronto), March 15, 2008.

Fox, Margalit. "Irving Cohn, King Cupid of the Catskills, Dies at 95." *New York Times*, October 3, 2012.

Freedman, Morris. "The Green Pastures of Grossinger's." *Commentary*, July 1954.

Fricke, David. "Janis Joplin: The Woodstock Experience" (CD review). *Rolling Stone,* July 20, 2009.

Gates, Henry Louis Jr. "Whose Canon Is It, Anyway." *New York Times*, February 26, 1989.

Geffen, Joel S. "Jewish Agricultural Colonies as Reported in the Pages of the Russian Hebrew Press." *American Jewish Historical Quarterly* 60 (1971).

Glueck, Grace. "A Not-Quite Utopia Where Artists Shared Their Talents." *New York Times*, April 22, 2005.

Gold, Russell. "Faulty Wells, Not Fracking, Blamed for Water Pollution." *Wall Street Journal*, March 13, 2012.

Gordon, John Steele. "Mephistopheles of Wall Street." *American Heritage*, December 1989.

———. "To a Spectacular Dying Young." *American Heritage*, November 1992.

———. "Wall Street's Ten Most Notorious Stock Traders." *American Heritage*, Spring 2009.

Graham, Adam H. "Next Stop: Catskills." *Travel+Leisure*, August 2011.

Grossinger, Tania. "Catskills Homecoming." *Daily News* (New York), October 1, 1995.

Groth, Michael E. "The African American Struggle Against Slavery in the Mid-Hudson Valley, 1785–1827." Hudson River Institute, 1993. www.hudsonrivervalley.org.

Hanley, Robert. "Copter Crash Kills 3 Aides of Trump." *New York Times*, October 11, 1989.

Hargreaves, Reginald. "Burgoyne and America's Destiny." *American Heritage*, June 1956.

Heaton, Claude Edwin, M.D. "Yellow Fever in New York City." *Bulletin of the Medical Library Association*, April 1946.

Hernandez, Raymond. "Young, Rich and Relocating Yet Again in Hunt for Political Office." *New York Times*, July 11, 2013.

Higgins, Bill. "Mark Ruffalo's Water Crusade." *Hollywood Reporter,* May 6, 2011.

Hill, Michael. "Catskills Still Searched for Gangster's Buried Treasure." Associated Press, July 16, 2005.

Hollander, Sophia. "Catskills' Kutsher's Turns Back the Clock." *Wall Street Journal*, August 24, 2010.

Hond, Paul. "The Gas Menagerie." *Columbia Magazine,* Summer 2012.

Horn, Jordana. "Live from the Catskills." *Jewish Daily Forward*, January 11, 2012.

Hunt, Spencer. "Shale Driller Must Report Chemicals." *Columbus* (OH) *Dispatch*, September 30, 2013.

Ingersoll, Ernest. "At the Gateway of the Catskills–Part 1." *Harper's New Monthly Magazine,* May 1877.

Ingraffea, Tony, and Mark Ruffalo. "Don't Frack Illinois (or North Carolina, Georgia, Maryland, New York, Virginia, or Florida)." *Huffington Post*, April 4, 2013.

Ingram, Henry Balch. "The Great Bluestone Industry." *Popular Science Monthly*, July 1894.

Israel, Steve. "Who Knew About Woodbourne on a Summer's Saturday Night?" *Times Herald-Record* (Middletown, NY), August 28, 2005.

Jacobs, Andrew. "Kosher Pizza and Wild Oats in the Catskills." *New York Times,* September 2, 2005.

Johnston, R. H. "The Auto a Good Road Producer." *New York Times*, January 17, 1909.

Joselit, Jenna Weissman. "Leisure and Recreation in the United States." In *Jewish Women: A Comprehensive Historical Encyclopedia,* jwa.org/encyclopedia, March 1, 2009.

Kanfer, Stefan. "In New York: Simon Says Condo." *Time,* October 27, 1986.

Kilgannon, Corey. "Weekdays, the Rabbi Dined Out." *New York Times,* August 21, 2009.

Klein, Judith. "History in the Making." *Columbia Magazine,* Winter 2011–12.

Kompanek, Christopher. "Band Width." *New York Post,* May 12, 2011.

Leonard, Mike. "Brightly Hued Makeover Revives Rural Town." *Today* show, November 7, 2012. www.today.com.

Levine, Dr. Yitzchok. "Jewish Colonial Farming in America: An Experiment That Went Terribly Wrong." *Hamodia Magazine,* February 3, 2010.

Littenberg, Marcia. "The *Tummler*: Carnivalian Laughter in the Catskills." *Jewish Folklore and Ethnology Review* (1997).

Loftin, A. J. "The Ashokan Reservoir." *Hudson Valley Magazine,* July 17, 2008.

Long, Jay. "Joseph Naughton Receives Prison Conviction for Violating Probation." *Hudson Valley Insider,* May 1, 2011.

Lyon, Joshua. "Company in Eden." *New York Times,* July 25, 2013.

Lyons, Richard D. "Catskills Reawakening After a Long Sleep." *New York Times,* July 25, 1981.

Lyttle, Bethany. "House Tour: Kingston, N.Y." *New York Times,* March 11, 2011.

Martinez, Julio. "Saturday Night at Grossinger's" (regional theater review), *Variety,* June 20, 2005.

Mascia, Jennifer. "Few Laughs Left in a Catskill Town Struggling to Survive." *New York Times,* December 19, 2009.

May, Allan. "Dutch Schultz: Beer Baron of the Bronx." *TruTV True Crime Library.* www.crimelibrary.com.

McGarth, Charles. "Robert Caro Is a Dinosaur, and Thank God for That." *New York Times Magazine,* April 15, 2012.

McKelway, St. Clair, and A. J. Liebling. "Who Is This King of Glory?–I, II, III." *New Yorker,* June 13, 20, 27, 1936.

Navarro, Mireya. "Latest Drilling Rules Draw Objections." *New York Times,* July 15, 2011.

———. "A New Weapon in the Fracking Wars." *New York Times,* March 29, 2012.

New York Central & Hudson River Railroad. *Health and Pleasure on "America's Greatest Railroad": Descriptive of Summer Resorts and Excursion Routes, Embracing More Than One Thousand Tours by the New York Central & Hudson River Railroad.* New York, July 12, 1895.

Nocera, Joe. "A Fracking Rorschach Test." *New York Times,* October 5, 2013.

Noggle, Burl. "The Twenties: A New Historiographical Frontier." *Journal of American History* 53 (1966).

Novinson, Michael. "Fire Destroys Tamarack Lodge in Wawarsing, Leaves Several Families Homeless." *Times Herald-Record* (Middletown, NY), April 7, 2012.

O'Connor, Anahad. "Interior Secretary Rejects Catskill Casino Plans." *New York Times,* January 5, 2008.

O'Keefe, Brian. "Exxon's Big Bet on Shale Gas." *Fortune,* April 30, 2012.

Oltman, Adele. "The Hidden History of Slavery in New York." *Nation,* October 24, 2005.

Persico, Joseph E. "Feudal Lords on Yankee Soil." *American Heritage,* October 1974.

Pogrebin, Robin. "Shaping a Plaza's Next Century." *New York Times,* June 24, 2013.

Popper, Nathaniel. "Hasidic-Controlled School Board Roils Rockland County." *Jewish Daily Forward,* December 7, 2009.

Putnam, G. W. "Four Months with Charles Dickens." *Atlantic Monthly,* October 1870.

Randall, Michael. "Bloomingburg Residents Pack Meeting with Protests." *Times Herald-Record* (Middletown, NY), September 27, 2013.

Renehan, Edward J. Jr. "Jay Gould's Roxbury." *Guide Magazine,* Catskills Mountain Foundation. www.catskillmtn.org.

Revkin, Andrew C. "The Stuff of Dreams: Dutch Schultz's Buried Loot." *New York Times,* November 1, 1997.

Richler, Mordecai. "The Catskills: Land of Milk and Money." *Holiday,* July 1965.

Rippa, Josh. "Dean Gitter: The Catskills' Last Resort?" *Chronogram,* May 2002.

Rosenberg, Noah, and Peter Applebome. "In Catskill Communities, Survivors Are Left with Little but Their Lives." *New York Times,* August 29, 2011.

Rosenberg, Shmarya. "Controversy over New Satmar Hasidic Village Continues." FailedMessiah .com, September 24, 2013.

Rosencrans, Dorothy. "King Cupid." *Boca Raton News,* December 18, 1999.

Ross, Alex. "Joyful Noise: Michael Tilson Thomas's 'American Mavericks' Festival." *New Yorker,* April 16, 2012.

Rothstein, Mervyn. "From Jewish Eden to Embarrassment." *New York Times,* January 6, 1990.

Sager, Jeanne, and Fred Stabbert III. "Few Answers to Death at Western Hotel." *Sullivan County Democrat,* April 15, 2008.

Semple, Kirk. "A Dilemma, a Promise, a Voice: After the Storm." *New York Times,* September 5, 2011.

Sen, Indrani. "Digging for Ramps: Too Deep?" *New York Times,* April 20, 2011.

Shepard, Richard F. "Jennie Grossinger Dies at Resort Home." *New York Times,* November 21, 1972.

———. "Pop Rock Festival Finds New Home." *New York Times,* July 23, 1969.

Shpall, Leo. "Jewish Agricultural Colonies in the United States." *Agricultural History* 24 (1950).

Spooner, W. W. "The Van Rensselaer Family." *American Historical Magazine,* January 1907.

Sullivan, John. "Tuxedo Historical Society Invites Memories, Memorabilia from Red Apple Rest." *Times Herald-Record* (Middletown, NY), July 27, 2009.

Taylor, Kate. "Fire in Catskills Destroys Site of Old Brown's Hotel." *New York Times,* April 16, 2012.

Terrell, Ellen. "Robber Barons: Gould and Fisk." Library of Congress website, September 26, 2012.

Traster, Tina. "Callicoon Calling." *New York Post,* August 4, 2011.

Tynan, Kenneth. "Frolics and Detours of a Short Hebrew Man." *New Yorker,* October 30, 1978.

VanSpanckeren, Kathryn. *Outline of American Literature.* United States Information Agency website, undated.

Vogel, Carol. "A Billionaire's Eye for Art Shapes Her Singular Museum." *New York Times,* June 16, 2011.

Vora, Shivani. "Escapes: The Simple Life." *New York Times,* December 11, 2008.

Wadler, Joyce. "Every Teenager Should Have a Summer of '65." *New York Times,* July 14, 2013.

Walsh, Bryan. "Could Shale Gas Power the World?" *Time,* March 31, 2011.

Whitman, Victor. "Empire Resorts Talks with Former Cappelli Partner on Concord." *Times Herald-Record* (Middletown, NY), April 12, 2011.

———. "Showdown in the Catskills: Judge Orders Hasidim to Get Out." *Times Herald-Record* (Middletown, NY), August 5, 2009.

Williams, Roger M. "A Rough Sunday at Peekskill." *American Heritage,* April 1976.

Wisby, Herbert A., Jr. "Bolton Brown: Dresden's Other Famous Son." *Crooked Lake Review,* November 1995.

Wraight, Scott. "Inside Golf: The Front Nine, U.S. Golf Courses with the Most Terrifying Names." *Sports Illustrated,* March 3, 2005.

Zimmer, Chester G. "Schoharie Valley Floods." *Schoharie County Historical Review,* Fall/Winter 1996.

FILMS

Bergstein, Eleanor (writer), and Emile Ardolino (director). *Dirty Dancing.* Vestron Pictures, 1987.

Bernstein, Walter (writer), and Martin Ritt (director). *The Front.* Columbia Pictures, 1976.

Carey, Tobe (coproducer/director). *The Catskill Mountain House and the World Around* (documentary film), 2010.

Hirsch, Michael, Richard Lowe, and Daphne Pinkerson (writers), and Daphne Pinkerson (director). *Triangle: Remembering the Fire.* HBO Documentaries, 2011.

Kober, Arthur (writer), and Alfred Santell (director). *Having a Wonderful Time.* RKO Pictures, 1938.

RADIO PROGRAM

Gilliand, John (producer). *Pop Chronicles of the 40's: The Lively Story of Pop Music in the 40's.* San Francisco: KSFO-AM, September 26, 1970.

STAGE PRODUCTIONS

Dunlop, William. *A Trip to Niagara; or, Travellers in America.* 1828.

Korber, Arthur, and Joshua Logan (writers, based on Korber's *Having Wonderful Time*), and Harold Rome (composer and lyricist). *Wish You Were Here.* 1952.

Twist, Mary Lewis's farm, Callicoon Center, New York, 2015
(Courtesy V. Wilson)

Index

Page numbers in *italics* refer to illustrations.

Humboldt, Alexander von, 81
Hunter, Douglas, 5
Hunting, Ephraim, 145
Hunting Tavern, 145, 149
Huntington, Daniel, 71, 75–6, 77
Hurleyville, 218, 226
Hurricane Irene, 180
Huston, Reeve, 108, 133, 134, 148
Huston, Walter, 136
Hutton, Lawrence, 221–2
Hyde, Edward, Third Earl of Clarendon (Lord
 Cornbury), 16–17
Hyde Park, 345–6
hydraulic fracturing, x, 392–401

Ichabod Crane (character), 35, 37, 39, 40, 67
Ideal Plaza, 294
Incredible String Band, 359
Indian Gaming Regulatory Act, 371, 374
Ingraffea, Anthony, 394
Inman, Henry, 210–11
Inness, George, 82–3
Inniss, Ruth and Roy, 298–299
International Ladies' Garment Workers' Union,
 314, 335–6
interracial movements, 340–50
"In the Catskill Mountains" (Samuel), 257
Irish tourism, 295
Iroquois nation, 12, 17
Irvin, Mary, 237
Irving, Ebenezer, 37
Irving, Peter, 33
Irving, Washington, 27–41, 50–1, 54, 65, 67, 98,
 156, 229
 Ballston Spa, 94, 95
 Diedrich Knickerbocker hoax, 27–30, 41–2
 essays and stories, 36–41
 local legends, 30–5, 48, 96, 105
 newspaper writing, 33–4
 "Sunnyside" home, 51, 54, 228–9
Irvington Hotel, 335–6
Isham, Samuel, 56
The Island at the Center of the World (Shorto), 4
Issac McCaslin (character), 53
Italian tourism, 295
It Happened in the Catskills (Frommer and
 Frommer), 302
Itinerarium (Hamilton), 85–6
It's a Wonderful Life, 39, 279

Jacks, Elizabeth, 61, 63, 64, 67–72, 75, 79, 80
Jackson, Andrew, 74, 228
Jacobs, Claire and Jeremy, 368
Jacobs, Max, 368

James, Duke of York, 12
Jay, John, 21
Jefferson, Joseph, 38
Jefferson, Thomas, 103, 182
Jefferson Airplane, 359, 361, 368
Jennie and the Story of Grossinger's (Pomerantz),
 245
Jessen, Friedrich, 231
Jewett, 299
Jewish farming communities, 216, 239, 243–4, 328
Jewish immigrants, 220, 224, 239–40, 243, 303,
 382–3
Jewish tourism, x–xi, 215–28, 295
 anti-Semitism, 175–6, 222–5, 229, 230–1, 327,
 329, 335–7, 365
 cottages and bungalow colonies, 255–8, 383
 entertainment, 310–21
 ethnic segregation, 217–28, 229, 249–50
 farmhouses and boardinghouses, 240–9
 food and dining, 303–10
 Golden Age, 282–325, 364–77
 Grossinger's Terrace Hill House, ix, 248, 249,
 259, 263, 282–8, 290–1
 Hirsch Fund, 243
 hotel and resort ownership, 249–59
 kuchalayn arrangements, 252–4, 255
 land development, 224–7
 matchmaking, 321–5
 Old vs. New World values, 257
 ultra-Orthodox sects, 370, 378–9, 382–5
Jimi Hendrix and Gypsy Sun and Rainbows, 359
Jockey Hill, 127
Johansson, Ingemar, 301
John Burroughs Association, 175
Johnson, Van, 317
Johnston, R. H., 252
Jolson, Al, 38
Jones, Abigail, 65
Jones, John Paul, 45
Joplin, Janis, 353, 359, 360, 361, 362
A Journey to Ye Cat Skill Mountains with Billy
 (J. Bartram), 85
JPMorgan Chase, 183
Juet, Robert, 5–11

Kaaterskill Clove, 83, 98, 108
Kaaterskill Clove Highway, 253
Kaaterskill Creek, 209, 211, 391
Kaaterskill Falls, 83, 85, 96, 251
Kaaterskill: From the Catskill Mountain House to
 the Hudson River School (Gildersleeve), 90
Kaaterskill Hotel, 200–6, 251–2
Kaaterskill Station, 205
Kael, Pauline, 302

A NOTE ON THE TYPE

This book was set in Garamond, a type named for the famous Parisian type cutter Claude Garamond (ca. 1480–1561). Garamond, a pupil of Geoffroy Tory, based his letter on the types of the Aldine Press in Venice, but he introduced a number of important differences, and it is to him that we owe the letter now known as "old style."

The version of Garamond used for this book, Berthold Garamond, is an interpretation of the original Garamond types by Günter Gerhard Lange. It was released in 1972.

Composed by North Market Street Graphics,
Lancaster, Pennsylvania

Printed and bound by Tien Wah Press,
Singapore

Designed by Cassandra J. Pappas